Controversial Images

Controversial Images

Media Representations on the Edge

Edited by

Feona Attwood
Middlesex University, UK

Vincent Campbell
University of Leicester, UK

I. Q. Hunter
De Montfort University, UK

and

Sharon Lockyer
Brunel University, UK

palgrave
macmillan

First published 2013 by
PALGRAVE MACMILLAN

Palgrave Macmillan in the UK is an imprint of Macmillan Publishers Limited, registered in England, company number 785998, of Houndmills, Basingstoke, Hampshire RG21 6XS.

Palgrave Macmillan in the US is a division of St Martin's Press LLC, 175 Fifth Avenue, New York, NY 10010.

Palgrave Macmillan is the global academic imprint of the above companies and has companies and representatives throughout the world.

Palgrave® and Macmillan® are registered trademarks in the United States, the United Kingdom, Europe and other countries.

ISBN 978–0–230–28405–0

This book is printed on paper suitable for recycling and made from fully managed and sustained forest sources. Logging, pulping and manufacturing processes are expected to conform to the environmental regulations of the country of origin.

A catalogue record for this book is available from the British Library.

A catalog record for this book is available from the Library of Congress.

10 9 8 7 6 5 4 3 2 1
22 21 20 19 18 17 16 15 14 13

Printed and bound in the United States of America

Contents

List of Tables and Figures

Tables

Figures

Acknowledgements

We would like to thank the following for supplying and allowing us to reproduce the following images: Rob Beschizza at BoingBoing for 'Dude, her head's bigger than her pelvis'; Georgi Kozhuharov for the billboard image of Azis; Corbis for the images of militants burning the Danish flag; Camp X-Ray and Cho Seung Hui; Trevor Brown for Humpty; China Hamilton for the still from NF713; Division Creative Agency Inc. for the Captivity image; and the Random House Group Limited for the cover image of Michael Buerk's book, *The Road Taken*.

Ian Hunter would like to thank the Faculty of Art, Design and Humanities at De Montfort University for granting him study leave during which he co-edited the book.

Notes on Contributors

Rüstem Ertuğ Altınay is a doctoral candidate at New York University, US. His main area of research is gender, sexuality, and body politics in Turkey. He has published in a range of academic journals and edited volumes and has held visiting research fellowships at Internationales Forschungszentrum für soziale und ethische Fragen in Salzburg, the George Eckert Institute for International Textbook Research, and the Orient Institute Istanbul.

Feona Attwood is Professor at Middlesex University, UK. Her research is in the area of sex in contemporary culture, and in particular, in onscenity; sexualization; sexual cultures; new technologies, identity and the body; and controversial media. She is the editor of *Mainstreaming Sex: The Sexualization of Western Culture* (2009) and *porn.com: Making Sense of Online Pornography* (2010)

Martin Barker is Professor at the University of East Anglia, UK. He has researched and published extensively across many fields, including the history of censorship campaigns and audience responses to controversial films and other materials. He led the international project into the reception of *The Lord of the Rings*, and has conducted contracted research for the British Board of Film Classification into audience responses to screened sexual violence. He has published 13 books, most recently *A 'Toxic Genre': The Iraq War Films* (2011). He is Joint Editor of the online journal *Participations*.

Bruce Bennett is Lecturer in Film Studies in the Lancaster Institute for Contemporary Arts at Lancaster University, UK. His publications include articles on Georges Bataille and film, cinema and the war on terror, the co-edited collection, *Cinema and Technology: Theories, Cultures, Practices* (2008) and the forthcoming monograph, *The Cinema of Michael Winterbottom: Borders, Terror and Intimacy*.

Paul Brighton worked briefly in commercial radio, before joining the BBC. He was a news and current affairs presenter on BBC Radio for almost 20 years, before joining University of Wolverhampton, UK, where he is now Executive Principal Lecturer and Head of Media and Film. His other books include *News Values* (2007) and *Original Spin: Downing Street and the Press in Victorian Britain* (forthcoming).

Vincent Campbell is a lecturer in the Department of Media & Communication at the University of Leicester, UK. His published work to date concerns journalism, political communication and the application of new media technologies to traditional media forms such as documentary and factual entertainment.

Catherine Ann Collins received her PhD from the University of Minnesota, and is a professor in the Department of Rhetoric and Media Studies at Willamette University, US. She writes and teaches in the areas of visual rhetoric, narrative theory, the rhetoric of war, memory and memorials, and media framing. Recent publications are in *Continuum*, *Media International Australia*, *Interdisciplinary Aspects of Climate Change*, and *International Dimensions of Mass Media Research*.

Jeremy Collins lectures in media studies at London Metropolitan University, UK. His research interests include risk communication, political communication, media ethics and news management, and he is course organizer for the MA programme in Communications Management (Public Relations).

David Douglass is Dean of Campus Life and Professor of Rhetoric and Media Studies at Willamette University, US. He earned his BA and MA at the California State University, Fresno, and his PhD at the Pennsylvania State University, all in Speech Communication. He has served as editor-in-chief of the Journal of the Northwest Communication Association, and his recent scholarship focuses on autobiography, visual rhetoric, and metaphor.

I. Q. Hunter is Reader in Film Studies at De Montfort University, Leicester, UK. He has published widely on cult and exploitation films, including *British Science Fiction Cinema* (edited, 1999) and *British Trash Cinema* (forthcoming).

Meredith Jones is Senior Lecturer at the University of Technology, Sydney, Australia, where she coordinates courses in Interactive Multimedia. Her research is based around the intersections between culture and technology, gender, popular media studies and feminist theories of the body. She is the co-founder (with Suzanne Boccalatte) of the Trunk books series (trunkbook.com), the first of which was *Hair* (2009). Her publications include *Skintight: An Anatomy of Cosmetic Surgery* (2008) and (with Cressida Hayes) *Cosmetic Surgery: A Feminist Primer* (2009).

Steve Jones is Lecturer in the Department of Media at Northumbria University, UK. His research is centred on the topics of violence and sex,

focusing on the horror genre in particular. His theoretical interests are primarily based around the philosophy of self and gender studies. He is currently writing a monograph entitled *Torture Porn: Popular Horror in the Era of Saw*.

Julia Kennedy is Senior Lecturer in Journalism at University College Falmouth, UK. Her research interests lie in the intersection of representations of crime, conflict and trauma with new media technologies. She has published work on YouTube and the Madeline McCann case in *Journalism Studies* and is currently writing about young people, the Internet and censorship.

Plamena Kourtova is a PhD Candidate in Ethnomusicology at Florida State University, US, and is a native of Bulgaria. Her research interests include Balkan popular music, ethnopoetics, nationalism, the economy of music, and global popular culture. She is currently working on her doctoral dissertation on the topic of popular music and culture in Bulgaria after 1989.

Sharon Lockyer is Lecturer in Sociology and Communications at Brunel University, UK. She researches in the sociology of mediated culture and critical comedy studies. She has published in a wide range of academic journals. She is the editor of *Reading Little Britain: Comedy Matters on Contemporary Television* (2010) and the co-editor (with Michael Pickering) of *Beyond a Joke: The Limits of Humour* (2005, 2009).

Stephen Maddison is Principal Lecturer in Cultural Studies at the University of East London, UK. He is the author of *Fags, Hags and Queer Sisters: Gender Dissent and Heterosocial Bonds in Gay Culture* (2000) and has published work on the cultural politics of sexuality in a number of journals and edited collections. He is working on a monograph titled *The Myth of Porn*. He co-runs the website www.opengender.org.uk.

Susanna Paasonen is Professor of Media Studies at the University of Turku, Finland. Her research addresses Internet research, pornography, popular culture and affect theory. She is the editor of *Pornification: Sex and Sexuality in Media Culture* (with Kaarina Nikunen and Laura Saarenmaa, 2007), *Working with Affect in Feminist Readings: Disturbing Differences* (with Marianne Liljeström, 2011) and the author of *Figures of Fantasy* (2005) and *Carnal Resonance: Affect and Online Pornography* (2011).

Julian Petley is Professor of Journalism and Screen Media in the School of Arts, Brunel University, UK. His most recent publications are *Film and Video Censorship in Modern Britain* (2011) and *Censorship: A Beginner's*

Guide (2009). He is co-principal Editor of the *Journal of British Cinema and Television*, chair of the Campaign for Press and Broadcasting Freedom and a member of the board of Index on Censorship.

Caroline Ruddell is Lecturer in Film and Television at St. Mary's University College at Strawberry Hill, UK. She has published on witchcraft in television, anime and the representation of identity onscreen. Caroline is currently researching the use of Rotoshop in filmmaking, and is also working on aspects of the Gothic and fairy tale in popular film and television. She is Reviews Editor for the Sage publication *animation: an interdisciplinary journal* and sits on various editorial boards.

Clarissa Smith is Reader in Sexual Cultures at the University of Sunderland, UK. Her research is in the areas of sexuality in contemporary culture and, in particular, pornographies, their production, consumption and regulation. She is the author of *One for the Girls! The Pleasures and Practices of Women's Porn* (2007).

Adam Stapleton is a PhD candidate in the school of Communication Arts at the University of Western Sydney, Australia, where he has worked previously as a casual academic. His dissertation, currently under revision, examines the development of heterogeneous forms of child pornography. His published work focuses upon the social and conceptual problems that are related to the proliferation of child pornography within Anglophone culture. He is currently writing a monograph on the globalization of lolicon culture for a series on transgression. Broader research interests include horror films, low brow art and other forms of loathsome entertainment.

Introduction: Media Controversy and the Crisis of the Image

Feona Attwood, Vincent Campbell, I.Q. Hunter and Sharon Lockyer

The media are inextricable from controversy. Their emergence and development have been dogged, determined and accelerated by censorship, media panics and public fascination with the seemingly uncontrollable spread of disturbing and taboo-breaking images into everyday life. Yet 'controversy' is a rarely used and much under-theorized term in academic studies of the media, even though controversies over specific images, from 'video nasties' to snapshots from Abu Ghraib, have structured our understanding of the media's power, seductiveness and dangers.

Examining controversial images is important for understanding media because it reveals the workings of censorship and regulation, the construction of social and sexual norms and taboos and the limits and conventions of media forms and genres and how these are challenged and overturned. This collection, which offers a series of instructive case studies of recent media controversies, provides a fruitful starting point for considering key issues of representation, performance and interpretation; wars over imagery; models of media use; shifts in regulation; ethics and aesthetics; modes of reflection and interaction; the relation of pleasure, cruelty, disgust, arousal and horror; and the shifting boundaries of what is and is not acceptable. Controversial images may be 'at the edge' of what is permissible, but this is because the image is now at the centre of concerns about technology, representation and surveillance in a mediascape obsessed with sensation and novelty, the fabrication of shock and conflict, and a fascination with what constitutes the 'real'. Especially important, of course, is analysing the impact of the Internet, which makes controversial images indiscriminately accessible and virally omnipresent and increasingly abolishes distinctions between public and private. The goal of this book is to show how controversial images not only raise questions about media ethics in relation

1

to human rights and responsibilities but are intimately involved in fundamental issues such as how relations between the media and its audiences and the global and the local are built and maintained; why clashes between cultures and within cultures occur around and through media; how the development of new technologies disturbs established ways of doing things; and how controversies are created, sustained, managed, exploited, appropriated and enjoyed by a range of interested parties, from politicians and media barons to regulators, critics and fans. The study of controversial images is essential at a time when the media seem ever more invasive and private life ever more closely surveilled, and when consensus about the regulation of media is increasingly hard to reach.

The elements of controversial images

Although a seemingly contemporary concern, the controversial image has a long history, and what has made imagery 'controversial' has been, and continues to be, complex and fluid. We can find examples of controversial imagery in religion, for instance, throughout history. Iconoclasm, the destruction of religious icons and other symbols, has often accompanied important political or religious changes and the term has come to be associated with challenges to convention and tradition. Central to the controversial nature of imagery in this context are concerns about various types of harm that might befall people exposed to these images. The 'media effects' tradition goes back a very long way, with its assumption that images have a special power to bypass the conscious mind and pervert our 'true' natures. Sixteenth-century ecclesiastical discourses emphasized the role of profane images in provoking lust and a concern with dangerous forms of representation can be found in 'religious, then in moral and juridical and finally in aesthetic and medical [...] discourses' (Falk 1993: 2–7). In moral discourses on aesthetics the clear distinction that is made between modes of reception suggests that a presumed lack of distance from images is associated with controversial uses of media. Distance, reflection and contemplation are presented as necessary for an 'aesthetic experience' while closeness to images breaks this bourgeois ideal of aesthetic contemplation (Falk 1993: 7–11).

The 'closeness' of images and the discomfort they may provoke also lies in their ability to disrupt boundaries of various kinds, and the capacity for imagery to disrupt boundaries has expanded over time. Once images remained restricted in their prevalence and accessibility

but now technologies of reproduction and dissemination have enabled physical boundary disruptions. Controversies have dogged new media technologies such as television, videogame consoles and the Internet which reach into spaces previously perceived to be, on the one hand, private and personal and, on the other, under patriarchal or familial control. In doing so, they can disrupt, and arguably democratize, hierarchies of access to knowledge and entertainment, which is one reason why controversy often focuses on young people's use of media technologies. Similarly, controversial images can now reach outwards through those same technologies, crossing geographical boundaries and bringing imagery acceptable in one context into new contexts where it becomes controversial or even profane. As well as crossing physical or social boundaries images may also confuse generic boundaries and conventions, transgress established norms and violate community standards of taste and respectability. They are often popularly described as going 'beyond the limits' or boundaries of 'acceptability', or being on the edge of what is deemed 'appropriate' and 'acceptable' within a specific sociocultural context.

Narrow notions of 'media effects' are often the source of controversies about images, underpinning anxieties about representations that might inappropriately inspire us or deaden our proper responses. All the chapters in this book, however diverse their topics, are united in criticizing the simplistic, often psychological, theories of media effects that underpin popular journalistic discussions of our interaction with controversial images. Such images make things too visible, bringing to light and 'on-scene' what should be kept off- and 'ob-scene'. They may be too graphic or explicit in style or content. Some genres – especially what Linda Williams (1991) calls body genres – are particularly productive of controversy, both because of the way they depict the body and because they have a physical or arousing affect on the body. Studies of the abject (Kristeva 1982) and disgust (Kipnis 1996; Miller 1997) have provided ways of exploring why certain images may be disturbing, and how ideas of the self and its relation to the world are often represented through depictions of the boundaries between the inside and outside of the body and of things that violate that boundary. Academic work has focused on those genres that are controversial because they display and 'move the body' – the horror film (Carroll 1980; Brottman 1997; Jancovich 2002); comedy (Lockyer and Pickering 2005); and pornography (Williams 2004; Church Gibson 2004; Attwood 2010; Paasonen 2011), as well as screen violence to the body (Hill 1997; Schlesinger 1992, 1998; Simkin, 2011). A broader category of 'extreme' or shocking images has more

recently become the subject of scholarly attention (Boothroyd 2006; Jones 2010). Chapters on shocking art, body horror, reactions to 'shock' images on YouTube, porn featuring animals, 'torture porn' horror and hardcore film, explore these particular themes around transgressing the boundaries of the body in this collection.

It may be that it is not the image itself that is controversial, but rather the increasing ease with which imagery can be accessed, replicated and manipulated. Moreover, there is what might be called a contemporary crisis of the image, as all images, even photographic ones that seem indexically linked to reality, are now suspect because of digital manipulation and copying. Here controversy may arise within creative industries and media professions over questions of the production, presentation and dissemination of images, linking in to deeper questions of the ethics of the production of media images. Several chapters in this book focus on precisely these questions, from what is or is not acceptable in movies, television programmes, or videogames, to questions about accuracy in news media representations of issues of social importance.

Another significant area in which images often become controversial is in relation to political discourses and matters of public debate. These have most typically manifested in discussions about media effects and violence (Barker and Petley 2001); moral panics (Cohen 1972; Thompson 1998; Critcher 2003) and related censorship campaigns (Barker 1984a, 1984b; Barker, Arthurs and Harindranath 2001); propaganda, free speech, and censorship (Herman and Chomsky 1988; Petley 2007; French and Petley 2008); the role of media technologies in surveillance (Andrejevic 2007; Magnet and Gates 2009); public and political scandal (Montgomery 1986; Dubin 1992; Lull and Hinerman 1997; Thompson, 2000); conflict (Cottle 2006); and war reporting (Hammond and Herman 2000; Thussu and Freedman 2003; Hoskins 2004; Hoskins and O'Loughlin 2010). Of particular interest here are controversial images that appear in the context of news. Imagery in the news, whether still or moving, is often, perhaps surprisingly, absent from many critical and analytical accounts within journalism studies. Becker argues that in the case of news photography this has been because of tensions within debates about the function and purpose of journalism. She writes:

Despite its very visible presence in the daily and weekly press of the past century, photography is rarely admitted to settings in which journalism is discussed, investigated and taught. Whenever the distinction is drawn between information and entertainment, or the

serious substance of a journalism appealing to an intellectual read-
ing public is defended against the light, trivial appeal of the popular,
photography falls within the popular, excluded from the realm of
the serious press.

(Becker 1992: 130)

This is perhaps all the more surprising when news imagery has been
crucial to the capturing and codifying of major world events for well
over a hundred years. Moreover, given that the focus of news photo-
imagery from the earliest days – Becker cites the early case of the sinking
of the USS *Maine* that precipitated the Spanish-American War in 1898
(2003: 293) – has been on violence, disaster, conflict and crime, and
that imagery of the dead and dying has become routine in news around
the world, the lack of critical and analytical attention to news imagery
is especially striking (one rare exception being Taylor 1998). Several
chapters in this collection, on controversies about suicide bombers,
spree killings, and wars, address this gap in journalism studies.

The structure of the book

This collection explores these themes and debates with the aim of
incorporating several dimensions of debates around controversies, as
a starting point for thinking about controversial images. The eclectic
range of material contained in the book is an indication in and of itself
of the complexity and fluidity of the notion of a 'controversial image',
and the purpose here is not to try and categorize and theorize a univer-
sal concept of controversial imagery. Drawing on new perspectives in
cultural studies, it considers a wide variety of *types of image* – newspaper
cartoons, advertising and fashion photography, music videos, photo-
journalism, news media, art works, hardcore porn film, anime, horror
and exploitation movies, video games and YouTube reaction videos. It
also examines these in a *range of contexts*, taking in controversies over
the use of Photoshop in a French magazine and an American fashion
campaign; the outrage caused in Muslim countries by the Danish paper,
Jyllands-Posten; the relations between Bulgarian and Euro-American pop
cultures; news reporting in Turkey; British representations of a school
shooting in the US; censorship in a range of countries including the UK
and Australia; torture porn films in the broader context of a 'War on
Terror'; audience responses to an Italian exploitation film and 'video
nasty'; and the experiences of British journalists reporting from around
the world. The collection is divided into four parts, each dealing with a

different aspect of controversy, focusing in turn on controversies over representation, the construction of controversy, ethical and aesthetic issues, and finally on audience engagement with controversial images.

Controversy and representation

The first part is concerned with issues of representation and reality. It raises questions about the ways in which the meanings of images are produced, how images can be used to sustain and question ideas about identity, and how the reworkings and recirculations of images work for and against the management of their meanings.

In the first chapter Meredith Jones discusses controversies about the use of Photoshop and its impact on body image, concerns that are based on the ideal of photography as accurately mirroring and upholding reality. As she shows, Photoshop and other digital media have problematized this ideal; images are now frequently digitally manipulated and have become 'an integral part of the performance of public life'. Jones discusses three examples. The first is a Photoshopped nude image of the philosopher Simone de Beauvoir, which was seen by some as an invasion of her privacy and an expression of gender inequality. Interestingly, the use of Photoshop caused little comment, perhaps because in an image of this sort it works to update and even 'clothe' its subject. The second, an excessively distorted image of a model used in a Ralph Lauren campaign, was widely linked to the view that the manipulation of images impacts negatively on women's body image. The third, an advertising campaign for Dove beauty products and deodorants, apparently criticizing 'unreal' images and linking its own products to 'real beauty', was hugely successful, though as Jones notes, supportive of the view of beauty and commodification that it was supposedly critiquing. Concerns over the legitimate use of Photoshop highlight a continuing set of anxieties about the ways that representation and reality are supposed to be connected, while demonstrating that, in fact, media and the body are not separate; bodies are mediated, body image is intertwined with images, and we can now be said to inhabit 'media-bodies'.

In the second chapter, Catherine Collins and David Douglass investigate responses to the 'Mohammed' cartoons published by the Danish newspaper, *Jyllands-Posten*, in 2005, which resulted in global controversy characterized by protests and riots, the torching of Danish embassies, the boycotting of Danish products, death threats and actual deaths. Noting that it was the creation of the cartoons and 'the implications of the act of publication' rather than their content that led to the

controversy, they discuss the importance of images for a sense of identity and belonging, and how our traditions of interpreting these are still embedded in older Western and Muslim frameworks for making sense of images of the body. For many Muslims, using a framework derived from Islamic religious traditions, the cartoons were about *resemblance* which 'amounted to an affront, even to blasphemy', while many Westerners regarded the cartoons as *representing* the Prophet Mohammad and thus having a 'referential relationship' to its subject. They conclude that the study of visual interpretation and its relation to different cultural contexts remains in its infancy, and that understanding this is becoming more urgent given the uncertain and difficult times we live in.

Plamena Kourtova's chapter takes up this question of the role of cultural context in producing the meanings of images. Playing with social norms and expectations around sexual identity and challenging sexual taboos have been the mainstay of numerous Euro-American popular music performers from David Bowie to Madonna to Lady Gaga. Asking what happens when these particular styles and performances are copied and reproduced in different contexts, the chapter focuses on a flamboyant and provocative Bulgarian pop-folk performer, Azis. Although commercially successful, Azis' music videos have been banned, advertisements for his singles have been censored and his work has been described as 'savage' because of its display of homosexuality and homoeroticism. The chapter shows how contemporary Bulgarian understandings of homosexuality, homophobia and identity are both influenced and challenged by nationalism and the West. It explores the ambiguities and complexities of Azis' image and performance style and discusses how imitation may become a vehicle for negotiating the tensions between the local and global, sameness and difference, the self and Other, and freedom and shame.

The final chapter in this part focuses on official photographs of the Guantánamo Bay prison camps in Cuba and the struggle for definitional control over the War on Terror in the context of a 'war of images' where the volume of images that are now produced and circulated makes control more challenging than ever before. Looking at two widely circulated photographs of Camp X-Ray, Bruce Bennett explores the tensions between propaganda, photojournalism and historical documentation in their appropriation and re-interpretation by news media and in their wider reception. He argues that their controversial status rests not so much on their content as on the way in which the photographs embody an information system and a political order in which power is exercised through the choice of particular ways of making the camp

visible while making others invisible. The blurring of roles between military personnel and journalists, and therefore between propaganda and reportage, marks the emergence of a kind of 'simulated journalism', though what is also interesting is what happens in the reception and circulation of images like these and the ways in which they continue to be 'reframed, reworked and reinterpreted.'

Constructing controversies

The second part of the collection focuses more closely on the media framing of events as controversial, and on how this depends on their mobilization and construction within particular frameworks. These include established codes of appearance and their meanings, models for understanding the media – particularly that of 'media effects', a developing crisis in the representation of children and a series of overlapping legal frameworks that constrain the way that films are classified.

Ertug Altinay's chapter explores the case of a failed suicide attack by two women affiliated with a Kurdish guerilla organization in Turkey, how the visual appearance of the women, dubbed by news media 'the terrorists with highlights', became a central feature of the way this was reported, and how images of the women seemed to present as much of a challenge to the Turkish state as the attempted bombing. Altinay shows how the modernization of Turkey has involved attempts to control and shape the visual identities of Turks and non-Turks, especially women, and how in that context the appearance of the terrorists proved to be so controversial. Women's appearance has been considered particularly important in marking the transformation of the country from an Islamic Empire to a secular Western nation state and the remodelling of Kurdish women's bodies worked to demonstrate the assimilation of the Kurds into this project. Altinay argues that the dress and in particular the 'highlights' used as a disguise by the suicide bombers operated as signs of modern, urban Turkish identity; the women 'seemed to be transformed properly into Turkish citizens'. Their adoption of this style was controversial precisely because it parodied the 'natural modernity' of Turks and revealed this code of appearance as an imitation.

In the following chapter, Jeremy Collins examines how particular narratives come into play in news reporting and how news media often utilize ideas about controversial imagery in *other* media as a way of making sense of certain types of events. Focusing on British newspaper reports of the Virginia Tech spree killing of 2007, he explores how the killings were represented as being causally connected to 'media

violence', drawing on a 'media effects' model that is often used in news media accounts despite the long-standing critiques of it within media research. Collins concludes that the killer Cho Seung Hui's own use of a 'multimedia manifesto', and the links made by media commentators between images of Cho and images in the Korean gangster film *Oldboy* (2003), 'provided a means for the news media to re-present an established explanatory theme in which violence in the "real world" can be explained by, or even blamed on, violent imagery in popular culture'.

Adam Stapleton's chapter examines controversy around the work of the artist, Trevor Brown, in the context of developing legislation on images of minors and fictitious persons. As it notes, arrests of parents who have taken nude photos of their children, alongside the withdrawal of advertising campaigns and the removal of artists' images from galleries because of their representation of children, suggest that anxiety about images of children is 'part of a significant and developing crisis'. Trevor Brown's work plays with the boundaries between childhood and sexuality, using images of dolls, toys, and 'Lolita' girls, and draws from a range of representational forms including children's books, pornography and medical images. Stapleton shows how this kind of representational play is becoming more dangerous because it is framed by new legislation which has moved away from the idea that child pornography is a record of abuse and towards the control of images of 'fictional' persons which have been drawn, painted or generated by computer. In this construction of controversy the law invites us to adopt a 'paedophilic gaze' which has no impact on the actual sexual exploitation of children but serious implications for the way that creative expression and imagination are treated.

Issues of regulation are also taken up in Julian Petley's chapter, this time in relation to the frameworks within which the UK's British Board of Film Classification operates. The BBFC has undergone a quiet revolution in recent years, overseeing in 2000 the de facto legalization of hardcore pornography at R18, passing hitherto banned or cut 'video nasties', leaving controversial films untouched and banning only a handful of extreme horror movies, such as *Murder Set Pieces* (2004), *Grotesque* (2009) and (for a short while) *The Human Centipede 2* (2011) (Petley 2011). But the BBFC still censors a considerable number (up to 24%) of R18 'sex works' or hardcore pornography. Petley analyses the BBFC's censorship policy in recent years, at a time when controversial images are more easily available than ever and censors are easily bypassed by viewing films online. He describes the overlapping legal frameworks within which the BBFC operates and the audience research they commission which,

though having no legal force, further legitimizes their policy of cuts. He concludes that the numerous laws the BBFC must negotiate represent considerable if indirect state involvement in censorship. In addition, because the BBFC goes beyond its proper role of interpreting the strict legal rules and makes cuts to films according to extra-legal considerations such as bad taste, its activities encroach 'into areas of taste and morality which some may consider should lie beyond its remit'.

Ethics and aesthetics in controversial media

The third part of the collection focuses on the ethics and aesthetics of controversial images, and on forms which have become especially controversial because they stretch the boundaries of realism, as in violent anime, or appear particularly 'extreme', as in the pornography of Max Hardcore, the 'torture porn' movie, and the images of bestiality that circulate online in adverts for animal porn. These forms are also controversial because of their relation to broader concerns about the ways in which the production of images is connected to the power relations between men and women and humans and animals, and to the presence of real cruelty and violence in the world.

In the first chapter Caroline Ruddell looks at body horror in the Japanese anime film, focusing especially on *Ichi the Killer* (2002), an animated prequel to Takashi Miike's 2001 live action film. Her concern is with the expanded opportunities animation offers for representing and defamiliarizing the body, and the ethical issues posed by a style of representation that is unconstrained by realism and that allows the impossible to be represented. *Ichi the Killer* shows the body in bits, exploded, an object of horror, and links sex with violence – Ichi becomes aroused when he commits or witnesses violent acts. As well as analysing the destruction and abjection of the body in relation to the genres of horror and porn, with their shared visceral affectivity, Ruddell shows how anime raises particular questions about gender and power because of its distance from Western representational conventions and excessive images of pure physicality. Both male and female characters are subject to bodily rupture and the film's violence provides a way of dealing with coming of age issues and difficulties with older generations, the reconciling of desires with social norms and the problems of gendered identity.

Gender and power relations are also the focus of Stephen Maddison's discussion of one of the most controversial manifestations of contemporary imagery – the porn films of US director 'Max Hardcore'. Although

Hardcore, who was jailed for obscenity in 2009 and released in 2011, remains something of a pariah in the porn industry, Maddison argues that his brutal, anti-erotic but innovative films have been influential in shifting porn towards a focus on bodily distress and the representation of sex as hard and unpleasurable performative work. Hardcore's films such as the *Cherry Poppers* (1994–7), *Hardcore Schoolgirls* (1995–2000) and *Extreme Schoolgirls* (2003–6) series are compilations of scenarios in which Hardcore has sex with adult women dressed as young girls. Anal sex features heavily, as well as deep-throating, gagging, vomiting, urination, enemas, and the use of speculums. Taking Hardcore's films as representative of contemporary porn, Maddison pursues the idea that porn's saturation of culture and its promise of instant gratification is an ideal symptom/image of consumer capitalism, in which an insistence on the pursuit of pleasure through consumption leads only to frustrated engagement with 'an endless flow of content'. Hardcore's work replaces the spectacle of pleasure with 'spectacular involuntary convulsions' and performances of 'blank' domination, raising questions about the significance of arousing images and the role of pleasure in culture.

The subject of Steve Jones's chapter is the most controversial of recent cycles of films – the 'torture porn' movie, a group of over 70 R-rated thrillers, usually classed as horror films and linked by their alleged misogyny and 'gratuitousness', despite being diverse in nature and with a majority of male victims. Originating in a 2006 article by David Edelstein in *New York* magazine, the term 'torture porn' was initially attached to films such as Eli Roth's *Hostel* (2005), with its explicit torture set-pieces, and the *Saw* series (2004–10) but also embraced Mel Gibson's *The Passion of the Christ* (2004), *Casino Royale* (2006) and the Fox TV series, *24* (2001–10), in which torture was a significant plot device. It may also be understood as part of a flourishing of violent imagery in all kinds of media in countries around the world, in the context of much easier access to scenes of real violence, suffering and death online. Jones shows that 'torture porn', as a discursive category, is – much like 'video nasty' – both useful in highlighting thematic similarities among otherwise unrelated films and unavoidably pejorative and damning. The journalistic use of 'porn' as a suffix attached to graphic and indulgent depictions of anything, from food to architecture, carries built in disapproval. 'Torture porn' is a scapegoating label intended to Other not just the films but their viewers.

Jones argues that one of the key problems with torture porn was that films such as *Hostel* and *Saw* became *too visible*. Usually marginal and easily ignored, the horror genre found itself moving towards the

cultural centre, perhaps because it resonated with the War on Terror. The use of 'porn' as a label marked a demand that body horror should retreat again to 'the outskirts of the cultural radar'. Jones traces how the films comment on war, the role violence plays in culture and the nature of morality. But he emphasizes that it is not enough simply to argue that the films reflect or critique images of torture; they need to be situated within a more general cultural fascination with cruelty and 'humilitainment'.

Cruelty is a central concern of the final chapter in this part by Susanna Paasonen. She notes that while pornography is often understood as being at the bottom of an aesthetic hierarchy of cultural forms, what is less well recognized is that there are also hierarchies *within* porn. The depiction of bestiality in animal porn resides at the lowest levels – it is understood as taboo and dehumanizing, and as part of a wider system of representation in which animals stand for the non-human and for the senses. Examining spam adverts for animal porn sites, Paasonen notes how these emphasize 'hyperbolic nastiness and titillation' and offer spectacles of the 'extraordinary and bizarre'. When the ethics of animal porn are discussed, the focus is usually on the female performer and whether her performance is degrading or can be considered consensual. But as Paasonen points out, the animals involved in animal porn are mainly companion animals, farmyard animals, livestock and animal labourers; rather than wild animals they are under human control or are human property. Animal porn tends not to challenge human control over animals, but depicts them as objects of sexual activity and as extensions and mirrors for human desire. At the same time they remain symbols of otherness, and perhaps of 'realness' and 'authenticity'.

Engaging with controversial images

In the fourth and final part the focus moves to various kinds of engagement with controversial images, an engagement that is often understood as dangerous and harmful.

Martin Barker offers a provocative alternative to this kind of thinking through a case study of audience responses to *House on the Edge of the Park* (Ruggero Deodato, 1980), an Italian exploitation film cut by the BBFC for its scenes of rape and sexual violence. Barker emphasizes that audience members approach films, even disreputable ones like this, with different and unpredictable expectations and varying degrees of cultural and subcultural capital. Unexpectedly, audience members often responded to the film on the level of its *ideas*, which spoke to them in

class terms. *House on the Edge of the Park* pitches working-class Others against arrogant and complacent representatives of the middle class, so that the rape of middle-class women becomes a sort of class revenge, as in other 'home invasion' films such as *Straw Dogs* (1971) and *A Clockwork Orange* (1972). These viewers read the film as political rather than simply slavering over or recoiling from the gendered violence that worried the BBFC. Barker goes on to analyse the enthusiastic response of one male viewer, a committed fan of exploitation horror thrillers, whose intense engagement with the film's offer of visceral pleasures would for some mark him out as a 'vulnerable' and therefore 'dangerous' member of the audience. 'Exploitation films like *House*', he concludes, 'create terrains of intensified reflection', though this '"doubling" of arousal and reflection, of excitement and horror, will never be comprehensible to nervous critics'. But Barker suggests that the fan's rapt engagement with the film actually enables him to understand it more fully than 'properly' distanced viewers who, unfamiliar with the tropes of exploitation cinema, are unable to frame the film within the genre's physically and intellectually arousing expectations and pleasures.

Arousal and horror are explored in a very different way in the chapter by Julia Kennedy and Clarissa Smith on YouTube reaction videos. Their case study is what has become known as the *Spankwire* video, a two-and-half minute video montage which went viral in 2007–8 and has been described as 'One of the Scariest Videos Out There'. The montage shows scenes of genital modification, fire-play, needle-play and suspension, originally intended as a taster for a body-modification website but recirculated on YouTube and elsewhere for its shock horror qualities. The montage was also the subject of an attempted prosecution as 'extreme pornography'.

Focusing on audience reaction videos and commentaries on these, Kennedy and Smith describe how the montage is seen through the reactions of viewers, becoming in the process a kind of user-generated cinema of attractions and a 'freak show' that exaggerates the exotic and erotic, shock and sensation. What the reaction videos and commentaries appear to demonstrate are the pleasures of being shocked and horrified and the willingness of audiences to participate in these. Reacting to the video becomes part of a game requiring participation, self-scaring, bravery and emotional exhibitionism, and emphasizes a community of experience, suggesting that responses to controversial images may be much more complex than the ones that are often assumed.

Vincent Campbell's chapter offers a case study of a 'moral panic' in video game history. This was the media backlash against *Call of Duty: Modern*

Warfare 2 (2009), a first-person shooter which despite being lauded as a masterpiece of entertainment design caused controversy because it allowed the player to 'become' a terrorist and participate in a massacre at a Russian airport. Campbell shows how the controversy focused on the 'moral condemnation of the narrative context' and the affects that this might produce in players. He pays closest attention to those characteristics of interactivity, immersiveness and sense of presence that are often thought of as the most – indeed uniquely – dangerous aspects of video games. But he argues that far from inciting violence, it is precisely those characteristics that allow the game to complicate players' moral response to the massacre. Videogames are becoming more sophisticated and challenging, sometimes requiring 'self-reflection and moral decision-making' and the controversial scene in *Call of Duty* is notable for its self-reflexiveness about the ethics of killing and morally challenging in offering the player opportunities for reflecting on the narrative implications of 'violent' gameplay. In other words, he concludes, *Call of Duty: Modern Warfare 2* is a threshold game in an emerging art form.

The subject of the final chapter by Paul Brighton is controversial imagery in the context of British television news journalism and the ways in which well-known journalists negotiate the tensions of producing and transmitting potentially controversial imagery. The tradition of public service broadcasting in Britain has left broadcast journalists working within a culture of regulations and guidelines concerning tastes and decency, leading to a recurring 'scenario of the frustrated journalist in the field, seared by his experiences, and the nervous (and, perhaps, back-watching) duty editor'. Interestingly, Brighton notes that despite a culture shaped by guidelines, the boundaries of what can be broadcast shifts over time according to negotiations between editors and journalists, rather than being a fixed set of absolute rules. Exploring accounts from leading figures in television reporting, such as Martin Bell and Kate Adie, he traces how 'reporters operate [...] on an almost intuitive sense of what is and is not broadcastable', yet also find ways to challenge and test 'the limits of what the newsroom teams and the viewing public, whose interests newsrooms may see themselves as protecting, deem acceptable'.

As new media penetrate further into the home, blurring distinctions between public and private, and rendering the obscene or simply culturally unacceptable more easily accessible than ever, it is important that media controversies are not made the excuse for greater censorship and the demonization of 'dangerous' images and the audiences that consume them. The case studies in this book, by offering alternatives to

reactionary notions of 'media effects', suggest how we might achieve a more subtle understanding of controversial images and thereby negotiate, more successfully but also more calmly, the difficult terrain of the new media landscape.

References

Andrejevic, M. (2007) *iSpy: Surveillance and Power in the Interactive Era* (Lawrence, KS: University of Kansas Press).

Attwood, F. (ed.) (2010) *porn.com: Making Sense of Online Pornography* (New York: Peter Lang).

Barker, M. (1984a) *A Haunt of Fears: The Strange History of the British Horror Comics Campaign* (London: Pluto).

Barker, M. (ed) (1984b) *The Video Nasties: Freedom and Censorship in the Arts* (London: Pluto Press).

Barker, M., Arthurs, J. and Harindranath, R. (2001) *The Crash Controversy: Censorship Campaigns and Film Reception* (London and New York: Wallflower Press).

Barker, M. and Petley, J. (eds) (2001) *Ill Effects: The Media Violence Debate* (London: Routledge, 2nd edn).

Becker, K. E. (1992) 'Photojournalism and the Tabloid Press', in P. Dahlgren and C. Sparks (eds) *Journalism and Popular Culture* (London: Sage), pp. 130–53.

Becker, K. E. (2003) 'Photojournalism and the Tabloid Press' in L. Wells (ed) *The Photography Reader* (London: Routledge).

Boothroyd, D. (2006) 'Cultural Studies and the Extreme' in G. Hall and C. Birchall (eds) *New Cultural Studies: Adventures in Theory* (Edinburgh: Edinburgh University Press).

Brottman, M. (1997) *Offensive Films: Toward an Anthropology of Cinema Vomitif* (Westport, CT and London: Greenwood Press).

Carroll, N. (1980) *The Philosophy of Horror Or Paradoxes of the Heart* (New York, Routledge).

Church Gibson, P. (ed) (2004) *More Dirty Looks: Gender, Pornography and Power* (London: BFI Publishing).

Cohen, S. (1972) *Folk Devils and Moral Panics: The Creation of Mods and Rockers* (London: MacGibbon and Kee).

Cottle, S. (2006) *Mediatized Conflict: Developments in Media and Conflict Studies* (Maidenhead: Open University Press).

Critcher, C. (2003) *Moral Panics and the Media* (Buckingham: Open University Press).

Dubin, S. C. (1992) *Arresting Images: Impolitic Art and Uncivil Actions* (London and New York: Routledge).

Falk, P. (1993) 'The Representation of Presence: Outlining the Anti-Aesthetics of Pornography', *Theory, Culture & Society*, no. 10, 1–42.

French, P. and Petley, J. (2008) *Censoring the Moving Image* (Oxford: Seagull Books).

Hammond, P. and Herman, E. S. (eds) (2000) *Degraded Capability: The Media and the Kosovo Crisis* (London: Pluto Press).

Herman, E. S. and Chomsky, N. (1988) *Manufacturing Consent: The Political Economy of the Mass Media* (New York: Pantheon).

Hill, A. (1997) *Shocking Entertainment: Viewer Response to Violent Movies* (Luton: University of Luton Press).

Hoskins, A. (2004) *Televising War: From Vietnam to Iraq* (London: Continuum).

Hoskins, A. and O'Loughlin, B. (2010) *War and Media: The Emergence of Diffused War* (Cambridge: Polity Press).

Jancovich, M. (ed) (2002) *Horror: The Film Reader* (New York and London: Routledge).

Jones, S. (2010) 'Horrorporn/Pornhorror: The Problematic Communities and Contexts of Online Shock Imagery' in F. Attwood (ed) *porn.com: Making Sense of Online Pornography* (New York: Peter Lang).

Kipnis, L. (1996) *Bound and Gagged: Pornography and the Politics of Fantasy in America* (New York: Grove Press).

Kristeva, J. (1982) *Powers of Horror: An Essay on Abjection* (New York: Columbia University Press).

Lockyer, S. and Pickering, M. (eds) (2005) *Beyond a Joke: The Limits of Humour* (Basingstoke: Palgrave Macmillan).

Lull, J. and Hinerman, S. (eds) (1997) *Media Scandals: Morality and Desire in the Popular Culture Marketplace* (London: Polity Press).

Magnet, S. and Gates, K. (eds) (2009) *The New Media of Surveillance* (London: Routledge).

Miller, W. I. (1997) *The Anatomy of Disgust* (Cambridge and London: Harvard University Press).

Montgomery, H. H. (1986) *A Tangled Web: Sex Scandals in British Politics and Society* (London: Constable).

Paasonen, S. (2011) *Carnal Resonance: Affect and Online Pornography* (Cambridge, MA: MIT Press).

Petley, J. (2007) *Censoring the Word* (Oxford: Seagull Books).

Petley, J. (2011) *Film and Video Censorship in Modern Britain* (Edinburgh: Edinburgh University Press).

Schlesinger, P. (1992) *Women Viewing Violence* (London: BFI).

Schlesinger, P. (1998) *Men Viewing Violence* (London: Broadcasting Standards Council).

Simkin, S. (2011) *Straw Dogs (Controversies)* (Basingstoke: Palgrave Macmillan).

Taylor, J. (1998) *Body Horror: Photojournalism, Catastrophe and War* (Manchester: Manchester University Press).

Thompson, J. B. (2000) *Political Scandal: Power and Visibility in the Media Age* (Cambridge: Polity).

Thompson, K. (1998) *Moral Panics* (Routledge: London and New York).

Thussu, D. K. and Freedman, D. (eds) (2003) *War and the Media: Reporting Conflict 24/7* (London: Sage).

Williams, L. (1991) 'Film Bodies: Gender, Genre and Excess', *Film Quarterly*, no. 44.4, 2–13.

Williams, L. (ed) (2004) *Porn Studies* (Durham and London: Duke University Press).

Part I
Controversy and Representation

1
Media-Bodies and Photoshop

Meredith Jones

> Far from being defanged in the modern era, images are one of the last bastions of magical thinking.
>
> (Mitchell 2005:128)

> [A]ny understanding of contemporary visual mediation that ignores software does so at its own peril, in an age when cinema has become synonymous with Final Cut Pro, photography with Photoshop, writing with Microsoft Word, and on and on.
>
> (Galloway 2006: 321)

We have always adjusted photographs to suit different temporal and spatial moments: their borders morph as we snip or rip to remove unsavoury elements – the ex-husband, the child who became a criminal, the awful handbag. Photographic imagery is made from what lurks outside the frame as much as by what is contained within it. And yet, photography's own mythology tells a different story: that something complete has been captured. Even as we know that outside every image hover ignored or invisibilized 'truths' we still hold onto a cultural belief that photography offers a direct link to the real. Photoshop and other image-manipulating software programs magnify tensions around photography's connection to the factual. For in Photoshop what is in the frame, from the start, is adjusted and manipulated. As soon as an image has been touched by a Photoshop tool it is augmented, reduced, enhanced or changed in some way. And increasingly, all of our important global images are photoshopped: we now expect that adjustment has happened, even as we continue to demand that photographs represent the real.

This chapter explores this tension via three controversial photoshopped images of women's bodies: the nude picture of Simone de Beauvoir on the cover of *Nouvel Observateur* (January 2008), the Ralph Lauren campaign featuring heavily photoshopped images of model Filippa Hamilton-Palmstierna (October 2009) and the Dove *Evolution* video (2006). The de Beauvoir image was thought by many to have been used inappropriately given the philosopher's eminent place in intellectual history. That it had been photoshopped was less controversial at the time, but is the focus here. The Hamilton-Palmstierna image was controversial because it had been so heavily photoshopped it hardly resembled a real body anymore. The Dove video made a provocative and somewhat political statement about the use of Photoshop in beauty and fashion media, explicitly linking this to women's and girls' poor body image.

I preface the arguments presented here with a clear statement that all vision is media-laden. By this I mean that seeing is always mediated, whether we are considering the particular capabilities and limitations of the human eye, the frame and physical protection provided by the plate glass window, or the views provided by the ubiquitous big and little screens that populate the contemporary world. In turn, every image is both physically and metaphorically 'framed' – constructing its narrative through processes of inclusion and omission. Thus, image-making becomes a profoundly political act. As Judith Butler writes, 'although restricting how or what we see is not exactly the same as dictating a storyline, it is a way of interpreting in advance what will and will not be included in the field of perception' (2009: 66).

This theoretical position – that technologies of vision interpret and create the ways we see and even what we are able to see – leads to a slightly more complex concept, namely, that technologies of vision do not simply represent or reflect existing objects but also play a role in bringing them into being. Alexander Styhre, pace Karen Barad's theory of agential realism, argues that matter itself can be understood to be created through the use and implementation of 'specific technological systems and visual media' (2010: 66). If matter is only perceived via biological or material mechanisms, it therefore follows that it is made in conjunction with those mechanisms. So, rather than trying to determine whether an image is 'accurate' or not it is far more useful to think about how it was created and what it creates. As Styhre concludes in relation to Barad's (2003) analytical framework, it 'invites us to think of visualization in fresh terms, in terms of the possibilities accomplished on the basis of a visual medium rather than its accuracy in a realist epistemology' (2010: 66).

Here I suggest that bodies, as matter, are in some sense brought about through media.[1] I explore how bodies and media configure each other and specifically ask how 'media-bodies' come about in the age of Photoshop.

Photography, Photoshop and the real

[D]igital technology does not subvert 'normal' photography, because 'normal' photography never existed.

(Manovich 2003: 245)

Photography, unlike painting or drawing, is thought by many to be 'a mirror with a memory'. Whereas painting 'has always vacillated in a zone between the real and the symbolic' (Bazin 2005: 10–12), photography alone, of all the representative and visual technologies, has been characterized as having the power to relate an unadulterated, unemotional and objective truth. Film theorist André Bazin summarizes this line of belief usefully:

[O]riginality in photography as distinct from originality in painting lies in the essentially objective character of photography. For the first time, between the originating object and its reproduction there intervenes only the instrumentality of a nonliving agent.

(2005: 13)

The belief in photography as truth-teller happened in part because photographic techniques came of age in parallel with post-enlightenment science. The two supported each other's claims to be reason-based and objective: 'at the moment of its birth, photography was explicitly understood in relation to this prestigious notion of modern vision, and was widely recognized as the modernization by science of its own privileged vision' (Slater 1995: 221).

Thus photography, a medium lauded for its accurate, technical and objective rendering of how things appear, has been and is still widely experienced as being fundamentally connected to the real. This has been cause for major philosophical questionings and critiques (Sontag 1977; Baudrillard 2009; Butler 2009). It has also meant that photography, as a medium, has often faded into the background, even disappeared, as its content takes centre stage. According to artist Silvia Kolbowski, 'It is the unself-conscious assumption of a realist discourse about photography that allows for the mediation of the medium to recede' (1990: 154). The introduction of digital photography along with image-manipulating

programs like Photoshop has meant that photography's intimate ties with truth and reality have been more explicitly called into question. In 1990, the year Adobe Photoshop 1.0 was released, photography critic Fred Ritchin wrote:

> [A]s the public begins to perceive photography as unreliable, those who control its uses should clearly understand what they are doing to the photograph. They should address both the question of image manipulation by the computer and the more general tendency to use photographs to illustrate preconceived ideas and self-fulfilling prophesies.
>
> (1990: 36–7)

Adobe's Photoshop is a computer software used to edit, manipulate and create images. It has been through 11 versions over the last 20 years, is available in 25 languages and its tools are now applied to most still images in mass media.[2] In Photoshop images can be cropped or extended and unique environments can be created. The software is widely available and professional training is not needed to make basic use of it: an hour's experimentation allows one to remove spots and wrinkles, elongate and narrow bodies, change skin tone and eye colour. The word Photoshop has entered the general lexicon and the verb 'to photoshop' is widely used to denote processes of retouching, compositing and general digital manipulation, even when it has occurred in other programs.

Discussions about Photoshop, especially as it relates to images in the mass media, often go hand in hand with discussions about photography. But Photoshop is a medium in its own right, particularly for its ability to create (in the hands of skilled practitioners) unique images with little or no connection to an original photo. However, it is most controversial when combined with more traditional modes of photography and representation, specifically for the ways it is used to 'enhance' faces and bodies in line with mainstream beauty ideals of youth, slenderness and whiteness. Photoshop is not necessarily something 'done' to unwilling subjects of photography after the fact, rather it has become an integral part of the performance of public life, with celebrities such as Madonna and Lady Gaga employing Photoshop technicians as members of their image-making entourages along with makeup, hair and costume specialists.

Not only is there a general recognition that most commercial photographs have been photoshopped, there is also now an expectation that

they have been digitally manipulated. Thus the position that photography once held as a 'transparent' medium with a closer link to reality than other visual technologies such as painting has come into question. Instead of placing photography outside of other visual arts and lauding its special connection to the real, the rise of Photoshop and digital photography have helped us to place it in the wider history of representation in which idealizing and enhancing are par for the course: 'in the age of Photoshop, the alleged certainty of the photographic is subject to generalized suspicion' (Hansen 2006: 228, also see Bull 2010: 21–2).

The nude philosopher

In January of 2008 the French magazine *Le Nouvel Observateur* used a picture of Simone de Beauvoir on its cover to celebrate what would have been the philosopher's hundredth birthday. This black and white photograph was taken by Art Shay in Chicago in 1952 (Shay was a friend of de Beauvoir's lover, Nelson Algren). Shay describes it as a 'furtive' snapshot, and writes that de Beauvoir 'playfully called me, "You naughty man" when she heard my Leica shutter click, but merely laughed when I shot a few more frames' (2010). He says he neither sold nor exhibited the picture until after her death. The image shows de Beauvoir standing at a bathroom mirror putting her hair up. She has her back to the camera and wears nothing but high heels. If we compare *Le Nouvel Observateur*'s cover with Shay's original, it is clear that Photoshop has been used. The lighting is brighter, thus eliminating uneven skin tones and shadows, especially in the bottom half of the picture. De Beauvoir's buttocks, thighs and knees have been slimmed and smoothed.

There was controversy when the issue came out: various rival publications claimed it was a violation to publish a nude photo of an eminent philosopher, the feminist group Les Chiennes de Garde demanded in a protest outside the magazine's offices that it put a nude photo of its (male) editor on the cover of the next issue, and many people commented that a nude photo of someone such as Jean-Paul Sartre would never have been used in such a way (see Lichfield 2008; Nadia 2008). Nathalie Petrowski wrote in *La Presse* (Montreal, Canada) 'On the day when the Nouvel Obs has the nerve to show us the bare behind of a great male thinker, we will be able to say that equality between men and women has at last been achieved' (quoted in Byrne 2008).

However, while there was much written about the supposed invasion of privacy and the gender inequality evident in the choice of image for the cover, very few people wrote critically about the Photoshop

treatment that it had received. A couple of exceptions were Karen Moller's 2008 *Swans Commentary* piece:

> I felt insulted for her. Was it not enough to be admired worldwide as an intellectual? Did she have to be perfect physically as well? (The French do take national pride in their women and are personally offended if they aren't considered beautiful.) Airbrushing or Photoshop-retouching seemed to take away a part of her special and very personal identity – a refusal to accept her as she was, one might say. I wonder what Simone de Beauvoir would have thought.

Parisian blogger Eliane characterized the dominant reactions like this: 'How shameful it is to dig out this nude picture of a dignified writer and put it on first page, just to sell more copies!' before offering her own reading of the scandal: 'Then, of course, the original photo came out, which started a righter [sic] contest: the real indecency was to use Photoshop to model her figure according to modern taste' (2008).

These two voices were in a very small minority and are the only critiques of Photoshop's role in the affair that I have found in English. So why was there such a furore over the nudity while there was barely anything about the photoshopping? If we consider the context – the cover of a mainstream magazine – we realize that while the nudity was unusual and controversial the photoshopping was standard. So used are we to photoshopped images on the covers of magazines that we have learned to see un-photoshopped images as 'wrong'; in this sense the image of de Beauvoir does look 'better' after it has been manipulated. What struck me when I first compared the two images was that in the original she somehow looks more nude, more exposed. We are so unused to seeing imperfections that when they do appear they make the subject seem more vulnerable, more revealed. Perhaps, because we are so accustomed to Photoshop's effects now, it would be almost unseemly not to photoshop de Beauvoir for the mainstream press. In this way, Photoshop is a sort of clothing or mask – it is used to hide or cover certain individualizing features and thus works as a kind of uniform. Thus on this magazine cover de Beauvoir has been treated like a contemporary celebrity. Her image has been tweaked to fit the conventions of our times rather than to remain strictly historical. And we might ask: if it is insulting and degrading to photoshop de Beauvoir then does the same apply to photoshopping other eminent feminists, for example Hillary Clinton, who appears 'enhanced' on countless magazine covers? Is it nothing more than a contemporary convention? Or could it even be a mark of respect?

One thing is certain: by photoshopping de Beauvoir we make her contemporary – we bring her, even initiate her, into a new world of photographic manipulation, a world that she did not experience. Perhaps the important issue is not what Photoshop has done (slimmed her in line with current feminine ideals) but simply that Photoshop has been used. What better proof that a historical figure is relevant and worthy of attention in this era than to show her photoshopped in the same way that all the most important celebrities and politicians are? The message may not be that de Beauvoir's body is not 'good enough' but that she is here being actively visually incorporated into the aesthetic value system of the contemporary world. To leave her un-photoshopped would render her image old-fashioned, confining it to her era and making her less relevant to contemporary values.

Thus it is precisely the lack of outrage over the photoshopping of de Beauvoir here that is significant. This kind of 'enhancement' is ubiquitous, is seen as innocuous and is utterly expected. In the context of a highly controversial image that was discussed in the international press, its photoshopping hardly rated.

Dude, her head's bigger than her pelvis

Another photoshopped image that circulated in 2009 caused a very different reaction. *BoingBoing* blog re-published an advertisement for Ralph Lauren clothing with the caption 'Dude, her head's bigger than her pelvis' (Jardin 2009).

Reactions ranged from 'is this a joke?' to many such as the two quoted below:

> This kind of disgusting presentation of women is what leads to bulimia and other excessive psychological illnesses. ... This kind of distorted advertising somehow needs to be banned (or at least punishable with severe fines), it is even more dangerous than tobacco advertising!
>
> (ecobore 29 September 2009)

And

> France is currently considering a bill that would require photos that have been electronically manipulated to be labeled as such.
>
> Bring it on – this one is so bad as to be laughable, but I'm tired of seeing digitally enhanced ideals of what someone else considers beautiful.

Ralph Lauren opens new outlet store in the Uncanny Valley

By Xeni Jardin at 10:10 pm Tuesday, Sep 29

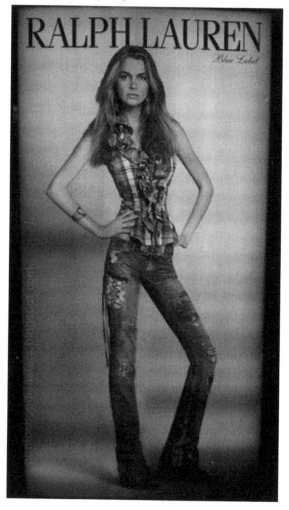

Dude, her head's bigger than her pelvis. From Photoshop Disasters
(thanks, Antinous!)

Figure 1.1 BoingBoing reprints a heavily photoshopped image of model Filippa
Hamilton-Palmstierna

This is why the Dove Real Beauty campaigns have ben [*sic*] so popular [...] they're real women, with real bodies, who are beautiful even if they don't look like the 'experts' say they should.

(Anon 30 September 2009)

Ralph Lauren took legal action against *BoingBoing* but failed in making the blog remove the image, its accompanying comments or the follow-up articles (Doctorow 2009). Ralph Lauren then issued an apology – 'After further investigation, we have learned that we are responsible for the poor imaging and retouching that resulted in a very distorted image of a woman's body' – but not before another similarly adjusted image had hit the web. Again Ralph Lauren's Photoshop technicians had rendered the model's hips and waist inhumanly narrow – indeed, so narrow that some vital organs would have to be missing (*Mail Online* 2009). While it seems that in retrospect Ralph Lauren saw the images as mistakes or failures, there is still the nagging knowledge that they must have been inspected and approved by many people before being made public.

Although the company quickly removed the images from its publications they continued to circulate widely on the web. The public outcry was widespread and typical of a reported general dissatisfaction with the ubiquitous use of Photoshop to adjust images of women's bodies. The broad argument in this line of thought (typically expressed in the two quotes above) is that body image, especially women's body image, is affected by mass-media images (Bordo 1997): we ingest images 'perfected' in Photoshop, know that our own bodies and faces do not compare favourably to them, and therefore become dissatisfied with our appearances and with ourselves (Featherstone 2010: 193, also see Weiss 1999).

We could say that the outcry against the Ralph Lauren images arose from this cultural discontent and because these particular images displayed adjustments that were more extreme than usual. However, I suggest that the anger about these 'unbelievable' images is misdirected. If anything, a protest against Photoshop's 'believable' images would be more in line with the argument that digital manipulation of photographs creates unrealistic body image expectations in women. That argument, logically, should embrace rather than rally against images adjusted to look 'unnatural' in Photoshop because in those images there is less 'deception', less attempt to make people believe that the figures represented are in any way real. Photoshop, as we know from its use by artists, is able to create dreamscapes and fantastical bodies. The Ralph

Lauren images are hardly artistic but they are totally stylized. The super-thinned bodies look like watercolours, washed out and slightly blurry, while the heads in contrast become large and bubble-like. Photoshop normally presents bodies that may be in some way achievable with enough dieting, gymwork and cosmetic surgery. I suggest that when Photoshop goes one step further as it has here (deliberately or not) and presents bodies that are clearly impossible, it is embracing its own dis-connection with 'the real', distancing itself further from the belief that photography has an inherent connection with truth. In this way – if we believe that images influence body image – such images make it easier for people to see that 'real' bodies are profoundly different to those represented in mass media. The angst around the Ralph Lauren images is, on the surface, about the oppressive expectations placed on women's bodies. But I suggest that at another deeper and unspoken level it is about an ongoing cultural reconfiguring of photography's connection to the real.

The campaign for real beauty

There is a growing fascination in comparing photoshopped and non-photoshopped images. Celebrities such as Britney Spears and Jamie-Lee Curtis have emphasized their own 'authenticity' by releasing non-photoshopped pictures of themselves,[3] while magazines feature non-photoshopped covers and 'photoshop free zones' in order to have readers see them as not being responsible for women's poor body image.[4]

Paradoxically, the cultural trope of railing against the 'unrealistic' presentations of Photoshop is now so common that it has been taken up by advertisers themselves – the very group that uses these tools and processes to greatest profit now has an interest in 'undermining' them. Dove *Evolution* is a video that is part of the Dove Campaign for Real Beauty advertising campaign mentioned favourably by Anon, quoted above. The video shows a young woman who is pretty by most standards staring at the camera. Then, in fast motion, we see a team of makeup artists and hairdressers set to work glamorizing her. After they are done a photo is taken and an invisible Photoshop artist goes to work, elongating her neck, arching her eyebrows, widening her eyes, etc. The final shot is a pullout that shows the image – looking very different to the original woman's face – on a billboard. Fade to black, and white text comes up that says 'No wonder our perception of beauty is distorted. Take part in the Dove Real Beauty Workshops for Girls'. This one-minute video was hugely popular through 2006 and quickly

became viral. It was used in classrooms to discuss relations between body image and media and it spawned many parodies and copies.[5] It won two Cannes Lions awards for advertising and led to huge financial success for Dove, with sales growing by 700 per cent (Hoggard 2005). There are complex messages and meanings being addressed here. Dove's accompanying website states that 'the principle behind the campaign is to celebrate the natural physical variation embodied by all women and inspire them to have the confidence to be comfortable with themselves' (Dove website). However, there is no denying that the campaign's raison d'être is to sell Dove's new beauty products and deodorants along with its more established soap. Marina Hyde wrote in *The Guardian* 'let's not forget that the Dove Campaign for Real Beauty is in fact the Dove Campaign to Shift Soap' (2005) and Rebecca Traister wrote in *Salon* 'Dove has a worthy new ad campaign that tells women to embrace their curves. Too bad they're hawking cellulite cream' (2005).

The hypocrisy that Traister notes here is important because it is part of a set of complex cultural contradictions where sub-texts are given voice alongside main texts, even where they appear to be undermining those dominant paradigms. In previous work I have shown how Makeover Culture, the paradigm that I argue overarches all beauty imagery in Western culture, contains many oppositions and inconsistencies (Jones 2008). However, I have also noted that such contradictions often work to support mainstream cultural narratives, beliefs and values. They create what Hodge and Kress (1988) describe as discursive intercourses that are vital to dominant paradigms. Intersections between dominant and 'resistant' discourses help to make up what Hodge and Kress call 'ideological complexes' by which they mean 'a functionally related set of contradictory versions of the world' (1988: 3). 'Functionally related' is a key term here because this tension between the dominant and the resistant is used by powerful groups (such as advertisers) to both incorporate and domesticate modes of resistance. The incorporation of resistant sub-texts, crucially, renders the dominant paradigm stronger.

Thus the Dove Campaign for Real Beauty works by using apparently contradictory messages to support a dominant paradigm – in this case playing to a presumed public dissatisfaction with 'unreal' images of women being used to sell beauty products. It is a hugely successful campaign then, not because it in some way tells the 'truth', but because it uses resistant discourse to fortify a dominant paradigm. It does so by flattering its audience: positioning us as informed, intelligent and even radical consumers. Dove compliments and congratulates us on not

being dupes, on not being fooled. The *Evolution* video enlightens audiences about what is 'real' and what is not. However, in terms of cultural complexity its revelatory 'truth' actually supports the cultural message it supposedly undermines. In other words, pedagogy and disclosure are used in the service of recruitment into the very system supposedly being undermined, something that should, of course, be no surprise given the commercial nature of the enterprise.

Judith Butler writes that if

> norms are enacted though visual and narrative frames, and framing presupposes decisions or practices that leave substantial losses outside the frame, then we have to consider that full inclusion and full exclusion are not the only options ... the point would not be to locate what is 'in' or 'outside' the frame, but what vacillates between those two locations, and what, foreclosed, becomes encrypted in the frame itself.
>
> (2009:75)

The Dove campaign purportedly puts in the frame what is usually left out – it throws light on the elided. However, its images and videos are still highly edited – like all effective advertising there is much that is actively left much out, including its own raison d'être.

The image of Simone de Beauvoir, controversial on so many levels, barely made a splash in terms of its Photoshop because in this respect it was utterly ordinary. It made de Beauvoir 'modern' and fitted her image to contemporary cultural norms. Photoshop in this instance remained invisible. As Galloway argues, 'any mediating technology is obliged to erase itself to the highest degree possible in the name of unfettered communication' (2006: 320). The Ralph Lauren image, crude and clumsy, a designated failure on many levels, made Photoshop very visible indeed, provoking anger. Although directed at the depiction of women's bodies, I suggest that the anger was also about an escalating de-coupling of the represented and the real in our everyday mediascapes, a de-coupling that is being largely facilitated by Photoshop. The Dove campaign consciously embraces well-worn debates around Photoshop and women's bodies to create a successful and sophisticated marketing tool that is at heart more manipulative and more insidious than the set of values it supposedly sets out to undermine. All three of these examples address attitudes towards changing relations between the real and the represented. They each highlight a 'new normal' in some way: a 'normal' where digital manipulation of bodies is commonplace and is even

expected. Each of the texts caused controversy because it underscored, deliberately or by accident, the very complex relationship that visibility has to life in both three dimensions ('real life') and in two dimensions (images).[6]

Media-bodies

> The digital age [...] far from being technically determined in any straightforward way by computers and the Internet, spawns new forms of fleshly, analogue, nondigital experience.
>
> (Mitchell 2005: 313)

I suggest that the controversies around the photoshopped images discussed earlier indicate more than debate around practices and beliefs about beauty as they relate to women's bodies. Crucially, they also highlight cultural anxieties around the (mis)connections between representation and reality. Photoshopped images remind us that while it is easy to naïvely conceive of technologies of visual media (especially photography) as able to show actual bodies and objects, closer analysis reveals that rather than being able to represent fact they create what we might call reality-hybrids, or in the case of bodies, media-bodies. These images/bodies are boundary crossers: neither fully fabricated nor fully connected to fleshy life, they are part of two worlds. This is what is simultaneously so confronting and so potentially wondrous about them: they occupy a double-place that is horrifying while also offering us new ways of being.

What do I mean by media-bodies? This term is an attempt to stop seeing media as distinctly separate from bodies, impacting upon them (and upon related psychological objects like 'body image') from outside. Media-bodies is the beginnings of a theory that allows us to see media and bodies as symbiotic: mutually dependent and mutually creative. With 'media-bodies' I mean to evoke the ways in which our bodies are mediated, the ways in which our body images are intertwined with images, photoshopped or not, that wraith-like, envelop and penetrate us. This mediation may always be a source of cultural tension and controversy. Its manifestations are likely to continue to engender concerns about dangerous images, effects, misrepresentations and so on, which is one reason it is so important to analyse it.

Kolbowski, writing about fantasies and the fashion photograph's image of feminine perfection, asserts that seer/seen and subject/object

positions for viewer and viewed are overly simplistic. Rather, she insists that identification and non-identification with images is always utterly mutable:

> [P]leasure, therefore, could be said to reside as much in the slippages of positions, the misalignments, as in the masochistic alignment with an unattainable object of perfection that is culturally reinforced.
>
> (1990: 142)

If we follow this line of thought then there is complex pleasure to be gained in acknowledging the ongoing intercourses between body and image, between real and represented, rather than attempting to divide them.

Conclusion

Bodies and faces make up the vast majority of images circulated in the global mediasphere, and yet it could be said that we no longer have bodies: instead, we now inhabit 'media-bodies' that are ghostly and flickering, enlivened and destroyed by Photoshop and other visual media rather than by organic processes.

Recalling Karen Barad, matter is produced through the use of particular apparatuses: 'Apparatuses are dynamic (re)configurings of the world, specific agential practices/intra-actions/performances through which specific exclusionary boundaries are enacted' (2003: 816). Thus media-bodies can be thought of as those junctures where flesh meets visual technologies and where bodies are connected to images.

The Enlightenment and the belief systems it spawned united truth and the visual through visual technologies such as photography. These technologies seemed to promise transparency and a direct line to the real. Digital media such as Photoshop have the power to definitively problematize the belief in such a link. However, there is still a cultural comfort in connecting photography to the real; hence the anger and angst that arise when Photoshop becomes less than invisible, and hence the space that is made for 'heroes of the real' like Dove that reassure us that there is a real, and that it can indeed be properly represented.

The questions that need to be asked in relation to Photoshop are not ones of the real and the virtual, or of truth and dishonesty, or of exclusion and inclusion. Rather the most important, urgent and interesting question we can ask of Photoshop is the same question that applies to all media: how am I reconfigured and created by you, just as I make

you? How do our bodies become one? Where does my media-body end and yours begin?

Notes

1. I have also explored this idea in Jones 2009.
2. Photoshop's deployment in art and graphic design is another matter entirely (see Wolf 2010). This chapter addresses those images we see daily in magazines and on billboards and it is not in its scope to discuss artistic uses of the tool.
3. For examples see *Daily Mail* 2010 and Wallace 2002.
4. See *Celebrity Fix* 2009.
5. See for example *Slob Evolution*, an Emmy Award-nominated short film at http://www.youtube.com/watch?v=7-kSZsvBY-A.
6. I address this complex relationship between two and three dimensions in an article (Jones 2012) in *Fashion Theory*.

References

Barad, K. (2003) 'Posthumanist Performativity: Towards and Understanding of how Matter comes to Matter', *Signs: Journal of Woman in Culture and Society*, 28, no. 3, 801–31.

Batchen, G. (1997) *Burning With Desire: The Conception of Photography* (Boston: MIT).

Baudrillard, J. (2009) *Why Hasn't Everything Already Disappeared?* trans. C. Turner. (London: Seagull Books).

Bazin, A. (2005) [1967] 'The Ontology of the Photographic Image' in *What Is Cinema?* Volume 1 trans. H. Gray (Berkeley: University of California Press).

Bull, S. (2010) *Photography* (Abingdon: Routledge).

Butler, J. (2009) 'Torture and the Ethics of Photography: Thinking with Sontag' in *Frames of War* (London: Verso).

Byrne, P. (2008) 'Not Shutting Up For A Second: Simone de Beauvoir (1908–1986)', *Swans Commentary*, http://www.swans.com/library/art14/pbyrne61.html, date accessed 1 November 2010.

Celebrity Fix (2009) 'Sarah Murdoch goes without Photoshop', http://entertainment.msn.co.nz/blog.aspx?blogentryid=525914&showcomments=true, date accessed 1 November 2010.

Daily Mail (2010) 'Britney Spears Bravely Agrees to Release Un-Airbrushed Images of Herself Next to the Digitally-Altered Versions', http://www.dailymail.co.uk/tvshowbiz/article-1265676/Britney-Spears-releases-airbrushed-images-digitally-altered-versions.html, date accessed 1 November 2010.

Doctorow, C. (2009) 'The Criticism that Ralph Lauren doesn't Want you to See!' *BoingBoing*, http://boingboing.net/2009/10/06/the-criticism-that-r.html, date accessed 1 November 2010.

Dove website, http://www.dove.co.uk/, date accessed 1 November 2010.

Eliane (2008) 'Paris: Stormy birthday party for Simone de Beauvoir!', *Paris Connected*, http://parisconnected.wordpress.com/2008/01/16/paris-stormy-birthday-party-forsimone-de-beauvoir/, date accessed 1 November 2010.

Galloway, A. R. (2006) 'Language Wants To Be Overlooked: On Software and Ideology', *Journal of Visual Culture*, 5, 315–31.

Hansen, M. (2006) *Bodies in Code: Interfaces with Digital Media* (Abingdon: Routledge).

Hoggard, L. (2005) 'Why we're all beautiful now', *The Observer*, 9 January, http://www.guardian.co.uk/media/2005/jan/09/advertising.comment, date accessed 1 November 2010.

Hyde, M. (2005) 'Wrinkled or Wonderful?', *The Guardian*, 7 January, http://www.guardian.co.uk/world/2005/jan/07/gender.uk2#article_continue, date accessed 1 November 2010.

Jardin, X. (2009) 'Ralph Lauren Opens New Outlet Store in the Uncanny Valley', *BoingBoing*, http://www.boingboing.net/2009/09/29/ralph-lauren-opens-n. html, date accessed 1 November 2010.

Jones, M. (2008) *Skintight: An Anatomy of Cosmetic Surgery* (Oxford: Berg).

Jones, M. (2009) 'Media-Bodies and Screen-Births: Cosmetic Surgery Reality Television' in T. Lewis (ed) *Television Transformations: Revealing The Makeover Show* (New York: Routledge).

Jones, M. (2012) 'Cosmetic Surgery and the Fashionable Face', *Fashion Theory: The Journal of Dress, Body and Culture*, 16, no. 2, 193–210.

Kolbowski, S. (1990) 'Playing with Dolls' in C. Squires (ed) *The Critical Image* (Seattle: Bay Press).

Kress, G. and Van Leeuwen, T. (2006) 'The Semiotic Landscape: Language and Visual Communication' in *Reading Images: The Grammar of Visual Design* (2nd edn) (London: Routledge).

Le Nouvel Observateur, 3 January, 2008, http://sexismoemisoginia.blogspot. com/2010/05/simone-de-beauvoir-e-o-mito-da-beleza.html, date accessed 15 April 2010.

Lichfield, J. (2008) 'Still the Second Sex? Simone de Beauvoir Centenary', *The Independent*, 9 January, http://www.independent.co.uk/news/world/europe/ still-the-second-sex-simone-de-beauvoir-centenary-769122.html, date accessed 1 November 2010.

Mail Online (2009) 'Second Ralph Lauren Model in Photoshop Row as she's Airbrushed to become Impossibly Skinny', http://www.dailymail. co.uk/news/worldnews/article-1221675/Ralph-Lauren-new-photoshop-row-SECOND-image-model-airbrushed-make-head-larger-waist-emerges. html#ixzz15Mk7444f, date accessed 1 November 2010.

Manovich, L. (2003) 'The Paradoxes of Photography' in L. Wells (ed) *The Photography Reader* (London: Routledge).

Mitchell, W. J. T. (2005) *What do Pictures Want? The Lives and Loves of Images* (Chicago: University of Chicago Press).

Moller, K. (2008) 'Art Shay's Traces Of A Bygone America', *Swans Commentary*, http://www.swans.com/library/art14/moller08.html, date accessed 1 November 2010.

Nadia, C. (2008) 'Behind Simone de Beauvoir's derrière', *The Republic of Dissent*, http://www.globalclashes.com/2008/01/undressing-simo.html, date accessed 1 November 2010.

Ritchin, F. (1990) 'Photojournalism in the Age of Computers' in C. Squires (ed) *The Critical Image: Essays on Contemporary Photography* (London: Lawrence and Wishart).

Shay, A. (2010) 'Good Nudes From My Naughty World', *Swans Commentary*, http://www.swans.com/library/art16/ashay20.html, date accessed 25 May 2011.

Slater, D. (1995) 'Photography and Modern Vision' in C. Jenks (ed) *Visual Culture* (London: Routledge).

Sontag, S. (1977) *On Photography* (London: Penguin).

Styhre, A. (2010) 'Organizing Technologies of Vision: Making the Invisible Visible in Media-Laden Observations', *Information and Organization*, 20, 64–78.

Traister, R. (2005) '"Real Beauty" – or Really Smart Marketing?' *Salon Magazine*, http://www.salon.com/life/feature/2005/07/22/dove/, date accessed 1 November 2010.

Wallace, A. (2002) 'Jamie Lee Curtis: True Thighs', *More Magazine*, http://www.more.com/2049/2464-jamie-lee-curtis-true-thighs, date accessed 1 November 2010.

Wolf, S. (2010) *The Digital Eye: Photographic Art it the Electronic Age* (Munich: Prestel Verlag).

2

Representation and Resemblance in the Case of the Danish Cartoons

Catherine Collins and David Douglass

> I don't think that Mohammad will be drawn in a
> Danish newspaper for the next 50 years.
>
> (Carsten Juste, editor-in-chief of the Danish
> newspaper, *Jyllands-Posten*, 2006)

For many observers, the worldwide furore resulting from the publication of 12 cartoons featuring the Prophet Mohammad in a small Danish newspaper during the autumn of 2005 proved difficult to understand. Interviews conducted by the BBC evoked characterizations of the crisis as 'ridiculous,' and 'absolutely too much' (Buchanan 2006), and an American columnist confessed to being 'perplexed' at what he considered to be the 'gross overreaction by average Muslims around the world,' provoked by what were, after all, 'only' cartoons (Nethaway 2006).

Without doubt, there was much to be distressed about as the fallout from the publication of the cartoons 'left half the globe reeling' (*The Guardian* 2006: 23). Direct consequences included the firing or arrest of dozens of journalists and editors, worldwide demonstrations involving hundreds of thousands of protestors, the destruction of numerous embassies, economic boycotts resulting in the loss of hundreds of millions of dollars in revenue, and the death of approximately 150 people. The episode was heralded as a clash of cultures, a striking intersection of secular democratic freedoms and religious fundamentalism, and a significant step towards war. Surveying this range of effects, Michael Kimmelman (2006) of *The New York Times* has asked rhetorically of the cartoons whether any other modern works of art have 'provoked as much chaos and violence'.

It is significant that the flashpoint of the controversy was the act of creating images of the Prophet rather than any particular features

of the drawings themselves. The precision of this focus and the range of responses make the episode a valuable case study for discerning the interpretive frameworks invoked by any inscription of the body. In this chapter, we will show that key functions of representation and resemblance stand as ends of a spectrum of interpretive possibilities regarding such images, and that the particular framework utilized by individuals and groups derive from socially and historically situated assumptions.

Argument, Islam and the bodily image

The fact that the Danish cartoons were bodily images is of considerable significance, and responsible for much of the confusion and antagonism generated between discourse communities. This is not to say that bodily imagery is the only point of focus that might be applied to the affair. Various other interpretive and analytic frameworks have been brought to bear, and it may be helpful to situate briefly the present analysis so as to clarify the goal that we seek. Much work has been conducted on the putative functions of humour and satire in the cartoons (e.g. Lewis et al. 2008). Martin observed the vital role that humour plays in identifying and negotiating boundaries among values and people 'by playing with the incongruities of multiple meanings and conflicting viewpoints' (2008: 17). Lewis pointed out that the use of satire in cases such as the Danish cartoons can 'intensify (rather than vent) hostility and the perceived harm of victims' (2008: 13). Müller, Özcan and Seizov identified the potential that cartoons have for what they refer to as 'dual controversy,' 'meaning that both the content and message of the cartoon as well as its form or style can be controversial.' This tendency towards provocation is heightened by the 'property of the cartoon genre to combine humor with criticism' (2009: 29) in such a way that may be invisible to the author but felt all the more keenly by the target.

A second perspective often used in conducting inquiry into the Danish Cartoons involves the consideration of issues related to principled commitments of one type or another, such as those to freedom of speech, racial and religious equity, and civic tranquility (e.g. Modood et al. 2006). Modood situated the events surrounding the controversy in a wider domestic and international context that was 'already deeply contested' in terms of social principles (2006: 5). His consideration of antecedent conditions, including justified Muslim resentment based on a lack of respect and the more general cultural movement towards lack of protection for religious commitments, led him to the conclusion that the Danish Cartoons amount to racism. In contrast, Hansen analysed

the events in terms of a comprehensive commitment to freedom of expression, argued against Muslim exceptionalism, and concluded that 'offense is the price of living in a liberal society, one that has been paid by many groups before' (2006: 15).

The present study seeks to answer the question 'why did this particular publication trigger the response that it did?' The argument represented by this analysis holds that the depiction of bodily imagery served as an irreducible flashpoint for the events that followed, and that no account that overlooks this fact can fully explain what happened. Oring (2008:23) poses the rhetorical question, 'Would an op-ed piece making this point have drawn as much criticism as the cartoon did?' The answer is clear: It would not have done so, and the reasons have everything to do with the fact that the cartoons were images of the Prophet.

Given our focus on the communicative functions of images, it may be helpful to provide a short list of assumptions regarding their functions that we take to be important here. First, the distinction of visuality (in contrast to verbal textuality) is one of interpretive operations; images are images because they are viewed, whereas verbal texts are read. The nature of a visual artifact, then, is epistemic rather than ontological, and to say that something is an image is to say something about its use rather than its nature. These categories are not rigid, however, and their flexibility in use provides insight into the distinction between them: As interpretive viewing operations become increasingly prescribed and segmented, as is the case in structuralist approaches, for example, viewing becomes more and more like reading. Conversely, when text is understood for its visual form, as in the case of concrete or size poetry, its interpretive functions approach those of the visual. Second, visual artifacts are semantically less stable than are textual artifacts, and admit in most cases a greater degree of interpretative latitude. Lacking the more clearly defined semantic components characteristic of verbal texts, images evoke a wider range of interpretive responses than do verbal texts. Third, images often evoke a visceral or affective response from viewers remarkable in its immediacy and authority, and this is particularly true of bodily images. Fourth, images, like verbal texts, are apprehended and interpreted in context. This context includes cultural viewing traditions, personal experiences, attributions of authorship and intentionality, aesthetic value, and more. Fifth, and finally, the interpretive contexts for images, unlike verbal texts, are often unseen and unacknowledged. Images are often treated as if they serve an evidentiary purpose, conveying unmediated conclusions requiring no interpretation at all.

Much ado has been made throughout the cartoon controversy of a purported Islamic prohibition of images of Allah and the Prophet Mohammad, but the facts militate against the simplistic assumption of a sharp Christian-Muslim or secular-Muslim divide. Many Muslims viewed the images simply as cartoons. For example, Jihad Momani, Editor-in-chief of the Jordanian newspaper *Shihan*, wrote that at first viewing he saw 'only silly cartoons without meaning' (Chen 2006). Others found them objectionable, but trivial. In describing his reaction, Lebanese Imam Sheik Muhammad Abu Zaid observed: 'For me, honestly, this didn't seem so important. I thought, I know that this is something typical in such countries' (Fattah 2006). How, then, can we explain the deep offence and militant reaction of so many others?

Insight may be gained into this span of reactions by consideration of the historical traditions governing sacred images. The deepest roots of such traditions reach, with so many others, to Plato. His scathing characterizations made in *The Republic* of images as only 'imitation of appearances' (1992) rendered them equivalent to lies, and image-makers in this depiction are the equivalent of liars. He considered both images and image-makers to be misleading, lacking virtue, and ultimately of little use. The basis of his critique involved his conception of imitation, or mimesis, which he took to be 'far removed from the truth, for it touches only a small part of each thing and a part that is itself only an image'. Any attempt to imitate the eternal forms which comprise true reality fail by virtue of their base construction in worldly material, and, thus, they fall far short of truth.

This distrust of imagery on the basis of its removal from truth resonated well into the early Christian period where it coincided with prohibitions drawn from the Judaic tradition against images, and was codified in the second Biblical commandment: 'Thou shalt not make thee any graven image, or any likeness of any thing that is in heaven above, or that is in the earth beneath, or that is in the waters beneath the earth' (Deuteronomy 5: 8, King James version). The prior commandment forbids taking other gods, and the subsequent one forbids worship of graven images or likenesses. Together, these three prohibitions may be taken as strictures against idolatry, and graven images serve as the very emblems of the sin.

One might well wonder, given this early set of prohibitions, that the Christian tradition did not evolve the same type of hostility to graven images as was manifest in the extreme version of the Islamic response to the Danish cartoons, and, indeed, such was the case during the early Roman period. But by the third century, the Gnostic project of

combining Christianity and paganism resulted in an easing of prohibitions against resemblance, and images and effigies of Christ began to appear in temples. Such images of sacred subjects proliferated well through the seventh century, attended by a growing body of doctrine. These doctrinal-based justifications included the conviction that by being made flesh, Jesus had superceded Old Testament prohibitions against idols; the notion that virtue resided in images of virtuous figures – miracles and other supernatural phenomena were increasingly attributed to sacred pictures and other depictions; the popularity of 'pictures not made with hands,' believed to have been created in heaven by God himself or some other divine figure and thus beyond reproach; the idea that worship of an image passed on to the prototype; and recognition of the propagandistic value of images (Pope Gregory I called them the 'books of the illiterate'; see Martin 1978: 23).

During the seventh century the Prophet Mohammad was taken to have sided strongly against imagery at large, and icons in particular, judging representation of the divine to be a satanic innovation. This judgement was represented in the Koran only indirectly, where, for example, the stipulation that '[Allah is] the originator of the heavens and the earth . . . [there is] nothing like a likeness of Him' (Ch. 42 v. 11) was read as a proscription against representation. Justification was also found in an exchange between Abraham and his relatives, often interpreted as an injunction against idolatry: '[Abraham] said to his father and his people: "What are these images to whose worship you cleave?" They said: "We found our fathers worshipping them." He said: "Certainly you have been," you and your fathers, in manifest error"' (Ch. 21, v. 52–4). The subject was treated most directly in the Hadeeth, a collection of sayings drawn from the life of the Prophet Mohammad. There he is described as having 'cursed the picture-makers' (v. 3, bk. 34, n. 299), and is quoted asking, 'Don't you know that angels do not enter a house wherein there are pictures; and whoever makes a picture will be punished on the Day of Resurrection and will be asked to give life to (what he has created)?' (v. 4, bk. 54, n. 447). As a consequence of such injunctions, mosques were devoid of any semblance of Allah or the Prophet Mohammad, and Islamic art in general eschewed such images in favour of geometric and symbolic design.

Conflict between those who disdained religious images and those who venerated them, respectively called iconoclasts and iconodules, waxed and waned for well over a thousand years, with notable outbreaks of political and theological confrontation occurring first during the Byzantine period, during the Protestant Reformation in northern

Europe, and again during the French Revolution. It may not be necessary to trace the details of the controversy further in order to make the following summary, albeit at the risk of oversimplification of an extraordinarily complex and lengthy historical debate. We might say that the interpretive traditions relative to sacred images fractured during the middle ages. Among Christians, from early in the Roman period there emerged a tradition of iconicity in which images were treated as representations of their sacred subjects. Iconic representation was conceived as writing, not art, and iconographers were authors and religious adherents rather than artists. At the same time, strong and sustained impulses towards iconoclasm frequently led to violent clashes over the acceptability of such images, largely on the basis of what was seen as false resemblance leading to idolatry. Iconoclastic doctrine was manifest in a variety of Islamic, Judaic, and Christian sects. A considerable amount of cross-doctrinal migration took place in which the Bible, Koran and Talmud, as well as religious authorities in both religious and secular traditions, were solicited for justification of iconoclastic policies. Similarly, defence of iconography often turned not only inward to Christian doctrinal explications, but also outward to pagan sources. Altogether, conflict between iconoclasm and iconodulism arose within religious traditions, rather than across or between religions. Still, throughout periods of transition, Islamic tradition held most closely to the iconoclastic doctrine, and aversion to bodily images of the Prophet grew to become a widely held cultural piety.

The case of the Danish cartoons

On 30 September 2005, *Jyllands-Posten*, a Danish national newspaper with a circulation of 150,000, printed 12 cartoons depicting the Prophet Mohammad on page 3 of the second section of the newspaper. Some of the drawings were innocuous, such as one depicting the Prophet dressed in simple white attire and sandals, holding a staff and leading a pack-animal. Several others were explicitly ironical or self-referential, such as that of a cartoonist labouring late at night over a drawing of Mohammad. Still others were more hostile, such as one depicting a glowering Prophet wearing a bomb in place of a turban. The goal for the feature, according to editor-in-chief Carsten Juste (2006), was to promote dialog on the subject of Islam and censorship.

The initial response to the publication was limited to a few angry letters, but in mid-October two of the artists received death threats, rekindling debate and prompting a series of highly publicized and

inflammatory anti-Muslim remarks on Danish talk shows. A demonstration by approximately 5000 Muslims and supporters in Copenhagen followed, along with a growing number of formal complaints lodged with the Danish prime minister. In response to the growing pressure, both the prime minister and editor Carsten Juste issued apologies for offence to Muslim sensibilities (*The Guardian* 2006: 23).

In spite of this unrest, protest remained largely limited to Denmark until mid-January, when the Norwegian daily *Magazinet* reprinted the cartoons. Immediately thereafter, the Berlin-based German newspaper *Die Welt* ran a version of the bomb-turban drawing on its front page under the headline 'Protests Against Mohammad Pictures Successful.' The French tabloid *France Soir* followed suit, with a succession of additional reproductions thereafter. *The Guardian* reported that episodes of reproduction by major newspapers numbered in 'the dozens,' and that 'scores of TV channels, including almost all the major French stations and the BBC,' broadcast the images (2006: 23).

Reaction to this international exposure was immediate. *France Soir's* owner Raymond Lakah sacked editor Jacques Lefranc 24 hours after the publication of the drawings in what he called 'a powerful sign of respect for the intimate beliefs and convictions of every individual' (BBC 2006). Vebjørn Selbekk, the editor of *Magazinet*, received threatening anonymous emails and numerous death threats, and the decision was made to remove the images from the newspaper's website. Ministers from 17 Arab countries called on the Danish government to punish the artists who had drawn the images. In Palestine, thousands of protestors burned Danish flags, chanting 'death to Denmark,' and over 10,000 protesters joined forces to demonstrate in Egypt. Protests took place as far afield as Thailand, Indonesia, India, Nigeria, and the Philippines. The Euro-Mediterranean Parliamentary Assembly Bureau (EMPA) and European Parliament issued statements calling for 'responsible use of freedom of the press and of expression,' and condemned 'any disrespect of religions as well as any attempt to incite religious hatred, xenophobic or racial remarks' (Kirk 2006).

Response was not only symbolic and political, but financial as well. Calls for boycott of Danish goods spread quickly and had immediate effect. Spokesperson Louis Honre characterized the situation as a 'public uprising' that 'spread like wildfire,' and estimated that the boycott was 'practically 100% successful' (Rhanem 2006). Nigerian legislators burned Danish and Norwegian flags inside Parliament and barred Danish companies from bidding for an upcoming major construction project. They also voted unanimously to cancel a $25 million contract

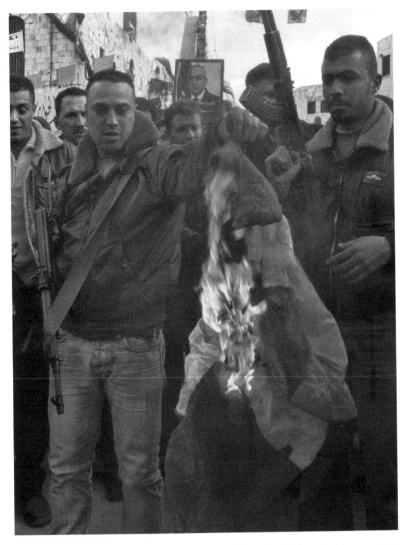

Figure 2.1 Palestinian militants burn Demark's national flag during a protest over the *Jyllands-Posten* cartoons

to buy 14 Danish buses and issued a call to Nigerian citizens to boycott goods from Denmark.

Jyllands-Posten offices in Aarhus and Copenhagen were evacuated due to bomb threats, and the Danish Red Cross evacuated employees

from Gaza and Yemen after death threats were received there. Shaykh Abu-Sharif, speaking for the Usbat al-Ansar group, called for 'beheading the blasphemers and all those who abuse Islam and the divinities,' and called on Osama bin Laden 'to take revenge immediately' (Zaatari 2006). bin Laden himself issued a videotaped appeal in April urging Muslims to boycott all Western goods from countries that supported Denmark, and he instructed his followers to begin for a 'long war' (CNN 2006).

Sustained attention to the incident abated in the summer of 2006. However, since that time the episode has repeatedly been evoked in a series of incidents and commemorations: 'Blasphemy Day' was established to coincide with the 30 September publication date of the cartoons; Tyranny of Silence, a collection of essays on free speech, was published on the fifth anniversary of the event; an assassination attempt on Kurt Westergaard, one of the artists, took place in 2010 at his home in Arhus; and in November 2010 Danish Foreign Minister, Lene Espersen, held a meeting in Cairo to discuss the continuing legacy of the event.

Interpretations of bodily image in the cartoon controversy

Responses from authorities and various stakeholders in the Danish cartoon image event reflected two different perspectives, one based on the religious traditions of Islam and the other grounded the political values of democracy. In the arguments articulated following the initial publication of the cartoons, these perspectives were manifest in (1) the location of the controversy in relation to free speech; (2) the attribution of motive; and (3) calls for action.

Cartoons and free speech

For responses grounded in Islamic tradition, the cartoons were lent an evidentiary force unrelated to any particular aspect of their depiction of the Prophet. Their transgression lay in the act of depiction itself, the blasphemy of similitude or resemblance, rather than any specific feature of the images. Indeed, references to specific features were virtually absent from such discourse. Rather, the images were taken as an affront simply because they were images of the Prophet. Observation of this affront was most frequently accompanied by a discussion of freedom of speech, a value that was subsumed within a religious set of priorities. Turkey's Prime Minister Erdogan, articulated this perspective succinctly: 'freedom of expression is important, but what is holy to me

is more important' (*Economist* 2005: 48). The rationale for this choice derived from the relationship between the two values. The concept of free expression was not rejected, but subordinated and viewed as a qualified right. Mohamed Abdul Bari, chairman of the East London Mosque, explained that 'the hallmark of any civilized society is not just that it allows freedom of speech, but that it accepts this freedom also has limits' (Akbar et al. 2006).

Thus, within this discourse community, free expression did not extend to a critique of beliefs or traditions associated with the representation of the Prophet. Freedom of expression was valued, but only within the constraints of religious piety.

Arguments grounded in political values also located the debate in a context of free speech, but in a markedly different fashion. Within this discourse, free speech was treated as a transcendent value, essential to democratic society and among the most vital of individual rights. The editor of *Die Welt* asserted that the ability to subject the most sacred elements in society to criticism, satire and laughter serves as a core of Western culture (Crichton 2006). The Ayn Rand Institute (2006) defended the cartoons as an instance of dissent, criticism, and free expression, all of which it judged to be essential components of 'rational culture'. Such defences often juxtaposed the cartoons with analogous affronts to Christianity, such as photographer Andres Serrano's 'Piss Christ,' author Dan Brown's *The Da Vinci Code*, or playwrights Richard Thomas's and Stewart Lee's *Jerry Springer: The Opera*. In each case, Western tolerance for impiety was contrasted with Islamic prohibitions, and these, in turn, were construed as evidence of Muslims' intolerance and intransigence.

Attribution of motives

A second important feature of the cartoon discourse was the attribution of sinister motives to the Other. Western media served as one frequent target for Muslim critics. Bangladesh Foreign Minister Murshed Khan contended 'the Western media knows very well that the publication of photos or drawing portraits of Muhammad is completely restricted. By reprinting the cartoons published by the Danish daily, they have consciously incited hatred against the Muslims of the world, including those in the Western countries' (Global News Wire 2006c). In a similar vein, Afghan presidential spokesman Karim Rahimi asserted that the West understood fully the religious restrictions violated in the cartoons, and intentionally disrespected Islam by republishing them repeatedly

(Global News Wire 2006d). It bears mention that apart from calls for boycotts or other economic sanctions against Denmark, surprisingly few arguments that appeared in international media centred on Danes, *Jyllands-Posten*, or the cartoonists themselves. In many cases, the Other remained unspecified as 'those responsible.'

Many assessments linked the cartoons to a broader anti-Muslim agenda. In an editorial in the *Tehran Times* Hasan Hanizadeh wrote that publication of the cartoons was 'part of a comprehensive plan to confront Islam,' and an 'ideological offensive against Islam,' which gave rise to 'Islamophobia' (Global News Wire 2006a). In some cases, links were made to conspiracy theories, or to historical enmity. Former editor Samir Ragab wrote in the Egyptian state daily *el-Gomhuria*, 'It's no longer a matter of freedom of thought or opinion or belief. It's a plot hatched against Islam and Muslims, the preparation of which began many years ago' (Thomsen 2006: 12). Evidence of an agenda other than defence of free speech was found in the perception of a double standard; Iran's Supreme Leader Seyed Ali Khamenei, among others, noted the widespread practice of banning holocaust denials, and questioned why objections to the violation of free speech was not at issue in those cases (Xinhua General News Service 2006).

For their part, participants who supported publication of the cartoons were quick to castigate Islam and radical Muslims. An editorial in *The Indian Express* (2006) asked 'is it not time we stood up against Islam's repeated attempts to impose its will, values and ideas of blasphemy on the rest of us? Is it not time that we demanded that Islam retreat to the private sphere it inhabited before the advent of the Ayatollah Ruhollah Khomeini and Osama bin Laden?' Cartoonist Martin Rowson asserted that Islamic response had 'nothing to do with drawing and everything to do with control and hegemony. It [was] the Muslim clergy exercising their power with the easiest form of attack – being permanently offended' (Crichton 2006). As with the opposition, these voices presumed in the Other motivation and intention.

Calls to action

Framed as blasphemy, deliberate confrontation, and age-old conspiracy, the cartoons were used to justify demonstrations, boycotts, and even violence as appropriate responses. *Vakit* editor-in-chief, Hasan Karakaya, a religious moderate, began his opinion with the premise that 'no acts of violence are more violent than portraying the Prophet as a "Terrorist,"' and argued that 'Muslims are wholly justified in reacting

as they do, which includes "torching a few embassies."' He called on 'the whole world' to understand that 'whoever attacks Muslims' sacred values will pay the price' (BBC World Monitoring 2006). At the extreme end of this logic, Sheik Abu Sharif, spokesperson for the militant Osber al-Ansar, argued 'We will not be satisfied with protests. The solution is the slaughter of those who harmed Islam and the Prophet' (Global News Wire 2006b). A preacher at al-Omari Mosque in the Gaza Strip was still more explicit: 'We will not accept less than severing the heads of those responsible'. The original publication and subsequent republication of the cartoons were characterized as 'part of the war waged by the decadent West against the triumphant Islam. To the billion Muslims: where are your arms? Your enemies have trampled on the prophet. Rise up'.

The response from the West, represented in the work of numerous journalists, including Michelle Malkin, Kathleen Parker, Robert Spencer, Judith Klinghoffer, and many others, called for the re-publication of the cartoons as a matter of journalistic solidarity and free speech integrity. Michelle Malkin went so far as to display on her website an icon of a Danish flag with the words 'I support Denmark in the struggle for freedom of speech,' and she urged others to 'buy Danish' (Malkin 2006). Newspapers as diverse as *The Boston Globe* and *The Brussels Journal* asserted that 'now we are all Danes.' In these ways the democratic community called others to a Western, democratic identity through symbolic action, oblivious to the fact that the action itself constituted a direct attack on Islamic piety by reproducing the original egregious offence. This served to confirm the initial attribution of motive and lend further justification to the proposed actions. In this manner, the exchanges created a cycle of escalation.

Discussion

At this juncture, it might be tempting to characterize the cartoon publication as a conventional public controversy that happened to involve bodily images. The cartoons ostensibly at the centre of the controversy were virtually invisible in the discourse; almost no attention was lent to the composition of the images, their nuanced signification, text captions or any other material component. Instead, they were accepted by both sides as unproblematic in the meaning they conveyed. Implications of the act of publication at large replaced more detailed interpretation, so much so that the cartoons might be said to have meant in ways only distantly related to the particular and detailed images they depicted.

We take this feature to yield an important theoretical point: In contrast to verbal text, visual imagery is most often apprehended all at once, and its meaning is assumed to be manifest. The double meaning of 'manifest' in this context, referring both to clarity of literal sight and to understanding, is illustrative. The act of seeing is conventionally assumed to be synonymous with understanding. In this case, the cartoons' meaning was assumed to be clear, which left participants in the debate free to confront each other over what followed from the publication. In fact, as we hope to have demonstrated, the meanings attributed to the images varied radically based upon contrasting assumptions regarding representation and resemblance. Westerners tended to assume the cartoons merely represented the Prophet Mohammad – that is, the images bore a referential relationship to their subject – while for many Muslims the images purported to resemble the Prophet, and so amounted to an affront, even to blasphemy.

The distinction between representation and resemblance has implications that reach beyond this particular case. The wide range of latitude available in the interpretation of images as either references or literal reflections makes the visual medium an unstable form. William Jones (2009) has argued that in times of great strife and uncertainty, such instability may not be tolerable, and other, more stable conveyances of meaning will be preferred. This tendency is manifest not only in regard to visuality, but also in regard to irony, satire, and various other forms of communication, whether verbal or visual, that share the characteristic of multiple interpretive possibilities. Indeed, Jones observed at least a temporary 'end' of satire, irony and the boundary-play typical of all such forms following the 9/11 attacks on New York and Washington DC due to a 'wave of public animosity' (2009: 27). The loss of tolerance for plural perspectives and layered meanings at the edge of orthodoxy rendered the use of such forms for political subjects unpatriotic in the US and many other Western countries, at least.

Although tolerance for boundary-play may wane at moments of great challenge, one might argue it is exactly at such moments that dynamic semantic forms are needed most. The tendency at such times towards ideological rigidity and polarization is reflected as much in our forms of discourse as it is in their content. Accordingly, sustaining the use of unstable forms might well serve as a prophylaxis against narrowing thought and contracting reason, and in this manner improve both the quality of national sense-making and the possibility of international dialogue. Engagement and tolerance begin at home, after

all, and enduring a plurality of communicative forms would seem to serve as an excellent foundation for international and intercultural engagement.

This line of thought is confounded by the fact that means by which we make sense of images are so deeply embedded in our interpretive processes that the role that they play in discourse is hidden from view. Recognition of the political and spiritual implications of images has a long and conflicted history, as illustrated by our discussion of the historical inclinations towards iconoclasm and iconodulism. However, our understanding of the fundamental commonplace ways that visual imagery works upon us is limited. A related feature of this demonstration has been the stability of visual interpretive traditions over time. The general trajectories of Western and Muslim visual traditions were established well over a thousand years ago, and these trajectories have remained largely intact. Unlike textual interpretive traditions, which have undergone radical transformations and given rise to modern academic disciplines, the study of visual interpretation remains in its infancy, and has been largely passed over in the domain of art history in favour of historical and objectivist frameworks.

Taken as a whole, the cartoon controversy demonstrates the utility of images in construing identity. The arguments that unfolded in the wake of the publication served rhetorically to construct communities based upon religious or secular pieties, and the iconic function of images rendered them ready vessels for such pieties. The link from image to ideology is typically historical, narrative and associational rather than propositional or rational. Consequently, the cartoons in this case and images of the body at large served as ideological conveyances par excellence.

References

Akbar, A., Evans, J., McSmith, A. and Ebbutt, T. (2006) 'Moderate Muslims Rail Against Extremists', *The Independent*, 8 February.

Ayn Rand Institute (2006) http://www.aynrand.org/site/PageServer?pagename=support_free_speech, date accessed 1 August 2006.

BBC (2006) 'French Editor Fired over Cartoons', 2 February, http://news.bbc.co.uk/1/hi/world/europe/4672642.stm, date accessed 3 March 2006.

BBC World Monitoring (2006) 'Review of the Turkish Islamist Press 8 Feb 06', 8 February.

Buchanan, M. (2006) 'Cartoon Outrage Bemuses Denmark', 1 February, http://news.bbc.co.uk/2/hi/europe/4669210.stm, date accessed 3 March 2006.

Chen, J. (2006) 'Cartoons Are Silly', *Newsweek*, 4 February, http://www.msnbc.msn.com/id/11175022/site/newsweek/, date accessed 3 March 2006.

CNN (2006) 'Purported bin Laden Tape Denounces West's Response to Hamas', 23 April, http://www.cnn.com/2006/WORLD/meast/04/23/binladen.tape/, date accessed 30 July 2006.

Crichton, T. (2006) *Sunday Herald*, 5 February.

Economist (2005) 'An Image Problem', 3 December, 48–9.

Fattah, H. M. (2006) 'At Mecca Meeting, Cartoon Outrage Crystallized', *The New York Times*, 9 February.

Global News Wire (2006a) 'Iran Press Insulting Cartoons US Israel Plot to Create Rift Between Islam, West', 3 February.

Global News Wire (2006b) 'Anger Sweeps Middle East over Cartoons', 4 February.

Global News Wire (2006c) 'Bangladesh Parliament', 7 February.

Global News Wire (2006d) 'Four Afghan Demonstrators Killed as Demos Intensify', 5 March.

The Guardian (2006) 'How Cartoons Fanned The Flames Of Muslim Rage', 5 February, 23.

Hansen, R. (2006) 'The Danish Cartoon Controversy: A Defence of Liberal Freedom' in T. Modood, R. Hansen, E. Bleich, B. O'Leary, and J. H. Carens (eds) (2006) 'The Danish Cartoon Affair: Free Speech, Racism, Islamism, and Integration', *International Migration*, 44, no. 5, 7–116.

The Indian Express (2006) 'The Right to Laugh at the Gods', 4 February.

Jones, W. P. (2009) '"People Have to Watch What They Say": What Horace, Juvenal, and 9/11 Can Tell Us about Satire and History', *Helios*, 36, no. 1, 27–53.

Juste, C. (2006) 'The Editor and the 12 Cartoons', Jyllands-Posten, February 10.

Kimmelman, M. (2006) 'A Startling New Lesson In The Power Of Imagery', *The New York Times*, 8 February.

Kirk, L. (2006) 'Global Diplomacy To Curb Muslim Cartoon Protests', EUObserver.com, 8 February, http://euobserver.com/843/20856, date accessed 5 March 2006.

Lewis, P. (2008) 'The Muhammad Cartoon Conflict: Implications for Humor Research and Advocacy' in P. Lewis, C. Davies, G. Kuipers, R. A. Martin, E. Oring, and V. Raskin (eds) 'The Muhammad Cartoons and Humor Research: A Collection of Essays', *Humor*, 21, no. 1, 11–16.

Lewis, P., Davies, C., Kuipers, G., Martin, R. A., Oring, E. and Raskin, V. (2008) 'The Muhammad Cartoons and Humor Research: A Collection of Essays', *Humor*, 21, no. 1, 1–46.

Malkin, M. (2006) 'First They Came for the Cartoonist', 1 February, http://michellemalkin.com/archives/004428.htm, date accessed 4 March 2006.

Martin, E. J. (1978/1930) A History of the Iconoclastic Controversy (New York: AMS Press).

Martin. R. A. (2008) 'Thoughts on the Muhammad Cartoon Fiasco' in P. Lewis, C. Davies, G. Kuipers, R. A. Martin, E. Oring, and V. Raskin (eds) 'The Muhammad Cartoons and Humor Research: A Collection of Essays', *Humor*, 21, no. 1, 16–21.

Modood, T. (2006) 'The Liberal Dilemma: Integration or Vilification' in T. Modood, R. Hansen, E. Bleich, B. O'Leary, and J. H. Carens (eds) 'The Danish Cartoon Affair: Free Speech, Racism, Islamism, and Integration' *International Migration*, 44, no. 5, 4–7.

Modood, T., Hansen, R., Bleich, E., O'Leary, B., and Carens, J. H. (2006) 'The Danish Cartoon Affair: Free Speech, Racism, Islamism, and Integration', *International Migration*, 44, no. 5, 3–62.

Müller, M. G., Özcan, E. and Seizov, O. (2009) 'Dangerous Depictions: A Visual Case Study of Contemporary Cartoon Controversies', *Popular Communication*, no. 7, 28–39.

Nethaway, R. (2006) 'Yikes, It's Only a Cartoon', 9 February, http://www.wacotrib.com/news/content/shared/news/nation/stories/2006/02/NETHAWAY_COLUMN_0209_COX.html, date accessed 1 March 2006.

Oring, E. (2008) 'The Muhammad Cartoon Affair' in P. Lewis, C. Davies, G. Kuipers, R.A. Martin, E. Oring, and V. Raskin (eds) 'The Muhammad Cartoons and Humor Research: A Collection of Essays', *Humor*, 21, no. 1, 21–6.

Plato (1992/380 BC) Republic trans. G. M. A. Grube (Indianapolis, IN: Hackett Publishing).

Rhanem, K. (2006) 'Morocco Condemns Publication of Prophet Satirical Cartoons', *Morocco Times*, 13 January.

Thomsen, P. B. (2006) 'Danes Call Envoys Home over Prophet Cartoons', *Irish Times*, 3 February.

Xinhua General News Service (2006) 'Iranians Stage New Violent Protest Against Mohammad Cartoons', 7 February.

Zaatari, M. (2006) 'Thousands Protest Prophet Outrage', *Daily Star*, 4 February, http://www.dailystar.com.lb/article.asp?edition_id=1&categ_id=1&article_id=21950, date accessed 4 March 2006.

3
Imitation and Controversy: Performing (Trans)Sexuality in Post-Communist Bulgaria

Plamena Kourtova

> Azis is what every man fears to be and what every woman dreams of becoming, something in between Marilyn Monroe and Marilyn Manson.
>
> Azis[1]

Vignette 1

In the Fall of 2004 a billboard located in downtown Sofia and in close proximity to the statue of the Bulgarian independence hero and revolutionary, Vasil Levsky,[2] became the source of controversy. The billboard advertised a new single by the pop-folk singer, Azis. A campaign by intellectuals and pop music performers called for it to be removed because of the provocative appearance of the singer, dressed in a woman's corset that accentuated his lower body and revealed his buttocks. Following an order by the Secretary of the Ministry of Internal Affairs[3] the billboard was taken down. Reflecting on the event, the Bulgarian National Radio interviewed Azis and asked him if he was offended and angry with the ministry official. The performer replied that he could not possibly be upset with such an attractive man.

Vignette 2

It is a dark night and flashes of imagery reveal a church building and a muscular man nailing pieces of wood together into a cross. A clarinet solo slowly weaves into a processed electronic groove and a kuchek rhythm penetrates the darkness. A disembodied face appears, floating in the dark night sky with bleached blond hair, beard, and red

devilish eyes. The inside of a Catholic church is revealed where Azis kneels, flagellating himself. Blood runs down his back as a man dressed as a Catholic priest approaches him. The priest begins to wipe the blood from Azis' back slowly, sensually, taking his robe off. Azis begins to sing: 'I want to sin with someone now [...] I want to burn in the flames of passion [...] C'mon, give it to me now.' The Catholic priest and Azis embrace, naked in front of the church altar.[4]

The Bulgarian pop-folk performer, Azis, gained notoriety and fame in the music business during the early 2000s and has built a reputation as a performer who shocks his audiences and Bulgarian society with an unapologetic display of gender-bending homoeroticism. While this has been widely perceived as commercial shtick, it has also stirred up the racial and gender norms of post-Communist Bulgaria and raised questions about the freedom of artistic and commercial expression in the context of democracy, capitalism, and European Union membership.

Mimesis and Alterity

In his 1993 book *Mimesis and Alterity*, Michael Taussig argues that 'the mimetic faculty is the faculty to copy, imitate, make models, explore difference, yield into and become Other' (1993: xiii). Building upon this definition, Taussig describes the power of mimesis as a relationship between copy and original wherein the imitation embodies the power of what is copied. Mimesis is more than an abstraction of reality or a free-floating set of ideas. Its power to constitute alterity or change plays with the same and the different and with relationships between a self and an Other. As Taussig notes, 'mimesis registers both sameness and difference, of being like and of being other, yet all identity formation is engaged in this habitually bracing activity in which the issue is not so much staying the same, but maintaining sameness through alterity' (ibid:129).

Thinking about sameness and difference as enacted and performed in the context of Euro-American popular music culture, one can easily identify the presentation of gender and sexuality as frequent points of interaction and conflict between a self and an Other. In the 1950s Elvis was condemned by a white, middle-class American audience because of the suggestive gyrations of his hips and legs during live performances (Szatmary 2010: 50). In the 1970s and early 1980s American and British musicians performed and gendered difference by embodying and mapping it on stage. David Bowie, Kiss, The New York Dolls, Alice

Cooper and Queen mimetically reproduced the styles of specific female performers such as Janis Joplin and Liza Minnelli as well as more generic feminine figures, creating androgynous alter egos that replicated, through make up and dress, the sensuality of femininity in a male body. This kind of performance was also incorporated into the presentation of bands like Twisted Sister and Mötley Crüe who combined feminine looks and misogynistic lyrics and music in a mimetic performance of gender within the visual spectacle of metal (Walser 1993: 124–8). The sexual aggressiveness of masculine rock bands was in turn mimetically reproduced in the imagery of 'Like a Virgin', 'Like a Prayer' and 'Justify my Love' by Madonna (Lewis 1990: 123).

As Marjorie Garber notes, these kinds of performances have worked to call into question 'received notions of "masculine" and "feminine", straight and gay, girl and woman, boy and man' (1992: 354). They have also worked to multiply the ways in which sexual personae are presented. For example, Madonna, who built a reputation for pushing the boundaries of female sexuality in videos such as 'Express Yourself' (David Fincher, 1989), 'Justify My Love' (Jean Baptiste Mondino, 1990) and 'Erotica' (Fabien Baron, 1992), is also credited with the invention of a variety of fictional personae that reference sexual preferences such as bisexuality and SM fetishes and qualities ranging from submissiveness and sensuality to mysticism and aggressiveness. In 'Frozen' (Chris Cunningham, 1997) Madonna is a mystical, shape-shifting sorceress-like creature levitating in the middle of a desert, capable of controlling nature. In 'Die Another Day' (Traktor, 2002) she appears to be tortured in a prison, with bruises and bloodstains all over her face and body, but is physically strong and resistant to the violence she is subjected to. In 'Nothing Really Matters' (Johan Renck, 1999) she is a Japanese inspired geisha surrounded by futuristic costumed, robot-like dancers of Asian descent.

Like Madonna, Lady Gaga's performances play with multiple personae, and are characterized by notably exaggerated visual stylistics. These include a variety of manipulations of the female body, such as her animal like spine in 'Bad Romance' (Francis Lawrence, 2009) and costumes that both emphasize and blur gender distinctions. In 'Bad Romance' she transforms from a futuristic diva into a middle-eastern princess in a jewelled headdress, while in 'Telephone' (Jonas Åkerlund, 2010) she appears as an androgynous, bisexual convict wearing a dress made of chains and lit cigarettes shaped into sunglasses.

In all of these cases the work of glam rockers, metal bands, and pop artists such as Madonna has been met with resistance. The lack of

tolerance towards such visual and lyrical representations of masculinity and femininity contributed to the formation of the Parents Music Resource Center and the tightening of censorship of music production in the 1980s (Korpe 2004: 184). But the unprecedented visibility of sexuality, which Madonna embraced in video and on stage, has also contributed to the creation of the pop music diva – a powerful female music performer who explores sexuality openly and purposefully. The commercial visibility of difference has thus become profitable even as it has caused public discontent. Today, the spectacles of shock, sexuality and the 'doing of gender' (West and Zimmerman 2002: 42) continue to develop in many directions in the controversial performances of outspoken performers such as Marilyn Manson and female divas including Britney Spears, Christina Aguilera, Beyonce and Shakira.

Within the pop-diva circuit, the performance of gender takes on quite specific characteristics such as the visual display of the abs and hips and skin that is moist, sweaty and visibly tanned. Divas such as Christina Aguilera and Britney Spears combine such stylistics with the pronounced racy quality of their songs' lyrical content. In the 2002 video 'Dirrty' (David LaChapelle), for example, Aguilera fights inside a boxing ring in tight leather pants and a bikini top, the choreography of the song emphasizing her hip and buttock movements. Britney Spears' 2001 hit 'I'm a Slave 4 U' (Francis Lawrence) uses a more gentle dance style but in both performances female sexuality and bodily display are linked and the gaze of the performers is directed at the camera at all times, as if singing to each and every male in the audience. This display of seductiveness has become a standard tactic in the performance of the body as a sexualized and desiring object.

This chapter examines the flamboyant performance style, music and imagery of Azis through the vocabulary of mimesis and alterity and in relation to Euro-American popular culture, gender performances and spectacles of difference. I argue that Azis embodies the Otherness of Euro-American popular music culture by purposefully sexualizing his performances to a level of controversy. In this mimetic process he reproduces and reconfigures various levels of Otherness in musical, physical, sexual and visual ways. Such 'shameful' and controversial artistic expression is particularly complex in the light of Bulgaria's integration with the West as a recent member of the European Union. I explore the performances of Azis as musical and visual manifestations of 'freedom' linked to representations of the self within a profitable capitalist context. I trace the way this freedom becomes a complicated nexus of problematic social categories and is transformed into a display of what Taussig (1993) refers

to as 'savagery' – an inherent property of mimesis in its historical context of colonial encounters between the West and its Others.

Post-communism and pop-folk

The 1989 regime change from Communism to parliamentary democracy in Bulgaria was largely the result of economic failure and of the inability of the Communist regime to adapt to broader social changes. Yet while popular disenchantment with Communist ideology led to its demise, as in the rest of Central and Eastern Europe during the 1990s, the pace and nature of the changes in Bulgaria were quite different. In contrast to the changes in countries such as Poland or Hungary, the Bulgarian political and economic transformation was operationalized in a top-down manner – Communist Party members directed and controlled the change. The lack of agency elsewhere in Bulgarian society allowed the Communist elite to maintain a relatively strong influence over the transition process and transform its political influence into economic clout (Giatzidis 2002: 56).[5]

Throughout the 1990s the refashioned Communist elite retained its status and control, taking advantage of the economic opportunities presented by the deregulation and privatization of media. The controlled nature and corruption of the political and economic transition from Communism to capitalism also resulted in an identity conflict on a social level. On the one hand, the previously restricted and idealized world of Euro-American popular culture flooded the public space, creating a sense of freedom – a freedom to consume, embody, copy and imitate artistically and creatively. On the other, for many, overt commercialism and heterogeneity within popular culture and music was seen as an out-of-control and 'savage freedom,' particularly when it challenged established sociocultural boundaries and understandings of gender, sexuality, high and low culture and notions of Bulgarianness.

Within this process, which historian Maria Todorova (1997) has called balkanization, Bulgarians became acutely conscious of their regional affiliation with the Balkans as the 'Other' of Europe. Balkan countries such as Bulgaria are considered as a savage, mythical territory that is industrially backward and lacking the advanced social relations and institutions typical of the developed capitalist West; less complex, and cultivated (Todorova 1997: 12). The emergent Bulgarian nation of the early twentieth century attempted to deny its Ottoman heritage. During the Communist period (1945–89), these attitudes were enacted politically: Roma and Turkish minorities were forbidden to speak their

native language or practice their religion and their names were purpose-fully Bulgarianized. This philosophy of assimilation was an emblem of the pure, homogeneous society the Communist party wanted to create and present to the world. Since the fall of the Communist regime in 1989, the attitudes underscoring these policies have continued in day-to-day cultural and social discourse. Colloquial expressions such as 'Gypsiness' and 'Gypsy business' persist, denoting contamination, destruction, decay and lack of effort. As Peycheva explains (1998: 139), in Bulgaria 'gypsiness' is rendered as a kind of 'philosophy' that explains the country's economic and cultural decay. The term 'Gypsy' is still a prevalent label for the Bulgarian Romani minority, and is also used to refer to the musical and cultural elements of pop-folk that signify Romani or Gypsy culture as unclean and distasteful.

This perception has led to some expressions within popular culture and music that are representative of Roma/Turkish minorities being seen as shameful and non-European. 'Freedom' has been understood in relation to an aesthetic category of appropriateness, but also as something that is located between a backward East and a developed and civilized West. Balkan nations such as Bulgaria downplay the musical and cultural legacy of the Ottoman Empire in an attempt to present themselves as genuine, high-cultured European nations. The Otherness constructed by the perceived West has become deeply internalized within the region and underscores perceptions of Ottoman cultural and musical markers as 'foreign'.

Pop-folk,[6] or chalga (Turkish for 'musical instrument'),[7] is a musical phenomenon that flourished in the 1990s and may be seen as the embodiment of these transformations and tensions. Its roots are quite complex, embracing new Yugoslav folklore music, the jazz-oriented Bulgarian wedding music made famous internationally by Ivo Papazov and his wedding orchestra in the 1980s, and various popular music forms (Buchanan 2007: 229). Pop-folk uses an electronic, processed sound closely related to mainstream Western popular music (electric guitars, drums, synthesizers, vocal effects), but its predominant rhythmic framework builds on the kuchek rhythm – a cyclical pattern generally associated with Roma/Turkish music making and performance styles.[8]

Through the early 1990s pop-folk grew rapidly to include multiple media markets including radio stations, television channels and print media. Its commercial proliferation was often, like other economic endeavors in post-Communist Bulgaria, attributed to the monetary investments and tastes of a new economic elite – the former Communist elite turned nouveaux riches who were pop-folk's main investors and

consumers. The term chalga, used interchangeably with pop-folk, came to denote not only the oriental musical flavour of the style, but also the context which gave rise to this new economic class with lowbrow tastes and the political and economic corruption associated with the transition from Communism to capitalism.

The imagery and poetics of pop-folk have often been seen by Bulgarian intellectuals as trite, low-brow and kitsch. On a visual level, pop-folk employs sexual suggestiveness, female nudity and manufactured orientalist imagery such as depictions of a provocative type of belly dance. This is evident in album covers, in the style of its music videos and in the fashion sense of the majority of its female performers. For example, a popular visual style employed by pop-folk stars includes open collars and gold chains for men, and Barbie doll make-up, tight skirts and the use of plastic surgery including breast enhancement, face-lifts and rhinoplasty for women. This latter practice is often referred to by pop-folk's detractors in the phrase 'fake cleavage' as a metaphor for the 'fake' qualities of the style.

Pop-folk's explicit visual style has also contributed to the perception of female pop-folk performers as idols associated with a commercial and materialistic lifestyle, which they display both on and off stage. The celebrity lifestyle of Western pop music and Hollywood divas is emulated by local Bulgarian pop-folk female stars who adopt similar stage names such as Preslava, Kamelia and Anelia. These pop-folk divas appear in fashion magazines, gossip columns and daytime television talk shows to discuss their fashion sense, diets, relationships and house decorations. The textual qualities of pop-folk songs are also seen as pornographic, dirty and lacking a coherent narrative because of their colloquial and often vulgar exploration of the Bulgarian transition such as the devaluation of Bulgarian currency, the markers of capitalist success and the importance of personal profit to romantic and sexual relations. Collectively, these qualities have positioned pop-folk within a tense public debate as a symbol of cultural and economic corruption.

Azis

In the uncertainty of post-Communist politics, images of Turco-Muslim threat infiltrated Bulgarian identity politics, laced with newly cast images of historical and contemporary 'foreign' threats... As in the past, Bulgarian elite and popular images of the nation have co-opted and confronted salient categories of Europeaness vs. Asianness, West vs. East, civility vs. barbarity in an attempt to

untangle Bulgarian from Muslim. The resultant discourse, far from a monolithic anti-Turkish campaign, has revealed the complexities of Bulgarian national debates. In a sense, this process has revealed that concepts of 'foreignness' are as internally divisive as the supposedly essential cleavages between Bulgarian and Muslim.

(Neuburger 2004: 201)

Born as Vasil Boyanov, Azis rose to fame in the late 1990s. He developed the stylistic of pop-folk by sexualizing the male rather than the female body and by embodying the perceived crudeness and barbarity of overt male sexuality within a generally homophobic society and an already sexually suggestive musical style. His Romani descent further problematized the tensions that Neuburger has identified in the context of Bulgarian minority politics. The controversy over the Azis billboard in 2004 that I mentioned at the beginning of this chapter illustrates these tensions, showing how popular culture meanings are always multivocal. The campaign for its removal was instigated by popular music performers and the municipality of Sofia protested about its 'shameful' display of sexuality close to a symbol of Bulgarian history and national integrity. However, others recognized its value in breaking taboos, insisting that Azis' scandalous display of the homoerotic body was purposeful, both commercially and socially. 'The purpose of this billboard is to scandalize,' they stated in an interview for the newspaper Дневник. 'This is the way contemporary pop culture, and underground culture, realizes itself in the public space. Azis is a representative of this subculture and seeks to instigate a reaction within and from the most conservative portions of society through controversy and the breaking of social taboos' (Keremidtchieva 2007).

Indeed, Azis' commercial endeavors, both musical and non-musical, always seem to affirm and enhance his image as a controversial performer who capitalizes on the shock value of homosexual imagery within a society which is unaccustomed to public display of homoeroticism. In his live performances, ranging from small clubs dedicated to pop-folk music to grandiose concerts at soccer stadiums, Azis portrays a variety of sultry, sexualized female characters interacting with buff male dancers. Similarly, in his video productions he imbues the soft porn visual stylistics of pop-folk with an ostensibly homoerotic and transsexual character.

In a 2005 photograph in the Bulgarian issue of Playboy, Azis is depicted with legs shaved and in fishnet tights and with his upper body and chest covered with a white feather. In the forefront of the image is an anonymous, buffed male model lying at his feet. The femininity

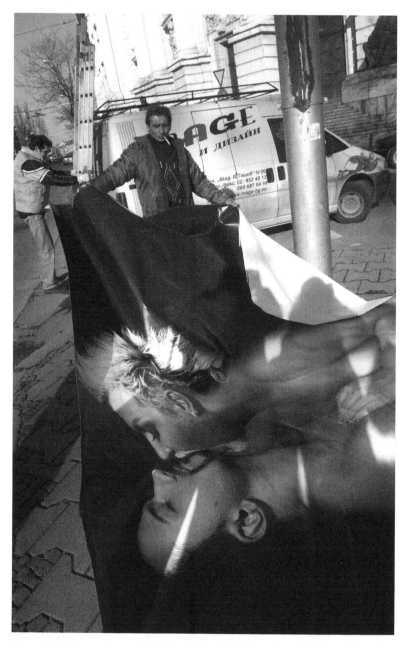

Figure 3.1　The controversial billboard image of Azis is removed

suggested by the way he is posed and styled contrasts with his bleached, white facial hair and masculine biceps.[9] In the video,'Ледена Кралица' ('Ice Queen') from the album *Together* (2004), he wears a white, glossy one-piece bathing suit complemented by white feather coat, white feather knee-high boots and white hair, beard and eyebrows. Similarly, in the music video 'Но Казвам ти, стига' ('I'm telling you, enough', Danail Shturbanov, 2004) from the album *The King* (2004), he transforms into a dark, voluptuous, oriental Goddess covered in heavy make-up, transparent veils and a jewelled crown, but retains a marker of physical masculinity his thick, well-groomed bleached beard. He wears a full body suit of tight leather with black gloves and high-heeled boots, giving him the look of a futuristic dominatrix. In both videos, Azis' performance – gentle hip movements, sultry gaze into the camera, swinging hand gestures and accessories – suggest the female body. These simultaneous displays of femininity and masculinity within a homoerotic setting have drawn an ambiguous public response, pitched somewhere between disgust and fascination.

While the gender bending and androgynous explorations of popular music stars such as David Bowie and Freddie Mercury have set a precedent in the history of global popular music, the case of Azis is particularly interesting because it has no precedent within the Bulgarian post-Communist environment. It establishes a connection between commercial explorations of femininity associated with the rise of female pop divas such as Madonna, Shakira, Beyoncé, Christina Aguilera, and Jennifer Lopez and visual displays of sexuality.

In contrast to these stars, the sociocultural positioning of Azis is influenced by the perception of pop-folk as culturally shameful, of the Romani minority with which he identifies as unclean, and by his display of homosexuality and homoeroticism which is seen as degrading. For Bulgarian audiences the sexual style of pop-folk and its shocking permutations in Azis' music multiply its status as 'Other' and it is often considered as a savage version of a higher-level western popular culture.

To date Azis is the author of ten music albums and is one of the highest paid pop-folk performers within the industry. Yet Bulgarian audiences and in particular, pop-folk fans, exhibit a general ambiguity towards him and his success. Audiences that despise pop-folk and consider it a low-brow representation of Bulgaria's cultural heritage and an embodiment of economic corruption see Azis as glorifying a lack of taste and as a cheap imitation of Euro-American pop culture. These generally belong to an intellectual elite who understand popular culture as low culture. Consumers of pop-folk accept Azis' sound but not his image. They praise

his music but consider his explicit homosexual imagery unacceptable. These reactions are evident in audience responses such as 'I love listening to him, but I cannot bear to watch him,' as well as derogatory comments describing him as a 'gypsy fag who can actually sing'.[10]

Becoming an other: The performance of savagery

As a relationship between a copy and an original, mimesis is often a complicated process in which it is far from easy to say who is the imitator and who is the imitated. Enacted in a powerful display of homosexuality within the broader context of entangled and problematic social categorizations, Azis' performances seem to articulate and specify the particular tension that exists in the relationship of Bulgaria as part of the Balkans to the perceived West.

Broadly, Azis represents the cultural 'savagery' of the country and the region in the way he emphasizes the common roots of all Balkan people through melody and rhythm that is characteristic of the entire region. Thus, his minority status, lack of education and active participation in a musical style which many consider to have questionable moral and aesthetic qualities are transformed into a problem of pan-Balkan identity. As Azis notes in an interview, 'You are in the Balkans, in the middle of gypsy land, and what do you listen to, heavy metal and rap? You don't have that culture or that history. Do not deny your Balkan roots' (Brunwasser 2006). Yet his mimetic manipulation of 'savage' qualities unfolds further within the specificity of his musical and visual celebrations of love, sexual desire and drag. On the one hand Azis becomes an Other, copies an original in very literal terms by embracing the idea of being a woman. As a naturally dark-skinned Roma, he transforms into an exotic lady who wears heavy make-up and mini skirts and has white, bleached hair. The savage minority status that bears the stigma of Otherness in Bulgarian society is transfigured as a white, sexually provocative woman, not unlike many other female pop-folk singers and Euro-American pop stars. Moreover, in his high-pitched vocal style Azis employs an unusually high tessitura for a male singer. The impressive agility of his voice, however, unfolds within a style that builds upon and incorporates the vocal folklore tradition of Bulgaria in terms of female repertoire, stylistic ornamentation, expression and even verb forms.

This last layer of Otherness may be considered with respect to the expression of homosexuality and homoerotic desire. Often uncensored, the sexual relations in Azis' videos are exclusively homosexual. While the performance of sexuality in pop-folk has become a standard tactic

for commercial success, the images in Azis' videos carry quite different connotations. The way Azis normalizes homosexuality through the techniques of heterosexual display speaks to his mastery of mimesis. Drag and sex between men is generally perceived as a symbol of the West's demoralizing influence, a notion articulated in a generic homophobia among Bulgarians who often see homosexuality as an expression of the democratic state's 'overly-free' attitudes.

In the process of copying Bulgarian pop-folk female artists, Western female pop-idols, whiteness and heterosexual relations, Azis' performances become interrelated chains of copies, of mimetic processes. To that end, the sensuousness and vivid materiality of Azis and his music as a musical and visual copy become even more powerful than the originals that he mimics. In acquiring mimetic power and manipulating it through the savage aspects of both the Balkans and the perceived West, Azis becomes a spokesman against racist and homophobic attitudes in Bulgarian society. For example, in an interview regarding the removal of his controversial billboard in 2004, Azis claimed that this event might work against Bulgaria's candidacy for the European Union (Bulgaria joined the EU officially in 2007). 'One of the clauses of the EU constitution,' he said, 'is that membership is granted when the country shows acceptance and no discrimination against people based on sexuality, ethnicity and such.' The journalist asked Azis if he felt discriminated against because of the removal of the billboard. Azis replied 'It seems to me that I was! It also seems to me,' he continued, 'that the authorities and the media are making it sound as if I am suggesting that everyone should become a homosexual when I am simply advertising my new single' (Mihailova 2004).

Azis' commercial success and popularity also allow him to manipulate the images of savagery and Otherness in political terms; an aspect expressed in his attempt to enter the Bulgarian parliament. In 2005 Azis was elected an honorary member of the EuroRoma Party and headed the party's cultural committee. Although he did not become a member of parliament he made a number of proposals including scholarships for Romani children with high marks in school. These, he insisted, should be funded through the salaries of the EuroRoma party members currently in parliament. In many ways, the divided response to Azis' music, a love-hate relationship, illustrates the public reaction to Bulgaria's adoption of democracy and what that entails in social and cultural terms. While shameful, an embodiment of Otherness, Azis has become an example of how individualism develops within a sociocultural order that is still holding on to the nostalgic egalitarianism of the Communist past without negating regional identity and roots.

As Azis says, 'here people think the American dream can only happen in America. I am a living example of how a simple, normal villager, can become a super star in this country. I am the Bulgarian dream' (Brunwasser 2006).

Conclusion

With every new performance, Azis perpetuates the power to imitate and acquire the power of the originals he mimics. In resonance with Taussig's (1993) argument, Azis yields towards the Other, yet constitutes and reconfigures both sameness and Otherness, Balkanness and Euro-American popular culture expressions. As I have argued, the performances and images of this flamboyant singer are more than part of a profitable economic strategy. Rather, they provide a space that is a musi-cultural nexus, where the tensions of local and global, self and Other are articulated through chains of mimetic representations. This tension is complicated by the marginal position of Azis as a dark-skinned Roma performer using a musical style with a bad reputation, a man who dresses as a woman and 'shamefully' displays his homosexuality both off and on screen. Yet in his performance such a derogatory position is empowering to the extent that individuality is expressed even in an intolerant society, and the freedom to be shameful is presented as an empowering quality. It is within the freedom to copy, imitate and openly display images of Otherness that such popular culture phenomena become the domain of social tensions and of the negotiation of identity.

Notes

1. Azis' statement was made upon his entry into the house of *VIP Brother*, the 2007 season of the television reality show which featured Bulgarian celebrities. See Kenarov (2010) for a more complete version of this quote.
2. Vasil Levsky (1837–73) is credited with igniting and strategizing the revolutionary movement in Bugaria that led to the country's independance from Ottoman rule.
3. In 2004 the secretary of the Ministry of Internal Affairs was General Boiko Borisov who subsequently became the mayor of Sofia and then the prime minister of Bulgaria. As a former firefighter and faculty at the police academy, Borisov has gained a macho reputation – firm, uncorrupted and upologetic. Azis' comments allegedly referred to Borisov's bodybuilder physique, a form of imagery widely exploited in his music videos.
4. This description refers to Azis' controversial music video 'Хайде, почвай ме' ('C'mon, start me up', Stilian Ivanov, 2004). The song appeared on his 2004 album *The King*, released by Sunny Music and was rated inapproriate for children under 18 years of age.

5. For further discussion of the political and economic changes in Bulgaria and the Balkan region see Pridham (2000); Anderson et al. (2001); Giatzdis (2002); Ekiert and Hanson (2003); and Bjelic and Savic (2005).
6. See Rasmussen (2002, 1995) for a disscussion of the musical and socio-cultural dynamics of Yugoslav music, and Dimov (1999, 1996); Peycheva (1999, 1998); Levy (2000, 1999); Rice (2002); Statelova (2003) and Buchanan (2007) for a discussion of Bulgarian pop-folk.
7. kuchek (also kyuchek) is a prevalent dance style and the underlying rhythmic framework of pop-folk. Both are of Romani-Turkish origin and have roots in Ottoman court celebrations (see Buchanan 2007). Today the rhythm exists in a variety of forms in the music cultures of different Balkan countries.
8. The root of the word also refers to a small ensemble of Middle Eastern and European instrumentation (chalgyia) and a Roma professional wedding musician (chagadziya). Other common terms used to refer to pop-folk include novfolk (new folk), modern folk, and ethnorock, while puns like balkanto stress the Balkan flavour of the style.
9. See Kurkela (2007) for a discussion of the construction of orientalist imagery and sexuality in pop-folk videos. http://www.avtora.com/news/nowini/albena_petrowa_i_azis_w_playboy_42.
10. Kantareva, M. (2009), 17 June, personal interview and Slavova, I. (2010), 9 July, personal communication.

References

Anderson, R. D., Fish, S. M., Hanson, S. E. and Roeder, P. G. (2001) *Postcommunism and the Theory of Democracy* (New Jersey: Princeton University Press).

Azis (2006) http://www.youtube.com/watch?v=l49nPemSNe0, date accessed 20 May 2011.

Azis (2004) 'I'm telling you, enough', *The King*. Sunny Music.

Bjelic, D. I. and Savic, O. (2005) *Balkan as a Metaphor: Between Globalization and Fragmentation* (Cambridge, MA: MIT Press).

Brunwasser, M. (2006) 'Azis', *PRI's Global Hit*, 2 August, http://www.pri.org/theworld/?q=node/3519, date accessed 1 May 2011.

Buchanan, D. A. (ed) (2007) *Balkan Popular Culture and the Ottoman Ecumene: Music, Image, and Regional Political Discourse* (Maryland: Scarecrow Press, Inc).

Dimov, V. (1996) 'Folkbymut I popharacteristikite my: Kam sociokyltyrniat portret na savremennata etnopo myzika v Bulgaria' ('The Folk-Boom and its Pop Characteristics: Towards the Sociocultural Portrait of Contemporary Bulgarian Ethnopop Music'), *Bulgarian Foklore*, 6, 4–17.

Dimov, V. (1999) 'Vurhy niakoi idelogemni aspecti na Bulgarskata etnopo myzika' ('On Some Ideological Aspects of Bulgarian Ethnopop Music'), *Bulgarian Musicology*, 1, 45–57.

Ekiert, G. and Hanson, S. E. (eds) (2003) *Capitalism and Democracy in Central and Eastern Europe: Assessing the Legacy of Communism* (Cambridge: Cambridge University Press).

Garber, M. (1992) *Vested Interests: Cross-Dressing and Cultural Anxiety* (New York: Routledge).

Giatzdis, E. (2002) *An Introduction to Post-Communist Bulgaria: Political, Economic and Social Transformation* (Manchester: Manchester University Press).

66 *Imitation and Controversy*

Kenarov, D. (5 October 2010) *La Pelanga*, http://lapelanga.com/introducing-vassil-boyanov-aka-azis, date accessed 29 August 2011.

Keremidtchieva, V. (2007) http://www.dnevnik.bg/print/arhiv_za_grada/2007/11/20/399603_boiko_borisov_naredi_da_svaliat_homoseksualnite/?print=1, date accessed 1 May 2011.

Korpe, M. (ed) (2004) *Shoot the Singer!:Music Censorship Today* (New York: Zed Books Ltd.).

Kurkela, V. (2007) 'Bulgarian Chalga on Video: Oriental Stereotypes, Mafia Exoticism, and Politics' in D. Buchanan (ed) Balkan Popular Culture and the Ottoman Ecumene: *Music, Image, and Regional Political Discourse* (Maryland: Scarecrow Press, Inc.).

Levy, C. (1999) 'Replika po povod proiavite na popfolka' ('A Viewpoint on Pop-Folk Demonstrations'), *Bulgarian Musicology*, 1, 66–71.

Levy, C. (2000) 'Prodycirane na Poslania v Savremennata "Etnicheska" Myzika' ('Contemporary "Ethnic" Music: Producing Meanings'), *Bulgarian Musicology* 3, 69–89.

Lewis, L. A. (1990) *Gender Politics and MTV: Voicing the Difference* (Philadelphia: Temple University Press).

Mihailova, A. (2004) http://novinar.bg/?act=news&act1=det&mater=MTQxOTsz MA==, date accessed 25 October, 2011.

Neuburger, M. (2004) *The Orient Within: Muslim minorities and the negotiation of nationhood in modern Bulgaria* (Ithaca, NY: Cornell University Press).

Peycheva, L. (1998) 'Tziganiata i bulgarskata Identichnost: Aksiologichni Aspekti', ('"Gypsy-ness" and Bulgarian Identity: Axiological Aspects'), *Bulgarian Folklore*, 1–2, 132–41.

Peycheva, L. (1999) 'Sablaznenata Myzika: Chalgata spored romskite myzi-kanti' ('The Tempted Music: Chalga according to Roma Musicians'), *Bulgarian Musicology*, 1, 59–65.

Pridham, G. (2000) *Experimenting with Democracy: Regime Change in the Balkans* (New York: Routledge).

Rasmussen, L. (1995) 'From Source to Commodity: Newly-Composed Folk Music of Yugoslavia', *Popular Music*, 14, no. 2, 241–56.

Rasmussen, L. (2002) *Newly Composed Folk Music of Yugoslavia* (New York: Routledge).

Rice, T. (2002) 'Bulgaria or Chalgaria: The Attenuation of Bulgarian Nationalism in a Mass-Mediated Popular Music', *Yearbook for Traditional Music*, 34, 25–46.

Statelova, R. (2003) *The Seven Sins of Chalga: Toward an Anthropology of Ethnopop Music* (Sofia: Prosveta).

Szatmary, D. P. (2010) *Rockin' in Time: A Social History of Rock-And-Roll* (New Jersey: Prentice Hall).

Taussig, M. (1993) *Mimesis and Alterity: A Particular History of the Senses* (New York: Routledge).

Todorova, M. (1997) *Imagining the Balkans* (Oxford: Oxford University Press).

Walser, R. (1993) *Running with the Devil: Power, Gender, and Madness in Heavy Metal Music* (Middletown, CT: Wesleyan University Press).

West. C and Zimmerman, D. (2002) 'Doing Gender' in S. Jackson and S. Scott (eds) *Gender: A Sociological Reader* (New York: Routledge).

4
X-Ray Visions: Photography, Propaganda and Guantánamo Bay

Bruce Bennett

The prison at the Guantánamo Bay naval base in Cuba has become one of the most symbolically dense sites of the 'war on terror'. Images of the prison have come to communicate not merely the technical processes by which the US military detains selected prisoners of war, but the relationship of the USA with the rest of the world, a visual rendering of power – cultural, imperial, military, legal and physical. Despite careful control of access to the site, and of the range of images that are publishable (see Clark 2010a), many images of the detention camps located at Guantánamo Bay – Camp Delta, Camp Iguana, Camp X-Ray – have circulated across various media. The prison remains an object of dramatic force, reconstructed on the stage for the 2004 documentary drama by Victoria Brittain and Gillian Slovo, *Honour Bound to Defend Freedom*, Jai Redman's 2003 art installation in Manchester, *This is Camp X-Ray*, and in the film docudrama, *The Road to Guantánamo* (Mat Whitecross and Michael Winterbottom, 2006). It served as the squalid setting for several scenes in the Hollywood comedy, *Harold and Kumar Escape from Guantanamo Bay* (Jon Hurwitz and Hayden Schlossberg, 2008) and in 2008, the human rights campaign group, Amnesty International, also staged one of a number of 'dissent events' (see Scalmer 2002) in protest against the Guantánamo Bay prison by placing activists, dressed as prisoners, inside a replica 'Guantánamo cell' outside the US embassy in London.[1] However, the most familiar images of the prison, which have been the source for many subsequent images and imaginings of the prison, remain two photographs from a series published on 18 January 2002 in a press release by the US Department of Defense. These images show some of the first group of 'enemy combatants' captured in Afghanistan to be held in the newly opened Camp X-Ray 'holding facility'.

Resembling shots taken illicitly by a press photographer, but in fact official publicity images taken by US Navy photographer Shane T. McCoy on 11 January, they show prisoners with their hands bound together, wearing face masks, eye masks, ear defenders, gloves, and orange overalls, being 'in-processed' by military police inside a wire-fenced compound. These photographs, which were initially received with shock and outrage, have come to serve as controversial images for the wider 'war on terror', both for its defenders and its opponents. Subsequent images have failed to displace or over-write McCoy's photographs which have acquired a definitive status as representations of the US government's degradation of international justice in the operations of the war on terror. As journalist George Monbiot suggests (2008), writing on the historical legacy of George Bush's presidency:

> one image is stamped indelibly on this presidency: the trussed automata in orange jumpsuits. It portrays a superpower prepared to dehumanise its prisoners, to wrap, blind and deafen them [...] It wanted us to know that nothing would stand in its way: its power was both sovereign and unaccountable.

The conscious motivation behind the distribution of these publicity images was unclear, although Judith Butler asserts that a key reason for putting the prisoners on display was triumphal, 'to make known that a vanquishing has taken place, the reversal of national humiliation, a sign of a successful vindication' (2006: 77–8). Certainly, rather than merely documenting the admission of prisoners into Camp X-Ray, these images employ the visual tropes of photojournalism to dramatize the 'making safe' of the captives, demonstrating their disempowerment and de-individualization before an international audience. Moreover, far from being the sign of a commitment to transparency and accountability in the treatment of these prisoners, I would argue that these ambiguous photographs have a contradictory function. The controversial status of these images rests not so much on the ostensible content of the photographs, as on the way in which the photographs embody a political order in which power is exercised through the management of the visible. As John Pilger observes, US Army commander, General David Petraeus has described the invasion of Afghanistan as a 'war of perception [...] conducted continuously through the media' (Pilger 2010: 6), and in this respect the war in Afghanistan is one frontier in a much broader political project concerned with controlling the flow and interpretation of images and text. Accordingly, in appearing to make

the camp and its occupants publicly visible in this carefully managed way, McCoy's photographs simultaneously work to ensure the invisibility of the camp, the radical silencing and isolation of the occupants, and the concomitant suspension of Guantánamo Bay prison from the regime of international law. John Berger suggests 'a photograph, whilst recording what has been seen, always and by its nature refers to what is not seen. It isolates, preserves and presents a moment taken from a continuum' (Berger 1980: 293). The photograph represents a selective decision or action that excludes other possible moments and views. In making one moment visible, then, the photograph is a paradoxical sign of the invisibility of other moments, the sign of a simultaneous action of concealment and exposure, censorship and candour.

These photographs prompt a number of urgent questions about the politics of representation and visibility, US imperialism, indefinite detention and the heterotopic spaces of the Guantánamo prisons, the use of torture and the suspension of rights associated with this 'war'. They also raise questions about the status of photojournalism in relation to propaganda. This chapter will address these questions through a close analysis of these controversial images, their circulation and reception, and the troubling of the boundaries between press release, propaganda, and document that they enact.

Combat camera and illusive photojournalism

The photographer Shane McCoy was employed in a Navy 'Combat Camera' unit, one of several 'visual information acquisition units' comprising groups of photographers and videographers whose job is to document a broad range of military activities. Combat Camera photographers and video camera operators produce photographic documentation of combat operations, 'combat support operations, humanitarian efforts, scientific research, and related peacetime activities such as exercises and war games'.[2] The imagery they produce is passed on to the Pentagon in Washington, whence it can be distributed throughout the Department of Defense, but the visual material produced by Combat Camera has a broad range of uses from legal documentation and mission assessment through to 'information warfare' (propaganda or disinformation) and public affairs (community relations and media liaison). Combat Camera personnel are frequently referred to as photojournalists, and indeed the material they produce is used by the military's official TV channels, newspapers and periodicals such as the Navy's magazine *All Hands* (founded in 1922 and now published by the US 'Naval

Media Center'), *Marines*, or *Airman*. This designation of these military personnel as journalists indicates a wilful blurring of distinctions between photo-reconnaissance, historical documentation, propaganda and reportage in contemporary visual culture.

Naval officer Aaron Ansarov explains the function of Combat Camera in these dramatic terms:

> The assignment [...] simple. The objective [...] illusive. The cost [...] immeasurable. We are the men and women who go through great risks to get the shot. We extraordinary videographers and photojournalists train with the best, operate in the worst and get noticed the least. Our mission is to be there when history happens. Ever notice that photo or video clip in the news, book, or documentary? Well, someone had to be there. Someone had to get the shot. Someone had to tell the story. We are that someone.[3]

One of Combat Camera's primary roles is expository, explaining military operations both to the public and the military chain of command, but it is also concerned with documenting and narrating history, and it appears that this self-description of these military personnel as documentarists or photojournalists is un-ironic. This naming moves some way beyond the mechanisms of managing reporting through press pools and embedding that were pioneered by the British military in the Falklands conflict (see Brothers 1997: 206–9). With the function of displacing and undermining the authority of independent publications and broadcasters, it comprises what might be termed 'counter-journalism' (as a counter-terrorist strategy) or 'simulated journalism', through the creation of a parallel system wherein recruits can be trained in a military journalism college, such as the Defense Information School in Maryland, before going on to provide material for the official entertainment and news agency, 'Defense Media Activity' (see http://www.dma.mil).

Ansarov's comment that their objective is 'illusive' rather than 'elusive' is perhaps a mis-spelling which inadvertently identifies the interminable play of misdirection, self-delusion and fantasy in which these image-makers are engaged. In a recent critical survey of war reportage, Geoff Dyer suggests that 'in Iraq and Afghanistan we are perhaps glimpsing the end of the era of the combat photographer as a special category of occupation, the twilight of the photographer *as novelist* in the way that [Robert] Capa [...] and Eugene Smith were visual novelists' (original emphasis, Dyer 2010). Dyer speculates that it is the superabundance of photographs in circulation that has dissipated the

author function of photojournalism; whether or not this is the reason, the figure of the professional Comcam photojournalist can certainly be understood to mark both the displacement and parody of a certain ethics of journalism. The romantic conception of the photojournalist, epitomized by the figure of Capa, is of a heroic, commercially and institutionally independent, ethically conscientious witness whose published work constitutes a measure of truthfulness by which other, official accounts can be tested. Photojournalism challenges the narrative and moral adequacy of the various histories of particular events and provides the basis for the construction of other narratives. Of course, this conception of the photojournalist relies upon a questionable investment in the status of the photograph as proof and the understanding that, as Susan Sontag puts it, 'photographs furnish evidence' (1973: 5). As John Taylor suggests, far from being a transparent document, the meanings of a photograph are modified by the contexts in which it is used and viewed: 'photography as evidence [...] reveals points of view held by photographers and editors who make it available; its use helps to confirm beliefs and hopes or sometimes to fashion spheres of controversy' (1998: 60). Of course, semantic instability is a quality of any photograph, but ontological questions of authenticity can take on a greater urgency in relation to documentary or journalistic photographs as questions of meaning give way to questions of the struggle for hermeneutic control. For Berger, for instance, what is at stake in the interpretation of a photograph is the validation of a certain world-view: 'Hence the crucial role of photography in ideological struggle. Hence the necessity of our understanding a weapon which we can use and which can be used against us' (1980: 294). Photojournalistic practice and discourses of journalism are characterized by a particularly heightened awareness of the use-value of photography, the ways in which a photograph can be appropriated and put to work ideologically and politically. This struggle is dramatized especially well in the Camp X-Ray photographs.

The first image (Figure 4.1),[4] shot through the links of a wire fence, shows ten kneeling captives in orange caps arranged along an alley running between two rows of cells. They are accompanied by two military policemen, dressed in camouflage uniforms that blend with the greys, beiges, pinks and blues of the background. One of the MPs seems to be haranguing a captive, or perhaps he simply has to shout because they're wearing ear defenders. He may merely be leaning in to look or listen more closely to one of the men – it is unclear. Other figures watching this scene from behind the fence are just visible. All the figures within the alley are carefully framed within a single square of the fence.

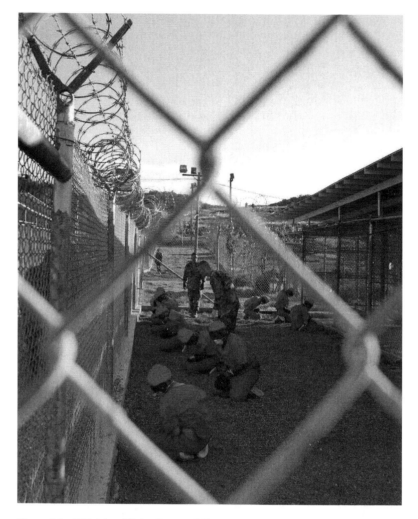

Figure 4.1 Official publicity image of Camp X-Ray

In the second image, although the temporal relationship of the two
scenes is uncertain – shot from a high angle over the top of the wire
fence, seventeen kneeling captives are visible, some of them bare-
headed. A military policeman – presumably the one who was leaning
over one of the men in the first image – walks between the two rows
of prisoners, reading a piece of paper. The second policeman stands at
the far end of the corridor watching the kneeling men, and another five

uniformed figures are also watching the proceedings from outside the fence. Barbed wire and coiling razor wire run along the bottom of the frame in the foreground.

Viewed without captions it is unclear exactly what is taking place in the ritual captured in the photographs – the kneeling men, arranged so that they all face away from one another, are in an apparently uncomfortable position with their legs crossed beneath them on the gravel floor, and a number of them are doubled over as if in pain, fear, or from the cold. It might be that some of them are falling asleep or have slumped into the most comfortable position available, but the pose with heads bowed and hands clasped in front of them is also a parody of prayer, as if to reinforce the assumption that these are zealots.

The initial impression is that these photographs are unstaged. The photographer is unacknowledged by the figures within the images and the fact that they are taken from outside the fence implies that the photographer is an incidental witness with limited access, peering over or through the wire in order to steal the shots. Positioned by this perspective as an external, illegitimate observer rather than a participant in the action, we might imagine that he happened upon this scene as he was passing through the camp. He is simultaneously proximate but distant, and is also consequently positioned as a representative of us, rather than a representative of the US government, the Navy, or the coalition of the willing. And, of course, the visual emphasis upon the fences asserts the extreme danger posed by these people who must be handled and photographed, like wild animals, with great caution. As Edmund Clark, whose own photographs of the Guantánamo Bay prison include very few prisoners or guards, observes, 'we've seen lots of pictures of people in orange jumpsuits, and plenty of photojournalistic long lens imagery of Guantánamo, and I'm not really sure what that tells anyone. In a way it just reinforces our paranoia, our fear and our suspicion' (Clark 2010b).

Whether or not it is an effect of accident or technique, these appear to be judicious compositions; they both use sharply receding perspective to dramatic effect, as if to emphasize the fact that the captives are trapped with no way out, and they both foreground the wire fence, incorporating it into the design of the image. McCoy has explained that the second photograph was taken by placing the camera on a monopod, setting the automatic timer and hoisting it above his head, which does suggest that the composition of the image is partly a matter of luck, and the lens flare in the right hand corner of the photograph does indicate a degree of accident (Rosenberg 2008). Nevertheless, the curving razor wire and barbed wire in the immediate foreground dominates

the image, aggressively filling the bottom third of the frame, while in the other, by far the most reproduced image, the wire fencing occupies more than half of the frame, almost as if gesturing towards modernist abstraction, destabilizing the relationship between the flat picture plane and the depth of the image.

This has two significant effects – the first is that the ostensible subject of the photograph, which is the assembly of the prisoners, is relegated to the background of the image, reducing the prisoners to an undifferentiated group. A second effect is that the wire is used as a frame within the frame of the photograph, reiterating visually the enclosure of the captives through their visual capture within the square of bent wire. In several ways, then, these photographs repeat or perform the capture, confinement and exclusion of the prisoners in a visually stylish or self-reflexive manner, offering us an image of frames within frames, spaces divided and transected by screens and barriers.

These images are often tightly cropped and recomposed when they are reproduced, effectively rejecting the distancing device of the original composition and reducing the spatial complexity of the photograph in order to focus our attention on the figures in the image, perhaps in a humanitarian gesture of recognition and greater melodrama, but also to render the images in a conventional reproducible format for newspaper and magazine pages, web pages and the backdrops for TV news reports, excising the extraneous information. The first image is frequently cropped so severely that all that is visible is the group of figures within the links of the fence.

In the background of both of these images, a guard tower emblazoned with a US flag is just visible and this redundant detail, like an advertising hoarding, betrays the fact that these images are staged in a different sense in so far as the mise-en-scène of the prison camp itself is a set, a tableau vivant constructed for certain audiences. These are images of the theatre of war. Floodlights are visible overhead, the actors are in colour-coded costume, we are positioned alongside the other watching figures in the picture as audience members and, of course, in place of opaque prison walls are fences (fourth walls) that purport to hide nothing. These images echo the archetypal representation of a prison in Gustave Doré's 1872 engraving of the exercise yard of London's Newgate prison, which shows a group of prisoners trudging in an endless circle within the high walls, while three onlookers stand watching. The echoes of Doré's image in McCoy's photographs again indicates that these photographs are more than spontaneous objective documents of this event but composed in such a way that they invoke a genre of images

of incarceration, although they refer to very different models of the carceral. Camp X-Ray is a prison camp that realizes the disciplinary and design principles of Jeremy Bentham's panopticon. As Michel Foucault explains, the repressive principle of the panopticon is visibility:

> By the effect of backlighting, one can observe from the tower, standing out precisely against the light, the small captive shadows in the cells of the periphery. They are like so many cages, so many small theatres, in which each actor is alone, perfectly individualized and constantly visible. The panoptic mechanism arranges spatial unities that make it possible to see constantly and to recognize immediately. In short, it reverses the principle of the dungeon; or rather of its three functions – to enclose, to deprive of light and to hide – it preserves only the first and eliminates the other two. Full lighting and the eye of a supervisor capture better than darkness, which ultimately protected. Visibility is a trap.
>
> (1991: 200)

McCoy's photographs describe the panoptic theatrical mechanism of Camp X-Ray, the prisoners isolated from one another, deprived of sensory stimulation,[5] unable to communicate, exposed not just to their captors but to other observers as well as the international audience for these images, and unable to know when, whether and by whom they are being observed.

Although supposedly coincidental, since the camps are named using numbers or the phonetic alphabet used by radio operators, 'Camp X-Ray' implies an inverted space, its viscera or internal structures visible as if laid open to objective, compassionate diagnostic scrutiny or exposed beneath the paranoid gaze of a border agent or security guard. This is a prison, the name tells us, in which nothing can be hidden from the lethal, penetrating electromagnetic gaze. Of course, x-rays are only visible on screens or on photographic negatives and in this respect McCoy's photographs are integral to the apparatus of capture and exposure constituted by the prison.

Some months after they were distributed, the second of the images was removed from the press release archive on the Department of Defense website as unrepresentative and outdated. It is now marked as 'for Official use only', and the Department of Defense has done its best to prevent news organizations from using both of the images (Rosenberg 2008). The powerful impact of these images meant that they eclipsed other images of the prison and, in particular, of the permanent camps

that replaced the temporary structures of Camp X-Ray such as Camp Delta and Camp Iguana (where the children are held). Indeed, McCoy's photographs have become visual shorthand for the Guantánamo Bay prison. The posters for the films, *The Road to Guantánamo* and *Harold and Kumar Escape from Guantanamo Bay*, both reprise the orange outfits, wire fence and watchtower in a distillation of the key elements of the initial photographs, while in Steve Bell's 13 June 2006 cartoon in *The Guardian* (based on the image in Figure 4.1) the prisoner's caps are replaced with Mickey mouse ears while the MP shouts at them 'IS THERE ANYTHING YOU PEOPLE WON'T DO FOR PUBLICITY?' The cartoon refers to a comment by the US deputy assistant secretary of state that three suicides by prisoners were 'a good PR move to draw attention' (Goldenberg and Muir 2006). Bell's drawing confirms what is acknowledged in this statement, which is that a central function of the Guantánamo Bay prisons is as a public stage hijacked here (whether intentionally or not) by prisoners exploiting their limited capacity for self-representation by appropriating and inverting its publicity value.

Image, Text and Interpretation

The captions accompanying the photographs on the original press release read as follows:

> Detainees sit in a holding area in Camp X-Ray, Guantanamo Bay, Cuba, Jan. 11, 2002, to await in-processing. Camp X-Ray is the holding facility for detainees held at the U.S. Naval base during Operation Enduring Freedom.
>
> Detainees in orange jumpsuits sit in a holding area under the watchful eyes of Military Police at Camp X-Ray at Naval Base Guantanamo Bay, Cuba, during in-processing to the temporary detention facility on Jan. 11, 2002. The detainees will be given a basic physical exam by a doctor, to include a chest x-ray and blood samples drawn to assess their health.[6]

These explanations – written by the photographer – frame the moment not as a violently repressive encounter (although the threatening detail of the 'watchful eyes' suggests a tension), but as a routine, humane, professionally conducted process of institutional admission.

Writing about the relationship between image and text in late twentieth-century visual culture, Roland Barthes observes that images are rarely seen in the absence of accompanying written text, and that

one of the key functions of text in relation to images 'commonly found in press photographs and advertisements' is that of anchorage, securely attaching a polysemous image to a restricted range of readings (1977: 41). As Barthes explains:

the text directs the reader through the signifieds of the image, causing him to avoid some and receive others [...] With respect to the liberty of the signifieds of the image, the text thus has a repressive value and we can see that it is at this level that the morality and ideology of a society are above all invested'.

(ibid: 40)

It is usual for captions to be removed, edited or paraphrased when press photographs are reproduced in different contexts and so, therefore, the repressive function of the caption is restricted or thwarted – the author's control over the moral and ideological inference of the photographs is inevitably weakened. However, in this particular case the contradictory disjunction between the bland caption and the content of the image ensures that the caption is already displaced by the photograph. The caption assures us that there is nothing remarkable in this purportedly anodyne image of prisoners awaiting a routine medical exam, and effectively invites us not to linger over the photograph, but to move quickly on to the next image, whatever it may be, our gaze skimming across a stream of images.

Whereas Louis Althusser argued that we are incorporated ideologically as individual subjects in the symbolic moment in which we acknowledge a policeman's call, Nicholas Mirzoeff proposes that the exercise of state power can be understood as the injunction to keep moving. The captions to these photographs relay this power relation: 'Jacques Rancière has argued that the police now say to us, "Move along, there's nothing to see." The police interpellate the Western subject not as an individual but as part of traffic' (Mirzoeff 2006: 23). The caption similarly invites us not to look closely at the images although, despite this injunction to move along, McCoy's arresting photographs have nevertheless served to obstruct this flow. This is partly because of what they show and partly because of what they mask and what makes them controversial images is that this repressive inter-play of the visible and the invisible has been foregrounded in the reception. As Mirzoeff continues:

when the police say there is nothing to see, we do not believe them – nor are we supposed to. Rather, we know perfectly well that there is

something to see, but that we are not authorized to see it. For all the mass proliferation of images, the visuality of war remains profoundly undemocratic.

(ibid: 23)

More clearly than many other images to emerge from the ongoing war against terror, McCoy's photographs circulate within 'the sphere of the militarized image' which is circumscribed by a 'boundary between seeing and not being allowed to see' (ibid: 24). What is striking about the images is not just the visual representation of transnational militarized state power exercised through and upon these bodies, but their function as an extension or symbolic instrument of such power.

In this context, it is hard to credit official surprise at the reception of the photographs. A report from December 2006 by the American Forces Press Association (which produces reports for military news publications as well as for distribution to the international press) relates that:

Service members [at Guantánamo bay prison] said they are especially frustrated by repeatedly seeing television, movie and print images of detainees being held at Camp X-Ray, a considerably more austere temporary facility that was operated for only four months and has been closed for four years. Many international news stories still are illustrated with old photos of Camp X-Ray.

(Greenhill 2006)

The article goes on to correct the misperception that torture or mistreatment is taking place at Guantánamo bay, insisting that what people fail to appreciate is that 'the guard force and the intelligence people maintain a remarkable degree of restraint and equilibrium', despite having dealt with over 3000 instances of 'detainee misconduct' in the previous year 'including 432 assaults with bodily fluids, 227 physical assaults and 99 efforts to incite a disturbance or riot' (ibid.). Interviewed in the article, Navy Rear Admiral Harry Harris Jr., commander of the Joint Task Force in charge of the camps, invites foreign reporters to visit the camp in order to see for themselves how the camp has been improved over the intervening years with over $100m spent on upgrading the prison facilities: 'We're getting better at communicating,' he explains, 'but our opponents can lie and we can't, and so we have to fact check and make sure that we tell the truth' (ibid.).

What is stake here is, of course, not so much truthful communication as control over the ways in which images are interpreted. As Torie Clarke, the Pentagon spokesperson who authorized the circulation of the images, admitted:

> Did I ever misread what was in those photos [...] The problem wasn't that we released too much, it was that we explained too little [...] which allowed other critics to say we were forcing the detainees into poses of subjugation.
>
> (Rosenberg 2008)

However, the blurring of boundaries that permits Shane McCoy to be characterized as a photojournalist, is the same destabilizing movement that takes the capacity to fix the meaning of images out of the hands of government and military public relations. As Liam Kennedy observes, in a discussion of the relationship between photography and US foreign policy:

> the expansion of new technologies has produced a global media sphere in which images and information have become ever more difficult to control. The machinery of American public diplomacy [...] has struggled to adapt to these new conditions. The difficulty of conducting a war of images is compounded in a global information sphere that can swiftly expose and interrogate contradictions of declared values and apparent policies and actions.
>
> (2008: 279)

The adoption of digital photography has made the exchange and circulation of images ever more instant. Berger proposes that 'the very principle of photography is that the resulting image is not unique, but on the contrary infinitely reproducible' (1980: 291). This is even more the case with digital photographs, the accelerated temporality and the volume of images making the management of this circulation more challenging. As Susan Sontag observes (2004), discussing the effects of the soldiers' souvenir photographs of abuse in Abu Ghraib prison that were passed on to the US TV news:

> In our digital hall of mirrors, the pictures aren't going to go away. Yes, it seems that one picture is worth a thousand words. And even if our leaders choose not to look at them, there will be thousands more snapshots and videos. Unstoppable.

However the result of this superabundant heterogeneous proliferation of images is not a contemporary global media environment in which images are substitutable and indifferent, their meanings playing freely. The persistence of certain images is testament to Sontag's optimistic investment in the semantic power of images. As Rancière argues, the political problem with the contemporary globalized visual regime is not an anaesthetizing deluge of images:

> We do not see too many suffering bodies on the screen. But we do see too many nameless bodies, too many bodies incapable of returning the gaze that we direct at them, too many bodies that are an object of speech without themselves having a chance to speak. The system of information does not operate through an excess of images, but by selecting the speaking and reasoning beings who are capable of deciphering the flow of information about anonymous multitudes. The politics specific to its images consist in teaching us that not just anyone is capable of seeing and speaking.
>
> (2009: 96)

The controversial dimension of McCoy's photographs is not so much that they reveal a contradiction between values and action (which rests on a problematic commitment to photographic truth) as that they reveal how ways of seeing and interpreting images are circumscribed by and incorporated into an information system that reproduces unequal power relations. As Mirzoeff proposes, the pressing critical challenge in the face of this system is:

> to provide tactics and strategies for the visual subject in the era of global war [...] a person who is both the agent of sight – regardless of his or her biological abilities to see – and an object of discourses of visuality'.
>
> (2006: 22)

One such resistant strategy is a critically oriented contemplative gaze that refuses to 'move along' and pass over images such as these. It is a matter not merely of scrutinizing the images for hidden detail, nor of demanding to see more, but of 'seeing through' the illusive transparency of the photographs in order to recognize how transparency and visibility can function as critically diverting spectacular excess – as a trap. Ironically, the official withdrawal of the images extends this illusion, through the implication that international audiences were accidentally allowed to see

too much in a brief moment of slippage or excessive openness, but this censorious gesture also paradoxically confirms that the US government and military news agencies and personnel naturally tend towards transparency if not carefully managed. It implies that censorship is an a posteriori response, rather than an intrinsic function of the system. This is not a paranoid conceptualization of a total system that can anticipate and disarm any assault upon it, since I am arguing that McCoy's images have acquired an autonomous significance. However, what critical engagement with these images, and the system in which they circulate, must recognize is that they belong to a political order that functions not by concealment, nor by overexposure, but by a particular ordering of the perceptual field. What is controversial about these photographs is the information system that they represent, which is an intrinsic part of a system of economic, biopolitical and martial imperial power – the fact that they are taken by a Navy photographer simply highlights this. What is instructive about the reception and circulation of McCoy's photographs is precisely the way in which these images have been repeatedly reframed, reworked and reinterpreted, rather than passed over. This ongoing process of interpretation and re-interpretation reminds us that the acts of looking (at these images) are potentially political in so far as looking at controversial images can reconfigure the prevailing perceptual frames through which we perceive – and fail to perceive – the lives of others.

Notes

1. http://www.amnesty.org.uk/news_details.asp?NewsID=17598, date accessed 6 December 2010.
2. http://www.defenseimagery.mil/community/taskcomcam/navy.html, date accessed 12 November 2010.
3. http://www.defendamerica.mil/specials/CombatCamera.html, date accessed 12 November 2010.
4. http://www.defenseimagery.mil/imagery.html#a=search&s=camp%20x-ray% 202002&chk=6cfe0&sel=1000&guid=468628ba07bf4c9fa58370c11b0468124 e20ee4a.
5. McCoy suggests that the gloves and hats are not a means of sensory deprivation but simply because the weather was cold (Rosenberg 2008).
6. Captions taken from http://www.scoop.co.nz/stories/WO0201/S00047.htm, date accessed 24 February 2012.

References

Barthes, R. (1977) *Image, Music, Text* (ed and trans.) S. Heath (London: Fontana).

Berger, J. (1980) 'Understanding a Photograph' in A. Rachtenberg (ed) *Classic Essays on Photography* (New Haven, CT: Leete's Island Books).

Brothers, C. (1997) *War and Photography: A Cultural History* (London and New York: Routledge).

Butler, J. (2006) *Precarious Life: The Power of Mourning and Violence* (London and New York: Verso).

Clark, E. (2010a) *Guantánamo: If the Light Goes Out* (Stockport: Dewi Lewis).

Clark, E. (2010b) 'If the Light Goes Out: Edmund Clark's Pictures of Guantánamo Bay', http://www.guardian.co.uk/artanddesign/gallery/2010/nov/03/guantanamo-photographs-edmund-clark-gallery?picture=368316599#/?picture=368316595 &index=6, date accessed 2 December 2010.

Dyer, G. (2010) 'The Human Heart of the Matter', *The Guardian*, 12 June, http://www.guardian.co.uk/books/2010/jun/12/geoff-dyer-war-reporting?INTCMP=SRCH, date accessed 24 November 2010.

Foucault, M. (1991) *Discipline and Punish: The Birth of the Prison* (trans.) A. Sheridan (London: Penguin).

Goldenberg, S. and Muir, H. (2006) 'Killing themselves was unnecessary. But it certainly was a good PR move', *The Guardian*, 12 June, http://www.guardian.co.uk/world/2006/jun/12/guantanamo.topstories3, date accessed 11 July 2008.

Greenhill, J. (2006) 'Outdated Images of Detention Center, Mission Frustrate Guantanamo Troopers', 2 December, http://www.defense.gov/news/NewsArticle.aspx?ID=2272, date accessed 1 April 2008.

Kennedy, L. (2008) 'Securing Vision: Photography and US Foreign Policy', *Media Culture Society*, 30, no. 3, 279–94.

Mirzoeff, N. (2006) 'Invisible Empire: Visual Culture, Embodied Spectacle, and Abu Ghraib', *Radical History Review*, 95, 21–44.

Monbiot, G. (2008) 'Lost in the System', *The Guardian*, 17 June, http://www.monbiot.com/archives/2008/06/17/lost-in-the-system/, date accessed 27 June 2008.

Pilger, J. (2010) 'Why was this Event Reported as a Bloodless Victory Welcomed by all Iraqis?' *The Guardian* (G2 supplement), 10 December, 4–7.

Rancière, J. (2009) *The Emancipated Spectator* (trans.) G. Elliott (London and New York: Verso).

Rosenberg, C. (2008) 'Sailor's Photos became Icons of Guantanamo', 13 January, http://humanrights.ucdavis.edu/projects/the-guantanamo-testimonials-project/testimonies/prisoner-testimonies/sailors-photos-became-icons-of-guantanamo, date accessed 1 April 2008.

Scalmer, S. (2002) *Dissent Events: Protest, the Media and the Political Gimmick in Australia* (Australia: University of New South Wales Press).

Sontag, S. (1973) *On Photography* (New York: Farrar, Straus and Giroux).

Sontag, S. (2004) 'Regarding the Torture of Others', *The New York Times*, 23 May, http://www.nytimes.com/2004/05/23/magazine/regarding-the-torture-of-others.html?pagewanted=all&src=pm, date accessed 12 November 2010.

Taylor, J. (1998) *Body Horror: Photojournalism, Catastrophe and War* (Manchester: Manchester University Press).

Part II
Constructing Controversies

5
'The Terrorists with Highlights': Kurdish Female Suicide Bombers in Mainstream Turkish Media

Ertug Altinay

In April and May 2007 two female suicide bombers affiliated with the Kurdistan Workers' Party (Partiya Karkerana Kurdistan), a Kurdish guerilla organization listed as a terrorist organization by NATO, the United Nations, the European Union, and the United States, were caught in Adana, a major industrial city in the East Mediterranean region of Turkey. The Kurdistan Workers' Party, better known as PKK, has been active in the country since the late 1970s. Although it is not the major form of activity in their armed struggle against the Turkish state, PKK had begun shifting from conventional bombing to suicide bombing in the mid-1990s, with 11 of their 15 attacks having been performed by women. However, there was a difference in the media coverage of these two cases. First of all, the level of media interest was of particular significance. Although a male suicide bomber was also caught in May 2007, he was barely mentioned in the press. The media focus was on these two women, particularly their bodies. Ayfer Ayçiçek and Hatice Arat were presented in mainstream Turkish media as 'murderers with highlights' (Kibritoğlu 2007), 'bombers with highlights' (*Hürriyet* 2008), 'terrorists with highlights' (*Milliyet* 2007) or 'suicide bombers with highlights' (Gezer 2007) wearing 'the latest fashions', with the terrorist using the name Ebru Kara looking 'very well-groomed with her grey tank top, denim skirt, yellow flip-flops, white nail polish and highlighted hair' (Kibritoğlu 2007). Curiously, only a couple of the stories mentioned that the 'fashionable' looks of the suicide bombers were a strategy to avoid security screening, one that apparently failed. The others simply seemed, in some sense, to be 'terrorized' by the women's modern, urban looks, particularly their hair.

What was it that made the highlights so spectacular? How did a hairstyle manage to create a kind of terror? In this chapter I will move from

these questions to trace a Foucaultian genealogy of the subject positions made available to Kurdish women within Turkish modernist discourse, which I argue to be both postcolonial and colonialist. Exploring the history of Kemalist disciplinary discourses and technologies in Turkey in the 20th century, I will discuss their effects on bodies (Foucault 1984: 63) and how the dynamics of postcolonial modernization and nationalism in Turkey have shaped body politics in the country. Analysing fantasies about the body and subjectivity of the modern Kurdish female subject, I will map the place of these fantasies in what Meltem Ahıska terms the Turkish 'hegemonic imaginary', 'the realm of significations and representations that constitute and provide a historical mode of social being for individuals in the society' that is 'hegemonic to the extent that it is reinforced by power relations as the dominant mode of being and channels the desires of people to appropriate that mode of being' (2003: 370). I will also discuss how the ostensibly failed performance of these young, female suicide bombers emerged as a parody of those fantasies, creating disappointment and a unique terror.

Catching the train: Turkey's postcolonial modernity

Turkey has never been officially colonized. Yet, following Stuart Hall's definition of 'postcolonial', Nükhet Sirman argues that Turkey is a postcolonial state. In his definition of the colonial, both as 'a system of rule, of power and exploitation, and [...] as a system of knowledge and representation', Hall does not define postcolonial with reference to a particular space, but rather in a way that refers to global relations after the rise of globalization (1996: 254). His focus is on the 'social and political context in which social relationships and the cultural concepts through which they are understood and interpreted are saturated with comparisons to societies and cultures that are deemed to be more developed' (Sirman 2004: 40). With its clearly set goal of 'attaining the level of contemporary civilization'[1] – that is, the West – Turkey is very much a postcolonial context in Hall's sense of the term.

With the never attained yet constantly experienced desire to be modern, expressed by the still commonly used metaphor of 'catching the train',[2] Turkey's relationship with 'Western civilization' has been defined by a constant belatedness (Nalçaoğlu 2002: 146). The experience of postcoloniality was most intensely lived during the early years of the Republic under the leadership of Mustafa Kemal Atatürk and the Republican People's Party's single-party regime (1923–46), a period characterized by reforms in social, political, legal and cultural realms

that were implemented to create a secular (yet Sunni Muslim) Western nation-state. These reforms, often conceptualized as 'the Turkish modernization project', had their roots in the Ottoman modernization attempts that aimed to protect the Empire's territorial integrity against European colonial powers and the flourishing nationalist movements within the Empire. In the context of a nation-building project, the desire for modernization was entangled with concerns about retaining (which also meant inventing) a national essence. As such, modernization and nation-state building have been in an intricate relationship in Turkey. The modernist state elite perceived the secular nation-state as the modern mode of governmentality. The nation, defined as 'Turkish', set the standard of modernity as opposed to Ottoman subjects as well as to non-Turkish citizens. Mesut Yeğen notes that legal citizenship has never been the sole marker of citizenship in Turkey, and 'there has always been a gap between "Turkishness as citizenship" and "Turkishness as such"' (Yeğen 2009: 597). Although they were familiar with the Western tastes and lifestyle the state strived to promote, Greeks, Jews and Armenians could not be properly modern citizens of the Turkish nation-state because they lacked authentic Turkishness. Through economic policies accompanied by various forms of ethnic cleansing, ranging from the 1923 population exchange with Greece to the Wealth Tax (Varlık Vergisi) of 1942 and the Istanbul Pogrom of 1955, Turkey's non-Muslim minorities who had already been decimated in the late Ottoman Empire were further reduced to an even smaller minority, and the historically non-Muslim bourgeoisie was replaced by a Muslim one. The Kurdish population, the majority of whom lived in the rural areas in the Southeast of Turkey, was a Muslim minority. As long as they rejected their ethnic heritage, refrained from making any cultural or political demands based on ethnicity, stopped speaking Kurdish languages, identified as Turkish and accepted assimilation under the modernization and nation-state building project, they could become members of Turkish society. However, starting from the late Ottoman Empire where Young Turks implemented politics of forced Turkification, the Kurdish community resisted assimilation (Schaller and Zimmerer 2008: 8). This resistance continued in the Republican period and transformed into a radical Kurdish movement after the abandonment of promises of equality for Kurds and Turks and the abolition of the Caliphate (Bozarslan 2002: 847–8). As they resisted the assimilationist secular nation-state project, Kurds became stigmatized as the ultimate Others of Turkey's modernity and as needing Turks to modernize them. Thus, the discourse of modernization was employed to legitimize Turkish colonialism.

Colonized by the postcolonial: Framing Kurdish women's bodies

Body politics, particularly fantasies about Kurdish women's bodies and identities, played a significant role in the reproduction of ethnicized definitions of modernity in Turkey. However, the transformation of Kurdish bodies and the significance of the Kurdish female body for the Kurdish nationalist movement and the Turkish modernization project have enjoyed little academic interest. The still very limited literature on Kurdish women tends to focus on issues like women's political agency, interpersonal relations, and the experiences of immigrant women (e.g. Mojab 2001; Çağlayan 2007). While there is a significant body of literature on the Kemalist modernization project and the transformation of the female body (e.g. Göle 1997a; Göle 1997b; Arat 1998), and on Islamist women and their political agency as a group directly affected by the secularist modernization project (e.g. Göle 1997a; Göle 1997b; Özdalga 1997; Saktanber 2002; Arat 2005), little has been written about the experiences of Kurdish women.[3]

The Kemalist modernization and nation-building project is crucial for understanding the background against which Turkish and Kurdish women's bodies are shaped and interpreted. Because the Kemalist elite regarded the body as both the reflection of an otherwise not accessible 'essence' and a symbol of modernity, the regulation and transformation of bodies has been a primary concern for Turkish modernization. The apex of this obsession was undoubtedly what is known as 'the Hat and Dress Revolution'. Beginning in 1923, a series of laws progressively limited the use of selected items of clothing that connoted the Empire and Islam. The dress reforms started with regulations about the uniforms of particular groups like soldiers, policemen, judges, and students (Doğaner 2009: 35). During his Kastamonu speech in 1925 Atatürk presented the Western style hat to the public as the modern and only acceptable headgear. In September 1925 a resolution requiring civil servants to wear the Western style hat and dress passed. The transformation of the bodies of civil servants who represented the state aimed not only to create role models for the people, but also to mark the transformation of statecraft. In the same resolution, non-clergy men were prohibited from wearing religious dress (Doğaner 2009: 35). These policies aimed both to distinguish the Turkish state and society from the Ottoman Empire and the rest of the Middle East, and to undermine religious sources of power outside state control.

Possibly to prevent a public outcry, the Hat Law did not specify anything about female dress. Nevertheless, politicians and bureaucrats, including Atatürk himself, discouraged women from wearing the black veil and the headscarf. Moreover, female civil servants and close relatives of bureaucrats received official requests asking them to adopt Western fashions. This interest in the female body is in accord with mechanisms for women's inclusion in nationalist projects as identified by Floya Anthias and Nira Yuval-Davis (1994: 1480–1):

1. as biological reproducers of members of ethnic collectivities;
2. as reproducers of the boundaries of ethnic/national groups;
3. as participating centrally in the ideological reproduction of the collectivity and as transmitters of its culture;
4. as signifiers of ethnic/national differences - as a focus and symbol in ideological discourses used in the construction, reproduction and transformation of ethnic/national categories;
5. as participants in national, economic, political and military struggles.

These have also been the main ways in which women have been included in the Kemalist nation-state building project. The symbolic role of women has been particularly important in the Turkish case, because women were expected to actively participate in the transformation of the country from an Islamic Empire to a secular Western nation-state and to serve as symbols of this transformation.

The role of women as signifiers of ethnic difference was rather complicated in Turkey. Although certain strands of Turkish nationalism unquestionably had racist elements (Özdoğan 2001; Altun 2005; Maksudyan 2005) and their vestiges persist in some ultranationalist movements, the popular official discourse of the Kemalist nation-state building project was not systematically racist (Yıldız 2001; Arslan 2002). Hence, especially towards Muslim minorities, and particularly the Kurds, it was possible to adopt a policy of forced Turkification. By means of armed conflict as well as cultural and political assimilation, the Kurds were constructed as pseudo-citizens and prospective Turks (Yeğen 2009). In order to become proper citizens Kurds needed to give up any political or cultural demands on the basis of ethnic identity and identify as Turkish. In this context Kurdish women's bodies have emerged as the touchstone for the success of Turkey's assimilationist modernization and nation-state project. Because of the crucial role women play in the transfer of language and the reproduction of culture in Kurdish

society, the transformation of Kurdish women was regarded as being of the utmost importance for the transformation of Kurdish society and also served as a symbol of this transformation. This transformation, meaning the assimilation of the Kurds, would mark the success of Turkey's modernization and nation-state building programme. Because of these concerns, the education of Kurdish women has been of particular importance for the Turkish state.

In the early years of the Republic, a key actor in the state's attempts to transform Kurdish society was the educational expert, Sıdıka Avar, who worked as a teacher and administrator at Elazığ Girls' Institute (Elazığ Kız Enstitüsü). Established in the late 1920s, the girls' institutes combined the basic curriculum with intense home economics education, aiming to create the new female citizen for the new Republic. Graduates would be able to participate in the growing economy as qualified female labour, but would also be modern housewives equipped with the 'scientific knowledge' to fulfil their duties properly, create modern households, and raise ideal citizens for the country. In all girls' institutes, the transformation of the female body was a key concern, with a special emphasis on sartorial education. The schools also organized the first fashion shows in the country, and later diplomatic fashion shows in Turkey and abroad, to attest to the modernity of the country. The institute in Elazığ, established in 1940, is particularly interesting, because it aimed primarily to educate Kurdish women. As such, the modernizing mission of the institute gained an assimilationist dimension. In this institution, defined by a hierarchy between Turkish and Kurdish girls where Turks guided Kurds in their quest for modernity (Akşit 2005: 149), photographs of Kurdish girls were taken upon their arrival. Later, these photographs would be published in the institute yearbooks side by side with ones taken after their bodies were modernized, re-ethnicized and re-gendered at the institution (Yeşil 2003). The 'before' photographs taken immediately after their arrival depict girls in common local dress with disheveled hair, looking dirty and frightened. In the 'after' photographs, the girls wear the school uniform - a black dress with a large white collar. Their hair looks orderly and their bodies look clean. Even their postures have changed; standing upright, the girls now smile at the camera as modern Turkish women. This transformation of the body and self-care practices implies a transformation of subjectivity. The school uses the photographs to prove their success in transforming Kurdish women into Turkish citizens.

In her memoirs, Sıdıka Avar narrates Atatürk's successor President İsmet İnönü's visit to Elazığ Girls' Institute. Upon İnönü's request to see

a 'village girl', Avar presents Elmas Şimşek, 'a very clever girl who has absorbed the culture and corrected her accent' (Avar 1986: 122). Elmas is expected to demonstrate her virtuosity in performing Turkishness and she does so; she reads out loud a newspaper in Turkish and then shows her school uniform and her dress, telling İnönü that she made them herself. When İnönü allows her to kiss his hand to show her respect, Elmas kneels in front of him, kisses his hand and puts it on her forehead. Lifting her up by her shoulders, İnönü addresses the group of politicians and bureaucrats accompanying him: 'This is the achievement, the Kurd!'[4] Hearing this, a member of parliament rushes and grabs Elmas' right wrist. Waving her hand in the air, he says 'This hand will not hold a gun; this hand will not hold a sword. This hand is the hand of a friend; this heart is the heart of a friend! This hand holds the pen, this hand holds the needle' (ibid: 123). The scene reveals fantasies about Kurdish women and the transformation of Kurdish society. The body and subjectivity of Elmas has been transformed with the aid of the pen and the needle. She has been trained in the norms of modern Turkish femininity. Her body has been purged of the signs of Kurdishness, including clothing and language, and she has been transformed from an ethnic threat to a signifier of the mono-ethnicization of the society. She also becomes an agent for the reproduction of this transformation since she later becomes a teacher like Sıdıka Avar, and serves the Turkish educational system aiming to create other ideal Turkish citizens for the nation-state. Such Kurdish Pygmalion stories are still part of popular discourse and reflect fantasies of assimilation as well as assuring the Turkish story-tellers of their own modernity.

In Turkish nationalist discourse, Kurdish Pygmalion stories are often entangled with horror stories where the victims are Kurdish women. Studies show that domestic violence against women is not a more severe problem in the predominantly rural Southeast of the country where the majority of the population is Kurdish, than it is in the rest of the country – the figures are distressingly high everywhere (Altınay and Arat 2007). Nevertheless, popular discourse frames gendered violence as primarily targeted at Kurdish women, particularly those in rural areas. Kurdish women emerge as victims of Kurdish men and of a distinct and uniquely violent Kurdish culture and tradition. This discourse of violence legitimizes cultural oppression and forced Turkification, though in practice Kurdish women's access to legal institutions (İlkkaracan 2002–3: 16) and even healthcare services is limited. In this context, the modern, urban Kurdish female body is perceived as a signifier of emancipation from an oppressive culture of violence.

Concerns about the transformation of the Kurdish body, and Kurdish women's bodies in particular, go hand-in-hand with stigmas that frame them as the ultimate 'Other' of the modern Turkish identity. A very interesting example of this Otherness is found in the memoirs of Turkey's first Islamist style icon, Şule Yüksel Şenler. Coming from an urban, lower-middle class family, Şenler adopted the headscarf in the 1960s after she joined a sect upon the request of her brother. Due to her secular background she had trouble adopting Islamic dress. When she looked at the mirror she was worried that people would think that she was a maid or even a besleme, a poor girl, often from a rural background who was accepted into a more affluent household to work as unwaged household labour. When Şenler visited her grandmother to tell her that she would adopt Islamic dress, her grandmother made fun of her, telling her that people would think that she was Kurdish (Şenler 2007: 49). At a time when political Islam was not as powerful and the headscarf was neither as popular in urban regions nor as stigmatized by secular modernists as it is today, 'Kurdishness' emerged as a category to identify a stigma that was not necessarily ethnic. The headscarf connoted poverty, rural identity, and ignorance, and Kurdishness became a synonym for 'backwardness' and 'Otherness'.

The stigmas around the Kurdish body are also related to other signifiers of modernity. As in virtually all modernization projects, cleanliness and orderliness were key concerns in the Turkish project. The postcolonial modernist imaginary differentiated the Turkish Republic and its citizens from the Ottoman Empire as well as the Arab world, which it often associated with ignorance, backwardness, dirtiness, disorderliness, incompetence and unhealthiness. To become modern and Western it was important to create healthy and clean bodies. In this context the Kurdish body sometimes came to be identified with dirt and a characteristic stink. Through discourses that often employed pseudo-scientific theories of race and ethnicity, the Kurdish body and identity were constructed as 'naturally' the Other, fundamentally different from the Turkish self.

Different strands of Turkish nationalism not only perceive Kurdish women and Kurds in general as the ultimate Other of modern Turkish identity and an obstacle to the modernity of the country. Kurds also serve as the touchstone of the modernity of Turks, in need of Turks to teach them how to be modern and civilized, making it possible for Turks themselves to survive the precarious feeling of belated modernity that haunts them, and emerge as modern and Western.[5] This is the context in which the terrorists with highlights and the terror they created with their bodies should be explored.

Highlights and body politics in Turkey

In a cartoon first published in January 2010 in the weekly humour magazine *Uykusuz*, Umut Sarıkaya depicts a hairdresser surrounded by a group of older women with very fancy hairstyles (2010: 18). He looks as though he is on the verge of death in the arms of his colleague and says that doing the hair of all the members of the Republican People's Party's women's branch in one day has exhausted him. As Atatürk's party, the Republican People's Party still retains a strong secularist and modernist heritage and many of the women affiliated with the party's women's branch are Kemalist secular modernist women who indeed tend to care about their hair. The importance they attribute to hair is a consequence of the complicated relationship between women's hair and identity in Turkey. Secularism has been a main tenet of the Turkish modernization project and women's hair has been a major signifier of secularism, so, in certain cases, elaborate hairstyles may indicate a secularist identity. Hair colour is also of importance. The style of highlights the suicide bombers had, called 'röfle' in Turkish, is particularly popular in Turkey. In this style, dye in lighter shades is applied to tiny strands of hair, often dyed blonde and creating shadows to produce a more 'authentic' look. Since blondeness is associated with the West, röfle enables the person to embody a Western, and by default modern, identity. Blonde hair also implies a differentiation from Turkey's ethnic Others, Arabs and Kurds. Although there are blonde Kurds, stereotypes of the group present it as having dark skin and hair, framing Kurds as the 'natural Others' of modernity. Dying hair blonde is both a differentiation from the Kurds and a way of self re-ethnicization for Kurds - yet it is worth noting that re-ethnicizing the body is not necessarily always a primary reason for adopting certain hairstyles.

Even though röfle fails to create a persisting illusion of authenticity, it is still a signifier of social status. Having röfle, in a Veblenian sense, is a form of conspicuous consumption (Veblen 1994). It is a labour-intensive and therefore expensive procedure and signifies the ability to buy another person's time. Since the style needs to be maintained by regular root touch-ups, röfle also signifies leisure time. Even if one has the time and the money for the procedure, it is still necessary to have access to a professional hairdresser who is good at this rather difficult procedure, and this is not always easy to find, especially in rural areas. In this regard röfle is also a signifier of urban identity.

Néstor Garcia Canclini argues that a view of consumption as 'the ensemble of sociocultural processes in which the appropriation and use

of products takes place' (2001: 38) has often focused too much on its role as a means of creating divisions (e.g. Bourdieu 1987). Yet consumption also 'contributes to the integrative and communicative rationality of a society' (Canclini 2001: 40). From this perspective, the consumption of röfle is related to belonging to modern Turkish society and a way of embodying an urban, middle class, Western identity, modernity, and secularism. For Kurdish women röfle may also signify a re-ethnicization of the body and the embodiment of a Turkish identity. This is one of the reasons why the highlights of the suicide bombers attracted particular attention in mainstream Turkish media.

Terror, failure and parody: 'Terrorists with highlights'

As Dorit Naaman notes, suicide operations are generally performed by groups who lack large and well-equipped armies to serve as spectacles of political violence and attract media and public attention. When women partake in these operations 'their performance of violence and political agency – so drastically different from that of typical female roles in both news and entertainment media – enhances the sense of perplexity, fear, and aversion to the perpetrators of the acts' (2007: 935). Therefore, it is not surprising to see that not only in Turkey but also in Lebanon, Sri Lanka, Chechnya, Israel, and Iraq, women have been conducting suicide operations.

Despite the post-9/11 tendency in the West to associate suicide operations with Islamist fundamentalism, Robert Pape argues that these activities are primarily nationalistic acts (2003: 348–9). Although Pape's argument is not uncontested, it is important for understanding the secular organizations that employ suicide bombing, the three main examples of which are the pro-Syrian groups in Lebanon in the early 1980s, the Tamil Tigers in Sri Lanka, and the Kurdistan Workers' Party, the PKK (Fine 2008). The PKK is primarily a secular ethnic/nationalist movement. After 1999 its main goal of creating an independent Kurdish state was replaced with obtaining political and cultural rights for the Kurdish minority in Turkey. Belonging to the PKK is based first and foremost on the rejection of a Turkish identity and the Turkish nation-state. As such, Turkish people who self-identify as nationalists of sorts would tend to imagine the PKK militant's body as the exact opposite of their self-perception as modern Turks. In Turkish nationalist discourse deceased members of the organization are often referred to as 'carrions', stripping them of even their humanity. This was probably a major reason for the bodily technologies Ayfer Ayçiçek and Hatice Arat employed for

their mission. The urban, middle-class dress, polished nails, and most importantly, highlights, constructed the bodies of these young, female suicide bombers as Turkish and therefore innocuous. By inverting stereotypes about their bodies the women aimed to avoid security screening. However, both were caught before they could complete their mission. The failure was also productive though; their urban, modern, secular, middle-class, emancipated looking bodies attracted nearly as much media attention as a completed operation. Alongside the panic and fear any suicide operation may cause, this media interest was also related to the performative power of the parody the women engaged in.

In her discussion of performativity and performance, Judith Butler notes that 'performance, as bounded "act" is distinguished from performativity insofar as the latter consists in a reiteration of norms which precede, constrain and exceed the performer and in that sense cannot be taken as the performer's "will" or "choice"' (Butler 1993: 234). The incited by the bodies of the suicide bombers in this sense stemmed from a reiteration of norms concerning the body and identity in contemporary Turkey, rather than any conscious choice of the women. The contradiction the Turkish press perceived between the bodies and the political affiliations and performances of the 'terrorists with highlights' was embedded in the inversion of the Kurdish Pygmalion fantasy, which, as we have seen in the story of Elmas Şimşek, has been a constitutive myth of the Turkish modernization and nation-state project. Inverting this fantasy, the 'terrorists with highlights' created an unusual, arguably more terrifying form of terror through parody. According to Butler, parodic repetition of the original is nothing other than 'a parody of the idea of the natural and the original' (Butler 1999: 41), drawing attention to the constructed nature of identities. The 'terrorists with highlights' were imitating Turks and through this reiteration of the bodily norms of modern urban femininity their bodies revealed not only the failure of the modernization and nation-state project in assimilating Kurds or keeping them as clearly marked Others, but also the imitative structure of modern Turkish identity. Rather than the mimicry expected from Kurds, Ayçiçek and Arat presented a parody of the 'natural modernity' of Turks. Moreover, this parody challenged the status of Kurds as the 'doubly-belated' Others of Turkish modernity and as the guarantors of Turks' own modernity.

Conclusion

Kemalism and many other strands of Turkish nationalism have perceived Kurdish women as key agents in the reproduction of society and

culture in Turkey. While their Turkish counterparts have been expected to adopt and promote Western ways of living, Kurdish women have been expected to learn Western modernity from Turks through a process of double-colonization. At the entanglement of modernization and nation-state building projects the modern Kurdish female body had an intricate relationship with assimilation and colonialism. On the one hand, the fantasies and practices surrounding the modernization of Kurdish women both legitimized and facilitated Turkish colonialism. Thus, the modern, urban Kurdish female body came to be interpreted as a signifier of assimilation. On the other hand, with the structure of double-colonization and their 'doubly-belated modernity,' Kurds served as guarantors of Turks' own modernity. The 'terrorists with highlights' were important because of the way they played with Turkish modernist and nationalist fantasies concerning their bodies and identities. Young and attractive, with their secular and urban/Western looks, they seemed to be transformed into Turkish citizens. Those who did not know their ethnicity would perceive them simply as Turks and those who knew their ethnic identity could see them as two among the tens of thousands of Kurdish Pygmalions in the history of the nation-state. As suicide bombers however, 'the terrorists with highlights' inverted the colonial fantasies surrounding their bodies. Unlike women wearing the headscarf or Kurdish women whose bodies were not properly re-ethnicized and re-gendered, they looked Turkish yet did not identify as such. Engaging in a parody of the Kurdish Pygmalion fantasy and of the 'natural modernity' of Turks, they triggered the fear of death and of enemies within, and exposing the as well as the but also belatedness and uprootedness in the face of a postcolonial imitation that they exposed to be one.

Notes

I would like to thank Vincent Campbell, Tavia Nyong'o, Yasemen Birhekimoglu, Feride Eralp, Jale Karabekir, Sarah Bess Rowen, Gwyneth Shanks, and Dilan Yıldırım for their helpful comments and suggestions. This chapter is dedicated to José Esteban Muñoz.

1. Various formulations of this statement are found in Ataturk's epic speech on the history and politics of Turkey delivered to the Congress of the Republican People's Party in 1927.
2. The metaphor commonly used in Turkish media refers to the country's belated relationship to 'Western civilization' (Ahıska 2003: 370).
3. To my knowledge, the only work that deals with the subject is Sevim Yeşil's unpublished MA thesis on the Girls' Vocational Boarding School in Elazığ.
4. The word he uses is 'eser', also used for works of art, in either case implying an objectification of Elmas.

5. Similar dynamics of modernization also exist among secularist women in relation to women wearing the headscarf in Turkey.

References

Ahıska, M. (2003) 'Occidentalism: The Historical Fantasy of the Modern', *The South Atlantic Quarterly*, 102, no. 2/3, 351–79.

Akşit, E. E. (2005) *Kızların Sessizliği: Kız Enstitülerinin Uzun Tarihi* (Istanbul: İletişim).

Altınay, A. G. and Arat, Y. (2007) Türkiye'de Kadına Yönelik Şiddet http://www.kadinayoneliksiddet.org, date accessed 28 November 2010.

Altun, M. (2005) 'Extracting Nation Out From History: The Racism of Nihal Atsız', *Journal of Historical Studies*, 3, 33–44.

Anthias, F. and Yuval-Davis, N. (2000) 'Women-Nation-State' in J. Hutchinson and A. D. Smith (eds) *Nationalism: Critical Concepts in Political Science Volume Four* (London and New York: Routledge).

Arat, Y. (2005) *Rethinking Islam and Liberal Democracy: Islamist Women In Turkish Politics* (Binghampton, NY: State University of New York Press).

Arat, Z. F. (ed) (1998) *Deconstructing Images of the Turkish Woman* (Hampshire: Palgrave Macmillan).

Arslan, E. (2002) 'Türkiye'de Irkçılık' in T. Bora (ed) *Modern Türkiye'de Siyasi Düşünce: Milliyetçilik* (Istanbul: İletişim).

Atatürk, M. K. (1927) Nutuk: 1919–1927, http://www.atam.gov.tr/index.php?Page=Nutuk, date accessed 24 August 2011.

Avar, S. (1986) *Dağ Çiçeklerim* (Istanbul: Öğretmen Yayınları).

Bozarslan, H. (2002) 'Kürd Milliyetçiliği ve Kürd Hareketi (1898–2000)' in *Modern Türkiye'de Siyasi Düşünce Cilt 4: Milliyetçilik* (Istanbul: İletişim).

Bourdieu, P. (1987) *Distinction: A Social Critique of the Judgement of Taste* (trans.) R. Nice (Cambridge, MA: Harvard University Press).

Butler, J. (1993) *Bodies that Matter: On the Discursive Limits of Sex* (London and New York: Routledge).

Butler, J. (1999) *Gender Trouble: Feminism and the Subversion of Identity* (London and New York: Routledge).

Canclini, N. G. (2001) *Consumers and Citizens: Globalization and Multicultural Conflicts* (Minneapolis, MN: University of Minnesota Press).

Castoriadis, C. (1987) The *Imaginary Institution of Society* (trans.) K. Blamey (Cambridge: Polity Press).

Çağlayan, H. (2007) *Analar, Yoldaşlar, Tanrıçalar: Kürt Hareketinde Kadınlar ve Kadın Kimliğinin Oluşumu* (Istanbul: İletişim).

Doğaner, Y. (2009) 'The Law on Headdress and Regulations on Dressing in the Turkish Modernization', *bilig*, 51, 33–54.

Fine, J. (2008) 'Contrasting Secular and Religious Terrorism', *Middle East Quarterly*, 15, no. 1, 59–69.

Foucault, M. (1984) 'Nietzsche, Genealogy, History' in P. Rabinow (ed) *The Foucault Reader* (New York: Pantheon).

Gezer, M. (2007) 'Röfleli Canlı Bombanın Hedefi Asker ve Polismiş', Zaman, 30 May, http://www.zaman.com.tr/haber.do;jsessionid=ED72EC6CE209F70A65605D066A1795B1?haberno=545658, date accessed 30 November 2010.

Göle, N. (1997a) *The Forbidden Modern: Civilization and Veiling* (Ann Arbor, MI: University of Michigan Press).

98 'The Terrorists with Highlights'

Göle, N. (1997b) 'Secularism and Islamism in Turkey: The Making of Elites and Counter-Elites', *Middle East Journal*, 51, no.1, 46–58.

Hall, S. (1996) 'When Was the Post-Colonial? Thinking at the Limit' in I. Chambers and L. Curtis (eds) *The Post-Colonial Question: Common Skies, Divided Horizons* (London and New York: Routledge).

Hürriyet (2008) 'Röfleli Bombacıya 22 Yıl 7 Ay Ağır Hapis', 10 June, http://www.hurriyet.com.tr/gundem/9139477.asp?m=1, date accessed 28 November 2010.

İlkkaracan, P. (2002–3) 'Women, Sexuality, and Social Change in Middle East', *Al-Raida*, 20, no. 9, 14–22.

Kibritoğlu, M. (2003) 'Adana'da Canlı Bomba Ele Geçirildi', 23 May, *Milliyet*, http://www.milliyet.com.tr/2007/05/23/son/sontur39.asp, date accessed 30 November 2010.

Maksudyan, N. (2005) 'The Turkish Review of Anthropology and the Racist Face of Turkish Nationalism', *Cultural Dynamics*, 17, no. 3, 291–322.

Milliyet (2007) 'Röfleli Terörist Kafede Yakalandı', 14 April, http://www.milliyet.com.tr/2007/04/14/yasam/yas03.html, date accessed 26 November 2010.

Mojab, S. (2001) *Women of a Non-State Nation: The Kurds* (Costa Mesa, CA: Mazda Publishers).

Naaman, D. (2007) 'Brides of Palestine/Angels of Death: Media, Gender, and Performance in the Case of the Palestinian Female Suicide Bombers', *Signs*, 32, no. 4, 933–55.

Nalçaoğlu, H. (2002) 'Devrimci Öğrencilerin Özgül Fantezi Uzamı: "Seattle" a Selam Olsun!', *Toplum ve Bilim*, 93, 142–72.

Özdalga, E. (1997) *The Veiling Issue, Official Secularism and Popular Islam in Modern Turkey* (London: Routledge).

Özdoğan. G. G. (2001) *Turan'dan Bozkurt'a: Tek Parti Döneminde Türkçülük* (Istanbul: İletişim).

Pape, R. (2003) 'The Strategic Logic of Suicide Terrorism', *American Political Science Review*, 97, no. 3, 343–61.

Saktanber, A. (2002) *Living Islam: Women, Religion and the Politicization of Culture in Turkey* (London: I. B. Tauris).

Sarıkaya, U. (2010) *İşimdeyim Gücümdeyim* (Istanbul:Uyukusuz).

Sirman, N. (2004) 'Kinship, Politics and Love: Honor in Post-Colonial Contexts – the Case of Turkey' in S. Mojab and N. Abdo (eds) *Violence in the Name of Honor: Theoretical and Political Challenges* (Istanbul: Istanbul Bilgi University Press).

Şenler, S. Y. (2007) *Bir Çığır Öyküsü* (Istanbul: Timaş).

Veblen, T. (1994) *The Theory of the Leisure Class* (New York: Dover Publications).

Yeğen, M. (2009) '"Prospective-Turks" or "Pseudo-Citizens": Kurds in Turkey', *The Middle East Journal*, 63, no. 4, 597–615.

Yeşil, S. (2003) 'Unfolding Republican Patriarchy: the Case of Young Kurdish Women at the Girls' Vocational Boarding School in Elazığ', unpublished MA thesis (Ankara: Middle East Technical University).

Yıldız, A. (2001) *Ne Mutlu Türküm Diyebilene: Türk Ulusal Kimliğinin Etno-Seküler Sınırları (1919–1938)* (Istanbul: İletişim).

6
Constructing Effects: Disturbing Images and the News Construction of 'media influence' in the Virginia Tech Shootings

Jeremy Collins

News photographs can often provide troubling or problematic images. When Cho Seung Hui posted a package of videos, photographs and texts to the media in the midst of a shooting spree at Virginia Polytechnic Institute and State University (Virginia Tech) in April 2007 which left 32 dead, he provided them with pictures which were particularly controversial. These were the planned and orchestrated self-representations of a mass murderer, and were therefore immediately examined and interrogated for explanatory clues both by the police and the media. In this chapter, the ways in which these images were utilized in media discourses to explain the shootings is investigated via a content analysis of UK newspapers, with a particular emphasis on media effects as a frame of understanding. This framing occurred through the identification of the film *Oldboy* (Chan-wook Park, 2003), a 'chilling horror-revenge movie' (Hawkins 2009),[1] as a potential influence on Cho both in terms of the shootings themselves and, in a more limited sense, in terms of the images he produced as part of his 'multimedia manifesto'.

Describing the shootings

On April 16 2007, Cho Seung Hui, a student at Virginia Tech shot and killed 32 students and staff and wounded 17 others on the campus before committing suicide. The shootings began at around 7:15 a.m. with the murder of students Emily Hilscher and Ryan Clark in a dormitory room; at 9 a.m. Cho posted a package of media materials – videos, photos and texts – to NBC News in New York, before going on to shoot students and staff at the Norris Hall building of the Virginia Tech campus and killing himself at 9:51 a.m. (Virginia Tech Review Panel 2007: 26). The package

of materials, later described (allegedly by an NBC news presenter) as a 'multimedia manifesto' (Aoun 2007: 19) was considered to be important in allowing the possibility of explaining Cho's actions; nevertheless, according to an official review of the events commissioned by the Virginia state governor, his motives are 'unknown', and the contents of the package 'do not explain why he struck when and where he did' (Virginia Tech Review Panel 2007: 3).

The UK media representation of the shootings at Virginia Tech constructed them as part of a string of similar shootings in the US in which students have been killed and injured either by 'outsiders' or by students themselves within the grounds of an educational establishment. The *Daily Mail* for instance suggested a lineage back to the University of Texas shootings of 1966 (Gardner 2007), and the *Daily Star* listed seven such shootings between 1966 and 2006. Academic analyses make similar connections; Muschert and Carr identify nine such 'rampage school shootings' between 1997 and 2001 (2006), while others trace the phenomenon of high school shootings back to 'at least 1979' (Springhall 1999). While the precise definitions of these events might be problematic, it is clear that both in the media and elsewhere a frame of understanding was already present before the Virginia Tech shootings occurred. Nevertheless, the planning and forethought that the media package represents provides a singular object of interest for the media in their attempts to explain and contextualize shocking events and controversial imagery.

The 'media violence' discourse

Trend has noted the role that 'certain public figures' have played in 'rattl[ing] popular anxieties' (2007: 23) in their contributions to news coverage; he argues that such anxieties are linked to the media violence debate via inference and association rather than rational analysis (ibid.: 24). One of the intentions of this paper is to examine empirically the ways in which such inferences are produced within newspaper discourses.

A number of academics in the field of media and cultural studies have argued that the suggestion of direct causal effects between representations of violence in popular culture and 'real-life' violence has been comprehensively rebutted by empirical research evidence. Gauntlett's 'classic critique' of the effects paradigm argues that it should be 'laid to rest': 'the work of effects researchers is done' (Gauntlett 2005: 5). While carefully acknowledging the existence of media influence – the

impact that media content can have on the ways people understand and make sense of the world around them – Gauntlett analyses a wide range of studies employing different research methods (laboratory and field experiments, 'natural' experiments, statistical studies and others) before arguing that the direct effects paradigm is 'redundant' (Gauntlett 2005: 137). Similarly, Barker and Petley refer to 'mythical' media effects and criticize those who promote such 'populist, common-sense, crudely behaviourist' notions (1997: 7), and Cumberbatch suggests that many of the studies relied upon to support the argument adopt a 'grossly oversimplified approach' to media content and audience experience (2010: 364).

Despite the apparent strength of the empirical evidence, the 'common-sense' understanding of media effects has been argued to be the dominant discourse among popular (tabloid) newspapers and elsewhere in the news media; Hill argues that 'the "effects" debate demands attention because the media give it attention' (Hill 1997: 2). In the UK, one well-documented illustration of this can be found in the case of the murder of James Bulger in February 1993. Two 10-year-old boys abducted and murdered 2-year-old James in Bootle, Merseyside, and the case quickly generated a huge amount of news coverage. The trial judge commented on the 'similarities' between the manner of James' death and events in the 'violent video', *Child's Play 3* (Jack Bender, 1991), and the link this provided between the murder and a horror movie led to the case being 'dominated by arguments about the effects of the media' (Buckingham 1996: 21). Despite the police officer in charge denying that there was any evidence that the killers had seen the film (Critcher 2003: 67), the effects paradigm dominated much of the subsequent coverage and discussion of the case.[2]

In attempting to understand the power of the effects paradigm some researchers have emphasized the historical evidence of concerns around the popular entertainments of the 'underclass' (Critcher 2003: 76):

> lurking behind these fears about the 'corruption of innocent minds' one finds, time and again, implicit or explicit, a potent strain of class dislike and fear.
>
> (Petley 1997: 87)

eighteenth century theatre, nineteenth century music hall, vaudeville, silent movies, 50s horror comics, television, video games and more have in their time been accused of causing immorality and crime in the working classes (Pearso 1983; Barker 1984). This has been argued to

be a significant ideological aspect of the effects discourse, and Critcher quotes a particularly explicit example from a *Daily Mail* columnist who in response to the Bulger case describes the 'thousands of children' of lazy and feckless parents, who are uncontrolled, 'sniff glue ... scavenge for food ... (and are) free to watch increasingly horrific videos' (Lee Potter, quoted in Critcher 2003: 76). In this way, the failings of the 'lower' classes produce young people susceptible to the dangerous effects of popular entertainments.

Explaining school shootings

In order to examine the extent to which the Virginia Tech shootings were represented in media accounts as being causally connected to 'media violence' (that is, employing a conventional 'media effects' model), it is important to see how similar events have been covered in the past.

In April 1999, 12 students and a teacher were killed by Eric Harris and Dylan Klebold at Columbine High School, Littleton, Colorado. These were, at the time, the most deadly school shootings in US history, and a number of studies have investigated the role of the contemporary news coverage in their social construction. An *American Journalism Review* article published a few weeks after the shootings quoted LynNell Hancock, professor at Columbia University School of Journalism, as suggesting that the coverage had been less sensational than that of previous similar events (Pompilio 1999: 10); the shootings nevertheless generated a 'frenzied search for explanations' (Heins 2000: 14). Springhall, for instance, applied a 'hierarchy of causation' in his attempt to provide a historical perspective on the Columbine shootings, and suggested that while the 'roots of the problem ... lie in adolescent anger and frustration' (1999: 640), much of the media coverage focused on what he considered to be the 'preconditioning factors' of media violence and the easy availability of guns (ibid.: 639). He suggested that particular social concerns were reflected in the coverage as 'moral panic' fears: firstly, the fear of racism (underlying reports describing the killers' apparent interest in Nazi imagery); secondly, fear of guns (evident in the reports of the various weapons that were used, and how they were acquired); and thirdly, fear of such shootings occurring in suburban and rural settings (where previous shootings were considered to reflect the social problems of their predominantly urban settings) (ibid.: 625).

A fourth 'moral panic' related to the fear of violent mass media culture, which Springhall described as 'a favourite tabloid newspaper

scapegoat for school killings' (ibid.: 629), and he suggested that this became a key focus of some UK newspaper coverage:

> British right-wing newspapers almost uniformly identified forms of popular (if violent) entertainment ... as precipitants or triggers for the Columbine High school and other schoolyard killings.
>
> (ibid.: 631)

More plausible causal links are to be found, for Springhall, in the hierarchical nature of American high school social structures, and the tensions which arise from the perceived injustices inherent in such a hierarchy (ibid.: 635). Nevertheless, he suggests that criticisms of popular media culture in such cases represent 'a fear of the new technology that amuses the young but is beyond our adult capacity to comprehend or control' (1999: 630), and acknowledges the extent to which 'columnists and politicians' were keen to highlight the supposed role of 'media violence' as a factor in the shootings.

Consalvo examined the role of gender in the media construction of the Columbine shootings, and argued that while Klebold and Harris might superficially be understood to occupy a relatively privileged social position as white middle class young men, theirs was a subordinated masculinity in which they were apparently regarded as 'nerds' or 'geeks' by their peers (2003: 37). While these issues were mentioned in some news coverage, Consalvo suggested that media construction of the two killers largely tended to emphasize their 'monstrousness', and to implicitly accept a conventional masculine hierarchy which exonerated the bullies and 'jocks' who were at its apex (ibid.: 36). This focus on their 'underlying sickness' led, in Consalvo's view, to a failure in the news coverage to analyse complex explanations for the shootings:

> School culture, whiteness, and the hierarchic structure of masculinities were let off the hook far too easily, and instead media outlets focused on the more sensational elements: video games, guns, and the Internet.
>
> (ibid.: 40)

Similarly, Heins suggested that 'many politicians and media pundits focused on violent entertainment' to the exclusion of other potential explanatory factors (2000: 14), while Plasketes considered popular culture texts to be the 'usual suspects' in journalistic explanations (1999: 15). Plaisance argued that issues relating to the size and structure of US

high schools were largely ignored in favour of 'superficial, tangential' angles that more easily 'resonate with popular discourse' (2006: 1). Scharrer et al. noted in their analysis that Columbine stands out as an incident which allowed a particularly wide range of popular cultural texts and artifacts to be 'blamed' (including popular music, fashion, movies and video games) (2003: 82); they also noted the implied (but never explicit) distinction that was made between the 'serious' journalism of the newspaper coverage and the 'frivolous' entertainment media which were implicated in the shootings (ibid.: 90).

Muschert and Carr's analysis of *The New York Times* reporting of nine separate school shootings largely focused on methodological issues, but found that coverage over the period 1997–2001 shifted between a focus on local and 'present-tense' impacts, and emphasis on future impacts at a societal level (2006: 760). While this study does not discuss the possibility of media coverage raising causal explanations of such shootings, it does suggest two particular dimensions – spatial and temporal – which contribute to the way these consistently newsworthy events are framed.

Ogle et al. analysed the role of appearance in the media coverage of Columbine and how it became a key variable in the ensuing debates, noting that in such crisis cases journalists may feel pressured to provide 'resolutions or solutions' (2003: 3). Indeed, they suggest that the absence of the killers' own explanations means that media representations may be particularly important in 'constructing the "reality"' of Columbine, and that such accounts may also influence public policy (ibid.: 4). They found three kinds of 'claim' made regarding appearance: those referring to subcultural groups; those referring to social tensions and the motive of revenge; and those concerning the role of dress (trench coats) in facilitating the shootings by allowing weapons to be concealed (ibid.: 14). While these do not in themselves represent 'explanations' for the shootings, Ogle et al. argue that the emphasis on 'appearance cues' in the coverage helped to provide a 'ready and tidy solution' which 'may have shortchanged the discussion of an opportunity for "real" social change as a way to prevent future school shootings.' (ibid.: 25).

Method

A content analysis of the newspaper coverage of the Virginia Tech shootings was conducted in order to produce the primary data for this study. As a method for generating a 'systematic, and quantitative description of the manifest content of communication' (Berelson,

quoted in Hansen et al. 1998: 94), content analysis provides a baseline for further qualitative discussion and analysis of specific elements of the coverage.

A search of UK national newspaper coverage in the Nexis database using the search terms 'Cho' and 'Virginia' produced an initial sample of 311 articles between 17 April and 16 May 2007; this was added to a further sample of 51 articles referring to the story in the first 24 hours before Cho had been identified. It was clear that the coverage began to diminish substantially after seven days, so the analysis was limited to the 306 articles found in the first week. Duplicate reports, as well as regional edition articles (often partly duplicating UK/English edition material) and letters, were removed to leave the editorial content of the newspapers – a final sample of 232 articles. These included both reporting and comment and opinion pieces. In attempting to measure the relative frequency of explanatory themes in the coverage, paragraphs within the sample articles were coded according to the following six categories[3] derived both from initial readings of the material and from the literature. A total of 816 paragraphs were coded, 433 in broadsheet articles and 383 in tabloid articles.

Popular culture

This category is invoked primarily when reference is made to the link or similarity between the photos and videos of Cho which he sent to NBC and scenes in *Oldboy*, but also included are references to other popular culture artifacts such as computer games and violent movies generally.

Class/wealth hatred

This includes paragraphs suggesting Cho acted due to a hatred of the wealthy decadence of his peers: 'In a note discovered by the FBI in his dormitory room, Cho Seung-hui, 23, a South Korean student, railed against "rich kids", "debauchery" and "deceitful charlatans" at Virginia Tech' (Harnden and Spillius 2007a). However, if it is part of a wider descriptive repetition of his 'manifesto' or 'rant' then it is not coded as this material is inherently newsworthy whatever its content.

Sexual jealousy/obsession

This category includes all paragraphs which allude to Cho being 'jilted' or in a failed relationship, or in a more general sense to the 'domestic' nature of the initial dispute: 'Cho was "obsessed" with Emily Hilscher, 18, and went crazy when she jilted him, police sources revealed last night' (Burchell 2007a).

Gun availability

References to 'lax' gun laws, or that the gun debate has been re-ignited, are categorized here, such as one columnist's reference to the policies of the National Rifle Association which went on to argue: 'What it fails to acknowledge is that if you have murderous intent, guns make it far easier to kill people – and particularly to kill lots of people' (Sieghart 2007). However, accounts which were merely descriptive of how, where, or when the guns were bought were not included. This is problematic in the sense that such descriptions might be argued to carry an implicit rebuke; nevertheless, a conservative approach was adopted.

Mental/psychological illness

Paragraphs mentioning Cho's professors' concern over his writing, that he was 'troubled', and other discussions which describe his past treatment and referrals to counselling were coded here: 'A temporary detention order was issued after it was ruled he "presented an imminent danger to self or others as a result of mental illness"' (Smith 2007). Discussions of his student work (in particular, the creative writing material) were not in themselves coded; so references to his 'twisted, macabre plays' (Harnden and Spillius 2007a) were not coded.

Failure of officials

References either questioning or defending the decisions of the police and university officials, including the criticisms of students, are coded in this category. For instance, introducing the criticisms of a student, the *Daily Express* suggested that 'the response of the authorities to the initial shooting was the source of growing unease last night as the country tried to come to terms with the tragedy' (Twomey and Pilditch 2007).

Results

Categories of explanation

The relatively easy accessibility of guns (compared to the UK) was, marginally, the most commonly discussed explanation for the shootings. This reproduces a familiar British discourse constructing the US as hopelessly fixated on the 'freedom to bear arms', sometimes in comparison to a more pragmatic British approach. The second most common explanatory theme was that of mental illness, whereby the implicit assumptions of terms such as 'crazed gunman' and 'maniac' were also joined by more

specific questions around Cho's mental state including the problems which had been noted by a number of institutions in the past. The influence of popular culture was the third most common theme, and is discussed in more detail below, while the fourth focused on the apparent failures of different authorities either to act on Cho's apparent mental illness or to stop him once the shootings had begun. In explaining why there were so many deaths, this theme emphasized in particular the crucial delays between the first shootings in the student dormitory at 7:15 and those in the teaching buildings two hours later. The theme of sexual jealousy was discussed as a possible explanation when it was suggested that the first shootings might represent the revenge of a jilted boyfriend, while the issue of class hatred emerged largely due to Cho's writings, both in the manifesto and elsewhere, which were interpreted as attacks on the wealth and decadence of his fellow students. Paragraphs reflecting two further themes – assertions of evil in absolute moral terms, and the importance of ethnicity as an explanatory factor – were found in small numbers. The latter theme was mainly concerned with the extent to which Cho's Korean background had influenced his attitude to his peers, but this didn't become a major topic in the coverage. Finally, the issue of appearance, while mentioned in descriptions of Cho during the shootings, were not presented as aiding an understanding of why they occurred (unlike the discussion of the trenchcoats of the Columbine killers) and therefore were not recorded for the purposes of the present study.

Tabloid – broadsheet differentiation

The categories of explanation measured here show similar levels across both broadsheet and tabloid newspaper sectors. One difference between the two sectors relates to the discussion of the role of officials in the coverage, in that the broadsheet newspapers devoted relatively more time to this than the tabloids. *The Guardian* for instance described in some detail the setting up of an investigation into the 'slow response of the university and police' and whether 'police and officials should have been monitoring the killer Cho Seung-Hui more closely' (MacAskill 2007). Similarly, *The Daily Telegraph* reported criticisms of the university officials under the headline 'Signs were ignored, says stalked girl's stepmother' (Harnden and Spillius 2007b). Another distinction could be found between tabloid and broadsheet newspapers in terms of the easy availability of guns. While this might in one sense be expected to reflect tabloid expressions of the populist representation of trigger-happy Americans, in fact the broadsheets were more likely to emphasize this explanation. As with the category of official mistakes,

this could perhaps be understood to reflect a broadsheet emphasis on policy issues; the topic of gun availability is thus discussed in terms of its long term political-historical context (e.g. Elsworth 2007a) as well as within descriptive background reporting on the shootings (Shipman 2007). These two minor issues aside, the differences between tabloid and broadsheet newspaper coverage were largely negligible, with the arguable exception of the apparent tabloid emphasis on popular culture as an explanatory theme. This is discussed in more depth in 'Blaming Popular Culture', below.

Flow over time

Table 6.2 sets out the changes in the coverage according to the key categories in the week following the shootings. In the first few days following the shootings the availability of guns was presented as a key topic for concern. Debate also focused on two further issues: the possibility of sexual jealousy as a motive and the failings of officials. The former theme was raised initially in stories reporting that the unnamed

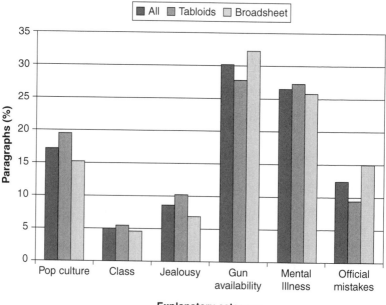

Table 6.1 Explanatory categories used in Newspapers by percentage of total paragraphs counted

'love-crazed killer' (Parry 2007) shot his girlfriend after being 'dumped' (Millar 2007), and gained further traction the following day when Emily Hilscher was named as the first victim and unofficial police briefings suggested she had either been in a relationship with Cho, or that he was infatuated or 'obsessed' with her (Seamark 2007); photographs of Hilscher supported this theme. Criticism of officials also emerged in the early coverage with the apparently 'fatal delay' after the initial shootings caused by an assumption that they were a 'murder/suicide' or a 'domestic shooting', and an innocent suspect distracting the investigation in its early hours (MacAskill et al. 2007). On the third day of coverage mental illness emerged as a dominant theme with Cho's history and the concerns of University staff and students reported. On the fourth day, one key issue dominated: the role of popular culture – and more specifically the influence of *Oldboy* – as an explanatory theme.

Blaming popular culture

Even before the emergence of the 'multimedia manifesto', there were some brief references to 'video games of absurd violence ... without

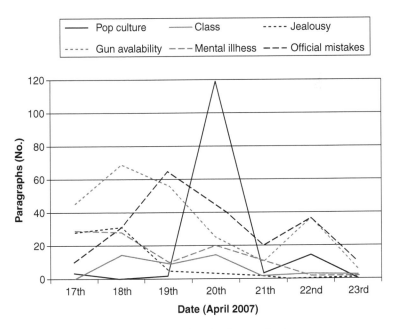

Table 6.2 Explanatory categories used in the first week of coverage

so much as a moral theme', and lamenting the 'kids crowding the multiplexes' who see the violence of Quentin Tarantino films as 'cool' (Laurence 2007). The posting of the 'multimedia manifesto' was reported on 19 April, and the images of Cho with weapons including pistols, a hammer and a knife were printed in many newspapers. The whole of the front page of the *Daily Mirror*, for instance, consisted of a photograph of Cho pointing a gun directly towards the camera. In the afternoon of 19 April the *London Evening Standard* printed the picture of Cho holding a gun to his head alongside a similar picture from Oldboy, with the headline 'Straight from a horror film'. Inside, a similarly direct comparison was made between Cho's pictures and stills from the film with the protagonist holding a hammer. The *Standard's* story suggested that the images were 'clues to (Cho's) motivation' and that he had 're-enacted scenes' from the film.

This approach was followed up by the national newspapers the following morning with some describing the shootings as a 're-enactment'

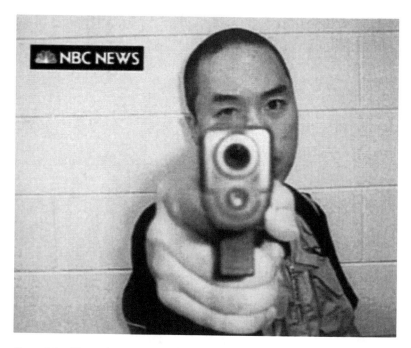

Figure 6.1 Cho points a gun at the camera in an image from his 'multimedia manifesto'

(*Express*, *Star*, *Mirror*), and many newspapers presented an explicit com-
parison between Cho's photographs and images from the film. This was
sometimes presented as the unofficial police view, and was also credited
to 'Virginia Tech Prof Paul Harrill, who told police of his observation
yesterday' (Maclean 2007). It seems clear that Harrill, perhaps via the
police, was the main source who made the link to *Oldboy* and arguably
set this particular explanatory theme running (although clearly others
may well have made it at a later point).[4]

The Daily Telegraph reported the story as raising 'concerns about links
between screen brutality and violent crime' in an article headlined
'Violent images in revenge film were echoed by college killer' (Elsworth
2007b), while the *Daily Star* referred to the 'Massacre of the movie
maniac' (Burchell 2007b). Alongside the news reporting, a number of
commentators referred to the *Oldboy* link; as with Columbine then,
'Columnists and politicians were quick to latch onto assertions that
the mass media might be a factor in these school tragedies' (Springhall
1999: 630). MP and chairman of the Culture Media and Sport Select
Committee, Gerald Kaufman, for instance, wrote in the *Telegraph* that
'the most chilling aspect of the Virginia Tech massacre' was that Cho
had been 'directly inspired' by *Oldboy* (Kaufman 2007). While also com-
menting on the availability of guns in the US, and dismissing the idea
of a return to stringent censorship, Kaufman suggested that 'people
like Cho' cannot distinguish between movies and real life, and the
film-makers have a 'wider responsibility than simply to enable aimless
people to pass the time until their next visual fix' (ibid.). The imagery
of addiction here echoes the concerns mentioned above, around earlier
cultural forms that would be supposedly uncritically consumed by the
weak-minded. In a similar comment article in *The Times* a University of
Virginia psychologist argued that Cho 'turned to violent movies to help
him visualise [the shootings]' which were a 're-enactment of a mass
slaughter' (Cornell 2007), and put forward the 'advertising works' argu-
ment for mass media effects which has been critiqued elsewhere (Barker
1997: 21–4; Gauntlett 2005: 103–10). Even more directly, a regular col-
umnist in *The Sun* argued that Oliver Stone's *Natural Born Killers* (1994)
inspired the Columbine shootings and that *Oldboy* 'made Cho shoot
dead 32 people at his college' (Shanahan: 2007).

Conclusion

The causal connections between popular culture imagery and mass
shootings have been a familiar theme in news accounts for some time.

It is therefore unsurprising that the Virginia Tech shootings initially attracted similar comments even before the emergence of the controversial images that formed part of Cho's 'manifesto'. Nevertheless, it is clear that the specific apparent connection to *Oldboy* provoked UK newspapers into presenting popular culture, and this film in particular, as helping to explain the shootings. This can in part be understood as the emergence of a common news frame which 'select[s] some aspects of a perceived reality ... in such a way as to promote a particular problem definition [and/or] causal interpretation' (Entman quoted in Chyi and McCombs 2004: 24). The relative absence of credible alternative frames (such as that of the 'jealous boyfriend' or a clear racial element) can also be seen as allowing this perspective to gain traction. The Columbine shootings in 1999 united the media 'in their search for explanations' which functioned 'as consolation, as insulation, protection against having to face not just the inexplicability of horror, but the horror of inexplicability' (Springhall 1999: 621, 622). The Virginia Tech shootings provoked a similar reaction which was only intensified by the emergence of Cho's 'multimedia manifesto' and given direction and shape by the apparent link to *Oldboy* as an artefact of popular culture which evoked the familiar frame of media effects. In this sense, the disturbing images of Cho provided a means for the news media to re-present an established explanatory theme in which violence in the 'real world' can be explained by, or even blamed on, violent imagery in popular culture.

Notes

1. *Oldboy* is rated R in the US, 18 in the UK (due to its containing 'frequent strong violence' (BBFC)), and concerns a man who is kidnapped and imprisoned without explanation for 15 years. On his release, he sets out to find out why he was jailed, and to take revenge on those responsible.
2. It should also be noted that CCTV images of James Bulger being led away from a shopping centre by the two boys who killed him also provided a shocking visual representation which, while not directly linked to popular culture, nevertheless intensified media concerns and demands for explanation.
3. Three further categories of explanation were coded for initially: 'Appearance' (in an attempt to produce a comparison with the Columbine shootings), 'Ethnicity' (in suggesting a racial intent), and 'Evil' (as an unqualified and explicitly moral explanation for Cho's behaviour). In each case however, it was clear that such explanations were not substantially present and were therefore not included in the quantitative analysis presented here.
4. Harrill's own blog describes how he mentioned the apparent similarity between Cho's poses and *Oldboy* when he contacted *The New York Times* to complain about their use of the 'manifesto' pictures on their website. He

makes it clear that he was not suggesting any causal link, and was 'naïve' to think his comments would not be 'co-opted' by the media (Harrill 2007).

References

Aoun, S. (2007) 'Idiots Box (Viewpoint Essay)', *Metro Magazine*, June.

Barker, M. (1984) *A Haunt of Fears: The Strange History of the British Horror Comics Campaign* (London: Pluto Press).

Barker, M. (1997) 'The Newsom Report: A Case Study in common sense' in M. Barker and J. Petley (eds) *Ill Effects: The Media/Violence Debate* (London: Routledge).

Barker, M. and Petley, J. (eds) (1997) *Ill Effects: The Media/Violence Debate* (London: Routledge).

BBFC (2011) 'Oldboy', http://www.bbfc.co.uk/AVF201523, date accessed 18 April 2011.

Buckingham, D. (1996) *Moving Images: Understanding Children's Emotional Responses to Television* (Manchester: Manchester University Press).

Burchell, I. (2007a) 'Beauty who made Loner Mass Killer', *Daily Star*, 18 April.

Burchell, I. (2007b) 'Massacre of a Movie Maniac', *Daily Star*, 20 April.

Chyi, H. S. and McCombs, M. (2004) 'Media Salience and the Process of Framing: Coverage of the Columbine School Shootings', *Journalism and Mass Communication Quarterly*, 81, no. 1, 22–35.

Consalvo, M. (2003) 'The Monsters Next Door: Media Constructions of Boys and Masculinity', *Feminist Media Studies*, 3, no. 1, 27–45.

Cornell, D. (2007) 'A 21st Century Massacre', *The Times*, 20 April 2007.

Critcher, C. (2003) *Moral Panics and the Media* (Maidenhead: Open University Press).

Cumberbatch, G. (2010) 'Effects' in D. Albertazzi and P. Cobley (eds) *The Media: An Introduction* (3rd edn) (Harlow: Pearson).

Elsworth, C. (2007a) 'Massacre Re-Ignites Firearms Debate in the US', *The Daily Telegraph*, 17 April.

Elsworth, C. (2007b) 'Violent Images in Revenge Film were Echoed by College Killer', *The Daily Telegraph*, 20 April.

Gardner, D. (2007) 'A Terrible Toll in the Country where the Gun is still Sacrosanct', *Daily Mail*, 17 April.

Gauntlett, D. (2005) *Moving Experiences: Media Effects and Beyond* (2nd edn) (Eastleigh: John Libbey).

Hansen, A., Cottle, S., Negrine, R. and Newbold, C. (eds) (1998) *Mass Communication Research Methods* (Basingstoke: Macmillan).

Harnden, T. and Spillius, A. (2007a) '"You made me do it" Killer was Obsessed with Girl Student; Note Revealed his Hatred of "rich kids"', *The Daily Telegraph*, 18 April.

Harnden, T. and Spillius, A. (2007b) 'Signs were Ignored, says Stalked Girl's Stepmother', *The Daily Telegraph*, 21 April.

Harrill P. (2007) 'Last Word on the Subject', 19 April, http://www.selfreliantfilm.com/?p=249, date accessed 16 November 2010.

Hawkins, J. (2009) 'Culture Wars: Some New Trends in Art Horror', *Jump Cut: A Review of Contemporary Media*, 51, 1–11.

Heins, M. (2000) 'Blaming the Media', *Media Studies Journal*, 14, no. 3, 14–23.

Hill, A. (1997) *Shocking Entertainment: Viewer Response to Violent Movies* (Luton: John Libbey).

Kaufman, G. (2007) 'Questions Film-Makers must ask themselves after Virginia Tech', *The Daily Telegraph*, 20 April.

Laurence, C. (2007) 'The Gun Mania that puts my boy in Danger every Time he goes to School', *Daily Mail*, 17 April.

MacAskill, E. (2007) 'Investigation: Police Response becomes Focus for Inquiry', *The Guardian*, 19 April.

MacAskill, E., Goldenberg, S. and Pilkington, E. (2007) 'Campus Massacre: Angry Students Demand Answers after being told it was Safe to go to Classes', *The Guardian*, 18 April.

Maclean, S. (2007) 'Killer in a Movie Fantasy', *Daily Mirror*, 20 April.

Millar, C. (2007) 'Bloodbath', *Daily Star*, 17 April.

Muschert, G. W. and Carr, D. (2006) 'Media Salience and Frame Changing Across Events: Coverage of Nine School Shootings, 1997–2001', *Journalism and Mass Communication Quarterly*, 83, no. 4, 747–66.

Ogle, J. P., Eckman, M. and Leslie, C. A. (2003) 'Appearance Cues and the Shootings at Columbine High: Construction of a Social Problem in the Print Media', *Sociological Inquiry*, 73, no. 1, 1–27.

Parry, R. (2007) 'Executed at Uni: 33 dead, 29 Hurt as Love-Crazed Killer Opens Fire', *Daily Mirror*, 17 April.

Pearson, G. (1983) *Hooligan: A History of Respectable Fears* (London: Macmillan).

Plaisance, P. and Deppa, J. (2006) 'Causes of Columbine: How News Framing Marginalized School Size as a Factor in the Tragedy', conference paper, International Communication Association Annual Meeting, 1–31.

Plasketes, G. (1999) 'Things to do in Littleton When You're Dead: A Post-Columbine Collage', *Popular Music and Society*, 23, no. 3, 9–25.

Pompilio, N. (1999) 'Lessons Learned from School Shootings Past', *American Journalism Review*, 21, no. 5, 10–12.

Scharrer, E., Weidman, L. M. and Bissell, K. L. (2003) 'Pointing the Finger of Blame: News Media Coverage of Popular-Culture Culpability', *Journalism and Communication Monographs*, 5, no. 2, 49–98.

Seamark, M. (2007) 'The Deadly Infatuation: Did Campus Gunman's Obsession with Student Spark Massacre?', *Daily Mail*, 18 April.

Seighart, M. A. (2007) 'Shooter Sophistry', *The Times*, 19 April.

Shipman, T. (2007) 'Gun Lobbyists give Backing to Checks which could have Thwarted Killer', *The Sunday Telegraph*, 22 April.

Smith, E. (2007) 'Time to Die', *The Sun*, 19 April.

Springhall, J. (1999) 'Violent Media, Guns and Moral Panics: The Columbine High School Massacre, 20 April 1999', *Paedagogica Historica*, 35, no. 3, 621–41.

Trend, D. (2007) *The Myth of Media Violence: A Critical Introduction* (Oxford: Blackwell).

Twomey, J. and Pilditch, D. (2007) 'Grin of a Silent Killer', *Daily Express*, 17 April.

Virginia Tech Review Panel (2007) *Mass Shootings at Virginia Tech: Report of the Review Panel* (http://www.governor.virginia.gov/TempContent/techPanel Report.cfm, date accessed 6 September 2010).

7

Border Patrol: Trevor Brown, Aesthetics and the Protection of Fictitious Children

Adam Stapleton

The marriage of reason and nightmare that has dominated the twentieth century has given birth to an ever more ambiguous world. Across the communications landscape move the spectres of sinister technologies and the dreams that money can buy. Thermo-nuclear weapons systems and soft-drink commercials coexist in an overlit realm ruled by advertising and pseudo-events, science and pornography. Over our lives preside the great twin leitmotifs of the twentieth century – sex and paranoia (Ballard 1995: 4).

On 15 December 2004, four books featuring work by the artist Trevor Brown that were to be delivered to my home were intercepted and seized by Australian Customs. An Italian publication, *Rope, Rapture & Bloodshed* (2001) and three Japanese publications, *Forbidden Fruit* (2001), *Medical Fun* (2001) and *Li'l Miss Sticky Kiss* (2004), were judged by the Office of Film and Literature Classification (OFLC) to be objectionable goods under regulation 4A (1A) of the Customs (Prohibited Imports) Regulations 1959. The publications contained drawings and paintings, many depicting figures resembling pubescent and young adult females, although other features suggest that they are dolls. The items were seized under the judgement that 'they depict bondage and describe or depict in a way that is likely to cause offence to a reasonable adult, a person who is, or who looks like, a child under 16 (whether the person is engaged in sexual activity or not)'. This initiated an 11-month process that required evidence of my record of scholarship, court appearances and an agreement between myself and the OFLC stipulating the narrow conditions within which this material might be shown to my colleagues and maintained in my possession. In November 2005, I went to the facility to collect the seized goods. I delivered the relevant paperwork and awaited the retrieval of the publications. An officer returned with

a box, but before surrendering the items she asked me to confirm the purpose of the acquisition. Although permission had already been granted by the director of the OFLC and a magistrate had verified the validity of the proceedings, I offered a response, not wanting to miss the opportunity to try to encapsulate my postgraduate research as a sound bite. However, my response faded as I noticed the expression of contempt on her face. 'Well', she retorted, 'as a parent, I think it's disgusting!' I left the building on the verge of tears, startled to be subject to this impromptu judgement.

This process of seizure, credentialization, and permission may seem a familiar one.[1] Images are powerful things and those that have the capacity to run afoul of the law tend to be those that have the capacity to provoke a strong affective response.[2] Prohibitions against pornography seem intimately related to its capacity to elicit interest, enjoyment, disgust and shame, and the kinds of art that are most likely to be mistaken for pornography are those which leave space for the expression of these emotions. While legal regulations are conventionally seen as the 'outcome of cognitive processes', emotions link the legal and social realms and, 'emotional processes are important in the formation of legal regulation' (Lange 2008: 401–2). However, some emotions – particularly disgust – incite responses that are counterproductive. Disgust seduces us, arousing the censorious urge to smash, bury, burn or flush the offending article. But, unlike anger, disgust is unable to purify. Disgust promotes shame and 'leaves us feeling polluted by the process' (Miller 1997: 204). The relationship between disgust and shame ensures that, even if the offending article is flushed out of existence, the memory is never completely eliminated.

Western law has a recurring obsession with the image and its capacity to affect social reality. My investigation here examines that obsession through an exploration of the controversy surrounding the work of the artist, Trevor Brown, in relation to recent legislation around the depiction of minors and of fictitious persons.

Art controversies

Controversies about the representation of children are prominent within contemporary Anglophone culture (Higonnet 1998), interconnected with broader debates about the 'sexualization' of culture (Attwood 2006). Since the late 1970s there has been an increase in the tendency to see prurience where once we would have seen innocence and this has intensified with the development of technologies that have

facilitated the circulation of child pornography and the formation of paedophile subcultures.[3] Concerns about the representation of children are most often directed towards photography, reflecting the popular notion that photography captures reality. The conflation of photographic realism and reality has fuelled controversies about the legality and ethics of producing, possessing and displaying images of children, particularly when nudity is involved.

Controversies around the representation of children have played out in a variety of ways. Some, such as the advertising campaigns of Calvin Klein of 1980 (Higonnet 1998: 150–1), 1995 and 1999 (Mohr 2004: 23–5) seem calculated to manipulate public anxiety over sexualized images of minors in order to generate publicity for a brand. Others appear to be the result of a genuine lack of consensus between different sections of the community rather than a flirtation with the dynamics of transgression and prohibition. These include the 1999 arrest of Ohio resident, Cynthia Stewart, for taking nude photographs of her daughter, Nora, intended as a way of creating a 'photographic memory of her childhood' (Powell 2010: 6) and the 1995 arrest, by Scotland Yard's Paedophile and Child Pornography unit, of newsreader Julia Somerville and her partner, for taking photographs of their daughter nude in the bath (O'Toole 1999: 217–27). Although in both cases the legal system ultimately recognized that the production of these images did not constitute criminal activity, the distress visited upon the families and the suggestion of impropriety represents a significant violation.

The kinds of images that most consistently provoke controversy are those intended for public display, often in the art gallery; for example in work by Robert Mapplethorpe in 1989, Sally Mann in 1992, Jock Sturges in the mid-1990s, David Hamilton in the late-1990s, Nan Goldin in 2007, Bill Henson and Polixeni Papapetrou in 2008, and Jan Saudek in 2011 (Higonnet 1998; O'Toole 1999; Julius 2002; Kammen 2006; Marr 2008). A brief examination of three controversies suggests that particular elements recur throughout these events, suggestive of the broader cultural shifts that facilitate them.

Upon publication of her third monograph, *Immediate Family* (1992), a collection of photographs of her children taken in the 1980s and 1990s, Sally Mann, a well-respected artist and recipient of fellowships from the Guggenheim and the National Endowment for the Arts, became associated with an assault upon public decency. Michael Kammen (2006: 80) argues that the controversy about Mann was a double scandal, her maternal status augmenting the anxiety that some viewers felt in response to her images of nude and defiant children.

Mann's close maternal relationship with her models divided opinion. For some, her role as a mother served as proof that she did not intend to exploit children for the sake of notoriety, while for others it reinforced the pity they felt towards her 'helpless art-abused children' (Julius 2002: 141). Higonnet (1998) and Kammen (2006) also argue that Mann's photography distressed viewers not only because it depicted children in provocative poses or in the nude, but because of its challenge to dominant notions of childhood innocence. This is apparent in 'Virginia at 4', in which the viewer's gaze is reciprocated by a being who appears fragile but commands a sense of agency. Such images violate the ideal of the Romantic child (Higonnet 1998: 196), suggesting that the boundaries between adulthood and childhood are porous.

In 2007 the display and seizure of Nan Goldin's 'Klara and Edda Belly Dancing' caused controversy in the UK. The image depicts two girls of four or five years of age playing in a modest kitchen setting. One girl stands over the other, wearing white underwear and a makeshift veil. The second girl is sliding between her legs. She is naked and her vulva is in clear view of the camera. Given that the image depicts girls who are clearly too young to be 'Lolitas' (Nabokov 1955: 16) and that they are not posed in a way that would usually be understood as provocative, it may be that its reception was due to the composition of the image being too vernacular, falling short of what some viewers expect from 'art' (Eck 2001).

In 2008 police officers supervised the removal of 20 of Bill Henson's photographs from the Roslyn Oxley 9 Gallery in Australia. The tabloid *The Daily Telegraph* declared 'Victory for decency as police close gallery: CHILD PORN "ART" RAID'. The offensiveness of naked adolescent bodies was clarified by moral campaigner, Hetty Johnston, who argued that 'pictures portraying sexualised imagery of young girls can never be called art. It is child pornography, child exploitation and it is a crime' (Marr 2008: 15). Johnston claimed that the production and display of the material validated paedophilic desire and she announced a campaign to confront the 'art world with its history of sheltering paedophiles' (Marr 2008: 132).

These controversies all contain common features. First, the objection to the display of the material is framed as part of a campaign against the promotion of child pornography. Second, the condemnation of the material occurs despite the level of respect that these artists are afforded within their community. Third, despite the appearance of significant public support, these outrages seldom generate indictments or prosecutions, much less convictions, having the perverse effect of affirming 'provocative art' (Kammen 2006: 82). However, although they are not

branded as criminals, the artists are relegated to an 'indeterminable' sphere of suspicion and contempt. At the same time, while the law is unable to reach its logical endpoint of prohibiting all representations for fear that they may have a lascivious effect, it is unable to disregard images as simply representations. In this way the image of the erotic child continues to haunt the periphery of visual culture. The common features of these events, which occur over several decades and a wide geographical proximity, suggest that anxiety about images of children is part of a significant and developing crisis.

In 2011 a piece by Saudek was removed on the eve of its Australian exhibition for the Ballarat International Foto Biennale after one individual complained to Tourism Victoria and to Ballarat local council.[4] The image was removed 'voluntarily' under the threat that the event would not receive government funding in the future. As this suggests, controversies not only carry the threat of legal action but have the capacity to influence the curatorial decisions of art galleries. They may also impact on corporate decisions. In 2007 an offended individual initiated a complaint to eBay subsidiary, Paypal, causing the closure of Trevor Brown's Paypal and eBay accounts (Brown 2008: 72–4; 89–90). Paypal justified their decision on the basis that 'any sexually oriented goods or services, involving minors, or made to appear to involve minors will automatically be treated as violations of the Mature Audiences Policy' (Brown 2008: 73). The inconsistency of this stance is indicated by the fact that eBay continues to permit other vendors to sell Brown's items and that Paypal is accepted at online stores that sell his publications. However, since the decision was made at corporate discretion, rather than by a court, there is no opportunity to challenge the ruling.

Trevor Brown's baby art

Brown began making the self-published art zine, *Graphic Autopsy*, in 1984. It comprised primarily of line drawings of women involved in bondage and other forms of sadomasochist activity. In 1993 Brown moved from Great Britain to Japan where his work became 'tainted by kawaii' (Liddell 2009). Kawaii, roughly translated as 'cute', has been popular in Japan since the 1970s, becoming a global phenomenon in the 1990s with the popularity of transmedia commodities such as Pokémon and Hello Kitty (Allison 2006: 16; Ashcraft and Ueda 2010: 98–9). Kawaii celebrates bright colours, miniaturization and an emblematic face that can be affixed to a range of commodities such as lunch boxes, backpacks, trading cards, animated programmes and games. Ashcraft

and Ueda contrast kawaii with beauty, arguing that, 'beauty is natural, but kawaii can be manufactured. And it's attainable – any girl can be cute' (ibid.). Kawaii represents an alternative regime of values that are intimately related to economic production and consumption.

Aspects of kawaii can be found in much of Brown's post-England work. In 1993 he began airbrushing images of dolls and other children's toys, the beginning of his 'baby art'. 'Teddy Bear Operation' (1994) shows a doll-like figure in green surgical scrubs with a scalpel in a latex-gloved hand. The patient, a teddy bear, is flat on an operating table wearing an oxygen mask. The bear's chest is open; white stuffing exposed, secured by forceps, with a needle and thread ready to repair the surgical invasion. 'Anatomy Doll' (1994) is an image of a plastic moulded doll without visible genitals, with obvious joins separating the limbs from the torso, and a frozen, interested gaze that suggests reciprocation with a viewer. However, the front of its skull and torso are transparent, exposing a brain and set of vital organs. Each organ is labelled in a diagrammatic way, with text in English and Katakana.

The doll, a central feature of Brown's baby art, carries a variety of connotations outside of its context as a children's plaything. Porcelain dolls are collected by antique doll aficionados and the populist doll enthusiasts in North America, but they have also been used by riot grrrl bands as icons of resistance, sexual agency and survival (Higonnet 1998: 193). Robertson (2004) argues that dolls are routinely disparaged by adults, perhaps because they have an 'undecidable' (Derrida 1988: 115–16) quality. However, in Japan dolls are afforded more respect (Robertson 2004: 6) and male involvement with doll making and collecting appears to be less stigmatized.

Brown's publication, *Alice* (2010), features images of Lewis Carroll's children's book characters and other miscellaneous characters from nursery rhymes. 'Humpty' (2008) depicts Alice and Humpty in front of a wall. Alice is holding Humpty, but appears indifferent to him and directs her gaze towards the viewer. She is thin, wears a frilled dress, and has a flower in her hair. He is obese, wearing polka dot pants, a striped shirt and a top hat decorated with an image of the Union Jack. His face is ruddy and he has boils on the back of his neck. He leers at Alice, salivating, with a diminutive erection bulging in his pants. This is a vulgar image but it is not lascivious. Rather, it is pathetic, both in the sense that Alice elicits sympathy from the viewer and that Humpty's arousal is distasteful, yet hardly threatening.

Brown's work also features 'Lolita girls' – figures with pubescent bodies depicted with varying degrees of sexual suggestiveness. Although

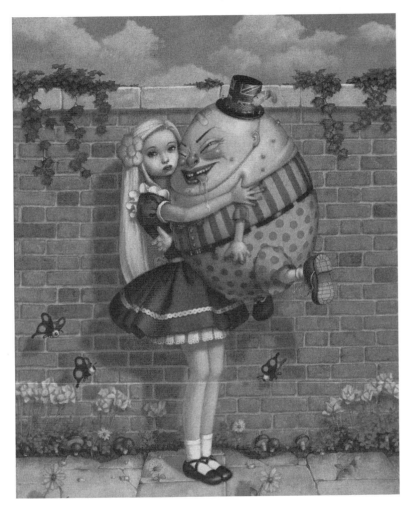

Figure 7.1 'Humpty', Trevor Brown, 2008

these feature nudity and references to bondage, the images appear devoid of eroticism. 'Slut' (2003) depicts a female on a white-sheeted mattress against a grey tiled wall and matching floor. She is wearing black military boots, black elbow-length latex gloves, demure white cotton underpants, and a steel open mouth gag. Her legs are spread with her right leg arched on the mattress and her left leg pointed towards the floor. She clutches her right breast with her right hand and gazes at the

viewer with her head tilted slightly to her right. Her left arm extends behind her, supporting her vulnerable pose. Despite her pose and gaze, the image offers a dark and disaffected view of sexual desire.

The law and fictitious persons

In contemporary Anglophone culture the lines between childhood and sexuality are sacrosanct. It is not surprising that Brown's willingness to play with these boundaries causes controversy, but broader shifts in the way that images of children are understood now make it increasingly likely that it may also be considered a criminal offence. While earlier definitions of child pornography frame it primarily as a record of sexual exploitation, more recent legislation includes images of fictional persons that have been drawn, painted or generated by computer or some other technological process. In the US 'child pornography laws are only constitutional where they depict actual minors' (Gillespie 2011: 66), but depictions of imaginary minors can still be prosecuted under existing obscenity statutes (Galbraith 2011: 90–1). In the UK the Coroners and Justice Act of 2009 has criminalized a wide number of images, including Japanese comic books and animated films that depict 'grossly offensive' images of fictional minors (Gillespie 2011: 163–75). In Australia the laws prohibiting child pornography and child abuse materials apply equally to photographs of actual minors and representations of fictitious persons.

In New South Wales child pornography is defined under Section 91H of the Crimes Amendment (Sexual Offences) Act 2008 as follows:

> [M]aterial that depicts or describes (or appears to depict or describe) in a manner that would in all the circumstances cause offence to reasonable persons, a person who is (or appears to be) a child:
> (a) engaged in sexual activity, or
> (b) in a sexual context, or
> (c) as the victim of torture, cruelty or physical abuse (whether or not in a sexual context).

Little sexual activity is depicted in Brown's art and none involves any person who appears to be a child. However, the question of whether he represents figures in a 'sexual context' is more difficult to establish. The depiction of genitalia or nakedness is not sufficient to create a sexual context in the legal sense, even if it does have the capacity to generate controversy. The importance given to 'sexual context' suggests an interest in controlling the interpretation of images as well as the

conditions of their production (Higonnet 1998: 106). This enables the criminalization of material that has the capacity to elicit sexual arousal, demanding a qualitatively distinct form of judgement from that focused on the depiction of sexual or abusive activities. What constitutes 'torture, cruelty and physical abuse' is also unclear and often predicated on a failure to distinguish between concepts like interrogation/torture, surgery/cruelty and discipline/physical abuse. Force is ambiguous; it demands an emotional response but the emotion that is elicited depends on the context in which the force is applied. The ambiguous qualities of violence recur throughout Brown's work.

Australian legislation makes clear that child pornography need not concern the depiction of an actual child as demonstrated in McEwan v Simmons & Anor, an appeal that was heard before the New South Wales Supreme Court in 2008. The appellant, Alan McEwen, attempted to overturn his conviction for possessing child pornography on the grounds that the material in question, which depicted characters from The Simpsons engaged in sexually explicit activity, did not depict but merely symbolized a child. Although the court acknowledged that 'the figures make no pretence of imitating any actual or, for that matter, fictional human beings', the images were covered by the legislation simply because they were figures. Whilst Justice Adams agreed that the distinction between the depiction of real and imaginary persons was 'profound', 'real and fundamental', he maintained that the legislation dictated that possession of either kind was a criminal offence. The decision to uphold this conviction has several important implications. Representations of minors, irrespective of whether they are the likeness of an actual person, are given a privileged status within legislation. In contrast to the lack of convictions in the art photography scandals I have described, the decision also indicates the value conferred upon material when a court recognizes artistic merit.

Mark McLelland (2012) has proposed that the expansion of existing regulations is evidence of the 'juridification of the imagination', the application of formal law to increasing facets of social interaction. The expansion of child pornography and child abuse material legislation is evidence of this, multiplying the kinds of material that are covered under these regulations and the kinds of contact with this material that constitute criminal activity. The Australia Council for the Arts' 'Protocols for Working with Children in Art', established after the 2008 controversy about Bill Henson's photography, is part of a growing trend of institutions establishing formal guidelines about images of children.[5] These have been established despite a lack of evidence of any abuse

occurring between artists and their subjects, functioning instead as a pre-emptive filter to determine what kinds of creativity and sentiments belong in art.

Current legislation resembles a marriage of 'reason and nightmare' (Ballard 1995: 4). It appears reasonable that society should try to ensure that exploitation is prevented and to punish individuals who incite or commit exploitative acts. But reason is imbued with a nightmarish tone when individuals are punished without inciting or committing such action. In the conviction against McEwan it is unclear who has been exploited. Rather than being a crime 'against all children' (Quayle et al. 2008: 20) it may be that this material has an effect upon the image of childhood. This is symptomatic of a neurotic approach to images and concepts. Sigmund Freud (1950: 35) argued that the nucleus of neurosis is a prohibition against touching and that anything that 'directs the patient's thoughts to the forbidden object, anything that brings him into intellectual contact with it, is just as prohibited as direct physical contact'. The way people think about and represent children supplants concern about the physical contact that adults have with children. Society makes laws not just to prohibit particular activities, but to perish the thought of them.

Trevor Brown, participatory culture and entertainment

Brown's art has the capacity to provoke a kind of neurotic response from some viewers and Brown seems to take some pleasure in archiving these responses. In his zine, *TabooXII: The Internet Hates Me: A Litany of Lies, Libel and Illiteracy* (2008: 6–12), he reprints the following comments that have been made about him by his detractors:

> You have to be really sick in the head to find some of this dudes art the least bit enjoyable. This is meant to appeal to pedophilia. Do a search on him ... When you think of the images he creates, its almost nausiating to view it ... I can honestly say I think it is as sick as shit.
>
> I'd like to paint a black eye on Trevor Brown's face as an expression of my emotions towards his work ... I hope Mr. Brown gets an out and out ass whoopin.
>
> I really hope trevor brown is beaten with a nightstick or something.

Yet Brown also attracts the kind of fans who, according to Henry Jenkins (2006: 131), have a kind of 'fascination with fictional universes'

which 'often inspires new forms of cultural production'. Brown's fans create derivative 'tributes' that he posts on his blog.[6] Typically, they show young females dressed to resemble a girl from his publications or attempt a full photographic reproduction of one of his pieces. Others have created character and outfit designs that can be purchased and worn within the virtual environment, Second Life. The Hotel Dare, an online art collective, engage in digital recreations of Brown's fictional universe, presenting a world of *Li'l' Miss Sticky Kiss* nurses attending to little girls undergoing surgery, with Trevor Brown images displayed on the wall. This area is accessible as an interactive environment through Second Life, and one member of this collective subsequently developed an online video.

Brown's willingness to promote these adaptations of his work is suggestive of a desire to maintain a sense of fun between himself and his audience and symptomatic of the broader contemporary media environment where audiences assume the status of 'prosumer' (Ritzer and Jurgenson 2010). Yet while media participation expands the ways in which audiences can interact with content it is risky in this context; Brown's fans risk criminal charges that relate not only to the possession of child pornography, but to its production.

Brown's work is controversial first and foremost because of his depictions of what appear to be minors, but also because it presents his audience with a variety of images that modulate between playfulness, aggression, seduction, and malice – a bruised celebrity and a fairy expelling a glorious stream of urine, images of childbirth, arrangements of extracted teeth, and teddy bear doctors administering injections to dolls with symptoms of chicken pox. He 'muddies the distinctions between high and low, undermines "authentic" art, and blurs the lines between safe, mainstream taste publics and dangerous, deviant subcultures' (Feil 2009: 141). His work contaminates the boundaries between forms of images, developing an aesthetic that sits between the iconography of pornography, illustrations for children's books and medical images. Whilst this may account for his appeal to his fan base, it is also what makes it difficult for audiences who are not familiar with this kind of work to appreciate it.

Brown's art synthesizes the visual elements of fetish pornography, medical images and illustrations from children's books. Yet although these forms have distinct qualities there is already a degree of overlap in style and register between them. Pornography and medical photography are mutually invested in vivid, realistic, magnified representation. Their difference arises not from a visual distinction – both genres produce

images of naked bodies and extreme close ups of genitalia – but from their intention. Pornography and children's illustrated books share narrative similarities, tending to be episodic works that feature simple characters and emphasizing 'fun' with the intention of eliciting enjoyment. Despite apparent visual differences, both are forms of entertainment, and perhaps this is the most productive way of assessing Brown's aesthetics and his relationship with his fans.

Alan McKee (2011) proposes that entertainment is not 'failed art' but has its own aesthetic system characterized by vulgarity, story, seriality, adaptation, happy endings, interactivity, emotion and the qualities of being fast and loud, spectacular and fun. All of these are present to varying extents in Brown's work; most obviously vulgarity, interactivity and fun. Vulgarity relates to the status of an artifact in comparison with other markers of good and bad taste. Brown's art is vulgar because it celebrates ephemeral and disreputable aspects of culture. Brown actively encourages dialogue and is explicit in his intention to entertain his audience, enticing audience members to join in by producing artifacts that invite a degree of interaction and co-authorship. In 2003 to coincide with the publication of *Li'l Miss Sticky Kiss* he released a paper doll edition of his fictional heroine that allowed the reader to mix and match her school uniform, nurse's uniform, and rubber bondage outfits, while his limited edition of Trevor Brown's *Alice* includes a kit to make a pop-up book. Brown has described his career as skating on 'thin ice for your delight or derision' (Liddell 2009), a description that conveys the sense that his work is about fun, about enjoying the sound of the cheers and the jeers as he skates towards ice that appears increasingly frangible.

Conclusion

Part of the problem with child pornography legislation in its current forms is that it privileges representation over the material realities of child sexual abuse (Ost 2009; Williams 2004). Furthermore, concern about the welfare of children is used to justify the prohibition of a range of materials that bear the most tenuous of links to this (Attwood and Smith 2010: 186). The law is unable to inhibit a perverse gaze at innocuous images of children (Howitt 1995: 161–81; Taylor and Quayle 2003). Instead it incites viewers to deploy a 'pedophilic gaze' in the examination of representations of children (Adler 2001). Works of a controversial nature may be redeemed through the recognition of 'educational purpose' or 'artistic merit', but a 'hidden Law'

(Žižek 2005: 230–1) of representational value determines what kind of contexts can be judged educational and what qualities animate an object with artistic merit, ensuring that a universal definition of obscenity is always beyond reach.

Suzanne Ost (2009: 130) argues that 'there is a clear line between, on the one hand, real images that depict the actual sexual abuse of children or pseudo-images that harmfully exploit a real child and, on the other, completely fabricated images that do not cause harm to an actual child'. This investigation of Brown and his fan culture suggests that his images have a cultural value distinct from those exchanged within online pae-dophile subcultures (Jenkins 2001). The prohibition of purely fictional images is an attack on the imagination (Galbraith 2011) that 'fails to take account of people's real-life, organic forms of engagement with culture' (Lucy 2010: 36). This has no discernible power to address the complex array of problems that are related to the domestic and com-mercial sexual exploitation of minors, of which the production of child pornography is part (Jenkins 2001; Estes et al. 2005; Lanning 2005a, 2005b; Leth 2005; Wolak et al. 2005; O'Donnell and Milner 2007: 69–70). Legislators should reconsider the current trend towards prohibiting the representation of fictitious minors and the tendency to treat these representations as if they are animate and vulnerable, detracting atten-tion that could otherwise be expended in addressing the ways in which actual children can be nurtured and protected.

Notes

The author wishes to express his gratitude toward Des Clark, the director of the OFLC, Amy Wooding, the exemptions officer who supervised his case, his solici-tors, the magistrates, Trevor Brown, and other parties who made this research possible.

1. In 1995 the film academic, Mikita Brottman, had video cassettes of two films – *Cannibal Holocaust* (Ruggero Deodato, 1980) and *Faces of Death* (John Alan Schwartz, 1978) seized by Customs. A statement detailing her research, a confirmation from her head of department and assurances that her materials would not be viewed by anyone else and only in a context related to the research project were required before her materials were returned (Kerekes and Slater 2011: 309–10). More disturbingly, in 2002 Bill Thompson and Andy Williams (2004: 113) had their computers, research data, drafts and teaching materials illegally seized by Thames Valley Police officers for a period of more than one year, as a result of a phone call that made an unsubstantiated claim that Thompson had been seen downloading child pornography. This resulted in erroneous media reports, an attack on the street, loss of research grants and other injustices. Both incidents are a sobering reminder of the tensions between academics and the law.

2. Affect has been theorized by Silvan Tomkins (2008) and developed by Donald Nathanson (1987, 1992). See the collection edited by Eve Sedgwick and Adam Frank (1995) *Shame and Its Sisters: A Silvan Tomkins Reader.*
3. As Tim Tate notes (1990), child pornography has been circulated via the Internet since the 1980s.
4. http://www.theage.com.au/entertainment/art-and-design/photo-withdrawn-after-child-prostitution-claim-20110821-1j4td.html, date accessed 24 February 2012.
5. http://www.australiacouncil.gov.au/__data/assets/pdf_file/0016/44314/Working_with_children_in_art_protocols_May_2010.pdf, date accessed 24 February 2012.
6. Examples can be found at http://www.pileup.com/babyart/blog/, date accessed 24 February 2012.

References

Adler, A. (2001) 'The Perverse Law of Child Pornography', *Columbia Law Review*, 209, 1–87.

Allison, A. (2006) *Millenial Monsters: Japanese Toys and the Global Imagination* (Berkeley: University of California Press).

Ashcraft, B. with S. Ueda (2010) *Japanese Schoolgirl Confidential: How Teenage Girls Made a Nation Cool* (Tokyo: Kodansha International Ltd).

Attwood, F. (2006) 'Sexed up: Theorizing the Sexualization of Culture', *Sexualities*, 9, no. 1, 77–94.

Attwood, F. and Smith, C. (2010) 'Extreme Concern: Regulating 'Dangerous Images' in the United Kingdom', *Journal of Law and Society*, 37, no. 1, 171–88.

Ballard, J. G. (1995) *Crash* (London: Vintage).

Bernhart, A. and T. Brown (2001) *Rope, Rapture & Bloodshed* (Bologna: Mondo Bizarro Press).

Brown, T. (2001) *Forbidden Fruit* (Tokyo: Pan Exotica).

Brown, T. (2001) *Medical Fun* (Tokyo: Pan Exotica).

Brown, T. (2004) *Li'l Miss Sticky Kiss* (Tokyo: Pan Exotica).

Brown, T. (2008) 'The Internet Hates Me: A Litany of Lies, Libel and Illiteracy', *Taboo*, 12, 1–100.

Brown, T. (2010) *Trevor Brown's Alice* (Tokyo: Pan Exotica).

Derrida, J. (1988) *Limited Inc* trans. S. Weber (Evanston: Northwestern University Press).

Eck, B. (2001) 'Nudity and Framing: Classifying Art, Pornography, Information, and Ambiguity', *Sociological Forum*, 16, no. 4, 603–32.

Estes, R. J, E. Azaola and Ives, N. (2005) 'The Commercial Sexual Exploitation of Children in North America' in S. W. Cooper, R. J. Estes, A. P. Giardino, N. D. Kellogg and V. I. Vieth (eds) *Medical, Legal, and Social Science Aspects of Child Sexual Exploitation: A Comprehensive Review of Pornography, Prostitution and Internet Crimes Volume One* (St Louis: G. W. Medical Publishing Inc).

Feil, K. (2009) '"Talk about Bad Taste": Camp, Cult, and the Reception of *What's New Pussycat?*' in J. Staiger and S. Hake (eds) *Convergence Media History* (New York and London: Routledge).

Freud, S. (1950) *Totem and Taboo: Some Points of Agreement between the Mental Lives of Savages and Neurotics* trans. J. Strachey (London and New York: Routledge).

Galbraith, P. (2011) 'Lolicon: The Reality of "Virtual Child Pornography" in Japan', *Image & Narrative* 12, no. 1, 83–114.

Gillespie, A. A. (2011) *Child Pornography: Law and Policy* (Abingdon: Routledge).

Higonnet, A. (1998) *Pictures of Innocence: The History and Crisis of Ideal Childhood* (New York: Thames and Hudson).

Howitt, D. (1995) *Paedophiles and Sexual Offences Against Children* (West Sussex: John Wiley and Sons).

Jenkins, H. (2006) *Convergence Culture: Where Old and New Media Collide* (New York and London: New York University Press).

Jenkins, P. (2001) *Beyond Tolerance: Child Pornography on the Internet* (New York and London: New York University Press).

Julius, A. (2002) *Transgressions: The Offences of Art* (Chicago: University of Chicago Press).

Kammen, M. (2006) *Visual Shock: A History of Art Controversies in American Culture* (New York: Vintage Books).

Kerekes, D. and Slater, D. (2001) *See No Evil: Banned Films and Video Controversy* (Manchester: Critical Vision).

Lange, B. (2008) 'The Emotional Dimension in Legal Regulation' in M. Greco and P. Stenner (eds) *Emotions: A Social Science Reader* (London and New York: Routledge).

Lanning, K. (2005a) 'Acquaintance Child Molesters: A Behavioral Analysis' in S. W. Cooper, R. J. Estes, A. P. Giardino, N. D. Kellogg and V. I. Vieth (eds) *Medical, Legal, and Social Science Aspects of Child Sexual Exploitation: A Comprehensive Review of Pornography, Prostitution and Internet Crimes Volume Two* (St Louis: G.W. Medical Publishing Inc).

Lanning, K. (2005b) 'Compliant Child Victims: Confronting an Uncomfortable Reality' in E. Quayle and M. Taylor (eds) *Viewing Child Pornography on the Internet* (Dorset: Russell House Publishing).

Leth, I. (2005) 'Child Sexual Exploitation from a Global Perspective' in S.W. Cooper, R.J. Estes, A. P. Giardino, N. D. Kellogg and V. I. Vieth (eds) *Medical, Legal, and Social Science Aspects of Child Sexual Exploitation: A Comprehensive Review of Pornography, Prostitution and Internet Crimes Volume One* (St Louis: G. W. Medical Publishing Inc).

Lucy, N. (2010) *Pomo Oz: Fear and Loathing Downunder* (Freemantle: Freemantle Press).

Liddell, C. B. (2009) 'Is there more to Controversial Art of Trevor Brown than Meets the Eye?', *Japan Today*, http://www.japantoday.com/category/arts-culture/view/is-there-more-to-controversial-art-of-trevor-brown-than-meets-the-eye, date accessed 6 November 2011.

Marr, D. (2008) *The Henson Case* (Melbourne: Text Publishing).

McKee, A. (2011) 'The Aesthetic System of Entertainment' in A. McKee, C. Collis and B. Hamley (eds) *Entertainment Industries: Entertainment as a Cultural System* (Abingdon: Routledge).

McLelland, M. (2012) 'Australia's "Child-Abuse Materials" Legislation, Internet Regulation and the Juridification of the Imagination', *International Journal of Cultural Studies*, 15, no. 5, 467–483.

Miller, W. I. (1997) The Anatomy of Disgust (Cambridge and London: Harvard University Press).

Mohr, R. D. (2004) 'The Pedophilia of Everyday Life' in S. Bruhm and N. Hurley (eds) *Curiouser: On the Queerness of Children* (Minneapolis and London: University of Minnesota Press).

Nabokov, V. (1955) *Lolita* (London: Penguin Books).

Nathanson, D. (ed) (1987) *The Many Faces of Shame* (New York and London: The Guilford Press).

Nathanson, D. (1992) *Shame and Pride: Affect, Sex, and the Birth of the Self* (New York and London: W.W. Norton and Company).

O'Donnell, I. and Milner, C. (2007) *Child Pornography: Crime, Computers and Society* (Devon: Willan Publishing).

Ost, S. (2009) *Child Pornography and Sexual Grooming: Legal and Societal Responses* (Cambridge: Cambridge University Press).

O'Toole, L. (1999) *Pornocopia: Porn, Sex, Technology and Desire* (London: Serpent's Tail).

Powell, L. (2010) *Framing Innocence: A Mother's Photographs, A Prosecutor's Zeal, and a Small Town's Response* (New York: The New Press).

Quayle, E., Loof, L. and Palmer, T. (2008) *Child Pornography and Sexual Exploitation of Children Online*, ECPAT, http://www.ecpat.net/WorldCongressIII/PDF/Publications/ICT_Psychosocial/Thematic_Paper_ICTPsy_ENG.pdf, date accessed 28 December 2010.

Ritzer, G. and Jurgenson, N. (2010) 'Production, Consumption, Prosumption: The Nature of Capitalism in the Age of the Digital "Prosumer"', *Journal of Consumer Culture*, 10, no. 1, 13–36.

Robertson, A. F. (2004) *Life Like Dolls: The Collector Doll Phenomenon and the Lives of the Women who Love them* (New York and London: Routledge).

Sedgwick, E. and Frank, A. (eds) (1995) *Shame and its Sisters: A Silvan Tomkins Reader* (Durham: Duke University Press).

Tate, T. (1990) *Child Pornography: An Investigation* (London: Methuen).

Taylor, M. and Quayle, E. (2003) *Child Pornography: An Internet Crime* (East Sussex: Brunner-Routledge).

Thompson, B. and Williams, A. (2004) 'Virtual Offenders: The Other Side of Internet Allegations' in M. C. Calder (ed) *Child Sexual Abuse and the Internet: Tackling the New Frontier* (Dorset: Russell House Publishing).

Tomkins, S. S. (2008) *Affect, Imagery, Consciousness: The Complete Edition* (New York: Springer Publishing Company).

Williams, K.S. (2004) 'Child Pornography Law: Does It Protect Children?' *Journal of Social Welfare and Family Law*, 26, no. 3, 245–61.

Wolak, J., Finkelhor, D. and Mitchell, K. J. (2005) in E. Quayle and M. Taylor (eds) *Viewing Child Pornography on the Internet* (Dorset: Russell House Publishing).

Žižek, S. (2005) *Interrogating the Real* (London and New York: Continuum).

8
'The Following Content is Not Acceptable'

Julian Petley

It is frequently assumed that the British Board of Film Classification (BBFC) cuts very few films and DVDs at '18' and 'R18'. Indeed, this is the impression given by the board itself, which states that 'adults should, as far as possible, be free to choose what they see, provided that it remains within the law and is not potentially harmful' (BBFC 2009a: 4) and that 'in line with the consistent findings of the BBFC's public consultations and the Human Rights Act 1998, at "18" the BBFC's guideline concerns will not normally override the principle that adults should be free to choose their own entertainment' (BBFC 2009a: 29). However, as the following table demonstrates, a good deal of censorship actually takes place at '18' and 'R18'.

Compare this with the cuts made in the other DVD classification categories in the most recent year for which figures are available, namely 2009.

In June 2009 the BBFC released new guidelines, which list the kinds of material most liable to cuts at '18' and 'R18', namely:

- Material which may promote illegal activity.
- Material which is obscene or otherwise illegal.
- Material created by means of the commission of a criminal offence.
- Portrayals of children in a sexualized or abusive context.
- Sexual violence or sexualized violence which endorses or eroticizes the behaviour.
- Sadistic violence or torture which invites the viewer to identify with the perpetrator in a way which raises a risk of harm.
- Graphic images of real injury, violence or death presented in a salacious or sensationalist manner which risks harm by encouraging callous or sadistic attitudes.
- Sex works which contain material listed as unacceptable at 'R18'.

(BBFC 2009a: 33)

Table 8.1 Total numbers of DVDs submitted in adults-only categories 2000–9

	2000	2001	2002	2003	2004	2005	2006	2007	2008	2009
18'	879	958	879	832	870	1048	1031	950	904	660
	(110)	(167)	(106)	(112)	(132)	(200)	(262)	(206)	(129)	(96)
	(12.5)	(17.4)	(12.1)	(13.4)	(15.1)	(19.1)	(25.4)	(21.7)	(14.3)	(14.5)
R18'	211	651	1061	1401	1387	1231	1217	1159	897	862
	(28)	(45)	(163)	(259)	(286)	(287)	(293)	(314)	(245)	(208)
	(13.2)	(6.9)	(15.3)	(18.5)	(20.6)	(23.3)	(24.1)	(27.1)	(27.3)	(24.1)
Rejected	4	1	2	3	2	7	1	1	2	3

Note: Numbers and percentages cut in brackets.
Source: BBFC Annual Reports.

Table 8.2 DVDs submitted in non-adult categories in 2009

Category	DVDs submitted	DVDs cut
U	1450	12 (0.8)
PG	2219	9 (0.4)
12	2453	2 (0.08)
15	2416	14 (0.6)

Source: BBFC *Annual Report* 2009.

With a few exceptions, such as *Idioterne/The Idiots* (Lars von Trier, 1998), *Intimacy* (Patrice Chéreau, 2001) and *9 Songs* (Michael Winterbottom, 2004), scenes of unsimulated sex are forbidden at '18'. Films 'whose primary purpose is sexual arousal or stimulation' are defined by the BBFC as 'sex works', and if these contain 'clear images of real sex, strong fetish material, sexually explicit animated images, or other very strong sexual images' (BBFC 2009a: 14) they will either be cut to remove the offending images or will be confined to the 'R18' category, unless the images can be 'justified by context' (BBFC 2009a: 29). 'R18' DVDs may be sold only in licensed sex shops or, in the case of films, shown only in specially licensed cinemas, which only the over 18s may enter. 'R18' DVDs cannot be supplied legally via mail order, because the Postal Services Act 2000 prohibits the posting of 'any indecent or obscene print, painting, photograph, lithograph, engraving, cinematograph film, book and written communication'.

However, by no means anything goes at 'R18', where 'the following content is not acceptable':

- Any material which is in breach of the criminal law, including material judged to be obscene under the current interpretation of the Obscene Publications Act 1989.
- Material (including dialogue) likely to encourage an interest in abusive sexual activity (for example, paedophilia, incest or rape) which may include adults role-playing as non-adults.
- The portrayal of any sexual activity which involves lack of consent (whether real or simulated). Any form of physical restraint which prevents participants from indicating a withdrawal of consent.
- The infliction of pain or acts which may cause lasting physical harm, whether real or (in a sexual context) simulated. Some allowance may be made for moderate, non-abusive consensual activity.
- Penetration by an object associated with violence or likely to cause physical harm.
- Any sexual threats, humiliation or abuse which does not form part of a clearly consenting role-playing game. Strong physical or verbal abuse, even if consensual, is unlikely to be acceptable.

(BBFC 2009a: 31)

Elsewhere the BBFC has explained that over half of the cuts which it makes at R18 'are to remove abusive and or injurious acts which, if copied could be harmful. This includes non violent sexual penetration with objects that could lead to injury or death and most instances of non violent erotic asphyxia ("breath play")' (BBFC 2007: n.p.).

The legal framework

As the above makes clear, the board must not pass anything which could be considered illegal, and thus must take account not only of the relevant laws but also how these are enforced by the Crown Prosecution Service (CPS) and the police, and how they are interpreted by the courts. Those which are particularly relevant to the '18' and 'R18' categories are the Offences against the Person Act 1861, the Obscene Publications Act 1959 and 1964, the Video Recordings Act 1984, the Criminal Justice and Immigration Act 2008, and a considerable battery of child protection legislation.

As noted above, the BBFC states that it cuts or bans 'material which is obscene', although what the board should say is that it cuts or bans

material which the CPS and the police think likely to be found obscene by a court. According to the Obscene Publications Act (OPA), an article is obscene if its effect is, 'if taken as a whole, such as to tend to deprave and corrupt persons who are likely, having regard to all relevant circumstances, to read, see or hear the matter contained or embodied in it'. Moral campaigners have repeatedly but vainly tried to introduce a 'laundry list' of obscene words and images into the OPA, but the police and the CPS generally confine their efforts to pursuing only material which they think juries or magistrates will find guilty. However, in order to help the BBFC in its deliberations, the CPS has actually provided it with a 'laundry list' consisting of the categories of material most commonly prosecuted under the OPA. These are:[1]

- Sexual act with an animal.
- Realistic portrayals of rape.
- Sadomasochistic material which goes beyond trifling and transient infliction of injury.
- Torture with instruments.
- Bondage (especially where gags are used with no apparent means of withdrawing consent).
- Dismemberment or graphic mutilation.
- Activities involving perversion or degradation (such as drinking urine, urination or vomiting onto the body, or excretion or use of excreta).
- Fisting.

As I have explained elsewhere (Petley 2011), if the police seize material which they believe to be contravening the OPA, the CPS must decide whether to prosecute for a criminal offence under Section 2 of the act or to opt for a civil forfeiture under Section 3. Section 2 cases can be heard either by magistrates or by a judge and jury, but if a defendant requests the latter, as is their right, they risk a tougher sentence if found guilty. If the CPS opts for a Section 3 prosecution, the material is brought before magistrates who can either release it or issue a summons for its forfeiture. In the latter case, any interested party can contest the summons (but very rarely does, mainly for fear of alerting the local press to their activities). This is, in fact, simply a quick and convenient (for the authorities, that is) form of local censorship carried out by police who know perfectly well that the material might not be convicted by a jury, and by magistrates who may not be qualified to judge it. However, although Section 3 cases heard by magistrates do not set precedents

in any broader legal sense (as do judgements handed down in crown courts) they do in fact have wider ramifications – because they constitute one of the factors which effectively limit what the BBFC feels able to pass at 'R18'.

The BBFC has to take into account such a superannuated and anachronistic piece of legislation as the Offences against the Person Act because of the infamous 'Spanner' case, which was occasioned in 1987 when the police discovered what they naively but entirely typically believed to be a 'snuff' video. They eventually discovered that it was actually a record of several gay men involved in heavy, but consensual, SM activity. And there the matter should have stopped. But, whether motivated by outraged moral rectitude or the desire to have something to show for the £4m which the investigation allegedly cost, the police and prosecuting authorities insisted on proceeding with charges of assault occasioning actual bodily harm. And, in a quite extraordinary judgement in 1990, Judge Rant ruled that, under the Offences Against the Person Act, BDSM activity provides no exception to the rule that consent is no defence to a charge of assault occasioning actual bodily harm or causing grievous bodily harm, if the injuries are more than 'trifling and transient' – which exact wording appears in the CPS 'laundry list' cited above, and which very clearly limits the kind of BDSM imagery which the board can pass at 'R18'.

More recently, and clearly building on the precedent set by the Spanner judgement, the Criminal Justice and Immigration Act made it illegal even to possess what it defines as 'extreme pornography'. As the BBFC *Annual Report* 2008 explains:

> In order for a work to be in breach of this legislation it must be pornographic – i.e. having been produced solely or principally for the purpose of sexual arousal – be obscene and, in an explicit and realistic way, portray either an act which threatens a person's life; an act which results, or is likely to result, in serious injury to a person's anus, breast or genitals; an act which involves sexual interference with a human corpse; or a person performing an act of intercourse or oral sex with an animal (whether dead or alive).
>
> (BBFC 2009b: 101)

However, deeply problematic though this offence may be (see Petley 2009), it is highly unlikely, given the board's extremely strict guidelines on 'R18' material, that it would ever have passed imagery such as this even before the act came into being.

The concept of 'harm', invoked repeatedly in the bullet points above, refers to the provisions of the Video Recordings Act which, as amended in 1994, states that the BBFC, when classifying DVDs, must have 'special regard (among the other relevant factors) to any harm that may be caused to potential viewers or, through their behaviour, to society by the manner in which the work deals with – (a) criminal behaviour; (b) illegal drugs; (c) violent behaviour or incidents; (d) horrific behaviour or incidents; or (e) human sexual activity'. The BBFC guidelines expand on this provision so as to include any 'harm to public health or morals' which might be caused by a DVD's treatment of any of these subjects, and also add that harm

> includes not just any harm that may result from the behaviour of potential viewers, but also any 'moral harm' that may be caused by, for example, desensitising a potential viewer to the effects of violence, degrading a potential viewer's sense of empathy, encouraging a dehumanised view of others, suppressing pro-social attitudes, encouraging anti-social attitudes, reinforcing unhealthy fantasies, or eroding a sense of moral responsibility.
>
> (BBFC 2009a: 4)

The board also makes clear that it regards as harmful 'portrayals of sexual or sexualised violence which might, for example, eroticise or endorse sexual assault' (BBFC 2009a: 29) and warns that 'any association of sex with non-consensual restraint, pain or humiliation may be cut' (BBFC 2009a: 15). Such representations are particularly likely to be cut on DVD 'because of the potential for replaying scenes out of context' (BBFC 2009a: 15).

The Protection of Children Act 1978, as amended by the Criminal Justice and Public Order Act 1994, states that 'it is an offence for a person to take, or permit to be taken, or to make any indecent photograph or pseudo-photograph of a child; or to distribute or show such indecent photographs or pseudo-photographs; or to possess such indecent photographs or pseudo-photographs, with a view to their being distributed or shown by himself or others'. 'Make' includes downloading images from the Internet and storing or printing them out. It was further amended by the Sexual Offences Act 2003 to raise from 16 to 18 the age at which a person is considered a child for the purposes of the act, and amended yet again by the Criminal Justice and Immigration Act so as to define indecent photographs of a child to include (a) a tracing or other image, whether made by electronic or other means (i) which is

not itself a photograph or pseudo-photograph, but (ii) which is derived from the whole or part of a photograph or pseudo-photograph; and (b) data stored on a computer disc or by other electronic means which is capable of conversion into an image of a kind which falls within the ambit of the act.

Indecent images of children are classified by reference to the UK Sentencing Guidelines Council which has established five levels of seriousness for sentencing purposes in child abuse cases. These are:

- Level 1. Images depicting erotic posing with no sexual activity.
- Level 2. Non-penetrative sexual activity between children, or solo masturbation by a child.
- Level 3. Non-penetrative sexual activity between adults and children.
- Level 4. Penetrative sexual activity involving a child or children, or both children and adults.
- Level 5. Sadism or penetration by an animal.

It does of course need to be made clear that the BBFC would never dream of passing images above level one, but the vague, catch-all nature of that level has led to its being (ab)used by the police against parents who have photographed their children naked and against galleries which have displayed photographs by Robert Mapplethorpe, Sally Mann and Tierney Gearon, and this must at the very least give the board pause for thought.

2009 saw the passing of the Coroners and Justice Act, sections 62 to 68 of which criminalize possession of what the act calls a 'prohibited image of a child'. The purpose of creating this offence was to close a loophole in the already considerable battery of child protection legislation by making it possible to target non-photographic images of children. Thus it was made a criminal offence to possess non-photographic images of children which are pornographic, 'grossly offensive, disgusting or otherwise of an obscene character' and which focus on a child's genitals or anal region, or portray a range of sexual acts 'with or in the presence of a child'. This, of course, catches cartoon/graphic imagery. Prior to this, although not explicitly in the statutes, the law had been interpreted to apply to cartoon/graphic images, but only where these were realistic and indistinguishable from photographs. Now the law covers all such images of children, whether realistic or not. One of the genres of graphic imagery which this captures is *lolicon* manga or *lolicon* anime, in which childlike female characters are often depicted in an erotic manner and a style resembling *shōjo* manga (girls' comics). As already noted,

the law defines a child as a person under the age of 18, but the Coroners and Justice Act adds that 'where an image shows a person, the image is to be treated as an image of a child if – (a) the impression conveyed by the image is that the person shown is a child, or (b) the predominant impression conveyed is that the person shown is a child despite the fact that some of the physical characteristics shown are not those of a child'. And in order to close any further loopholes, the act states that 'references to an image of a child include references to an image of an imaginary child'. This measure, too, must give the board cause for caution when considering certain kinds of Japanese animation.

BBFC research

The BBFC carries out research to aid its deliberations. For example, in 2006 it undertook research into teen references at 'R18', consulting mental health and legal specialists with professional experience in the field of sexual abuse of the young. They were shown extracts from DVDs involving children, and asked their opinion about the likely harm to a potential sexual offender and to an average person from viewing these works. The majority agreed that the latter would be unlikely to believe that sex with minors is a good thing, still less to develop a desire to have sex with minors. Potential sex offenders, however, were felt to be at risk of harm from material which 'to them, legitimises their pro-offending attitudes', scenarios which 'accurately depicted typical children's responses to abuse or which accurately depicted successful grooming or coercive abuser techniques and dialogue', and 'scenes which utilised signifiers associated with childhood and innocence in a hard core, adult sexual context' (BBFC 2006a: n.p.).

In the same year the BBFC undertook research into how sex DVDs are used in Britain, analysing the 525 questionnaire responses which they received from consumers of this kind of material. For the purposes of this chapter, the most significant findings were that

> 51 per cent of respondents had tried something new once after viewing a sex DVD, five per cent had sometimes done so, and five per cent often did so. The most frequent new activities tried out as a result of watching a sex DVD were new positions (23 per cent), followed by anal sex (seven per cent) and bondage (six per cent) (BBFC 2006b: 6). Only five per cent of respondents said that they had been harmed as a result of copying activities seen in a DVD (2006b: 7). 59 per cent of respondents said that certain activities are unacceptable

in a sex DVD, with 32 per cent disagreeing. In the former category, 63 per cent cited under-age or apparently under-age performers, 43 per cent bestiality, 28 per cent coercive or non-consensual sex, and 28 per cent violence, injury and pain.

(BBFC 2006b: 7)

In 2007 the BBFC published its report *Violence and Abuse in 'R18' Level Pornography*, the result of a consultation with forensic psychiatrists, forensic psychologists, criminal defence barristers and sociologists. The board admitted that 'it is very difficult to establish, from the published academic research, how harmful abusive pornography might be' (BBFC 2007: n.p.), but as a result of watching a number of extracts containing various kinds and degrees of abusive material, the panel members were

> extremely concerned about the potential for harm should anyone copy the erotic or aggressive asphyxiation or airway restriction as well as the possibility of drowning. Anything which, if copied, could lead to severe injury, or even death, was considered potentially harmful for any audience. ... Where there was felt to be a high potential for harm or potential for very serious harm from the acts of concern, this over-rode the performers' apparent consent; whether explicit on screen consent or implicit consent, implied by the presence on camera. This is backed up by the law [the Offences Against the Person Act] where it is not possible for an individual to consent to a physical assault.
>
> (BBFC 2007)

Concern was also expressed about the harmful effects on under age viewers (who, of course, shouldn't be watching 'R18' DVDs) being exposed to material involving degradation and humiliation, which could be seen as legitimizing offending behaviour, and, in particular, scenes in which women are referred to as sluts or whores, or where there are extreme power imbalances between male directors or performers and female performers. It was felt that such material 'promotes many myths regarding female sexuality which might be very harmful' and that 'many of the clips turned women (and men) into objects with holes to be done to, and with, and this could be harmful developmentally' (BBFC 2007). The BBFC thus concluded that its 'policy of cutting this extreme material is supported by the views of the experts consulted' (BBFC 2007).

Now that we have explained the board's guidelines at '18' and 'R18', along with the research and the legal requirements underpinning them,

let us examine how these actually impacted on the board's activities in 2009 and 2010.

Cuts at '18' in 2009 and 2010

In 2010 the BBFC made 17 cuts totalling 43 seconds to the remake of *I Spit on Your Grave* (Steven R. Monroe, 2010). This was

> in order to remove elements that tend to eroticise sexual assault (for example, through the use of nudity), as well as other elements that tend to endorse sexual assault (for example, by encouraging viewer complicity by the use of camcorder footage, filmed by the rapists, during the various scenes of sexual assault) ... In the cut version, the rape scenes feature only incidental nudity and are played largely off facial reactions.

> (http://www.bbfc.co.uk/BFF271143)

The cuts made to the cinema and DVD releases were identical. It's also worth noting that Meir Zarchi's original 1978 version had two minutes 54 seconds cut from it the last time it passed through the BBFC (in 2010), although when it was first submitted (in 2001) it was cut by seven minutes two seconds.

Even more heavily cut was *Srpski Film/A Serbian Film* (Srdan Spasojevic, 2010), which suffered 49 cuts across 11 scenes; these amounted to four minutes 11 seconds in the cinema version, and four minutes 12 seconds on the DVD. Again, these were to 'remove elements of sexual violence that tend to eroticise or endorse sexual violence. Further cuts were required to scenes in which images of children are intercut with images of adult sexual activity and sexual violence', even though the BBFC stresses that 'the film makers took precautions to avoid the exposure of the young actors to the film's most disturbing scenes and that, in the BBFC's view, no scene is in clear breach of the Protection of Children Act 1978'. Similarly, in the scene involving the rape of a new born baby, the action in the cut version occurs entirely off-screen, in spite of the BBFC admitting that 'the film makers used a prosthetic model during the filming of this scene and that no real baby was harmed'. The BBFC took particular exception to the scenes in which the central character, Milos, a porn actor who has been tempted out of retirement, is drugged and forced to commit various on-camera atrocities. These include decapitating a restrained woman during sex and raping his unconscious wife and son. According to the BBFC, the cuts required 'removed the

more explicit moments from these scenes and much of the action is now brief or implied rather than explicitly depicted'. The cuts in scenes involving children were required to

> remove shots which imply that children are witnessing sexual violence, sometimes enthusiastically, or where images of children are intercut with images of sexual activity and sexual violence. This includes a scene in which images of a young girl sucking a lolly are intercut with a scene of fellatio, a scene in which the same young girl appears to lean forward excitedly as she witnesses a scene of violent fellatio, and a scene in which Milos' brother is fellated by a woman whilst watching a family video, featuring his young nephew. All such intercutting has been removed from these scenes. In another scene, Vukmir [the fictional director in the film] attempts to persuade Milos to have a sex with an under-aged girl. Although Milos refuses, cuts were required to remove shots in which the young girl appears to be encouraging Milos to have sex with her. In spite of the fact that care was taken by the film makers to avoid exposing any of the young actors to anything disturbing, violent or sexual, this juxtaposition of images of children with sexual and sexually violent material is a breach of BBFC policy and Guidelines.
>
> (http://www.bbfc.co.uk/AFV272236)

However, the vast majority of cuts made to '18'-rated DVDs during 2009 and 2010 were made to 'sex works' which the distributor did not wish to be given an 'R18' and thus relegated to sex shops. So, from a whole host of possible examples (around 90 in 2009 alone), *Hot Cougars 2* was cut by 27 seconds 'to remove sight of female participants touching liquid resembling semen to lips and tongue', *Hot Cougars* by four minutes 19 seconds 'to remove shots of clearly unsimulated sexual activity (vaginal and/or anal penetration by penis and finger, oral–genital contact during cunnilingus, genital-genital contact and masturbation)', *Dreaming of Straight Boys* by 59 seconds 'to remove scenes of explicit sexual detail (oral–genital contact, digital anal penetration and sight of liquid resembling semen on genitals')', and *Razzle DVD Volume 9* by 15 seconds 'to remove sight of explicit sexual detail (firm, vigorous and sustained masturbation)', and so on, and on.

But it is not simply modern-day 'sex works' with varying amounts of hardcore activity which the board refuses to pass uncut at '18', as illustrated by the recent fates of *Fantasm* (Richard Franklin, 1976) and *Fantasm Comes Again* (Colin Eggleston, 1977).[2] Indeed, the BBFC

stressed that these films would not be passed uncut even at 'R18', and even if the distributor was willing to accept such a classification (which it wasn't).

Fantasm is an Australian soft-core film in which Professor Jungenot A. Freud [*sic*] recounts a number of his female patients' sexual fantasies. One of these involves being raped, and the BBFC required all verbal references to and visual enactments of this fantasy to be cut, on the grounds of sexual violence. Among the six minutes 25 seconds of cuts in this particular episode were the words of Professor Freud to the effect that 'it's a cliché of male chauvinism that deep down every woman desires to be raped, a cliché most women are at pains to deny', all sight of the patient being forcibly stripped and raped and then caressing and kissing the rapist, and Professor Freud's judgement that 'the puritanical association of sex and guilt is very strong in this subject. The fantasy is devised so she can relieve herself of responsibility for the sexual pleasure'.

The BBFC also required cuts in a scene in which a mother fantasizes about her son coming home from military service and taking a bath with her. The one minute 32 seconds worth of cuts here included Professor Freud's remark that 'incestuous desires are probably dormant in all of us. The strong religious, moral and ethical taboos surrounding the subject make it ideal for harmless fantasising', the mother's admission that 'I'm a bit ashamed to admit this, but I have this reoccurring sexual daydream where I have sex with my son', her comment: 'Son, you're so dirty', the shot of a photograph signed 'To mother, all my love, Johnny', the line, 'Wash me, son', and Professor Freud's observation that 'most little girls between the ages of about two and six have these feelings towards their fathers or their brothers or even their favourite uncles. It is not healthy to block this out'. However, as cut by the BBFC, on the grounds that it constituted a 'sexually abusive scenario', the scene consists simply of Candy Samples having a bath with an anonymous young man.

As a result of being asked to make these cuts, the distributor, Marc Morris of Nucleus Films, wrote to the BBFC on 15 July 2010, asking them to reconsider their decision and pointing out that:

> We feel that making these cuts would render the film worthless to collectors of this type of 70s camp erotica. The film is easily available from Amazon UK via Australia, Denmark and the USA in an uncut version and once the fans hear that we have issued a cut version they will simply skip our disc and purchase an uncut import, thus ruining our chances of recouping our costs.

The reply from the board's senior examiner Craig Lapper on 26 July clarified its reasons for its decisions:

> In the case of the incest scene, the Board's Guidelines make it clear that 'material (including dialogue) likely to encourage an interest in sexually abusive activity (for example, paedophilia, incest or rape)' is unacceptable. By presenting incestuous sexual activity within an overtly eroticised context, and by suggesting in the surrounding dialogue that it is normal for people – including very young children – to have incestuous sexual fantasies, the scene breaches the Board's Guidelines and policy. With regard to the rape scene, the Board's Guidelines at '18' state that the Board may require cuts 'where material appears to the BBFC to risk harm to individuals or, through their behaviour, to society. … This may include portrayal of sexual or sexualised violence which might, for example, eroticise or endorse sexual assault'. The scene in *Fantasm* eroticises sexual violence through its use of nudity and other sexual detail and endorses sexual violence by suggesting that the victim thanks the attacker for the rape and then enjoys the subsequent rape.

Fantasm suffered eight minutes of cuts in all, and its distinctly inferior sequel, *Fantasm Comes Again*, two minutes 27 seconds. Here the scenario consists of a young journalist learning the ropes as a newspaper's sexual advice columnist. One of the stories recounted by readers is a rape at a drive-in, which was cut by 55 seconds on the grounds that it associated sex with violence, thus involving consent problems and a sexually abusive scenario. Another is a threesome involving the supposedly 16-year old 'Virginia', Candy Samples, and an older man. In spite of clutching a toy dog (which is anyway animated to would-be comic effect), Virginia actually looks a great deal older than 16, while the relationship between the characters is pretty unclear, but the BBFC insisted on cutting references to Virginia's age and any suggestions that the characters might be in some way related, on the grounds of discouraging 'an interest in underage sex' and of ameliorating a 'sexually abusive scenario'. 15 seconds were also cut from a distinctly soft-core orgy to remove the sight in the background of an actress carrying a teddy bear (which I didn't even notice until the BBFC cuts list drew my attention to it). Extracts from these scenes in the end credits were also cut.

Cuts at 'R18' in 2009 and 2010

As noted earlier, over half of the cuts which the BBFC makes at 'R18' (involving 208 DVDs in 2009 alone) are to remove acts which, if copied,

could cause injury. The rest are accounted for by sight of other sexual activities which the board regards as illegal. Thus, for example, *My Teenage Blog* was cut by one minute 1 second 'to remove sight of man causing woman to gag and choke during fellatio, or by forcing a dildo into her mouth', *Itty Bitty Titties* by six minutes 58 seconds 'to remove references to suffocation and breath restriction during sexual activity', *A Girls Wish* by 2 seconds 'to remove sight of throat holding during fellatio', and *Pantyhose Secrets of Lady Tiffany* by five minutes 19 seconds 'to remove sight of vaginal penetration with a long thin object which has the potential to cause physical harm, in this case a riding crop'. Verbal references to under-age sex caused *Lust for Young Busts* to be cut by 13 seconds and *That Dick is Huge* by 3 seconds. *Raw Man #2 – Bareback Bootcamp* was cut by 2 seconds 'to remove an illegal offer to supply R18 level works by mail order', and *Folsom Leather* was cut by one minute 22 seconds partly 'to remove onscreen text constituting an illegal offer to supply R18 material online'. Cuts in this were also required 'to remove sight of lubrication contaminated with faecal matter'.

As noted earlier, the CPS has warned the board that is likely to prosecute for obscenity works containing sight of urolagnia. This was a problem in, to take but two of many possible examples, *Cougar's Den 2*, which was cut by 13 seconds 'to remove sight of a woman urinating over a man's stomach and genitals and a woman urinating whilst simultaneously being masturbated', and also in *Tom Bois*, which lost one minute 25 seconds of similar material. However, the difficulties into which this prohibition can lead the board is nicely illustrated by the convolutions which followed its request in 2009 to the director Anna Span to cut from her DVD, *Women Love Porn*, what it claimed were images of urolagnia but which she insisted were images of female ejaculation. However the BBFC has never acknowledged the existence of such a phenomenon, thus, for example, cutting six minutes 12 seconds of such material out of Ben Dover's *British Cum Queens* (originally submitted as *British Squirt Queens*) in 2001. This had prompted Louise Achille and Catherine Wilkinson to proffer medical testimony on behalf of Feminists against Censorship that female ejaculation does indeed exist, and to argue that the board's cuts were discriminatory (since it permits the sight of male ejaculation) and represented suppression of 'the acknowledgement of the full range of sexual response which exists in women'.[3] In response, Craig Lapper, then the board's chief assistant (Policy), argued that the BBFC does not actually take a view on whether or not female ejaculation exists, although it does accept that this is a 'controversial and much-debated

area with a range of views being taken amongst medical professionals'. He continued:

> The Board is content that the pornographic tapes so far presented to us as examples of 'female ejaculation' are in fact nothing other than straightforward scenes of urination masquerading as 'female ejaculation'. This has been confirmed by a female sexual health expert who the Board has consulted on a range of issues relating to videos intended for the 'R18' category.
>
> Quite the opposite of attempting to confront the issue of female ejaculation in a reassuring, sympathetic or informative light, the tapes in question appear to be nothing more than a cynical attempt on the part of porn distributors to get around the constraints imposed on urolagnia in sex tapes by the current interpretation of the Obscene Publications Act. It is worth noting that the kind of material that the Board has been cutting is regularly sold as 'orolagnia' in other European countries (France, Germany, Netherlands, etc.) where there is no equivalent legal restriction on the use of urine in sex videos. Indeed, although videos featuring urolagnia are very much in evidence on the continent, videos purporting to show 'female ejaculation' seem to be invisible. Perhaps female ejaculation is less exciting (or profitable) to pornographers and their viewers than urination? Generally speaking sex videos of the type encountered at 'R18' neither seek to inform nor educate about female (or male) sexuality but merely offer graphic (and grossly distorted) views of sex for the arousal of viewers ...
>
> The Board remains open minded about the issue of female ejaculation but we have yet to be presented with any pornographic video that has convinced us – or our medical advisor – that it consists of anything other than an excuse to display scenes of urolagnia. Such scenes are regularly found obscene by juries in the UK and therefore cannot be classified.[4]

Span stood her ground, producing yet more scientific evidence, including the book *The Human Female Prostate* by Milan Zaviacic, a noted professor of pathology at Comenius University, Bratislava, an article by an evolutionary biologist from the *New Scientist* (Moalem 2009), and the medical analysis of a sample produced by the performer in question which certified that it was definitely not urine. After Span threatened to take the board to the Video Appeals Committee it eventually agreed to pass the disputed scenes at 'R18', although a spokeswoman for the

BBFC suggested that their position on this subject remained unchanged, stating that

> In this particular work, there was so little focus on urolagnia [*sic*], that the BBFC took legal advice and the advice was that taking the work as a whole there was no realistic prospect of a successful prosecution under the Obscene Publications Act, and therefore the BBFC passed the work. However, were the focus on urolagnia [*sic*] to be more significant in other works, they would require cuts.
>
> (Quoted in Ozimek 2009a)

Clearly this vexed issue is still unresolved, as BBFC Senior Examiner Murray Perkins suggests:

> The BBFC has a neutral position on the question of female ejaculation, because the medical evidence is ambiguous and mixed. It's not at all the case that the Board denies the existence of female ejaculation, but the evidence is not in any way clear enough for the BBFC to say that female ejaculation exists. Maybe it does and maybe it doesn't. But actually that's really not the point, because the enforcement agencies are not interested in this distinction as things stand. For them if it looks like urination then for the purposes of whether or not it might be judged to be obscene, it is urination. And we have to take that into account. It's not the Board's business to interpret the Obscene Publications Act – we have to follow the guidance which we're given by the enforcement agencies.[5]

Bans in 2009 and 2010

These days no cinema films are actually banned outright by the BBFC, but an examination of those few DVDs which met this fate in 2009 and 2010 clearly illustrates the kind of material which the BBFC regards as unacceptable and the reasons why it does so.

> One of these was *NF713*, which the *Annual Report* 2009 describes as an extended sequence in which a man tortures a woman psychologically, physically and sexually. The woman is bound and restrained throughout and the man in question tortures the woman to make her confess to crimes against an unnamed 'State'. But ultimately the aim is to break her down, make her fully compliant, and eradicate her individuality and make her the mere number of the title.
>
> (BBFC 2010: 57)

In the board's view:

> With the primary focus on the woman's naked, humiliated body together with the conventional BDSM aspects of the later part of the work, it is apparent that the primary purpose of *NF713* is sexual arousal or stimulation. It is within the BBFC's strict policy on sex works that material will not be passed if it depicts non-consensual sexual activity (whether real or simulated), the infliction of pain or physical harm (whether real or simulated), or sexual threats, humiliation or abuse that does not form part of a clearly consenting role-playing game. *NF713* focuses exclusively on these elements. In addition to the concerns raised under BBFC Guidelines and policy on sex works, the submission also breaches BBFC policy on sexual violence through its eroticisation of the torture of the woman.

However, the film was photographed by one of the world's leading erotic photographers, China Hamilton, and stars Niki Flynn, a leading BDSM model and actress whose autobiography *Dances with Werewolves* (2007) is a forthright account of her work in the BDSM world. Unsurprisingly, both were outraged by the ban, Flynn arguing that the BBFC had made the film 'sound far worse and more graphic than it actually is. Frankly, in the cut submitted to the BBFC there is very little actual abuse shown and the focus is mostly on the psychological aspects of interrogation and the resulting Stockholm Syndrome'. She also took issue with the board's view that the film's primary intent was to arouse the viewer sexually and that thus it was a 'sex work'.[6] Meanwhile Hamilton pointed out that 'the narrative echoes what was accepted with little difficulty in *Closet Land* [Radha Bharadwaj, 1991], which also included extreme images of torture. The only difference lies in the extent to which the victim remains fully clothed and the fact that the BBFC seem to equate nudity with sexual arousal' (quoted in Ozimek 2009b).

Also banned in 2009 was *My Daughter's a Cocksucker* in which young women engage in fellatio with masked men whom they address as 'Daddy'. According to the BBFC, 'in this work the dialogue encourages the male viewer to be aroused by, among other things, the idea of instructing and watching their daughter in the act of fellatio. This effect is potentially heightened by the implication that the daughter also finds this paternal interest arousing'. Thus the film was banned on the grounds that it was likely to encourage interest in sexually abusive behaviour, namely incest, and the BBFC also objected to scenes 'in which the female performers were made to gag and choke during

Figure 8.1 NF713, China Hamilton, 2009

fellatio while their heads were firmly held, causing evident discomfort' (BBFC 2010: 58).

> In 2010 *Lost in the Hood* was banned. The BBFC described it as a US sex work focussing exclusively on the abduction and rape of a number of men. In each scenario, we see the predatory male characters choose a victim who appears to have become 'lost in the hood' (i.e. a bad neighbourhood in the US). They then abduct their chosen victim and force him to engage in sexual acts with them against his will. Each scene places a strong emphasis on the non-consensual nature of the sex, with the victims pleading to be released, showing discomfort and making unsuccessful attempts to escape. Similarly, the perpetrators display a high level of physical and verbal aggression. By presenting the spectacle of sexual violence within the context of an explicit sex work, whose primary intention is to sexually arouse the viewer, *Lost in the Hood* has the effect of eroticising and endorsing sexual violence in a potentially harmful fashion.
>
> (http://www.bbfc.co.uk/AVV268063)

Moving away from 'sex works' to the sub-genre known as 'torture porn', the Japanese horror film *Grotesque* was banned in 2009 on the grounds

that it 'presents the audience with little more than an unrelenting, unremitting scenario of humiliation, brutality and sadism' and largely consists of scenes of 'sexual or sexualised violence which endorses or eroticises the behaviour, and sadistic violence or torture which invites the viewer to identify with the perpetrator in a way which raises a risk of harm' (BBFC 2010: 57–8). However, the press release announcing the ban usefully expands on the notion of harm with which the BBFC operates, noting that 'the Video Recordings Act makes it clear that harm is not to be interpreted narrowly as behavioural harm, but may also include more insidious risks, and the board follows this approach in having regard to, for instance, moral harm and possible desensitisation'.[7]

Conclusion

The preceding analysis has drawn attention to the main laws which the BBFC must take into consideration when classifying and censoring films, particularly on DVD. It has also demonstrated that the number of such laws has increased in recent years. What this analysis suggests is that the role of the state in the film and video censorship process goes far beyond the government designating the BBFC as the statutory authority for classifying DVDs under the terms of the Video Recordings Act, thus giving BBFC DVD certificates a statutory force which their cinema equivalents lack. By passing laws which directly relate to, inter alia, the contents of cinema films and DVDs, and by requiring the BBFC not to classify any material which infringes those laws, the government is heavily involved in the censorship process, albeit by proxy, as are those state apparatuses, namely the police, the CPS and the courts, which interpret and enforce those laws. In 1942 it was suggested to the then home secretary, Herbert Morrison that BBFC examiners should be appointed by a minister and made responsible to the Commons, to which he famously replied that he freely admitted that the BBFC represented a curious arrangement, but added that

> the British have a very great habit of making curious arrangements work very well, and this works. Frankly, I do not wish to be the Minister who has to answer Questions in the House as to whether particular films should or should not be censored. I think it would be dangerous for the Home Secretary to have direct powers himself in the matter.[8]

Precisely the same arrangement, which depends of course for its effectivity on the government exercising very considerable indirect powers over the processes of film and DVD censorship, continues to this day.

The other, but closely related, matter which this chapter has addressed is that of how the BBFC actually interprets the laws of which it has to take account, particularly when it comes to dealing with controversial images in the '18' and 'R18' categories. In the interests of fairness I have attempted to explain the board's policies and actions in its own words, but it now needs to be asked whether the ways in which the board acts in these matters go beyond the strict requirements of these various laws and into areas of taste and morality which some may consider should lie beyond its remit.

So, for example, should the BBFC routinely cut all scenes of unsimulated sex out of 'sex works' at '18'? After all, these are works to be sold or rented to adults only and there appears to be nothing in either the OPA or VRA which absolutely requires the board to take such a hard and fast line on this matter. The BBFC, as we have seen, argues that images of unsimulated sex may be passed at '18' if 'justified by context', but surely the context in which the vast majority of these images appear is precisely one which is designed to be little more than a vehicle for sexually arousing images, and so this is the context in which they should properly be judged.

Second, does the 'harm' provision of the VRA really require the board to be quite so literal-minded as to make decisions about whether certain sexual acts depicted in 'R18' DVDs might be physically injurious if copied by viewers? After all, as noted earlier, their own research shows that only five per cent of their respondents admitted to being harmed as a result of copying activities seen in an 'R18' DVD. Is this not a matter for health professionals, and is not the most sensible solution to follow the good practice of all responsible BDSM websites and to provide viewers with the relevant safe sex advice on both the DVD packaging and the disk itself? As matters currently stand, the laws relevant to BDSM material, allied with the board's strict interpretation of them, seem designed simply to encourage BDSM aficionados to seek out works which have not been classified by the BBFC. This of course explains why the authorities are seeking increasingly to criminalize even the possession of certain kinds of pornographic material.

Third, does the 'harm' provision of the VRA equally entitle the board to go to the opposite extreme and to cut or ban works based on what are essentially moral judgements of those works? Leaving aside the fundamental objection that the idea of films harming people is based on a hotly contested model of 'media effects', one does wonder if it is really any of the board's legitimate business if, as noted earlier, a film may, in its view, cause 'moral harm' by 'desensitising a potential viewer

to the effects of violence, degrading a potential viewer's sense of empathy, encouraging a dehumanised view of others, suppressing pro-social attitudes, encouraging anti-social attitudes, reinforcing unhealthy fantasies, or eroding a sense of moral responsibility' (BBFC 2009a: 4). Much of the imagery cut by the board may indeed sound unpleasant in one way or another, but if study of the media teaches us anything it is surely that merely showing, let alone mentioning, something by no means necessarily endorses or encourages it. It is at this point that sympathy with the board for having to ensure that batteries of laws which are not of its making are not breached may, for some, transmute into irritation with it for appearing to play the role of a latter-day Miss Prism who, in *The Importance of Being Earnest*, famously defined fiction as works in which the good end happily and the bad unhappily, or the cinematic equivalent of Thomas Bowdler, who, in re-writing Shakespeare's plays for nineteenth century bourgeois sensibilities, 'endeavored to remove everything that could give just offence to the religious and virtuous mind'.

Finally, in the matter of images of young people of 18 or under, one assumes that there would be general agreement with the proposition that it should indeed be illegal to make, distribute or possess images which are records of the commission of a criminal act, namely child sexual abuse, or which might be used for the purposes of 'grooming' a child to engage in such an act. However, it is very doubtful whether the worst examples of child abuse images are ever submitted to the BBFC in the first place, given that, for obvious reasons, these almost always circulate in secret, and although the BBFC is obviously right to be alert to material which might be used in 'grooming', it really is extremely difficult to see how any of the child-related material noted above, and in particular the dialogue cuts to *Lust for Young Busts* and the 'Virginia' episode of *Fantasm Comes Again*, could actually be read as encouraging or endorsing an interest in under-age sex, as the BBFC claims. Again, sympathy with the BBFC for having to take into account the obsessive legal overkill which has resulted from governments' repeated attempts to dot every i and cross every t in the entire lexicon of child imagery may tend to dissipate when faced with examples of its actual practice in this area, which leave the distinct impression that extra-legal considerations too have entered into its deliberations. But suppose we assume for the moment that the BBFC's only concern is to avoid passing material which might be found to be illegal by a court. Then we also have to consider the possibility that it might be found not guilty, or that it might not even be taken to court in the first place. And this brings us

to the very nub of the matter, which is that cinema films and DVDs should be as free to take their chances in court as any other kind of material, and not subject to pre-judicial, let alone extra-legal, scrutiny by the BBFC. However, doing away with the protective patina of a BBFC certificate is the very last thing which distributors and exhibitors want, which is why, to all the various factors discussed in this chapter which censor the circulation of controversial images in cinemas and on DVD in the UK, must be added the complicity of the film and DVD industries themselves with the present, long-standing system of censorship.

Notes

1. http://www.cps.gov.uk/legal/l_to_o/obscene_publications/index.html, date accessed 22 March 2011.
2. For obvious reasons, most distributors would prefer not to draw attention to any cuts made to their films by the BBFC. I'm thus particularly grateful to Marc Morris of Nucleus Films for providing me with the full details of the cuts made to *Fantasm* and *Fantasm Comes Again*. In return, I'm happy to reassure potential viewers that most of the cuts are to dialogue, and that none in any way detract from the films' qualities as 'sex works'.
3. http://www.fiawol.demon.co.uk/FAC/femejac.htm, date accessed 15 March 2011.
4. Ibid.
5. In conversation with the author.
6. Quoted at http://www.melonfarmers.co.uk/bw_banned.htm#I_Am_Not_a_Number_1986, date accessed 20 March 2011.
7. http://www.bbfc.co.uk/press/newsreleases/bbfc-rejects-sexually-violent-japanese-horror-dvd, date accessed 20 March 2011.
8. http://hansard.millbanksystems.com/commons/1942/nov/19/film-censorship, date accessed 20 March 2011.

References

British Board of Film Classification (2006a) *R18 Teen References – Expert Consultation* (2006), http://www.bbfc.co.uk/downloads#policyandresearch, date accessed 15 March 2011.
British Board of Film Classification (2006b) *The Use of Sex Videos and DVDs in Britain: Summary of Findings of the BBFC Research* (London: British Board of Film Classification), http://www.bbfc.co.uk/downloads#policyandresearch, date accessed 20 March 2011.
British Board of Film Classification (2007) *Violence and Abuse in 'R18' Level Pornography – BBFC Expert Consultation 2007*, http://www.bbfc.co.uk/downloads#policyandresearch, date accessed 20 March 2011.
British Board of Film Classification (2009a) *BBFC: The Guidelines*, http://www.bbfc.co.uk/downloads#policyandresearch, date accessed 20 March 2011.

British Board of Film Classification (2009b) *Annual Report 2008* (London: British Board of Film Classification), http://www.bbfc.co.uk/downloads#policyandres earch, date accessed 20 March 2011.

British Board of Film Classification (2010) *Annual Report 2009* (London: British Board of Film Classification), http://www.bbfc.co.uk/downloads#policyandres earch, date accessed 20 March 2011.

Flynn, N. (2007) *Dances with Werewolves* (London: Virgin Books).

Moalem, S. (2009) 'Everything You Always Wanted to Know About Female Ejaculation', 30 May, *New Scientist*, 31–3.

Ozimek, J. (2009a) 'Fluid Sexuality: Female Ejaculation and Censorship in the UK', 15 October, http://carnalnation.com/content/35307/1001/fluid-sexuality-female-ejaculation-and-censorship-uk, date accessed 20 March 2011.

Ozimek, J. (2009b) 'British Film Board Rejects "Disturbing" Sexual Torture Film, 8 April, http://www.theregister.co.uk/2009/04/08/bbfc_extreme_film_legal_paradox/, date accessed 15 March 2011.

Petley, J. (2009) 'Pornography, Panopticism and the Criminal Justice and Immigration Act 2008', *Sociology Compass*, 3, no. 3, 417–32.

Petley, J. (2011) *Film and Video Censorship in Modern Britain* (Edinburgh: Edinburgh University Press).

Part III
Ethics and Aesthetics in Controversial Media

9
Cutting Edge: Violence and Body Horror in Anime

Caroline Ruddell

Anime – animation produced in Japan – contains a diverse range of controversial images depicting death, violence and sexual content. Whether in the form of swordplay, gunplay, fusions with technology or encounters with supernatural and fantastical elements, some of these texts show body horror at its goriest across an array of genres. Anime has a large audience in Japan and is becoming more available to viewers worldwide. In the 'Western' world anime texts often gain cult status, as with *Akira* (Katsuhiro Ôtomo, 1988), or artistic status as with *Ghost in the Shell* (Mamoru Oshii, 1995). Both films contain transgressive and apocalyptic images of death, violence and metamorphosis of the body. Some examples of Studio Ghibli's output such as *Princess Mononoke* (Hayao Miyazaki, 1997) that are largely marketed at a young audience also contain violent battles. It is perhaps the controversial nature of some anime texts that makes them appealing as cult films to a niche market outside Japan; such texts frequently make use of violent and sexual images for the purpose of narrative, spectacle and drama.

This chapter interrogates the nature and significance of controversial images in anime and pays attention to the medium through which such images are presented. Several theorists have argued recently that animation needs to be understood in relation to viewers in an 'ethical' sense and that the status of animation as *not* live action in no way undermines the understanding of such texts as 'real' by viewers (Buchan 2007; Hardstaff 2007). While not centred on spectatorship or ethics this chapter aims to get to the heart of the violent and apocalyptic images in certain examples of contemporary anime, focusing on a case study of *Ichi the Killer* (Shinji Ishidaira, 2002) – not the live-action Takashi Miike feature film but an anime prequel produced a year later. The film represents the body as abject and torn apart and this chapter will place

it within the context of debates about horror cinema and body horror imagery. The chapter also pays attention to the medium of animation. How might the depiction of violence be rendered (and read) through 'anime-ic' devices? Here the form and style of anime can be useful in developing an understanding of the visual pleasures on offer.

The spectacle of the abject body and body horror

Jay McRoy, writing of Hisayasu Sato's films, suggests that they explore 'both the abject dread and infinite possibility of the human body in a state of dissolution' (2008: 49–50). McRoy is discussing the live-action films *Naked Blood* (1996) and *Muscle* (1989), but the concept of the onscreen body as capable of projecting both 'abject dread' and 'infinite possibility' is useful because these concepts apply to the representation of the body in *Ichi the Killer*, as well as many other examples of anime, and because the use of animation allows for infinite possibilities in terms of representation. As Paul Wells suggests, 'Animation can defy the laws of gravity, challenge our perceived view of space and time, and endow lifeless things with dynamic and vibrant properties. Animation can create *original* effects' (1998: 11) (emphasis in original). The use of the medium of animation and its relationship with violent content is worthy of further exploration as its 'excursions into the impossible allow bodies to erupt and explode, fly and roar' (McCrea 2008: 10). McRoy's discussion of Hisayasu Sato's films is also useful as it outlines the importance of understanding body horror within both an aesthetic and cultural context, drawing on Kelly Hurley's work on body horror as a reconfiguration of generic and narrative conventions to present the body as a spectacle that is 'unfamiliar' (McRoy 2008). This 'unfamiliar' body is rendered as such in a variety of anime films and television series in that the body is presented in bits and pieces, torn apart, split down the seams, and inside out.

McRoy draws links between such a representation of the body and the cultural and political context of late capitalist Japan, discussing aspects such as censorship in Japanese cinema. This is important as Japan has produced much horror, both live action and anime, in contemporary years. Speaking specifically about Hisayasu Sato's films, McRoy notes that 'the body is dis-/re-figured in a way that at once exposes (makes "naked") and explodes (splatters) the social codes that inform its socially prescibed shape and meaning' (2008: 56). There are several lines of enquiry in writing on media that contain horrific content; often these approaches are divided between social/political contextual analysis and

psychoanalytical explanations. For example, Tudor and Carroll have noted that body horror can be seen in terms of the postmodern, where the fragmentation of social existence is linked explicitly to the representation of breaking bodily boundaries (Carroll 1990; Tudor 1995). Using a different approach, Creed (2002) has suggested that the representation of women in (body) horror can be thought through using Kristeva's concept of abjection.

It is not the intention of this chapter to debate the methodological issues in approaching horrific content in the moving image; however, it is important to understand that films that contain explicit content can be thought through in a number of ways. What is of interest here is that the body rendered as horrific in films can be linked to socially 'shaped' ideas or anxieties about the body and its borders *and* its potential for abject dread. The body has long been held as a site where social order and restriction can be played out and its problematic relationship to restrictions and 'social stability' (Turner cited in McRoy 2008: 64) is one of the thematic and aesthetic concerns of *Ichi the Killer*. This is worth briefly locating within a Japanese context; as Ian Conrich points out in relation to Japanese horror and the post-industrial crisis, in films that appeared to reflect the associated cultural changes 'there was a shared interest in social disorder, family dysfunction and economic and political stability' (2005: 95). It is also necessary to point out that *Ichi the Killer* does not fit into many of the conventions of the horror film; it is essentially a psychological thriller or drama that nonetheless contains images of extreme violence. Indeed, the tagline for the film is 'anime at its most extreme'. Discussions of body horror are useful in developing an understanding of these representations in *Ichi the Killer* because the body in disarray is central to these narratives.

Notions of excess and spectacle are important to understanding body horror, which Paul Wells describes as 'the explicit display of the decay, dissolution or destruction of the body, foregrounding bodily processes and functions under threat, allied to new physiological configurations and re-definitions of anatomical norms' (2000: 114). Or, as Linda Williams suggests, 'visual and narrative pleasures' can help in interrogating forms of 'body genres', and here she suggests that pornography, horror and melodrama all feature elements of sensation and excess (2004: 728–9). These genres are preoccupied with bodily excess which she attributes to 'the spectacle of a body caught in the grip of intense sensation or emotion', and which in horror is due to representations of terror and violence (Williams 2004: 729). What is interesting about *Ichi the Killer* is that it draws from conventions of both pornography and

the horror film; the 'cum shot' is dovetailed with the abject body, body horror, or the body in bits and pieces.

Genre is a pertinent issue here, particularly considering Williams' arguments that in some respects horror and pornography have similar modes of address and affect, in that they incite particular responses from their audiences. Anime spans multiple genres and hybrid genres from *shinto* (young girl's anime), a range of fantastical and science fiction genres, Westerns and *shonen* (young boy's anime), through to *hentai* or pornographic anime. But there are many examples of anime that draw on both explicitly sexual and violent material, and this is much more common in Japanese popular culture than in those of other countries. Napier argues that

> while not totally mainstream, pornography is nevertheless a major current within the world of anime. Contrary to Western stereotypes, Japanese pornographic anime is both thematically wide-ranging and narratively complex. Although enveloped in a hardcore sexual framework, the pornographic anime goes beyond the sexual in terms of plots, themes and settings.
>
> (2005: 63–4)

What is foregrounded in both horror and sexually explicit material is the body. Here, it is necessary to chart the representation of the body and the body in bits and pieces in *Ichi the Killer* to ascertain its position within the 'world of anime' and whether it is a representative or a deviant example of the form.

Ichi the Killer has been produced in several formats – it is a manga series and has been adapted as a live-action film by the infamous Takashi Miike and also as an anime film. The live-action film includes what can be considered controversial content right from the start of the film; the first four minutes include drug use, violence and sexual content. Importantly the sexual content is concomitant with violent acts; this is common to all versions of the *Ichi* stories, although in the anime version the violent and sexual content is more sporadic. This is partly because the anime film goes back to Ichi's past and gives some sort of explanation for Ichi's sexual and violent tendencies later in life. Ichi is portrayed as a deeply insecure individual who is consistently bullied at school and at home and has to endure listening to his parents' sado-masochistic sexual acts in the next room. He snaps at several points in the film and kills a school friend, his parents, and various animals along the way. The anime film thus paves the way for his later exploits

as a killer and assassin who kills his victims in a particularly sadistic manner. Ichi is portrayed as a shy and submissive individual until he becomes angry, when he becomes incredibly violent and murderous. Importantly, and controversially, Ichi becomes aroused when violent or when watching violent behaviour. In the anime film it is implied that his parents' sexual behaviour has perhaps influenced Ichi in terms of distinguishing between violent tendencies and arousal, something he is not able to do.

The live-action film introduces Ichi's sexual behaviour very early on as he watches a man beat a woman through glass doors; the man, on suspecting someone is outside, goes to see who is out there and all he finds is Ichi's semen dripping from a plant on the balcony – an image the viewer is allowed to enjoy in close-up. Susan Napier, writing on pornographic anime, suggests that 'more than any other genre (with the possible exception of horror, with which it is often linked), pornography brings the body to the fore, not only in terms of sexuality but also in relation to aesthetics, gender and social identity' (Napier 2005: 64). While Napier is writing specifically about pornography, the anime version of the story does feature sexually explicit material, particularly in relation to Ichi's mother who is shown in various masochistic positions during sex. Williams also notes that in pornography, horror and the melodrama 'the bodies of women figured on the screen have functioned traditionally as the primary *embodiments* of pleasure, fear, and pain' (2004: 730) (italics in original), and that these are 'genres of gender fantasy' (2004: 736). The body is, as Napier and Williams argue, at the fore here but it does throw into question issues of power and gendered and social identity. The violence associated with sex in *Ichi the Killer* (in both films) subjugates female characters *and* highlights gendered relationships in relation to power. What is key to all the sexual scenes in the anime version is that the sexual content is continually linked with violence; the portrayal of sexuality here is both conforming to gendered power relations and rejecting normative sexual relations.

In the opening of the anime version there is an initial scene of violence where Ichi fights Kakihara and chops off his arm as well as pushing a skewer through his nose. The film then reverts to a younger Ichi and the narrative explores his progression towards violent tendencies. During the film Ichi beats his friend from school to death and kills his parents in a similar way. These scenes are represented in a stylistically 'anime-ic' way (Lamarre 2002; Ruddell 2008), a feature that will be explored towards the end of this chapter. However it is the pivotal

scenes at the end of the film that render the body more explicitly in bits and pieces, and as abject and unfamiliar. Towards the end of the film Ichi loses his temper with three men who had previously antagonized him in the street. He breaks one man's neck in spectacular style so that his head snaps completely backwards before a dramatic stream of blood sprays from his neck. The remaining men are beaten till their heads literally explode or disintegrate, which results in Ichi getting an erection. The violence in the anime version of the story, while often linked to sexuality, is placed at the fore; the body becomes a site of destruction and sexual pleasure is linked to this rejection of social order as played out on or through the body.

The body here is rendered as permeable and in a state of dissolution, as is the case at the beginning of the film where Kakihara's arm is spliced off and his nose skewered. The killing of the three men is also reminiscent of scenes in *Fist of the North Star* (Toyoo Ashida, 1986) where the central character performs a particular style of martial arts that render his enemies' heads and bodies inside out or splattered and exploded from within. The visual depiction of exploding heads and bodies is explored in depth by Christian McCrea who argues that the spectacular nature of such images in anime allows for a viewing experience that is linked to excess and physicality. He argues:

> Where dimensional excess may be useful as an adjunctive concept is during these moments of pure physicality. It is ahistorical, acultural and atypical in the sense that rather than opening into realms, it quite specifically eats the signs which stand between it and our pure physical response.
>
> (McCrea 2008: 15)

McCrea's point is useful in understanding these excessive images in anime as transcending historical and cultural contexts – instead they become moments of pure physicality and potential visual pleasure. McCrea draws on Brophy's work on 'The Body Horrible', where 'the exploding body or body part is not unlike a cum shot' (Brophy cited in McCrea 2008:16). As Napier and Williams have noted, horror is often linked to pornography because they potentially create a particularly physical response from the viewer. This is perhaps at the heart of controversial images generally; a physical response (laughing, screaming, hiding from the screen, orgasm) is the intent of the text. The body is therefore important in terms of both the representation onscreen and the bodily or physical reaction of the viewer.

Abjection and *Ichi the Killer*

The idea of the abject can be fruitful here as it acknowledges the boundaries or borders of the body. In films that feature body horror, the body's boundaries and borders are often violated by being penetrated, ripped apart, or even morphed into unrecognizable human parts. In one sense the disruption of the body in such films relates to an identity crisis on the part of the character, a concept Mark Jancovich acknowledges more generally in relation to body horror (1992). In *Akira*, for example, Tetsuo's body swells and bubbles into a mass of matter that is unrecognizable as 'him', or even as any human body; his identity is thwarted as both his own personality and body are overtaken by an 'other', and his human shape is morphed into that which is distinctly not human. In anime this is particularly possible because of the medium through which it is created; literally anything can be drawn and animation is not bound to the limited possibilities of the human as represented in live action, despite CGI and technologies that might aid in metamorphosizing the human body.

In anime, the drawn edges or boundaries of the body are more distinct than in live-action cinema, where, as Vivian Sobchack notes, lines are not inherently perceptible (2008: 252). Where edges are more readily apparent and visible they are also more open to disruption and chaos; the borders of the body are more rigid in animation because they often have thickset outlines, but are also more fluid in that the line is a construct and can be deconstructed quite easily. This opening up of the body can be considered abject as the borders of the body are not always distinct. Brigid Cherry writes that 'abjection is linked to an adverse reaction such as disgust, nausea or horror caused by being confronted with an object that threatens to disrupt the distinction between self and other' (2009: 112). Such objects are usually considered as bodily and in *Ichi the Killer* representations of disgust are portrayed at the display of bodily fluids such as semen or blood and in relation to the body being torn apart. Elizabeth Gross (1990: 87), on discussing Julia Kristeva's theory of the abject, notes:

> What is new about Kristeva's position is her claim that what must be expelled from the subject's corporeal functioning can never be fully obliterated but hovers at the border of the subject's identity, threatening apparent unities and stabilities with disruption and possible dissolution. Her point is that it is impossible to exclude the threatening or anti-social elements with any finality.

Gross goes on to note that when the subject realizes such an impossibility this results in the sensation of abjection. The theory of the abject relates to that which must be expelled from the body; anything that disrupts the symbolic order and the subject within that order must be renounced from the body. An example is the experience of seeing a corpse; this disrupts the symbolic order because the corpse is no longer a subject and to maintain this order it should be a subject and therefore alive.

Although there is potentially a methodological contradiction between approaches that emphasize social contexts and psychoanalytic approaches, it is clear that the body, when theorized through the abject, is grounded in socially shaped ideas about the boundaries of the body and what can threaten those boundaries. What is important is that the abject can be considered as that which repels and attracts simultaneously, as there is spectacle in the display of the forbidden or taboo breaking of bodily boundaries. Such boundaries are never more permeable than in body horror cinema, and particularly in some genres of anime where bodies are torn apart on a regular basis. As McRoy argues of body horror cinema, it 'challenges the very notion of limits, exposing the borders mobilised to delineate genres, bodies, and nations as not only artificially constructed, but far more permeable than previously imagined' (2008: 63). It is also important to note that the abject in film theory is often thought through in terms of the feminine. Barbara Creed, for example, explicitly links the abject in the horror film to the 'monstrous feminine' (1993), which Cherry aligns with issues of separation from the mother and 'awareness of the boundary between 'me' and '(m)other' (2009: 115). However, in anime the abject is linked in a variety of ways to both male and female bodies in line with Napier's arguments that anime can break Western representational conventions and traditions of male and female sexual relations that centre on power dynamics and the representation of the body.

Ichi's behaviour and desires can be understood by considering the theory of abjection. In some ways he has little sense of what constitutes anti-social behaviour and his desires are perhaps id-driven. In fact he does attempt to reject his sexual tendencies when related to violence; in the anime film he tries to avoid beating up a woman he meets at karate class; even though she asks him to, he claims he is 'not like that'. However, Ichi *is* 'like that' and his sexual pleasure is continually linked to violence perpetrated against both men and women. In one sense then he is aware of what is considered 'normative' social behaviour and his shame at his own personal pleasure is his realization that he does

not fit into the social order. Gross writes that 'the subject must have a certain, if incomplete, mastery of the abject; it must keep it in check and at a distance in order to define itself as a subject' (1990: 87). Ichi continually struggles to master the abject as when, enraged, he obsessively disrupts the borders of the body by literally tearing bodies apart. In one scene in the live-action film 'cleaners' arrive to remove the evidence of Ichi's murder of a gang boss. On arrival they find the room literally dripping from floor to ceiling in blood, guts and various body parts. In the anime version Ichi beats his opponents' bodies to the point of death and renders their bodies a bloody, pulpy mess.

According to Gross, boundaries against the socially unacceptable must be set in order for the subject to take up a position as a social being in the symbolic (1990: 87). For Ichi these boundaries are constantly transgressed and he is unable to exist as a social being in the symbolic; he is an outsider in a double sense – set apart by his unusual behaviour and prevented from taking up a position as a social being by his continuing embrace of the abject through his defilement of bodily borders; he literally renders the inside of the body out. In many circumstances

Figure 9.1 Ichi the Killer and the 'body in bits', 2002

'literature, poetry and the arts are more or less successful attempts to sublimate the abject' (Gross 1990: 93) (and film is presumably one of these 'arts'). In *Ichi the Killer*, and many examples of anime, the body is spectacularly torn apart; perhaps this is less of a sublimation and more of an acknowledgement that the body is core to a sense of both individual and social identity.

Douglas (1966: 115) argues that

> [t]he idea of society is a powerful image. It is potent in its own right to control or to stir men to action. This image has form; it has external boundaries, margins, internal structure. Its outlines contain power to reward conformity and repulse attack. There is energy in its margins and unstructured areas. For symbols of society, any human experience of structures, margins or boundaries is ready to hand.

Borders and boundaries, according to Douglas, exist to maintain and ensure social conformity. But, as she notes, energy can be apparent in the margins and the grey areas, where borders are more permeable. The body can certainly be considered in this way, especially in representations in anime where the body becomes a site of disruption. Although there are similarities in the representation of Ichi in both the anime and live-action versions, it is the use of animation in the anime film that is particularly poignant where the abject or the body in bits and pieces is concerned. Here animation, in its infinite possibilities for representation, can literally distort the body and disrupt it from within in a way that is impossible in the photo-real without the use of CGI special effects, that is to say, animation. In animation, and by extension anime, this is possible because the medium of animation allows for the impossible to be represented.

The medium of animation

The live-action and anime versions of *Ichi the Killer* are similar in that they represent sex and violence in an explicit way, and the characterization of Ichi is also quite consistent. However, a key difference is that animation is able to represent the impossible or more internal spaces in both a psychological and biological sense. For example, an anime series such as *Neon Genesis Evangelion* (Hideaki Anno, 1995–6) focuses thematically on the identity of the protagonists and their transition from childhood to adulthood. The use of animation is vital here as towards the end of the series the visuals move entirely away from evoking the

real, or the 'hyper-real' (Wells 1998: 25) and become a series of sketches and swirling lines and colours. The juxtaposition of these visuals with the voiceover allows for an internal monologue that highlights the protagonist's insecurities, while the visuals' movement away from the real enables the representation of a more internal, psychological space.

The formal qualities of anime also have an impact on character development, spectacle and action (Ruddell 2008). It is important to consider the formal qualities of anime in relation to the representation of controversial content; the impact these images have (or not) is related to the language of cinema and animation and how the image, frame, space and movement are arranged. Anime has a distinctly 'flat' quality in that it is a 2D medium where foreground and background move against each other to depict movement (Lamarre 2002). It would be simple to suggest that anime is therefore so far removed from the 'real' indexical world that controversial images, or any other kind of images, have no impact. However, on the contrary, anime is a particularly dynamic medium; full of energy, pacey action, and spectacle, and as McCrea notes can powerfully represent and evoke moments of physicality and excess. Perhaps one of the central points to consider in relation to violent images is the speed with which they often take place in the frame. In *Ichi the Killer*, the violent fight scenes take place with extraordinary pace; accompanied by frantic thrash metal and often using a heavy black and red colour scheme, Ichi's attacks literally fly by through the swift movement of foreground images. As is common in anime, these fast movements are at times intercut with slower moving foreground images so that the viewer can appreciate the force of a particular blow. For example, when Ichi kills his so-called friend at school, there is a frantic pace to the scene, but there is a moment of stillness as the frame allows a close-up on the boy dying on the ground. In contrast to the speed of the former moments, the editing slows to allow the viewer to see the eyes of the boy gradually turn white as death takes him.

The stylistic format that anime often uses can be considered as 'anime-ic' rather than 'cinematic' (see Lamarre 2002; Ruddell 2008). One of the many pleasures of watching anime derives from its style of representing movement and space, which often differs from the cinematic organization of the frame and movement. Importantly the medium of animation, or the imagery mediated through animation, can be thought through as a kind of haunting, because of the nature of movement and stillness in animation, and because there is no indexical link to the 'real'. As McCrea argues 'What differentiates the realm of animated exploding bodies in anime and elsewhere from that of

their brethren in film is this sense of haunted unlife' (2008: 20). There is no indexical link to the real in anime, and certain imagery is prioritized through its particular stylistic qualities; viewers are encouraged to focus on the foregrounded image which is sometimes slowed in terms of 'editing' techniques to allow appreciation of the spectacle before us. Traditionally anime makes use of limited animation techniques where fewer frames are used than, for example, by Disney. Fewer frames mean a less fluid viewing experience where each movement of a character is not drawn in and there are jumps between elements of movement. In addition, fewer frames mean that often the foreground image is onscreen for longer than in classically edited live-action cinema or television. In an example such as *Ichi the Killer*, viewers are often asked to engage with images of violence and sexuality without the 'relief' of a cut away. It perhaps works in much the same way as the spectacle of bullet-time in a film such as *The Matrix* (Wachowski Brothers, 1999) (Ruddell 2008).

Much explicitly violent or sexual material can be considered negatively in relation to the representation of gender, the body and sexuality. However, I would follow Napier who suggests that much anime that is explicit in nature both highlights problematic gendered power dynamics and is actually more complex in its thematic and narrative content than is often acknowledged. *Ichi the Killer* is not a simplistic representation of a killer who sadistically tortures women. He is a troubled individual who cannot reconcile his desires with a societal 'norm' and he is aroused by violence perpetrated against men and women. In the film both male and female characters are subject to bodily ruptures and splitting. *Ichi the Killer* also shares some common themes and preoccupations in anime such as a focus on psychological anguish, gendered identity, technology and the technological body, coming of age issues and problems with older generations or parents, as well as apocalyptic and dystopian imagery. The characters' place in society and the world at large is often interrogated through such tropes, and Ichi is no exception to this as he is at odds with a societal 'norm'. The anime-ic style used in *Ichi the Killer* allows for the representation of bodies exploding with time, movement and space organized in such a way as to slow the moments of bodily rupture. As McCrea argues, these are moments of excess and physicality, and I would add, spectacle. The violence and sexual content of *Ichi the Killer* are excessive to the point of comedy and provide a variety of visual and narrative pleasures through spectacle, engagement with societal issues, and the raising of questions about gendered and sexual identity.

References

Buchan, S. (2007) 'Pervasive Animation, Ethics and Spatial Politics', conference paper, *Pervasive Animation* (London: Tate Modern).

Carroll, N. (1990) *The Philosophy of Horror: Or Paradoxes of the Heart* (London and New York: Routledge).

Cherry, B. (2009) *Horror: Routledge Film Guidebooks* (New York: Routledge).

Conrich, I. (2005) 'Metal-Morphosis: Post-Industrial Crisis and the Tormented Body in the *Tetsuo* Films' in J. McRoy (ed) *Japanese Horror Cinema* (Edinburgh: Edinburgh University Press).

Creed, B. (1993) *The Monstrous-Feminine: Film, Feminism, Psychoanalysis* (London and New York: Routledge).

Creed, B. (2002) 'Horror and the Monstrous-Feminine: An Imaginary Abjection' in M. Jancovich (ed) *Horror: The Film Reader* (London and New York: Routledge).

Douglas, M. (1966) *Purity and Danger: An Analysis of the Concepts of Pollution and Taboo* (London and New York: Routledge).

Gross, E. (1990) 'The Body of Signification' in J. Fletcher and A. Benjamin (eds) *Abjection, Melancholia and Love* (London and New York: Routledge).

Hardstaff, J. (2007) 'The Impossibly Real: Green Belting the Imaginary', conference paper, *Pervasive Animation* (London: Tate Modern).

Jancovich, M. (1992) *Horror* (London: B.T. Batsford).

Lamarre, T. (2002) 'From Animation to Anime: Drawing Movements and Moving Drawings', *Japan Forum*, 14, no. 2, 329–67.

McCrea, C. (2008) 'Explosive, Expulsive, Extraordinary: The Dimensional Excess of Animated Bodies', *Animation: An Interdisciplinary Journal*, 3, no. 1, 9–24.

McRoy, J. (2008) *Nightmare Japan: Contemporary Japanese Horror Cinema* (Amsterdam and New York: Editions Rodopi B.V.).

Napier, S. (2005) *Anime from Akira to Howl's Moving Castle* (New York and Hampshire: Palgrave Macmillan).

Ruddell, C. (2008) 'From the "Cinematic" to the "Anime-ic": Issues of Movement in Anime', *Animation: An Interdisciplinary Journal*, 3, no. 2, 113–28.

Sobchack, V. (2008) 'The Line and the Animorph, or "Travel is More Than Just A to B"', *Animation: An Interdisciplinary Journal*, 3, no. 3, 251–65.

Tudor, A. (1995) 'Unruly Bodies, Unquiet Minds', *Body and Society*, 1, no. 1, 25–41.

Wells, P. (1998) *Understanding Animation* (London and New York: Routledge).

Wells, P. (2000) *The Horror Genre* (London: Wallflower).

Williams, L. (2004) 'Film Bodies: Gender, Genre, and Excess' in L. Braudy and M. Cohen (eds) *Film Theory and Criticism* (Oxford and New York: Oxford University Press).

10

'It's Gonna Hurt a Little Bit. But That's Okay – It Makes My Cock Feel Good': Max Hardcore and the Myth of Pleasure

Stephen Maddison

In 2010 Steve Jobs, CEO of Apple, stated that the iPhone, iPod and iPad were not for watching porn on (Chen 2010). It was a typically hubristic statement from the man in charge of the world's largest technology company (Tweney 2010) and the second biggest company in the world (Satariano 2010). It was also a timely reminder that however 'mainstreamed' porn has become, it still lacks respectability, especially for a brand as prestigious as Apple. But Jobs' comments weren't just arrogant, they were disingenuous. We may be getting used to watching TV and film on our PCs, laptops, tablets and smartphones, as streaming and downloading services become faster, more reliable and gain greater market purchase against existing DVD, Blu-Ray, cable and satellite services, but we've been watching porn like this for years. The demand for media devices (and that includes iPods, iPhones and iPads) and the technology that drives them has been catalysed by demand for porn. This was the case with the emergence of VHS, and has remained so in the context of online commerce, where porn companies were the first to develop technologies for secure online payment, and to develop profitable business models for online content: 'pornography is the handmaiden of new technology' (O'Toole 1998: 352; Maddison 2000: 45–52; Ward 2003).

While some porn companies now trade on Nasdaq, and the chief competitor to Apple's iPhone may have its own app store just for porn (Chen 2010), pornographic images frequently remain controversial. Paul Little, aka Max Hardcore, was jailed in the US in 2009 for 46 months, having been found guilty of ten counts of obscenity relating to five movies (*Pure Max 16: Euro Version* [2004], *Max Hardcore Fists of Fury 3* [2004], *Max Hardcore Extreme Schoolgirls 6: Euro Version* [2004], *Max Hardcore Golden Guzzlers 5* [2003], and *Max Hardcore Golden*

Guzzlers 6 [2004]) showing fisting, urination and vomiting. To say that Max Hardcore's films are controversial is an understatement. Variously described as a 'devil in the flesh' (Scholtes 1998) and 'a boil on the ass of pornography' by a fellow porn producer (Hoffman 2003), Hardcore's own website boasted (before it was sequestered following his trial) that he will 'Savagely Sodomize Stupid Sluts!' who will 'get Throat-Reamed, Ass-Drilled and Fucked-Up Beyond Recognition!' because 'THEY deserve it – Because YOU demand it – Because I Alone Must Do It!'

Max Hardcore's work represents an inherent contradiction that points to a cultural and political undecidability about pornography itself. Although the Bush administration came to power promising to be tough on porn, Hardcore was the only conviction it secured in either term in office. Despite tough words, Bush's government showed little stomach for a war against porn. In this context, Max Hardcore represents an acceptable target for both the conservative constituencies Bush needed to appease and the porn industry itself, for whom Max is 'too' extreme. A representative review of *Max Extreme 4* says:

> Way too much choke fucking and slobber on her face for my taste ... I gave up on this piece of shit pedophile [*sic*] scene so I didn't have to rag on the use of the fucking speculm [*sic*]. What a fucking waste of thrity [*sic*] minutes of tape. Max, even you should be ashamed of this fucking garbage. ... This scene has zero sex appeal, it sucks and it's not worth the tape it was copied on.
>
> (RogReviews)

For both the Bush administration and the porn industry, the prosecution of Max Hardcore serves as an inoculation that protects them against the threat of extremity; as Barthes suggests, the myth 'immunizes ... by means of a small inoculation of acknowledged evil; [and] thus protects it against the risk of a generalized subversion' (Barthes 1993: 164). The contradiction here is that far from his extremity locating him beyond the standards of the industry, his work in fact serves as an acknowledged site of innovation that drives porn production across the sector. Max Hardcore, as many critics have noted, sets the standard for the rest of the industry. What today may appear 'extreme' in his films will soon become part of hardcore's generic standards: for example, it has been suggested that Max Hardcore invented 'extreme anal', a style of heterosexual genital play that now dominates much mainstream porn (Sholtes 1998).

In this chapter I want to explore the relationship between the extremity of Max Hardcore's work and the idea of pleasure. An important

proposition about Hardcore's films, which challenges our understandings of what porn is and what it is for, is the idea that they are too extreme to be pleasurable. For example:

> For every ten people who believe Max is a walking, talking, jerking, squirting incarnation of everything hideously wrong with adult films, there are ten thousand actively masturbating without apology to his brilliant fusion of colorful imagery, intolerable cruelty, female degradation and aggressive, determined brutality. ... In Mr. Hardcore's arena, anal sex became less of a plot point and more of a full-throttle narrative engine designed to humiliate and degrade multiple female performers at once, and as much as humanly possible. ... Sorry if you can't jerk off to that, but more often than not Max's films are less about masturbation and more about showing the audience something they don't exactly see every day.
>
> (Rotten.com; my emphasis)

Porn that isn't about establishing a correlation of affective responses between performers and consumers, that doesn't demonstrate pleasure on screen in order to secure pleasure in watching, raises important questions about what pornography is for, but also about the role of pleasure in culture. Nina Power has recently suggested that 'the sheer hard work of contemporary porn informs you that ... sex is just like everything else – grinding, relentless, boring' and that 'everything is merely a form of work, including, or even most especially, pleasure' (2009: 52, 55). The question of pleasure in pornography is problematic and rarely located in the context of subjectivity and capital (as opposed to being located in the context of gender inequality, psychoanalysis, and so on). This chapter questions what it might mean to think about the mainstream hardcore porn industry as an engine of pleasure. In Linda Williams' now iconic formulation, the pursuit of pleasure in porn is literally that – a diegetic frenzy to seek out the mechanisms of pleasure in bodies and represent them (1990: 267). This remains a compelling way of understanding the history of pornography. But it is becoming increasingly difficult not to relate pornography's search for pleasure to wider patterns of governmentality in neoliberalism, where pleasure lies at the axis of consumer culture, ideologies of freedom and choice, and the mechanisms for proliferating capital, as a kind of injunction by which the individual secures their selfhood. In this context, what does it mean to suggest that the pursuit of pleasure in porn rests upon it becoming increasingly extreme? And what happens when extremity is no longer pleasurable?

In the neoliberal society of control, pleasure is not a frill or a bonus but an injunction, a requirement of our subjecthood. Critics of post-feminism have documented the extent to which this structure is gendered: post-feminist ideology is distinguished by its claim for women's 'right' to sexual pleasure. This 'right' works to naturalize heterosexuality. However economically and professionally emancipated (or not) the post-feminist woman is, her emancipation is culturally less significant than the continuing plausibility of her sexual desirability within heterosexuality, as a legion of iconic post-feminist texts, from *Bridget Jones's Diary* (Sharon Maguire, 2001) to *Sex and the City* (HBO, 1998–2004), attest. This 'right' to sexual pleasure is intricately bound up with the extension of pornography into popular culture, and owes as much to commodification as to feminist sexual politics. Esther Sonnet has written about post-feminism in relation to the Black Lace series of erotic novels for women. She suggests that post-feminist values foreground individual, rather than collective, empowerment, and an entitlement to pleasure, where that pleasure isn't a function of political struggle, but is instead a function of consumer choice (Sonnet 1999). Post-feminism describes an ideological formation in which the rhetoric of female empowerment has been assimilated by capital, where it represents a hegemonic concession to the political success of feminism, but where female empowerment becomes a function of consumer culture, rather than a function of a structural redistribution of gender power.

Angela McRobbie asserts this position more strongly: 'gender inequalities ... are an integral part of resurgent global neo-liberal economic policies' (2007: 721). McRobbie identifies two key emblems of what she describes as the 'aftermath' of feminism. Firstly, the 'post-feminist masquerade' is a new form of feminine deference literally clothed in the privileges of consumer culture, arising self-consciously from women's capacity to earn, and seeking approval not directly from men but from the 'fashion and beauty system' (2007: 723–4). Secondly, the 'phallic girl' superficially refuses deference and assumes a licensed form of phallicism, enjoying culture, but renouncing feminism in order to preserve masculine approval. McRobbie suggests that 'the regulatory dynamics of this sexualized field of leisure and entertainment [defined by a tabloid language of masculinist pleasures] are disguised by the prevalence of the language of personal choice' (2007: 733).

These feminist analyses of pleasure and depoliticization relate to a wider account of neoliberalism that locates the incitement to pleasure as one of the ways in which we either become subjects of neoliberal governmentality (in Foucauldian paradigms), or the society of control

(in Deleuzian paradigms). Mark Fisher, drawing on both approaches, identifies interpassive 'depressive hedonia' as a characteristic mode of engagement with an endless flow of content: texting, YouTube, facebook, iTunes, fast food: always on, instant gratification, seemingly endless choices, endless pleasure (2009: 21). This is an appropriate and important model for understanding porn consumption in the current conjuncture. There has never been more porn, nor has it been more easily available. Most online porn sites offer weekly updates of short individual scenes rather than more infrequent (and expensive) feature length films. The very saturation of porn, not only in terms of its abundance and accessibility, but its integration into so much of our cultural life, seems to exemplify the idea that we consume porn interpassively while it performs our sexuality for us. Rather than inciting our desire to go out and find some 'real' sex, porn generates desire for porn itself: an endlessly updating parade of posthuman bodies, freakishly endowed and reassuringly standardized. 'Real' sex recedes as porn becomes the dominant mode through which sex is experienced. Fisher, following Deleuze, suggests that we experience authority as an 'indefinite postponement', an unresolved state of perpetual deferral in which 'external surveillance is succeeded by internal policing' (2009: 22) and which makes us subject to what Nikolas Rose has called 'government at a distance' (1996). Rose suggests that the individual's desire 'to govern their own conduct freely' and pursue 'a version of their happiness and fulfilment that they take to be their own' actually 'entails a relation to authority' even 'as it pronounces itself the outcome of free choice' (1996: 59). For Fisher, the consequence of these choices and of being hooked into 'the entertainment matrix' is 'twitchy, agitated interpassivity, and an inability to concentrate or focus' (2009: 24). Consequently we are unable 'to do anything else except pursue pleasure' (2009: 22, emphasis in original). Fisher's formulation is reminiscent of the Frankfurt School's analysis of the culture industry, and Adorno's concept of distraction in particular. But in the new analysis pleasure is no longer either a distraction or an amelioration of oppression but is agency itself, offering choices that feel like empowerment but which actually require our alienation as competitive individuals. Pursuing pleasure is one of the key ways in which we work, as Nikolas Rose puts it, to constitute ourselves in approved forms. 'Government at a distance' produces individuals looking to 'maximize their quality of life through acts of choice' (1996: 57).

Pleasure has always been a troublesome concept for porn, although these troubles have had different modalities. In representational and generic terms, pornography has been critiqued by two generations of

feminism for its apparent unequal distribution of pleasure along the axis of gender, while, technically, pornographic forms have themselves struggled to account for the physiological experience of pleasure. At the same time, the economic importance of porn poses a challenge: the drive for content and the necessity of innovation require considerable commodity and brand differentiation (Biasin and Zecca 2009). Linda Williams' work has had a critical role in assessing the meaning of the history of pornographic forms, particularly with regard to the question of pleasure. In her analysis of American stag cinema, a genre of approximately 2000 films produced between 1915 and 1968, and shown in all-male social settings such as frat houses and Masonic lodges, she suggests that the stag films offered men the pleasure of bonding with other men and were designed to solicit arousal, but didn't offer the opportunity of sexual satisfaction, as the male actors in stags didn't orgasm:

> [T]he stag film does not seem to want to 'satisfy' in this sense at all; its role seems rather to arouse and then precisely not to satisfy a spectator, who ... subsequently seek satisfaction outside the purely visual terms of the film – whether in masturbation, in actual sexual relations, or by channelling sexual arousal into communal wisecracking or verbal ejaculation of the 'homosocial' variety.
>
> (Williams 1990: 73)

She subsequently argued that porn was driven by the fantasy of capturing the 'truth' of female sexual pleasure, manifested as a 'frenzied' gaze upon the female body (1990: 267). In more recent work, Williams has suggested that such is the insistence with which porn breaches the public scene, that the notion of obscenity itself is no longer meaningful. She coins the term 'on/scenity' to identify 'the gesture by which a culture brings on to its public arena the very organs, acts, bodies and pleasures that have heretofore been designated ob/scene and kept literally "off-stage"' (2004: 3). Here the progression from porn as an antecedent to 'real' sex acts to its increasingly frenzied, and mainstream, gaze upon the sexualized body as an end in itself, is a history of commodity culture refining its reification of pleasure as the primary goal of the alienated subject.

The century of porn considered by Williams has witnessed considerable changes in the style of sex and the proportions and capacities of bodies on display, but pornographic realism continues to seek the truth of affective pleasures. This truth is representationally elusive, in both technical and philosophical terms. Performers may or may not be convincing;

the camera has to be in the right place at the right time; bodies and acts need to be lit so that we can see enough, but maybe not too much; performers need to manifest a degree of mutual responsiveness; relays of identification and desire are unstable and complex (as a generation of psychoanalytic film theory has demonstrated). Porn genres have historically worked to mitigate these instabilities, not always successfully. Nina Power suggests that the money shot has long been a key device in hardcore, designed to ensure that 'the audience get their money's worth' by proving that what they've seen 'has finally, irrevocably been proved to be "real"' (2009: 54). But Anne McClintock argues that the male cum shot is an 'overdetermined contradiction' in heterosexual porn, which represents the failure of phallic logic and signifies the 'asymmetry of female and male sexual pleasure' (1992: 123). She goes on to suggest that

> to portray a 'vaginal orgasm' means rendering the penis invisible inside the woman, while at the same time obscuring the vagina ... to portray a clitoral orgasm, excited by hands or mouth, is to refuse the primacy of the penis.
>
> (1992: 127)

And thus, in the context of a pornography driven by a phallic logic, female pleasure becomes unrepresentable; hardcore is, in one sense, fundamentally homoerotic in its invitation to men to 'identify vicariously with the spectacle of another man's pleasure' in the absence of its ability to account adequately for female pleasure in the context of heterosexuality (1992: 123).

In a now infamous interview with Martin Amis (2001, John Stagliano, the inventor of gonzo porn, asked about the industry's emphasis on anal sex, stated that

> Pussies are bullshit ... With vaginal ... you have some chick chirruping away. And the genuinely discerning viewer ... has got to be thinking: Is this for real? Or is it just bullshit? With anal, on the other hand, the actress is obliged to produce a different order of response: more guttural, more animal.

For Stagliano, the progression towards a more extreme form of sex that Lauren Langman has described as 'grotesque degradation' (2004) is driven by a search for authenticity.

As we've seen, some commentators and industry insiders view the work of Max Hardcore as 'too extreme', to the point where it may

no longer function as a libidinal stimulus. Such claims have strategic and ideological effects, particularly for an industry that Max Hardcore inoculates against legal stricture, as his recent incarceration in the US demonstrates. Here I want to attempt to isolate the question of pleasure and how pornography seeks to authenticate it. In the second scene of the compilation *Extreme Schoolgirls 1* (2003), Max performs with Drew, a young woman who is dressed in a tight pink baby-doll top and tight mini skirt and high platform shoes with frilly white ankle socks. Her hair is in pigtails, tied with purple and pink plastic baubles, and her face is made up in lurid pinks and purples. The scene takes place outside, with Drew lying on her back on a table for most of it. Max stands naked, either between her legs or stands over her head tipped back over the edge of the table. The scene is shot gonzo-style, with one camera that follows the action jerkily in medium shot, with occasional close-ups of Drew's face or genitals. The scene begins with Max noting how Drew has put on weight. He pulls up her top and caresses the curve of her belly. She agrees and asks him to help her lose weight. She kneels and performs oral sex on him, before Max leads her to the table and performs an enema on her. Drew lies on her back, top pushed up over her breasts, and mini skirt round her waist. After withdrawing the enema hose, Max steps to one side masturbating as Drew squirts the water out of her rectum. The camera pans from between her legs to a mid-shot of Max masturbating beside her. Drew tells him, 'Oh Max, please help me lose some weight'. Drew giggles and laughs as he performs the enema. Max penetrates Drew anally and she tells him to 'Plunge-fuck me, mister'. Max withdraws and walks around to her head. He tells her 'let's make you skinny' as he pushes down on her breasts and then throat until her neck is bent back over the edge of the table. Max stands over her head and throat-fucks her. In close up we see Drew vomit copious clear liquid over his penis which runs over her nose and eyes as Max asks her 'isn't that sexy?' The vomit smears her purple and pink makeup. As she wipes the vomit from her face Max returns between her legs and in medium shot we see him penetrate her anally. He performs another enema, telling her to gag herself with her own fist. We see a close up of the hose entering Drew's anus and then a medium shot of her lying on the table pushing her fist in her mouth as Max masturbates and performs the enema. He tells her to 'make yourself gag, you little cunt'. He penetrates her again, and in close up we see water pouring out of her anus as he removes his penis. Max returns to Drew's head, tipping it back over the edge of the table. He stands over her and throat-fucks her again. We can hear choking and gagging sounds. At the edge of the shot we can see her

hand pushing at Max's thigh. He withdraws his penis and in close up we see him masturbating into her mouth. He ejaculates, telling her to swallow it. He throat-fucks her again and she vomits over his penis and her face. We hear Max saying, 'and now you're really fucking skinny baby'. The scene cuts to a shot of the two performers standing side by side as they admire Drew's less rotund belly.

This scene typifies the work of Max Hardcore in a number of ways. Max himself is significantly older and less well endowed than is the norm for male performers in hardcore. The scene is characterized by a constant stream of instructions given by Max to Drew, and by her total passivity. The lack of vaginal or clitoral stimulation certainly signifies what McClintock calls the 'asymmetry of female and male sexual pleasure' (1993), and the use of medical instruments is very common in Max Hardcore films. In this scene he uses an enema hose and bag; often he uses steel forceps to hold open the mouths, anuses or vaginas of female performers. And aesthetically, Drew is a characteristic Max Hardcore performer with her mix of sleazy and childish attire. Max Hardcore's films tend to feature much more anal than vaginal penetration, and irrumatio (choke-fucking), often with women performers lying on their backs with their heads tilted back while Max pushes his penis into their throats from above. His films frequently include fisting of the vagina and anus, and the majority include him pissing into the gaping orifices of female performers. The latter practice is often extended, literally, with the use of rubber tubes that women use to suck Max's piss from their vagina or anus into their mouths. In *Harder than Hardcore 2* (2004) the same technique is used, only with Max's sperm rather than urine. Unlike many of his gonzo contemporaries, Max is always the only male performer in his films.

Another key feature of Max Hardcore's films is his characteristic variation on the staple cum shot or 'facial'. In Max Hardcore's films, makeup is used not to naturalize the standards of glamour set by the 'fashion and beauty system' (as McRobbie suggests is the case for the 'post-feminist masquerade' (2009: 61–9)), but to parody these forms and make female performers look younger than they are. In an interview with Rotten.com, Hardcore talks about his use of cheap makeup brands marketed at teens:

> Repeated reamings, piss and puke, and it's still there. Really amazing stuff. I had tried the brush-on high price crap and that's just useless. The eye shadow and cheek makeup I use is the low-cost stuff used by teens. Those are the only ones who have the bright pinks and blues that really pop on camera.

The culmination of most scenes in Max Hardcore's films are close up shots of the faces of female performers, smeared with urine, semen, makeup and their own saliva from being throat-fucked. In the scene from *Extreme Schoolgirls 1*, the climatic shot shows Drew's face, with her makeup smeared with semen, vomit and saliva. Here the search for pleasure, Williams' 'frenzied gaze', tips over into an incitement to sensation, where the involuntary convulsions of Drew's anus ejecting water, or her gag reflex causing her to vomit, displace the more conventional fetish (semen as pleasure). If female pleasure in this scene is potentially unrepresentable, Max Hardcore, as performer, director and producer, isn't going to try. Instead, Drew's body is the opportunity to display affective responses to his domination of it by a combination of penis, camera, medical implements, and parodies of feminine masquerade (both in the use of makeup, jewellery, shoes and clothing, and in the exercise of the disciplinary injunction to be thinner). That this is, in Power's words, 'hard work' for Drew as a performer, as it is for Max, seems unquestionable, but importantly the object of this work is less his cum shot (as would normally be the case, and where this cum shot would stand in for both his pleasure and hers) but her involuntary vomiting in response to his choke-fucking of her. The potential pleasures of being anally penetrated or given an enema by Max may be representationally obscure, but we are in no doubt that her body is responding strongly to stimulation when Drew vomits over her own face. These are, by any standards, spectacular ejaculations from her bodily cavities, directly related to Max Hardcore's stimulation. To what extent are such ejaculations meaningful as pleasure? We have already noted that some porn industry commentators suggest that the point of Max Hardcore's work is not to solicit masturbation; that is, it is not designed to establish a set of correlative set of affective pleasures between performers and spectators. So what is the meaning of films like *Extreme Schoolgirls 1*?

One way of answering this question is to compare the work of Max Hardcore with that of Rocco Siffredi, whose films feature comparable levels of choke-fucking and extreme anal. Rocco has a reputation for rough sex, but he is widely popular and certainly less vilified than Max Hardcore. There are perhaps two sets of structural differences between the two performer/auteurs. The first concerns their physical attributes: in the age of the 'viagra cyborg' (Davis 2009) and where huge and ever-hard penises are the pornographic standard (Maddison 2009), Rocco exemplifies this trend while Max confounds it. Rocco's penis is the model for an eponymous dildo, and has become something of a porn industry legend. The two men are similar ages, although Max is eight

years older than the 'Italian Stallion' and much less attractive. Secondly, Max Hardcore's films are characterized by a performative blankness that is at odds with the extreme acts taking place on screen. Max engages his female performers with crude misogynist incitements and instructions, and his films show the involuntary affect of his orgasm or of him releasing his bladder, but Max as a performer remains relatively unmoved by the acts he solicits from his co-stars. In contrast, Rocco Siffredi's films are characterized by a performative intensity that foregrounds Rocco's affective responses, in terms of sounds, bodily convulsions and fluids, as much as those of his fellow performers. The impression made by Rocco's performative persona is one of intense investment in the genital acts, and a desire to demonstrate pleasure in those acts. For Max Hardcore, maintaining phallicism is a function of attempting to maintain consistent mechanical, technical and discursive control of female bodies; for Rocco, whose films are frequently more carnivalesque, rowdy and include multiple male performers, phallicism is a more direct matter of performative endurance. And while Max Hardcore's work demonstrates consistent content, Siffredi's body of work is both more prolific and more diverse, at least within porn's generic standards. At his most extreme (the *Rocco Animal Trainer* series; currently up to volume 31) Rocco's work shares with Hardcore's an exemplification of the trend identified by Lauren Langman as 'grotesque degradation' of women (Langman 2004: 201). Elsewhere, however, Rocco experiments with other ways of performing sexually, encouraging female co-stars to rim him (*Rocco's Back* [2009] and *Rocco's Bitch Party* [2010], among others), acting in films with transsexuals (for example, *A Trans Named Desire* [2006]), and playing submissive in bondage games (*Rocco Piú Che Mai a Londra 2* [1997]). In comparison with Max Hardcore, Rocco's films may be less unpleasant, Rocco himself may be more decorative, more likely to solicit arousal through his appearance and enthusiasm, and his films may foreground a more familiar convention for negotiating the apparent indeterminacy of female pleasure; but how significant is this difference between the work of the two performer and director/producers?

Maurizio Lazzarato (n.d.) offers a more extensive account of the role of work in neoliberalism than Nina Power, but like her, he is concerned with the cultural implications of the extension of entrepreneurialism into everyday life. Lazzarato's account of 'immaterial labour' emphasizes the role of emotions and character in both the meaning of the commodity and in the kind of labour that produces it, where life/work and labour/leisure distinctions are collapsing and professional success depends upon the constant management of social relations and

networks. This account of work and commodities seems appropriate to a consideration of pornography, particularly in the context of an enquiry about the potential meaning of porn commodities that fail to deliver expected pleasures. Porn workers are affective labourers, whose work manages emotions and bodily states and who are insecurely employed and required to be entrepreneurial to succeed, and where porn labour inscribes not only affects, but bodies themselves in a kind of biomedical/clinical labour, with invasive use of the body's biological systems and sex workers as unregulated clinical labour (Waldby and Cooper 2006). Pornography transforms sex into informational spectacles and commodities that aren't 'destroyed' in the act of consumption but which generate a cultural environment of greater need, and where the distinction between porn consumer and porn producer has become more elastic, with a collapsing gap between professional porn production and amateur self display, and slippage between Internet dating, message boards and porn distribution. We could suggest that pornography is a form of immaterial sex, where the informational and cultural content of porn commodities is a function of affective labour partially distributed across an unstable divide between producers and consumers. Successful consumption of porn increasingly depends upon restive file browsing, with hands occupied not only in stroking the body, but the mouse or trackpad, opening and scrubbing through files to patch together a bricolage of quality pornographic moments. Access to porn itself is dependent on managing networks and social media where we must demonstrate entrepreneurial skill, choosing appropriate contractual subscriptions, following links and recommendations to new sites of free content, keeping up with chatrooms, torrent lists, blogs and feeds to ensure we aren't missing out on opportunities to realize our desires, and demonstrate our self-management. These patterns of entrepreneurialism of the self mirror the practices necessary to maintain professional success as an immaterial labourer. These are the conditions described by Fisher's notions of 'reflexive impotence' and 'depressive hedonia' (2009: 21), where pornographic pleasures, in all their accessibility, standardization and dependability, satisfy the need for work-centric patterns of social relations. This is the moment when the search for pleasure, as Power notes, becomes another form of work. If we accept this as an account of patterns of porn consumption in neoliberalism, the question is, how does the work of Max Hardcore fit this pattern?

In Max Hardcore's work pornography's historic search for the truth of pleasure has become a frenzied preoccupation with authenticity that is disconnected from any attempt to stimulate pleasure; what is sought

instead are the spectacular involuntary convulsions of the kind we see in *Extreme Schoolgirls 1*. But in its manifestation of a misogynist back-lash, this frenzy may be the expression of a resistance of the conditions of immaterial labour, of immaterial sex. Langman suggests that the increasing extremity of porn, and the rise of what he calls grotesque degradation of women, is a cultural symptom of a backlash against feminism, 'in retaliation for their assertiveness' (2004: 201). Such an account raises multiple questions about power and heterosexuality, and the ways in which porn consumption is gendered. In the context of a consideration of the relationship between pleasure and neoliberal sub-jectivity, however, Langman's account points to ways of understanding the drive towards extremity as an expression of political frustration. Earlier we saw how reviewers of Max Hardcore's work have identified that 'Max's films are less about masturbation and more about show-ing the audience something they don't exactly see every day' (Rotten. com). Instead of the 'vapid, vacuous Vivid Video girls' Max apparently offers a 'brilliant fusion of colorful imagery, intolerable cruelty, female degradation and aggressive, determined brutality' that makes other kinds of porn 'the functional equivalent of discardable Chinese takeout menus dangling from your front doorknob' (Rotten.com). Here this reviewer is describing the way in which Max's films rupture the condi-tions of 'depressive hedonia', celebrating the films' inability to deliver anticipated affective responses, and instead offering alternative affective demands: shock, disgust, discomfort, humiliation, anger, that rupture the conditions of immaterial sex. Where the work of Rocco exemplifies a passionate yearning for authentic affect, for a sexual and performative responsiveness that authenticates the project of porn as a representa-tion of the search for pleasure, Max offers a startling combination of blankness and excess, where the search for authenticity has become a grotesque misogynist parody of sexual pleasure. Unlike Rocco, heaving and sweating and cursing and coaxing, Max as a performer is blank, apparently refusing a degree of affective exploitation himself, even as he makes extreme demands of his fellow performers as affective labourers (the medical instruments, the vomiting and so on). If the work of both pornographers is animated by the same incapacity of the pornographic form to ultimately capture the truth of affective pleasure, in Hardcore's work we can see how the search for authenticity tips over into incite-ment to sensation (you may not be able to tell whether she's cum, but you can tell that she's been choking when she vomits).

This authenticity is tied then, to a cycle of extremity that necessar-ily depends upon the human capital of female porn performers. Such exploitation hardly seems like a promising arena for a programme of

political dissent, but I want to suggest that Hardcore's blank, abusive manifestation of this drive to authenticity is characterized by libertarian resistance to neoliberal subjectivity. If most mainstream hardcore porn (such as that characterized by Rotten.com's reviewer) is 'vapid' – a standardized, conveniently packaged search for affective pleasure that expresses the conditions of being a product of immaterial labour and which reinforces, in our consumption of it, our subjectification of Foucault's homo oeconomicus – Max Hardcore's porn ruptures the faultline inherent in such a system. Pleasure cannot be streamed as a guaranteed informational flow. Styling himself in the tradition of the transgressive figure of the phallic libertarian – a residually strong tradition in porn (Larry Flynt, Hugh Hefner, Gerard Damiano, John Stagliano) – Max Hardcore suggests that 'after I had been making movies for a while, it became an exercise in testing the limits of free speech' and that he has 'always enjoyed the role of agent-provocateur' (http://www.maxhardcoreblog.com/), and certainly his films take the pressures of commodity innovation, novelty and the frenzied search for pleasure to an extreme. In many ways this is a familiar libertarian discourse of porn, especially in the context of US debates about the First Amendment and the protection of free speech. Yet, the analysis of the role of pleasure in the currently dominant mode of capital may offer us the chance to rethink our understanding of the role of controversial images in porn, and shift focus from the residual 'tired binary' (Juffer 1998: 2) of the feminist/censorship axis of debate and refocus our critical attention on the question of how porn negotiates the poles of what I'm referring to as immaterial sex and the residual figure of the phallic libertarian. Both poles are powerfully seductive, associated with fantasies of freedom, individuality and empowerment, but both are constituted in highly asocial terms. Mainstream porn offers differentiation and choice as markers of our individuality and selfhood; Max offers a vision of liberty and selfhood, of sexual mastery rooted in the technical and mechanical control of bodies and affective responses. In this, Max Hardcore may help us to see the extent to which 'vapid' porn reinforces exploitation of our affectivity; where the limits of pleasure lie not in the capacity of bodies, or the technical apparatus of pornographic production, but in the inscription of that pleasure in the process of neoliberal subjectification.

References

Adorno, T. (1991) *The Culture Industry* (London and New York: Routledge).
Amis, M. (2001) 'A Rough Trade', *The Guardian*, 17 March, http://www.guardian.co.uk/books/2001/mar/17/society.martinamis1, date accessed 22 November 2010.

Barthes, R. (1993) *Mythologies* (London: Paladin).

Biasin, E. and Zecca, F. (2009) 'Contemporary Audiovisual Pornography: Branding Strategy and Gonzo Film Style', *Cinema & Cie: International Film Studies Journal*, 9, no. 12, 133–50.

Chen, B. (2010) 'Want Porn? Buy an Android Phone, Steve Jobs says', *Wired*, 20 April, http://www.wired.com/gadgetlab/2010/04/steve-jobs-porn/, date accessed 15 November 2010.

Davis, M. (2009) *Sex, Technology and Public Health* (Houndmills: Palgrave Macmillan).

Fisher, M. (2009) *Capitalist Realism* (Ropley: O Books).

Hoffman, D. (2003) 'Hoffman Hardballs Hardcore' http://www.lukeisback.com/ stars/stars/max_hardcore.htm, date accessed 29 April 2010.

Juffer, J. (1998) *At Home with Pornography: Women, Sex and Everyday Life* (New York and London: New York University Press).

Langman, L. (2004) 'Grotesque Degradation: Globalization, Carnivalization, and Cyberporn' in D. D. Waskul (ed) *net.seXXX: Readings on Sex, Pornography and the Internet* (New York: Peter Lang).

Lazzarato, M. (n.d.) 'Immaterial Labour' trans. P.Colilli and E. Emery, Generation-Online, http://www.generation-online.org/c/fcimmateriallabour3.htm, date accessed 24 May 2011.

Maddison, S. (2004) 'From Pornotopia to Total Information Awareness, or What Forces Really Govern Access to Porn?', *New Formations*, 52, 35–57.

Maddison, S. (2009) '"The Second Sexual Revolution": Big Pharma, Porn and the Biopolitical Penis', *Topia: Canadian Journal of Cultural Studies*, 22, 35–54.

Maddison, S. (2011) 'Is the Rectum Still a Grave? Anal Sex, Pornography and Transgression' in T. Gournelos and D. J. Gunkel (eds) *Transgression 2.0: Cultural Opposition in a Digital Age* (New York: SUNY Press) 86–100.

McClintock, A. (1993) 'Gonad the Barbarian and the Venus Flytrap: Portraying the Female and Male Orgasm' in L. Segal and M. McIntosh (eds) *Sex Exposed: Sexuality and the Pornography Debate* (London: Virago).

McRobbie, A. (2007) 'Top Girls?', *Cultural Studies*, 21, nos. 4–5, 718–37.

McRobbie, A. (2008) *The Aftermath of Feminism: Gender, Culture and Social Change* (London: Sage).

Power, N. (2009) *One Dimensional Woman* (Ropley: O Books).

RogReviews (n.d) 'Max Extreme 4', http://www.rogreviews.com/reviews/read_ review.asp?sku=512, date accessed 26 April 2010.

Rose, N. (1996) 'Governing "Advanced" Liberal Democracies' in A. Barry, T. Osborne and N. Rose (eds) *Foucault and Political Reason: Liberalism, Neo-Liberalism and Rationalities of Government* (London: UCL Press).

Rotten.com (n.d.) 'Max Hardcore', http://www.rotten.com/library/bio/pornographers/max-hardcore/, date accessed 29 April 2010.

Satariano, A. (2010) 'Apple passes PetroChina to Become Second-Largest Stock', 23 September, Bloomberg, http://www.bloomberg.com/news/2010-09-23/apple-passes-petrochina-to-become-world-s-second-largest-stock.html, date accessed 16 November 2010.

Scholtes, P. (1998) 'Devil in the Flesh', 14 January, *City Pages*, http://www.citypages.com/1998-01-14/arts/devil-in-the-flesh, date accessed 29 April 2010.

Sonnet, E. (1999) '"Erotic Fiction by Women for Women": The Pleasures of Post-Feminist Heterosexuality', *Sexualities*, 2, no. 2, 167–87.

Tapper, J. (n.d.) 'Court Deals Blow to US Anti-Porn Campaign' ABC News, http://abcnews.go.co/Nightline/print?id=433956, date accessed 2 May 2009.

Tweney, D. (2010) 'Apple passes Microsoft as World's Largest Tech Company', *Wired*, 26 May, http://www.wired.com/epicenter/2010/05/apple-passes-microsoft/, date accessed 16 November 2010.

Waldby, C. (1995) 'Destruction: Boundary Erotics and Refigurations of the Heterosexual Male Body' in E. Grosz and E. Probyn (eds) *Sexy Bodies: The Strange Carnalities of Feminism* (London and New York: Routledge).

Waldby, C. and M. Cooper (2006) 'The Biopolitics of Reproduction: Post-Fordist Biotechnology and Women's Clinical Labour', *Global Biopolitics Research Group Working Papers*, http://www.ioh.uea.ac.uk/biopolitics/networks_publications_working.php, date accessed 21 November 2007.

Ward, M. (2003) 'Will Porn Kick-Start the Video Phone Revolution?', 16 June BBC News, http://news.bbc.co.uk/1/hi/technology/2992914.stm, date accessed 16 November 2010.

Willeman, P. (2004) 'For a Pornoscape' in P. Church Gibson (ed) *More Dirty Looks: Gender, Pornography and Power* (London: BFI).

Williams, L. (1990) *Hard Core: Power, Pleasure and the 'Frenzy of the Visible'* (London: Pandora).

Williams, L. (2004) 'Porn Studies: Proliferating Pornographies On/Scene: An Introduction' in L. Williams (ed) *Porn Studies* (Durham and London: Duke University Press).

11
The Lexicon of Offence: The Meanings of Torture, Porn, and 'Torture Porn'

Steve Jones

Coined by David Edelstein in 2006, the term 'Torture Porn' described the sub-genre of horror films characterized by the *Saw* and *Hostel* series, and has since been adopted widely: the press referred to nearly seventy horror films between 2003 and 2010 as exemplifying the cycle. The discourse surrounding Torture Porn – also dubbed 'blood porn', 'carnography', and 'gorno' – suggests that it is 'possibly the worst movement in the history of cinema' (Aftab 2009: 12). My aim here is to challenge the simplistic and dismissive assumptions underpinning Torture Porn discourse. The images that fall under this rubric are evidently contentious, yet reaction to them rarely considers what values the films apparently contravene, and why, if the films are offensive, they are simultaneously so popular.

It is typically claimed that Torture Porn began either with the release of *Saw* (James Wan, 2004) (Cunin 2007; Floyd, 2007; Cashmore 2010), or *Hostel* (Eli Roth, 2005) (Maher 2010). Others argue that its true origins are the 'grand guignol of late-19th-century French street theater' (Brottman cited in Anderson 2007: 8; Johnson 2007). Torture is certainly nothing new in horror: Edgar Allan Poe's *The Pit and the Pendulum* (1850) is a bona-fide 'torture classic', while *Saw*'s megalomaniacal entrapments strikingly recall *The Abominable Dr Phibes* (Robert Fuest, 1971). The lineage of Torture Porn also includes the splatter films of the 1970s (Blake 2008: 139; Fletcher 2009: 81; McEachen 2010) and thus it is unsurprising that Torture Porn flourished at a time when 'remakes of landmark seventies horror films have now become routine' (Hays 2010). Torture Porn's kinship with 1970s horror appears to be a conscious move away from the 'jokey self-consciousness that had taken root in the genre via the *Scream* franchise [(Wes Craven, 1996–)]' and the PG-rated horror comedies that dominated horror till the early 2000s (Prince

2008: 288; Lockwood 2008: 41): by comparison Torture Porn seemed 'grindingly humourless' (Leith 2010: 22).

Although critics and scholars have singled out *Hostel, Saw, Captivity* (Roland Joffe, 2007), *The Devil's Rejects* (Rob Zombie, 2005), *The Hills Have Eyes* (Alexandre Aja, 2006), and *Wolf Creek* (Greg Mclean, 2005) as definitive examples of the sub-genre, it is remarkably difficult to pinpoint precisely what the characteristics of Torture Porn films are. It is not enough to say that they are horror films that dwell upon acts of torture and 'emphasis[e] confinement, traps and mutilation' (Murray 2008: 2; Newman 2009: 38): we must also apprehend who is being tortured and why. Motives for torture range from teaching victims a moral or spiritual lesson (*Saw; Penance* (Jake Kennedy, 2009)), causing suffering for personal gratification (*Hostel; Captivity*), using the victims as food (*Texas Chainsaw Massacre: The Beginning* (Jonathan Liebesman, 2006); *High Lane* (Abel Ferry, 2009)) or as sexual surrogates to propagate a closed community (*Hills Have Eyes 2* (Martin Weisz, 2007); *Timber Falls* (Tony Giglio, 2007); *Dying Breed* (Jody Dwyer, 2008)), exacting personal revenge (*Steel Trap* (Luis Camara, 2007); *Untraceable* (Gregory Hoblit, 2008); *The Horseman* (Steven Kastrissios, 2008)), turning a profit (*Turistas* (John Stockwell, 2006); *Vacancy* (Nimrod Antal, 2007); *Caged* (Yann Gozlan, 2010)), torturing for political purposes (*Torture Room* (Eric Forsberg, 2007); *Senseless* (Simon Hynd, 2008)), or for no clear reason at all (*The Strangers* (Brian Bertino, 2008); *The Collector* (Marcus Dunstan, 2009)). It is therefore obvious that Hicks's (2009) assertion that Torture Porn is driven by 'sadists thriving off extreme physical and psychological torture' is inadequate to encompass the range of films in the sub-genre, since torture cannot serve as a trope by which to satisfactorily categorize them. Moreover, as Morris observes, torture itself 'is by no means the exclusive province of horror' (2010: 45). My aim, then, is to make sense of what Torture Porn is and the terms according to which it has been critically reviled, beginning with the combination of 'Torture' and 'Porn' itself.

'Torture' plus 'Porn': Pushing boundaries and fuelling fires

One reason for the confusion over 'Torture Porn' stems from the conflicting ways in which the term has been applied to such a wide variety of films. On the one hand, the films are said to juxtapose violence with nudity, or emphasize sexual violence such as acts of rape and castration. On the other, they allegedly present non-sexual violence in such gory, close-up detail that their aesthetic is akin to pornography. It is implied

too that the films are consumed as a kind of violent fetish pornography by viewers who are sexually aroused by displays of torture. These definitions do not necessarily concur. In coining the term, Edelstein coupled 'Torture' with 'Porn' as a metaphor implying that contemporary horror is gratuitous to the point of obscenity. The spectacle of violence – the pornographication of torture, in other words – exceeds what is necessary to convey the meaning of the action in the narrative context. Critics thus allege that Torture Porn includes 'gratuitous violence-for-the-sake-of-violence' (Cunin 2007, my emphasis), and that violence constitutes the content (Aftab 2009: 12). These accusations emphasize comparisons between the uses of violence in contemporary horror and the narrative structures of pornography, in which (it is generally assumed) the storyline is only a veiled excuse to show sex. In Torture Porn, according to its detractors, visceral images of suffering are 'the point'.

Using 'porn' to describe horror implies something not just about the content of the images, but also about viewers' interaction with them. When critics describe Torture Porn as presenting violence 'for titillation' (Kirkland 2008: 43), they insinuate that audiences are sexually stimulated by the gore and suffering. One reviewer of the film *Turistas* went as far as to suggest that 'sex criminals should find it inspirational' due to its 'fascination with the mutilation and murder of nubile young women' (N. a. 2007). The leap from portrayal to audience intention here is, as Hutchings observes, a typical strategy employed in 'denigrating the horror genre' and 'arguing that the only people who could actually enjoy this sort of thing are either sick or stupid' (Hutchings 2004: 83). Matters are not helped by the filmmakers themselves discussing the images of violence in terms associated with pornography. Roth referred to the pus-laden removal of Kana's eye in *Hostel* as an 'eyegasm', while Shankland used the term 'money shot' – the depiction of male ejaculation in hardcore pornography – in reference to the torture set-pieces of *wΔz* (Tom Shankland, 2007).

Following this train of thought, reviewers predictably accuse the filmmakers of misogyny and assert that the films' violence is 'directed primarily against women' (Riegler 2010: 27; see also Cochrane 2007: 4; Floyd 2007: 64; Orange 2009: 7). Again, this is rooted in a discursive history surrounding the horror genre: slasher films were mistakenly accused of misogyny in precisely the same terms (Cowan and O'Brien 1990: 187; Saponsky and Moilitor 1996: 46). Allegations of misogyny equally misrepresent the content of Torture Porn. In the 42 films referred to as Torture Porn by three or more major international English language publications, 228 men and 108 women are killed and 275 men

and 136 women injured. As more than twice as many men than women are victims of injury and death, it is clear that simple accusations of misogyny require deeper consideration.

In fact, the 'misogyny' controversy can be traced to two central points in the Torture Porn cycle. The first was *Hostel*'s contrast between nudity in its first half and murder in its latter sequences, which is both uncommon in the cycle and is the point the film critically explores. The second was the poster campaign for *Captivity*, which depicted a woman undergoing a four-stage execution ritual labelled 'Abduction. Confinement. Torture. Termination' (Hill 2007: 8; Leydon 2007: 37; McCartney 2007: 19). It is telling that in these articles, the poster is the focus of negative attention, and virtually nothing is said about the somewhat tame content of the film itself.

These high-profile incidents were pivotal in the labelling of all Torture Porn films as misogynistic, further confirmed by citing the sole nude female in *Saw III* as evidence that all seven *Saw* films are pornographic.

What needs accounting for here is what is at stake in using the term 'porn' so explicitly. As Bernstein observed prior to Edelstein's article, '[t]o say that the depiction of horror can be pornographic is not a novel claim; the problem has been that this criticism has been employed

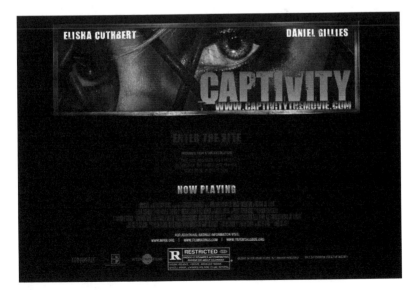

Figure 11.1 The *Captivity* website, featuring the controversial poster

without attempting to distinguish what in the pornographic requires acknowledgement and what denunciation' (Bernstein 2004: 10). The term Torture Porn is remarkably evocative because of the cultural power imbued in the word 'porn', a term that is inextricable from feminist debates that forged a connection between pornography and misogyny. In those debates, long before Torture Porn, asexual horror films such as *The Texas Chain Saw Massacre* (Tobe Hooper, 1974) and rape-revenge films such as *I Spit on Your Grave* (Meir Zarchi, 1978) were explicitly labelled 'porn' (Everywoman 1988: 19). Indeed, Jane Caputi (1992) used the term 'Gorenography' in reference to mainstream horror films fourteen years prior to Edelstein's coining of 'Torture Porn'.

This explains why the term Torture Porn gained so much ground in the mid-to-late 2000s. It articulated much more than a complaint about a particularly gory cycle of horror films. The term connects these films with an important set of contemporary debates about the politics of representation. These debates include Robert Jensen (2007) expressing concern over an apparent increase in cruel and humiliating depictions in the pornography being produced by major studios, as well as Levy (2005) and Paasonen et al. (2007) discussing what they perceive to be an increased tolerance of sexual depictions in culture generally. These arguments uncannily echo the public debates raised by feminism in the 1970s at a moment when, in the era of *Deep Throat* (Gerard Damiano, 1972), explicit sexual representations became popular in a mainstream context.

Here is the crux of the matter. Horror, like pornography, is a popular genre, yet one that is thought properly to belong on the peripheries of culture since its focus on the body is considered 'low-brow' (Hawkins 2007). However, the very nature of these genres is to push boundaries of acceptability. This necessarily involves a complex series of shifts and negotiations, played out via producers, audiences, fans, censors and critics. Indeed the very notion of what is deemed acceptable at any one time is reflected in such contestations. Through this process of boundary pushing and argumentation, what was once peripheral may move towards the centre over time. This movement is marked (usually in retrospect) by the visibility of key texts such as *Hostel*. At some point, the limits of acceptability are deemed (by consensus) to have been breached, and those genres are again pushed out of the mainstream. The boundary-challenging horror of Torture Porn, for example, rapidly moved from occupying a position of box office success (*Hostel*'s $19,556,099 domestic opening weekend gross in 2005 (boxofficemojo. com)) to direct-to-DVD ghettoization. As films have increasingly sought

to push boundaries, they have been subjected to increased censorship, or even outright banning. The British Board of Film Classification recently required cuts to *A Serbian Film* (Srdjan Spasojevic, 2010) and *I Spit on Your Grave* (Steven Monroe, 2010), and rejected *Grotesque* (Koji Shirashi, 2009) and *The Human Centipede 2: Full Sequence* (Tom Six, 2011). In each case, the combination of sex and violence was cited as the reason for censoring.

The use of 'porn' as a label works to illegitimate Torture Porn and demand that body horror retreats to its more 'fitting' position on the outskirts of the cultural radar. Hill, for example, declares that 'the most worrying aspect of this recent slew of films is the fact that they are accepted as the norm' (Hill 2007: 8), while Aftab states that 'at least [splatter] films knew their place in B-movie theatres' (Aftab 2009: 12; see also Cochrane 2007: 4; Skenazy 2007: 13). In highlighting – and scapegoating – Torture Porn as contravening standards of acceptability, the popular press is picking on a highly visible and culturally vulnerable proxy: Torture Porn is a symptom. Its narratives frequently reflect and discuss the role violence plays in culture, even if they simultaneously contribute to that culture. It is unsurprising then that the era in which Torture Porn flourished is also one in which other forms of violent imagery have thrived.

A crisis of meaning: 'Porn' in a time of war

As Alan Sinfield proposes, 'labeling a practice pornographic reflects a decision to regard it as bad', designating what cultural products or practice 'are worthwhile and which are not' (Sinfield 2004). While some of the confusion surrounding Torture Porn arises from a mistaken emphasis on 'porn' as implying sexual depictions, it may be more fruitful to adopt this approach to 'porn' as signifying what offends the moral majority at any given moment. In blurring two categories of representation by combining Torture and Porn, it is connoted that body horror taps into the worst of our culture's fears. In fact, the representations on offer in the multiplex are not the most vivid public images of body horror in the last decade. While those other forms of imagery drive this section, I am interested in the tensions that arise from using 'porn' so loosely as a pejorative term. Increased censoriousness and the apparent shifting of Torture Porn from the multiplex to the DVD market might seem to signal a victory for the moral majority. However, if it is a victory, it is surely a hollow one – first, because such imagery still exists and has a market, and second, because given the wealth of uncertificated imagery made

available via the Internet, it is unlikely that fictional horror film really does significantly contravene normative standards of acceptability.

The porn metaphor is shorthand designed to signal that the violent imagery offered in Torture Porn is offensive. Since Americans are typically 'more offended by sex than violence' (Sandler 2002: 211), using 'porn' to describe violence is particularly evocative. Yet, this approach is too busy pointing at the violence, and fails to deal with the fact that sex is displaced. If violence is now pornographic, it is unclear what position sexual portrayals occupy, or whether they are still perceived as more offensive than violent representations. Furthermore, it is uncertain how we are to describe sexual images if that is the case, since the lexicon of offence has been waylaid. This use of 'porn' problematically implies that sexual depictions (which are commonly grouped under that generic heading) are simplistic, ignoring how complex and multifarious such representations are. It equally fails to account for the new context of 'porn plus horror', and what that combination says about visual representation and its limits.

Indeed, 'porn' has been employed to explain a number of visual representations, being used to describe, for example, some portrayals of poverty, food or architecture during this same period (Lovece 2010; Yong 2010). The term 'porn' clearly signals less about the apparent content of these representations then, and more about the nature of representation itself in this era. If any depictions can be deemed distasteful – and this is the implication of applying 'porn' so liberally – then indecency loses its meaning: positing that anything can be graphic to the point of obscenity is one step away from declaring that nothing is graphic to the point of obscenity. Ultimately, the use of 'porn' in these contexts suggests either that representation is a gratuitous mode, or that a consensus on what is offensive cannot be reached.

One reason this difficulty may have arisen in this era is that the Internet provides greater access to a broader range of visual materials than previously available to domestic users. It has facilitated the distribution of images more befitting of the term 'Torture Porn' than the certificated fictional films labelled as such. One example that coincided with the Torture Porn cycle was the dissemination of 'war porn': images of dead Iraqis distributed by US soldiers, and exchanged on a now defunct subscription website (nowthatsfuckedup.com) which usually traded in images of partially clothed or fully nude women (Harkin 2006; see also Baudrillard 2006 and Ramirez 2010). In this instance, images of death were placed in an otherwise pornographic context, resulting in some confusion over how these images should be classified;

Andén-Papadopoulos has noted, for instance, that 'these images show aggressive fighting by troops who take what appears to be a near-sexual pleasure in violently destroying the enemy' (2009: 923). This politically invested celebration of death in a user generated forum parallels a broader movement in some channels towards exploring freedom of expression: Ogrish.com – which operated until 2006 – offered internet users unprecedented access to images of dead bodies taken from crime scenes, for example, under the slogans 'can you handle life?' and 'uncover reality'.

Part of that exposure involves circulating gruesome imagery that is politically motivated, including the hanging of Saddam Hussein in 2006 and al-Qaeda beheading videos such as that depicting the death of Daniel Pearl in 2002. But it was the series of photographs taken by US soldiers in the Abu Ghraib prison facility in 2004 that gripped the cultural consciousness more than these peripheral examples. Subjected to public scrutiny as evidence of war crimes, the photographs portrayed prisoners being tortured – seemingly without purpose – for the evident delight of the guards in charge of the facility. Many of the poses prisoners were made to adopt were sexually degrading. Again, these photographs are more appropriately labelled 'Torture Porn' than anything offered in the horror cycle.

Representations born of war are inescapably tied into the political circumstances out of which that imagery arose, in a way that the fictional representations of Torture Porn are not. Yet, these images of real-life horror have clearly influenced a number of the directors of Torture Porn films. Eli Roth, Joe Lynch, Zev Berman and Rob Zombie are among the directors who overtly cite images of the War on Terror as influencing the horror films they made in the mid-2000s. Films such as *Torture Room* and *Senseless* explicitly address American-Middle Eastern relations within their narratives. The 'War on Terror' has clearly inspired a number of Torture Porn directors and may have contributed to the popularity of their films.

Scholarly discussion of Torture Porn films predominantly seeks to correlate the cycle of films with these events (see Prince 2008: 282–3; Fletcher 2009: 81; Kattelman 2010; Kellner 2010: 6; Middleton 2010: 3). This is unsurprising given how explicit some Torture Porn directors are in making the same comparison, but I am concerned by this correlation because it has the cumulative effect of closing off meaning. It is so regularly posited that the contentious prevalence of 'War on Terror' discourse explains the significance of the Torture Porn boom that instead of being 'an answer', it appears to be 'the answer' to why these films

came into being. Moreover, there has been little discussion of what it means to translate these images of real violence into a fictional-generic context. In fact, such discussion of Torture Porn scapegoats the cycle in the same way as the pejorative press response, since it points away from the reality that the horror is reflecting and towards the films without dealing with what the real images themselves mean. To correlate Torture Porn with Abu Ghraib images, for instance, inadvertently contributes to the notion that Torture Porn callously translates the reality of war porn into entertainment.

Torture Porn is not simply a means of working through the trauma associated with those real war images, but is itself part of a broader cultural 'trend toward the celebration of cruelty, hurt and humiliation' (Presdee 2000). What needs addressing in these accounts of Torture Porn as reflection or critique of the War on Terror is why those images of real life violence came to cultural prominence during this period, and how they were being engaged with. The economic success of Torture Porn was born out of the same value system that deemed the images of Abu Ghraib to be offensive yet morbidly fascinating. When *Untraceable* depicts a website entitled www.killwithme.com in which the increasing number of active viewers facilitates the death of a bound victim, whose murder is streamed for the spectacle, it is commenting on the culture of viewership that surrounds such material, not simply the origin material itself. *Hostel Part 2* may depict people paying to torture and kill others, but in doing so it comments on American cultural attitudes towards foreign nations and the neo-liberal ideology that money buys inalienable rights and freedoms. That these freedoms in the film include permission to inflict suffering on others for one's own amusement is indicative of the horror underpinning American values, which is the target of Roth's satire. What is needed in Torture Porn criticism is a broader analysis that deals not only with correlations to the historical moment, but with the culture that situates Torture Porn: the kind of analysis Andén-Papadopoulos (2009), Dauphinée (2007), Chouliaraki (2006) and Juvin (2010) offer regarding imagery of real suffering.

The kind of 'humilitainment' present in American culture (Swartz 2006; see also Paasonen et al. 2007) – including the increase in degradation pornography and Reality TV shows such as *Fear Factor* (2001–6) as much as images of Abu Ghraib and Torture Porn – is recognizable and of concern to a number of nations. Far from being simply 'one-note expose[s] created to shock' (Holden 2009: 11), Torture Porn is a reflection of, not simply a reaction to, a host of broader philosophical issues concerning the nature of morality. While Lockwood suggests that

'[t]hese films can be understood as part of a paradigm shift, a 'turn to the extreme' across media and cultural forms' (Lockwood 2008: 41), more needs to be done to investigate precisely what value system is affronted by the presence of 'extreme' imagery: those values by which standards of acceptability are established. After all, imagined evils projected in the safety of a multiplex pale in comparison with the realities of 'war porn'. Since those images of reality-horror are available to us, I am doubtful that Torture Porn is sought out just because of its supposed extremity. In fact, to suggest as much leads to the conclusion that using 'porn' in relation to the certificated (sanctioned/controlled) and immensely popular images of Torture Porn is to empty the term 'porn' of meaning. If anything, the obscenity of the 'porn' aspect of Torture Porn is the cruelty one human being is willing to inflict on another, and this is a more universal theme than the majority of War on Terror readings of Torture Porn account for.

Conclusion: Opening the Torture Porn debate

My aim is not to close off meaning, but to open debate as to the nature and significance of Torture Porn, a cycle of films that instigated a boom in horror production. I opened with Aftab's declaration that Torture Porn is 'possibly the worst movement in the history of cinema' (2009: 12), yet I wish to conclude by fundamentally disagreeing with that assertion. Torture Porn has been vilified on grounds that are at best unconvincing and at worst incoherent. More importantly, critics of the cycle too often ignore the content of the films themselves, and fail to make sufficiently detailed connections between the cycle and the cultural sphere.

In fact, the Torture Porn cycle includes some of the richest and most challenging films in the horror genre, which are notable for their exploration of morality, social interdependency, and witnessing violence. These films should be approached from a range of theoretical positions, not only focusing on torture itself, or the apparent correlation between this sub-genre and the War on Terror. I have, for instance, sought to investigate the complexities of narrative construction and manipulations of time and space in the *Saw* series (Jones 2011). As a fan of the horror genre, I am surprised by how reticent many critics and scholars have been to engage with the wealth of material offered by this horror boom. In the spirit of encouraging discussion, I wish to close with some suggestions for avenues of future study.

In so persistently positing that the Torture Porn boom can be explained via the correlation with the War on Terror, scholars and

the popular press have presented Torture Porn as if it is an American sub-genre, ignoring that images of torture and humiliation have also flourished in horror cinema from France, the UK, Australia, Korea, Japan and Thailand (to name but a few countries) in the last decade. The transnational nature of the genre needs accounting for, since the correlation between American political concerns and this sub-genre implicitly presents America as the normative world-centre. It suggests the specific political concerns raised around the Bush administration are echoed in the cultural products of various nations. Even if that were the case, more needs to be done to work through Torture Porn as a globalized genre. If Roth made *Hostel* as an American response to Abu Ghraib (as he has stated), and his film then influenced filmmakers in other nations – for example Pascal Laugier proposes that *Martyrs* is a response to *Hostel* – then some account needs to be made of the patterns of affect internationally that emerged from these events. Moreover, some account needs to be made of the development of these horror motifs preceding the War on Terror, particularly the influence of Japanese body horror filmmakers on American Torture Porn (evinced by, for instance, the reverential cameo appearance in *Hostel* of Takashi Miike, the Japanese director of cult 'Asian extreme' horror films such as *Audition* (1999) and *Ichi the Killer* (2001)).

Many of the films referred to as Torture Porn do not fit neatly into the genre, or problematize the notion that Torture Porn is a low-brow, popular, multiplex phenomenon. I suggest that another aspect of Torture Porn discourse worth exploring is the way in which some non-English language films such as *The Passion of the Christ* (Mel Gibson, 2004) and *The Stoning of Soraya M.* (Cyrus Nowrasteh, 2008), or violent films made by European auteurs such as Lars von Trier (*Antichrist*, 2009) and Michael Haneke (*Funny Games*, 1997) are treated differently from American genre pictures such as *Hostel*, even when referred to as Torture Porn. These films frequently inspire debate about artistic merit or directorial intention rather than being dismissed. This line between 'art' and 'trash' is tied into broader debates regarding the cultural values attached to the horror genre, to non-English language film, and to transnational cinemas, all of which are exposed by the double-standard operating within Torture Porn discourse whereby 'world cinema' is defensible while horror movies – despite being comparable in content – are not.

There is scope for detailed discussion of how this sub-genre fits into a lineage of horror, accounting for the horror fandom Torture Porn filmmakers so frequently and openly express. Moreover, a detailed study of how horror fan communities have responded to the term would be

fruitful since there seems to be a general distaste for the label manifested in discussions on the online horror forums of Bloodydisgusting. com, Dreadcentral.com, Fear.net, IMDb.com, and so forth. Some horror fans seek to distance themselves from these films on the basis of the press discourse that situates Torture Porn fans as 'perverse'. Direct comparisons to previous horror sub-generic category labels such as 'slasher' or 'video nasty' in terms of the pejorative connotations and patterns of horror fans co-opting such generic labels would be worth exploring.

Critics who dismiss Torture Porn as 'garbage' (Robey 2007b: 31), 'celluloid trash' (Phillips 2010), and 'dumbed-down ... junk' (Conner 2009), miss the richness of the films themselves and the discourse they are contributing to. While that is in some senses a role critics are expected to play, I hope these films will receive more detailed and sustained attention than they have to date from scholars and fans of the genre.

Notes

1. The following directors explicitly discuss this desire to evoke 1970s horror in their DVD commentaries: Steven Shiel (*Mum and Dad*, 2008, Revolver Entertainment release), Eli Roth (*Hostel Part 2*, 2007, Sony Pictures release), Alexandre Aja (*Haute Tension*, 2005, Optimum Releasing release), Chris Smith (*Creep*, 2005, Pathé Distribution release).
2. Roth's commentary on the 2006 Sony Pictures DVD release of *Hostel*, and Shankland's commentary on the 2008 Entertainment One DVD release of *wΔz*.
3. Cited in the respective DVD commentaries for *Hostel 2*, *Wrong Turn 2* (2007, 20th Century Fox release), and *Borderland* (2010, Momentum Pictures DVD release), and the documentary *30 Days in Hell: The Making of The Devil's Rejects* (included on the 2005 Momentum Pictures DVD release of *The Devil's Rejects*).
4. Director interview on the 2009 Optimum Releasing DVD release of *Martyrs*.

References

N. a. (2007) 'Charming Fly Boys Pull Out of a Nosedive', *Daily Mail*, June, 1.

Aftab, K. (2009) 'Don't Lose Your Head', *Arts & Book Review*, 5 June.

Andén-Papadopoulos, K. (2009) 'Body Horror on the Internet: US Soldiers Recording the War in Iraq and Afghanistan', *Media Culture Society*, 31, no. 6, 921–38.

Anderson, J. (2007) 'Subtly Terrifying, Just Like Real Life', *The New York Times*, December 30.

Baudrillard, J. (2006) 'War Porn', *Journal of Visual Culture*, 5, no. 1, 86–88.

Bernstein, J. M. (2004) 'Bare Life, Bearing Witness: Auschwitz and the Pornography of Horror', *Parallax*, 10, no. 1, 2–16.

Blake, L. (2008) *The Wounds of Nations: Horror Cinema, Historical Trauma and National Identity* (Manchester: Manchester University Press).

Caputi, J. (1992) 'Advertising Femicide: Lethal Violence Against Women in Pornography and Gorenography' in J. Radford and D. E. H. Russell (eds) *Femicide: The Politics of Woman Killing* (Buckingham: Open University Press).

Cashmore, P. (2010) 'The Worst Film Movement Ever has Hit Rock Bottom', *The Guardian*, 28 August.

Chouliaraki, L. (2006) *Spectatorship of Suffering* (London: Sage).

Cochrane, K. (2007) 'For your Entertainment', *The Guardian*, 1 May.

Conner, S. (2009) 'Oh, the Horror', St. Joseph News-Press (Missouri), 30 October.

Cowan, G. and O'Brien, M. (1990) 'Gender and Survival vs Death in Slasher Films', *Sex Roles*, 23, nos. 3/4, 187–196.

Cunin, M. (2007) 'Slasher Movies Depart from Creative Classics, Desensitize Audiences', *Daily Gamecock*, 29 October.

Dauphinée E. (2007) 'The Politics of the Body in Pain: Reading the Ethics of Imagery', *Security Dialogue*, 38, no. 2, 139–55.

Di Fonzo, C. (2007) 'Gross Cinema: Waiting for the Gore Fad to Pass', *Intelligencer Journal*, 26 October.

Dworkin, A. and MacKinnon, C. (1988) *Pornography and Civil Rights: A New Day for Women's Equality* (Minneapolis, MN: Organizing Against Pornography).

Edelstein, D. (2006) 'Now Playing at your Local Multiplex: Torture Porn', New York, http://nymag.com/movies/features/15622/, date accessed 2 December 2008.

Egan, K. (2007) *Trash or Treasure? Censorship and the Changing Meanings of the Video Nasties* (Manchester: Manchester University Press).

Everywoman (1988) *Pornography and Sexual Violence: Evidence of the Links* (London: Everywoman).

Fletcher, P. (2009) 'Apocalyptic Machines: Terror and Anti-Production in the Post-9/11 Splatter Film' in L. Franklin and R. Richardson (eds) *The Many Forms of Fear, Horror and Terror* (Oxford: Inter-Disciplinary Press).

Floyd, N. (2007) 'Close up – Could critics of "torture porn" at least watch the movies?', *Time Out*, 20 June.

Gordon, B. (2009) 'Torture Porn should have no Place in a Theme Park', *The Daily Telegraph*, 16 April.

Harkin, J. (2006) 'War Porn', *The Guardian*, 12 August.

Hawkins, J. (2007) 'Sleaze Mania, Euro-Trash and High Art' in M. Jancovich (ed) *Horror: The Film Reader* (London: Routledge).

Hays, M. (2010) 'Rape-Revenge Remake Cranks up the Volume', *Globe and Mail*, 10 July.

Hicks, T. (2009) 'Horror Films Reflect the Times', *San Jose Mercury News*, 21 October.

Hill, C. (2007) 'Welcome to the Meat Factory', *Western Mail*, 22 June.

Holden, S. (2009) 'Cultures and Sexes Clash in the Aftermath of a Rape in Turkey', *The New York Times*, 7 August.

Hutchings, P. (2004) *The Horror Film* (Harlow: Pearson).

Jensen, R. (2007) *Getting Off: Pornography and the End of Masculinity* (Cambridge, MA: South End Press).

Johnson, K. C. (2007) 'Dissecting Torture Brutal Horror Movies Arouse Viewers, but Filmmakers Reject the "Porn" Moniker', *St. Louis Post-Dispatch*, 26 October.

Jones, S. (2011) '"Time is Wasting": Con/sequence and S/pace in the *Saw* Series', *Horror Studies*, 1, no. 2, 225–39.

Juvin, H. (2010) *The Coming of the Body* (London: Verso).

Kattelman, B. (2010) 'Carnographic Culture: Maerica and the Rise of the Torture Porn Film' in M. Canini (ed) *Domination of Fear* (New York: Rodopi).

Kellner, D. (2010) *Cinema Wars: Hollywood Film and Politics in the Bush-Cheny Era* (Oxford: Wiley-Blackwell).

Kirkland, B. (2008) 'Something about the Girl Next Door', *Toronto Sun*, 21 January.

Kohm, S. A. (2009) 'Naming, Shaming and Criminal Justice: Mass-Mediated Humiliation as Entertainment and Punishment', *Crime Media Culture*, 5, no. 2, 188–205.

Lehman, P. (2007) 'You and Voyeurweb: Illustrating the Shifting Representations of the Penis on the Internet with User-Generated Content', *Cinema Journal*, 46, no. 4, 108–16.

Leith, S. (2010) 'Freddy Krueger had the Third-Best Melty Face in Film. It's Nice to See him Thriving', *The Guardian*, 3 May.

Levy, A. (2005) *Female Chauvinist Pigs: Women and the rise of Raunch Culture* (New York: Free Press).

Leydon, J. (2007) 'Captivity', *Variety*, 23 July.

Lockwood, D. (2008) 'All Stripped Down: The Spectacle of Torture Porn', *Popular Communication*, 7, no.1, 40–8.

Lovece, F. (2010) 'A Final Cut?', *Newsday*, 24 October.

Maher, K. (2010) 'Gloom Raiders', *Times*, 2 October.

McCartney, J. (2007) 'Cut it Out', *The Sunday Telegraph*, 1 July.

McEachen, B. (2010) 'Plenty of Guts but no Glory', *Sunday Herald Sun*, 31 October.

Middleton, J. (2010) 'The Subject of Torture: Regarding the Pain of Americans in Hostel', *Cinema Journal*, 49, no. 4, 1–24.

Morris, J. (2010) 'The Justification of Torture Horror: Retribution and Sadism in *Saw*, *Hostel* and *The Devil's Rejects*' in T. Fahy (ed) *The Philosophy of Horror* (Lexington: University Press of Kentucky).

Murray, G. (2008) '*Hostel II*: Representations of the Body in Pain and the Cinema Experience in Torture Porn', *Jump Cut*, 50, http://www.ejumpcut.org/archive/jc50.2008/ TortureHostel2/index.html, date accessed 22 June 2011.

Newman, K. (2009) 'Horror Will Eat Itself', *Sight and Sound*, 19, no. 5, 36–9.

Orange, M. (2009) 'Taking Back the Knife: Girls Gone Gory', *The New York Times*, 6 September.

Paasonen, S., Nikunen, K. and Saarenmaa, L. (eds) (2007) *Pornification: Sex and Sexuality in Media Culture* (London: Berg).

Patterson, J. (2007) 'If only … Horror Directors wouldn't use Dodgy Subtexts to Justify their Gore', *The Guardian*, 23 June.

Phillips, M. (2010) 'BAFTA Fawns over Tarantino, but his Stomach-Churning Film is Still Giving me Nightmares', *Daily Mail*, 22 February.

Presdee, M. (2000) *Cultural Criminology and the Carnival of Crime* (New York: Routledge).

Prince, S. (2008) *Firestorm: American Film in the Age of Terrorism* (New York: Columbia University Press).

Radford, J. and Russell, D. E. H. (eds) (1992) *Femicide: The Politics of Woman Killing* (Buckingham: Open University Press).

Ramirez, J. (2010) 'Carnage.com', *Newsweek*, 155, no. 19.

Riegler, T. (2010) 'We're All Dirty Harry Now: Violent Movies for Violent Times' in M. Canini (ed) *Domination of Fear* (New York: Rodopi).

Robey, T. (2007a) 'It's not Scary – Just Revolting', *The Daily Telegraph*, 27 June.

Robey, T. (2007b) 'Film on Friday', *The Daily Telegraph*, 22 June.

Sandler, K. R. (2002) 'Movie Ratings as Genre: The Incontestable R' in S. Neale (ed) *Genre and Contemporary Hollywood* (London: BFI).

Saplonsky, B. S. and Molitor, F. (1996) 'Content Trends in Contemporary Horror Films' in J. B. Weaver and R. Tamorini (eds) *Horror Films: Current Research on Audience Preferences and Reactions* (New Jersey: Lawrence Erlbaum).

Schiesel, S. (2009) 'No Mercy and Ample Ways to Die', *The New York Times*, 12 October .

Sinfield, A. (2004) *On Sexuality and Power* (Columbia: Columbia University Press).

Skenazy, L. (2007) 'It's torture! It's porn! What's not to like? Plenty, actually', *Advertising Age*, 28 May.

Slaymaker, G. (2008) 'Film Reviews; the Movies', *Western Mail*, 23 May.

Smith, Anna Marie (1993) 'What Is Pornography? An Analysis of the Policy Statement of the Campaign against Pornography and Censorship', *Feminist Review*, 43, no. 1, 71–43.

Swartz, S. (2006) 'XXX Offender: Reality Porn and the Rise of Humilitainment' in L. Jervis and A. Zeisler (eds) *Bitchfest* (New York: Farrar).

Tait, S. (2008) 'Pornographies of Violence? Internet Spectatorship on Body Horror', *Critical Studies in Media Communication*, 25, no. 1, 91–111.

Yong, S. H. (2010) 'Many Sides of Porn', *Straits Times* (Singapore), 21 October.

12

The Beast Within: Materiality, Ethics and Animal Porn

Susanna Paasonen

Pornography has often been assumed to lack variety, value, quality, and complexity, and is usually seen as being at the bottom of the aesthetic hierarchy. But pornography is itself distinguished by inner hierarchies which rank artistic creations and porn with high production values higher than gonzo, reality and extreme pornographies. Animal pornography – also known as bestiality or sexual zoophilia – occupies the lowest levels of the strata as an illegal, or at best semi-legal, niche. This chapter explores the interconnections of bestiality and porn in the historical framework of human–animal relations – in relation to taboos and prohibitions that concern 'unnatural acts' and 'acts against nature,' and to the category of the human as it is defined and marked against and through its animal others. By considering spam email adverts for animal porn sites,[1] 'zoo porn' sites and a viral video, I investigate the interconnections of filth, transgression, and authenticity in animal porn as they tie into questions of materiality and ethics.

The canine stain

In a 1972 'loop' – a silent 8mm stag film titled *Dog 1* (or *Dog Fucker, Dog-A-Rama, Dogorama*) – Linda Marciano, soon to become Lovelace and the star of *Deep Throat* (Gerard Damiano, 1972), had sex with an Alsatian-like mutt (O'Toole 1998: 65). After the phenomenal success and mainstream visibility of *Deep Throat*, the first porn film to be shot on 35 mm film and exhibited to a mixed cinema-going audience, the loop gained considerable and lasting subcultural fame. In her memoir, Ordeal, Lovelace writes about making the film at gunpoint.

> If I could have foreseen how bad it was going to be, I wouldn't have surrendered. I would have chosen the possibility of death. I am able

to handle almost everything that has happened to me in my life ...
but I'm still not able to handle that day. A dog. An animal. I have
been raped by men who were not better than animals, but this was
an actual animal and that represented a huge dividing line.

(Lovelace and McGrady 2006: 111)

In Lovelace's account, pornography is a realm of bestial men and
degrading acts performed on women while bestiality itself stands for
ultimate disgrace and filth. The film acquires heavy symbolic meaning
as the worst moment of her life and complete abasement by her violent
husband and manager, Chuck Traynor: 'There were no greater humili-
ations left for me. The memory of that day and that dog does not fade
the way other memories do. The overwhelming sadness that I felt on
that day is with me at this moment, stronger than ever. (Lovelace and
McGrady 2006: 114). This is an image of the ultimate humiliation –
of grief, sadness, and disgust – that has been effectively mobilized in
anti-pornography campaigns such as those that Lovelace took part in
(Lovelace and McGrady 1986: 193–5). Being coerced to have sex with
an animal could be seen as an extension of the domestic abuse that
Lovelace documents as having suffered throughout her marriage.[2] Here
it becomes firmly associated with, and anchored in pornography that
is then characterized by depravity, subordination, and the systematic,
violent degradation of women.

Legitimacy, being socially recognized and even valued, is a recurring
trope in autobiographical texts by North American porn performers
and producers: respectability is a kind of Grail searched for in vain by
performers as diverse as Lovelace, Traci Lords and Ron Jeremy. While
Lords made a transition to TV, Hollywood productions and singing,
and Jeremy has achieved a kind of semi-legitimacy at the fringes of
mainstream popular culture (Shelton 2002), Lovelace's project failed.
As she tried to leave X-rated films, she found herself haunted by the
shadow of the dog film, which Al Goldstein of *Screw* had made public in
1973. References to bestiality resurfaced in interviews with her for years
to come and the mark of 'dog fucker' refused to wear off (McNeil and
Osborne 2005: 47–51, 99–101). Once the 'huge dividing line' separating
humans from animals had been crossed, the sexual act performed and
recorded on film, Lovelace was stigmatized in ways that prevented her
from exiting the lower sediments of the pornographic.

This anecdote points to several issues that are central in terms of ani-
mal pornography. First, it illustrates the role of bestiality as one of the
extremities of porn – an area of taboo that is considered both disgusting

and fascinating. Second, it indicates the rhetorical uses of bestiality as a symbol for pornography as dehumanizing. Third, the ethical considerations involved have mainly to do with the agency of the female performers whereas that of the canine has been less of an issue. Rewarded for his performance with dog biscuits, the mutt remains an alien other in Lovelace's account, a repelling creature similar to its owner and the people later watching the film. Fourth, the anecdote speaks of explicit boundary work, and traffic, between the categories of the human and the animal.

Insatiable, uncontrollable beasts

Describing men as 'not better than animals,' Lovelace refers to interspecies boundary work where the human is posed as an ethically, morally, and intellectually superior breed that may nevertheless fall to the level of beasts. This resonates with Western cultural history in which 'animal passions' have been central to the demarcation of the human and the animal since antiquity. Plato, for example, assumed that animals have no sense of reason or justice. As Gillian Clark (2000: 88) notes, according to this logic, '"animal passion" is fierce and overpowering. Animals are beasts. They are savage and antisocial. They cannot control their passions by reason and are unrestrained by respect for others, by a sense of fairness or by social order'.[3] In the seventeenth century, René Descartes, addressing the ways in which men (like animals, those automatons driven by immediate sensations) are animated by passions, emphasized the centrality of controlling one's passions, of being their master (Harrison 1992). The separation of 'man and beast' has also been firmly established in Christian theology, echoing the binary division of soul and flesh, mind and matter. Animals have been intimately identified with the sensory whereas, especially in Christian thought, the senses have been considered as the lower, bestial, component of man (Connor 2006). If the human senses are considered properties to be used, animals have been seen as ruled by their senses.

All this is not to say that the notion of animal passions has been uncontested as a means of creating hierarchical divisions where the human stands firmly at the top (see for example Derrida 2008). Porphyry, writing in the third century, argued that not only are animal passions evidence of the likeness of humans and animals, but that human lust is much more unbridled than that of animals: humans procreate when drunk and for the sake of the act itself, whereas animals do so for the sake of offspring (Clark 2000: 91). According to this idea,

morally correct forms of sexual behaviour involve the reproduction of the species. Similar lines of reasoning have reoccurred when marking out so-called natural sexual acts. The broad categories of 'unnatural acts', 'fornication against nature', 'sodomy', and 'buggery' have been, and still are, used in marking bestiality, anal and oral sex apart from acceptable forms of heterosexual coitus (Bolliger and Goetschel 2009). According to Christian notions, unnatural acts involving no procreative function are about the mere 'emission of seed' (Beirne 1997: 322; Laqueur 2003: 14–15). But while bestiality may have been forbidden in the Bible, it was only mildly punished until the 16th century. With modernity, the boundaries of human and animal became more elastic due to advances in the natural sciences and discoveries of 'monstrous races' in the colonies: and as 'animals were moving ever closer ... beasts became a threat' (Fudge 2000: 22). Fears concerning the status of humanity gave rise to acts of policing its boundaries against its various 'intimate others' (Rydström 2003: 1, 29–30). Bestiality became articulated as an act 'beyond words,' a sin against God and nature alike that threatened to pollute the species. Given its seriousness, it was punishable by the death of both the animal and human parties (Beirne 1997: 320; Fudge 2000: 21–3). Yet bestiality has also been considered less taboo and harmful than masturbation, an activity associated with various degenerative effects (Rydström 2003: 64–5; Laqueur 2003).

These 'unnatural acts' may have involved women and men, same-sex couples, or humans and animals: regardless of the exact constellation, they have been seen to break against the natural order of things. Legislation concerning homosexuality, anal, and oral sex has changed in most Western cultures since the mid-twentieth century while the focus of legislation concerning bestiality has shifted from the abuses of property rights and the moral universe towards animal rights and ethics. Animal porn is illegal in most Western countries on the basis of both obscenity and animal cruelty legislation, while bestiality has been identified as a psychopathology (Beirne 1997: 323–4; Earls and Lalumière 2002; Bolliger and Goetschel 2009). Meanwhile, advocates of sexual zoophilia have aimed to rearticulate it as a consensual lifestyle.[4]

Bestiality has been established as taboo at least since the early modern period, which may also explain some of its force, and appeal, as a pornographic genre. Writing on taboo and sexuality, Georges Bataille (1986: 256) argues that 'desire in eroticism is that of transgression of the taboos. Desire in eroticism is the desire that triumphs over the taboo. It presupposes man in conflict with himself.' Acts of transgressing taboos give rise to inner conflict that produces intense desire and pleasure

(Bataille 1986: 63–4, 107). Rather than losing their power or becoming undone in acts of breaching, taboos become both stronger and redrawn, since transgression 'suspends a taboo without suppressing it' (Bataille 1986: 36). Similarly Emile Durkheim has argued that norms themselves give rise to deviance—the 'policed boundaries of acceptability' come to face 'contestation, resistance, and transgression' (Langman 2004: 193; see also Jenks 2003: 16–32). Transgression both exceeds and supports the boundaries in question, as every 'rule, limit, boundary or edge carries with it its own fracture, penetration or impulse to disobey. The transgression is a component of the rule' (Jenks 2003: 7).

Sexual acts once deemed unnatural (from masturbation to anal and oral sex) have became standard fare whereas bestiality has not lost its social stigma. As a genre, pornography involves, and indeed dwells on, the breaching of boundaries, but bestiality represents one of the ultimate sexual taboos. Its taboo nature evokes reactions of disgust, disbelief, abhorrence, ridicule, indifference, and voyeuristic curiosity (Beetz 2009a: 46; 2009b: 98, 115). Bestiality is the focus of jokes, anecdotes, and innuendo as suggested by the inflatable sheep sex toys catered to bachelor parties or the apocryphal stories of the Empress Catherine the Great of Russia satisfying her insatiable desire with the aid of stallions. In the former example, the inflatable sheep, safe in its plastic shape designed to amuse rather than gratify, is a hypothetical channel for the assumedly omni-directional sexual drives of young men ('stags'). In the latter, sexual desire for horses can be seen as a hyperbolic reaction to the power of a female sovereign departing from conventions of gendered demeanour in the eighteenth century. Bestiality involves taboos meant to protect the intactness of the category of the human while, at the same time, they call for acts of breaching.

Back at the ranch

Spam email adverts for the site *Spunk Farm* feature photo collages with horses, women being penetrated by, sucking on, and licking penises (of species mostly impossible to define), with semen covering their cheeks. The images are accompanied by sentences highlighting the visual spectacle: 'Barnyard Babes Getting Creamed!'; 'Nasty Girls Getting Down and Dirty!!'; 'Sick & degenerate hardcore!'; 'Amazing, bizarre, nasty XXX!!!;' 'Spunkfarm—where harvesting cum is the most important thing!'; 'Girls will do anything for a load!!!' In the site logo, letters forming the word 'spunk' simulate the oozy texture of semen while the letters in 'farm' are rope-like in appearance: www.spunkfarm.com incorporates horseshoes and wooden textures. The popularity of the

term 'farm' in animal porn sites (for example, www.farmgirls.com, www. farmsex.com, farmsexshow.com, kinkfarm.com) owes to the infamy of *Animal Farm*, an underground bestiality video produced sometime between the late 1970s and early 1980s, and distributed on VHS.[5] The notoriety of *Animal Farm* is based on the description of the few who claim actually having seen it. In the TV documentary *The Real Animal Farm* (Molly Mathieson, 2006), for example, it is described as 'an evil, evil scumbag' and disturbing enough to make 'hard lads' either exit the room or vomit. *Animal Farm* stands for disturbing extremity and some of this aura also seems to stick to farm porn sites. The lexicon of 'nasty,' 'dirty,' 'sick,' and 'degenerate' deployed in the spam adverts frames the sites as 'amazing,' 'bizarre,' and hence attractive in its extremity. The terminology connects the human, the animal, fellatio, penetrative sex, degeneration, sickness, and plain nastiness in an extreme and taboo-defying pornographic spectacle. The co-articulation of image and text in the adverts amplifies a sense of hyperbolic nastiness and titillation.

The absence of male performers in the spam adverts may seem surprising. In the realm of commercial pornography this is much less of a surprise, since these sites are more indicative of how bestiality is 'mainstreamed' to consumers of online porn, than of animal porn as a subgenre. Zoophiles have made use of online forums from newsgroups to websites for sharing experiences, images, videos, and information on sex techniques (Miletski 2009: 18; Beetz 2009b: 114). Farm sites that place young female bodies firmly at their centre are a case apart. They can be associated with the logic of distinction central to online porn and the perpetual promise of novelty that contributes to its constant fragmentation. As the palette of online pornography widens in order to create new niches and markets, and as 'the mainstream' stretches to incorporate previously marginal subcategories, the overall visibility of fetishes and extremities increases (Patterson 2004: 106–7). Sites of the *Spunk Farm* kind seem to be produced for a broader audience desiring to see something extraordinary and bizarre (Beetz 2009: 116).

The advert for *Farm Girls* displays two images against a black background: in the first one, a young blonde woman holds a penis on top of her face covered in semen, and in the second, two women lick a penis dangling above them in what appears to be a barn. The penises are mostly covered with a black oval shape with the text 'censored' spelled in white block letters. Between the two images, captions read:

Forbidden XXX hardcore
Banned in over 51 states.

You've never seen anything like it!
Nasty, desperate country girls who will do anything for cock. The bigger the better!
NOTHING is too TABOO for these young sluts.
THE MOST SHOCKING & UNBELIEVABLE SEX ACTS.
You won't believe it till you see it!
CLICK HERE to live out your wildest fantasies!

The 'nastiness' and 'dirtiness' of interspecies sex is underscored in close-up photos of female faces, animal genitalia, and semen: women, more than the animals, become figures for the taboo. As Jack Sargeant (2006) points out, the figure of the 'nasty girl' is central to contemporary hard-core that aims to constantly push the boundaries of that which can be acted out and shown on the screen: nasty girls act out nasty things, and nastiness is their claim to fame. In the ad for *Farm Girls*, the realm of unbridled animal passions is juxtaposed with both promises and threats of censorship, illegality, and banning. These become guarantees of the shocking and extreme nature of the acts depicted, while also marking them as forbidden fruit. The last caption, however, suggests that the scenarios on offer involve the staging of desires and fantasies concerning, rather than originating from, the 'nasty, desperate country girls' and their animal companions.

The adverts for *Extreme Sex* feature an animation of a brunette woman sucking on the penis of a great Dane, and promise access to an 8-minute video of this; 'Watch Me F-U-C-K My Dog On Video!' and 'Watch Me Get F-U-C-K-E-D By the Familay [*sic*] Dog!' The senders of the messages are marked as female: 'Susan Fox' and 'Nikita Faust' suggest coy animal features and daemonic qualities with Slavic undertones, respectively. As is common in porn spam email, the female first person invitation disappears in the body of the message which refers to 'extreme sex,' 'Dutch Teen fucking her dog,' and 'Download movie.' This shift in address reframes the potential desires involved: as in the *Farm Girls* advert, they are attached to viewer curiosity and titillation, rather than the inclinations of Susan Fox and Nikita Faust.

Online animal porn tends to feature domestic animals (dogs and cats) and domesticated farm animals (horses, cows, donkeys, goats, etc.), rather than wild, uncontrollable beasts. In other words, the crossing of the inter-species boundary occurs in a highly safe and controlled framework for the human agents. The same goes for the range of animals historically involved in bestiality: companion animals, farmyard animals, livestock, and animal labourers such as cows, horses, sheep,

goats, pigs, chickens, turkeys, and, in urban settings, dogs, cats, and even rodents such as hamsters have been used for sex (Beirne 1997: 328; Rydström 2003; Beetz 2009a: 59; 2009b: 106–8). Such animals are in human possession and under human control in terms of their everyday bodily functions and lifespan. In this sense, bestiality is a variation of their position as someone's property—thing-like rather than 'subjects of a life' (Bekoff 2006: 9). Tame and close enough to be safe, the animals pose little danger to the human performer for whom the risk lies in the defiance of human taboos, laws, and norms concerning sexuality.

How to form consent with an eel?

The 30-second viral porn video *2 Guys 1 Horse*, named after the equally infamous viral video *2 Girls 1 Cup*, shows a man being anally penetrated by a stallion. The infamy of the video – which is in all likeliness the most widely known instance of online animal porn—owes to the fact that Mr. Hands, the human performer in question, died of internal bleeding caused by a perforated colon soon after the video was shot near Enumclaw, Washington, in 2005.[6] The video is an amateur record of the event and it has been distributed as extreme and shock pornography with the intention to shock and disgust, rather than to sexually arouse its viewers. The video sharing site YouTube hosts numerous reaction videos shot by people watching the video (either alone or in company), experiencing visceral gut reactions and expressing them with exclamations such as 'ewww!' and 'no way, man!' The disturbing qualities of the video owe to its status as a semi-snuff film – for actual bodily harm is occurring in it – but equally to the spectacle of male anal penetration where a horse is the active partner. *2 Guys 1 Horse* seems to be about animal passion out of control, this passion connecting Mr. Hands, the 'gay horse' and the man behind the camera. This impression begins to change, however, when considering that Mr. Hands trained the stallion to penetrate him: the animal passions in question were, then, very much human.

The basic ethics of pornography involves informed consent—that is, the parties should be of the age of consent and perform out of their own choice. This raises some fundamental, albeit potentially banal, questions concerning animal porn: for how exactly does one form consent with, say, an eel? To what degree are acts performed by a canine in return for a dog biscuit or the routines of the abovementioned stallion based on consent? It might just be, as Piers Beirne (1997: 325–6) argues, that we 'will never know if animals are able to assent – in their

terms – to human suggestions for sexual intimacy.' The term 'animal love,' used by some as synonymous with bestiality, marks the activity as taking place between consenting and loving partners (Bolliger and Goetschel 2009: 40) in what can be seen as the anthropomorphic attribution of 'human mental states (thoughts, feelings, motivations, and beliefs) to nonhumans' (Serpell 2005: 122). While I am certainly an advocate of interspecies interaction and attachment that challenges the ideological and ontological 'Great Divides' between the animal and the human (Haraway 2008: 15–16), I find little in the examples of animal pornography that I have encountered to challenge the separateness of these categories, let alone the control of the human over the animal, or the projection of human desires onto nonhumans. On the contrary, the boundary of the human and the animal tends to be rendered spectacular—consider, for example, the links in the web directory beastheaven.com that describe 'Cute little farmgirl eating pony cum,' 'Chunky woman fucking the family dog,' and a 'Farmslut sucking a black donkey cock.'

On the one hand, animals are depicted as objects of sexual activity (as 'sucked' or 'fucked'). They are made to embody hyperbolic, deeply and exclusively human notions of difference, lust, filthiness, transgression, taboo, and unbridled desire, on the other. These are not instances of curiosity about what animals may do, feel, think, or enable humans to do, feel, or think (Haraway 2008: 20). Speaking of the pleasure or desire of animals in porn is very much a ventriloquist act of the kind that Donna Haraway (1992: 311–3) addresses in the context of nature: people speak for animals-as-dummies, say things in their name since animals, for the most part, cannot articulate things for themselves. Such ventriloquism, speaking for others by taking their place, is representative of the continuum of Western human–animal relationships as ones of domination and the exercise of power-knowledge, rather than a departure towards less hierarchical arrangements. These articulations are more telling of the human than the animal, for, as Harriet Ritvo (1991: 70) points out, 'animal-related discourse has often functioned as an extended, if unacknowledged metonymy, offering participants a concealed forum for the expression of opinions and worries imported from the human cultural arena.' Animals function as objects of, extensions and mirrors for human senses and desire, and at the same time as symbols of otherness that mark the boundaries of human sociability, and are fetishized as such.

The elastic boundary separating the human from the animal is drawn largely on the basis that reason and language are properties that are

unique to, and characteristic of the human, whereas the affective – 'animal passions' and the sensory in general – represents the mutual ground between the species. If animals 'speak' through their bodies rather than through the means of language (Cummings 1999: 27), then the carnal exchanges of porn would seem to erode the carefully constructed boundaries separating the species. This is especially the case given the positive value attached to raw and unbridled lust within the genre where people, driven by animal passions, turn into bitches and studs.

Taboos are a specific feature of human sexuality. Sexuality is a matter of discourse, of 'sociohistorical material conditions' (Barad 2007: 147): a fundamentally human framework of intelligibility, and form and source of knowledge, identification, and categorization. As an assemblage of drives, desires, taboos, identifications, labels, and practices, sexuality is very much a human construction, and a relatively recent one (Foucault 1990; Laqueur 1990). It is not the best of frameworks for understanding animal motivations. One alternative would be to consider sexual acts as nodes in a broader nexus of bodily sensations and acts – as parts of an undifferentiated carnal way of being in and experiencing the world. Rather than being presented as an issue of 'animal sexuality,' bestiality could then be addressed as an issue of integrity and agency for both the animal and human performers: that which they perform or are made to perform, under what conditions, and how these performances increase or diminish their powers of activity.

Like Beirne (1997: 324), I find it problematic to limit considerations of bestiality to an anthropocentric position while bypassing the position, agency, and role of the animal party. Rather than disturbing the hierarchical relations of humans and (other) animals, animal porn seems to work the other way by making the animals perform according to human scenarios, scripts, and choreographies. Discussing animal porn as exemplary of such renegotiation efficiently blocks from view the ethical stakes involved in interspecies relations, such as the respect for and integrity of the animal partners, their volition and characteristic behaviour. The animals become mirrors for human desires, sexual transgression and extremity, as well as objects for performing them. This is less exemplary of anti-humanist dismantling or critique of the historical ideologies and institutions based on the premise of human specificity and superiority, than it is of exercising power over animal 'others.' Lauren Berlant (2006: 21) points out that investments in objects or scenes of desire 'and projections onto them are less about them than about a cluster of desires and affects we manage to keep magnetized to them.' When 'we talk about an object of desire, we are really talking

about a cluster of promises we want someone or something to make to us and make possible for us' (Berlant 2006: 20). What then are animals as objects of desire performing in the context of pornography? What kinds of desires and affects are magnetized to them?

Authenticity and materiality

In a short journalistic interview I made in the mid-1990s on the uses of pornography among university students, a male respondent announced his preference for animal porn. When asked for his reasons, he identified the sense of realness and authenticity that it entails. Regular pornography is performed and produced by actors skilled in simulation and there is no guarantee of the realness of the acts and sensations displayed. But animals do not pretend or lie – their arousal and climax is for real. This view seems to echo that of Descartes who saw animals as driven by passions they are unable to control, let alone simulate (Harrison 1992). Consequently, animal porn approximates or even stands in for 'the real' as images of raw sex. Realness and authenticity is central in understanding pornography. In animal porn, realness refers to the unstaged, the animalistic (or indeed, bestial), nastiness, and lack of gloss. It appears to carry the status of pre-sentation (mere showing) over representation (the mediated). In addition to the properties of the images and the gut reactions they evoke, realness is also a question of production and its material conditions.

Since the production and distribution of animal porn is illegal in many states and countries, most of the material available through zoophilic portals and web directories is amateur. Independent of the exact nature of emotional or sexual relations between animals and their owners – as elaborated in various documentary films on zoophilia – the acts recorded and circulated online are detached from possible intimacies and affective attachments. There is little to see except for the act itself. Indeed, intimacies and emotional bonds are not the stuff of pornography in general, for the genre is not primarily preoccupied with issues such as psychological complexity or character motivation.

In much online porn, visual and textual hyperbole and excess create a sense of artifice, of 'as if.' In the case of animal porn, some of this distance disappears and I find myself inescapably bound to questions of production and agency – who performs what, with whom, and under what conditions. The notions of presentation and representation also become blurry because of ethical considerations: the images document something I cannot, and do not want to, approach as a mere question of diegesis. This response may seem close to those of anti-pornography

authors arguing for porn as material acts and forms of abuse (e.g. Mason-Grant 2004). I am not, however, arguing that the women performing in animal porn must have been either fooled or forced—and that they are in any case abused—but that the impossibility of informed consent with animals renders animal porn unethical by default. A woman and a goat in a 'goat-play' video are not simply labourers of similar standing or agency: the goat, unlike the woman, is not taking up a role as work, nor does it have the option to refuse sexual advances.

In terms of ethics and pornography, the contexts for producing and circulating porn cannot be avoided for the simple reason that pornography's raison d´être is to dwell on the materiality of bodies, the resonances that occur in between the bodies performing and watching, and the technologies of recording, distributing, and consuming porn. Porn involves the organization and division of labour, particular forms of commodity production that are obscured if conceptualizing the products as mere 'texts' (cf. Villarejo 2003: 10). Issues of materiality are tied in with ethics in shifting focus to the physicality of bodies (be they animal or human), the conditions of their agency, and the desires that are magnetized onto them.

Animals in online porn symbolize and embody the transgression of sexual taboos concerning interspecies acts, unbridled sexual drive and lust, authenticity, presence, as well as the degeneration and humiliation of their human, and especially female partners. Unsurprisingly yet – at least for me – disturbingly, the desires and affects magnetized to them revolve very much around human sexuality, its shapes, boundaries, and frontiers. Although quintessential and central as porn performers, the animals are ultimately extras in the displays of desire and pleasure offered in pornography. They are symbols of simple lust while, like shoes, accessories, or body hair, they also occupy the role of fetishes as objects, rather than subjects of desire.

Notes

1. These ten adverts are part of an archive of 366 spam adverts collected in 2002–4. Two of these are for the video *Dutch Girl with Dog* and eight others for farm sites: *Spunk Farm, Girl Ranch, Farm Girls, Jungle Girls* (these four sites no longer exist), *Kink Farm* (http://kinkfarm.com/), and *Real Farm Sex* (http://www.realfarmsex.com/).
2. Cases of women being forced to perform similar sexual acts have been documented as incidents of domestic violence (Beetz 2009a: 55).
3. This figure is also one of unbridled sexuality, as in the mythological figures of satyrs. In ancient Greece these companions of Dionysus were visualized as

having perpetual and impressive erections. In ancient Rome they morphed into figures half human, half goat, and were often depicted in sexual congress with goats (Kendrick 1996: 6, 237). A boundary creature such as satyr is a figure for transgressive and ultimately uncontrollable sexuality driven by raw, animal passions.

4. See Beetz 2009b: 99–103. These perspectives have been depicted in documentary films such as *Animal Love* (Ulrich Seidl, 1995) and *Animal Passions* (Christopher Spencer, 2004).
5. The episodic film was a patchwork made from Danish 8mm and Super 8 films produced by Color Climax (the largest Danish porn production company) since 1969, and possibly also Alex de Renzy's 1971 *Animal Lover*, shot in California.
6. The story of Mr. Hands is depicted in the semi-documentary film *Zoo* (Robinson Devor, 2007).

References

Barad, K. (2007) *Meeting the Universe Halfway: Quantum Physics and the Entanglement of Matter and Meaning* (Durham: Duke University Press).

Bataille, G. (1987) *Erotism: Death and Sensuality*, trans. M. Dalwood (San Francisco: City Lights Books).

Beetz, A. M. (2009) 'Bestiality and Zoophilia: Associations with Violence and Sex Offending' in A. M. Beetz and A. L. Podberscek (eds) *Bestiality and Zoophilia: Sexual Relations with Animals* (Oxford: Berg).

Beetz, A. M. (2009) 'New Insights into Bestiality and Zoophilia' in A. M. Beetz and A. L. Podberscek (eds) *Bestiality and Zoophilia: Sexual Relations with Animals* (Oxford: Berg).

Beirne, P. (1997) 'Rethinking Bestiality: Towards a Concept of Interspecies Sexual Assault', *Theoretical Criminology*, 1, no. 3, 317–40.

Bekoff, M. (2006) *Animal Passions and Beastly Virtues: Reflections on Redecorating Nature* (Philadelphia: Temple University Press).

Berlant, L. (2006) 'Cruel Optimism', *Differences: A Journal of Feminist Cultural Studies*, 17, no. 3, 20–36.

Bolliger, G. and Goetschel, A. F. (2009) 'Sexual Relations with Animals (Zoophilia): An Unrecognized Problem in Animal Welfare Legislation' in A. M. Beetz and A. L. Podberscek (eds) *Bestiality and Zoophilia: Sexual Relations with Animals* (Oxford: Berg).

Clark, G. (2008) 'Animal Passions', *Greece & Rome*, 47, no. 1, 88–93.

Connor, S. (2006) 'The Menagerie of the Senses', *Senses & Society*, 1, no. 1, 9–26.

Cummings, B. (1999) 'Animal Passions and Human Sciences: Shame, Blushing and Nakedness in Early Modern Europe and the New World' in E. Fudge, R. Gilbert, and S. Wiseman (eds) *At the Borders of the Human: Beasts, Bodies ad Natural Philosophy in the Early Modern Period* (New York: Palgrave Macmillan).

Derrida, J. (2008) *The Animal that therefore I am*, M. Mallet (ed) trans. D. Willi (New York: Fordham University Press).

Foucault, M. (1990) *The History of Sexuality Volume 1: An Introduction*, trans. R. Hurley (London: Penguin).

Fudge, E. (2000) 'Monstrous Acts: Bestiality in Early Modern England', *History Today*, 50, no. 8, 20–5.

Earls, C. M. and Lalumière, M. L. (2002) 'A Case Study of Preferential Bestiality (Zoophilia)', *Sexual Abuse: A Journal of Research and Treatment*, 14, no. 1, 83–8.

Haraway, D. J. (1992) 'The Promises of Monsters: A Regenerative Politics for Inappropriate/d Others', in L. Grossberg, C. Nelson and P. Treichler (eds) *Cultural Studies: A Reader* (New York: Routledge).

Haraway, D. J. (2008) *When Species Meet* (Minneapolis: University of Minnesota Press).

Harrison, P. (2003) 'Descartes on Animals', *The Philosophical Inquiry*, 42, no. 167, 219–27.

Jenks, C. (2003) *Transgression* (London: Routledge).

Jeremy, R. (2007) *The Hardest (Working) Man in Showbiz: Horny Women, Hollywood Nights & The Rise of the Hedgehog!* (New York: HarperCollins).

Kendrick, W. (1996) *The Secret Museum: Pornography in Modern Culture* (2nd edn) (Berkeley: University of California Press).

Langman, L. (2004) 'Grotesque Degradation: Globalization, Carnivalization, and Cyberporn' in D. D. Waskul (ed) *Net.seXXX: Readings on Sex, Pornography, and the Internet* (New York: Peter Lang).

Laqueur, T. (1990) *Making Sex: Body and Gender from the Greeks to Freud* (Cambridge: Harvard University Press).

Laqueur, T. (2003) *Solitary Sex: A Cultural History of Masturbation* (New York: Zone Books).

Lords, T. (2003) *Underneath It All* (New York: HarperCollins).

Lovelace, L. and McGrady, M. (1986) *Out of Bondage* (New Jersey: Lyle Stuart).

Lovelace, L. and McGrady, M. (2006) *Ordeal* (New York: Kensington Publishing).

McNeil, L. and Osborne, J. (2005) *The Other Hollywood: The Uncensored Oral History of the Porn Film Industry* (New York: Regan Books).

Mason-Grant, J. (2004) *Pornography Embodied: From Speech to Sexual Practice* (London: Rowman and Littlefield).

Miletski, H. (2009) 'A History of Bestiality' in A. M. Beetz and A. L. Podberscek (eds) *Bestiality and Zoophilia: Sexual Relations with Animals* (Oxford: Berg).

O'Toole, L. (1998) *Pornocopia: Porn, Sex, Technology and Desire* (London: Serpent's Tail).

Patterson, Z. (2004) 'Going On-Line: Consuming Pornography in the Digital Era' in L. Williams (ed) *Porn Studies* (Durham: Duke University Press).

Ritvo, H. (1991) 'The Animal Connection' in J. Sheehan and M. Sosna (eds) *The Boundaries of Humanity: Humans, Animals, Machines* (Berkeley: University of California Press).

Rydström, J. (2003) *Sinners and Citizens: Bestiality and Homosexuality in Sweden, 1880–1950* (Chicago: University of Chicago Press).

Sargeant, J. (2010) 'Filth and Sexual Excess: Some Brief Reflections on Popular Scatology', *M/C Journal*, 9, no. 5, date accessed 8 August 2010.

Serpell, J. A. (2005) 'People in Disguise: Anthropomorphism and the Human-Pet Relationship' in L. Daston and G. Mitman (eds) *Thinking with Animals: New Perspectives on Anthropomorphism* (New York: Columbia University Press).

Shelton, E. (2002) 'A Star Is Porn: Corpulence, Comedy, and the Homosocial Cult of Adult Film Star Ron Jeremy', *Camera Obscura*, 17, no. 3, 115–46.

Villarejo, A. (2003) *Lesbian Rule: Cultural Criticism and the Value of Desire* (Durham: Duke University Press).

Part IV
Engaging with Controversial Images

13
Embracing Rape: Understanding the Attractions of Exploitation Movies

Martin Barker

The purpose of this chapter is to take the much-debated topic of screened rape and sexual violence, and to bring to bear on it some empirical evidence about audience responses, deliberately taking as my focal film one which has been deemed by many to be 'trash', 'worthless' and straightforwardly 'dangerous'.

A 2006 novel by Jed Rubenfeld takes as its premise Sigmund Freud's 1902 visit to America, and imagines his involvement in a murder investigation. At one point the narrator, an American psychiatrist, reflects on his discomfort at Freud's suggestion that his love-object may have oedipal desires for her father: 'The wish Freud imputed to Miss Acton revolted me. Disgust is so reassuring; it feels like a moral proof. It is hard to let go of any moral sentiment anchored by disgust. We can't do it without setting our entire sense of right and wrong a-tremble, as if we were losing a plank that supported the whole fabric' (Rubenfeld 2006: 271). I want to begin from this insightful thought on the nature of 'disgust', to explore how audience responses to watching sexual violence on screen can 'set a whole fabric a-tremble'.

The idea of showing sexual violence carries with it a host of perceived worries. One core one is the simple fear that depictions of rape may cause sexual arousal. Our culture maintains a pretty tight line on this – any depiction judged likely to arouse viewers, and especially male ones, is per se dangerous. We can see the workings of this line in a passing remark (and how often are these 'commonsense' assumptions revealed in such occasional uses!) in a *Guardian* interview with Catherine Breillat, on the release of her new film *Bluebeard* (2009). Cath Clarke, wanting to join in the redemptive reconsideration of Breillat's oeuvre, reconsiders her past films which have addressed sexual desire in unusual, dangerous guises. Those films 'left her with the nickname "the auteur of porn". In

truth, although these films were sexually explicit – exploring women's relations with desire – they were meticulously unerotic' (2010: 3). Not for me, Cath. To me, the power of *Romance*, for instance, was its capacity to arouse yet question me at the same time. It explored the fascinating possibility that a woman might enjoy bondage (with the bonus that it was a woman-director saying this) but then followed it in directions which among other things prompted small philosophical questions about the ideas of 'female and male desire' as big categories, and made me look at myself as a possible kind of viewer. But for Clarke, redefining the films as 'unerotic' makes them safe to praise. To admit to films being sexually arousing is to attach a smell of danger to them, because arousal is seen as basic, compulsive, overriding. And that, I would want to argue, is part of a much broader discursive structure within our society, with many roots and branches.

The recognition of female rape fantasies has generated its own difficult concerns. Brought to prominence by Masters and Johnson's (1966) research and made concrete by the Hite Report (2003) into women's sexuality, 'force fantasies' are enjoyed by a substantial proportion of women.[1] But that has aroused powerful fears that this might be misread. I recall a conversation with a female British Board of Film Classification (BBFC) staff member who cut off a conversation about this with the remark that women 'only enjoy the fantasy if it is really safe' – that is, not really rape at all, just being able to give in to desire. Men have no such 'excuses'. For a man to fantasize rape, or to enjoy a rape fiction, is to be disgusting. Yet rape and sexual violence constitute a significant part of the whole phenomenon of extreme cinema. Understanding audience pleasures and engagements with these is, thus, a fraught and risky business.

The many kinds of low-brow cinema have of course become hot topics for research and theory within film studies in the last decade. Some of this has been through individual scholars' involvements in fan communities; and the role of publishers like FAB Press has been important for nourishing those particular kinds of critical engagement. Film historians have dug with great success into the 'lost worlds' of film pornography, the drive-in movie tradition, nudie cuties, roughies, Italian *gialli*, the video nasties, and much more.[2] All this has been informed by Pierre Bourdieu's notions of taste and taste conflict, by revisionist feminisms, and by a general awareness of the politics of censorship. But several things are noticeable in this work. With the partial exception of cult movies (where it proves impossible not to discuss the kinds of use to which they are put), there is still a distinct lack of interest in how different audiences engage with and respond to these low-brow forms.

Yet alongside this goes an awareness of the *need* to rethink audiences away from the twin threats: mainstream assumptions that there are 'no redeeming values' in these films; and film studies' long tradition of working with notions of 'identification', which for these kinds of films would precisely seem to warrant mainstream fears.

Take as an example Jeffrey Sconce's excellent edited (2007) collection *Sleaze Artists*. Here, contributors repeatedly brush up against the issue of audience responses to the cycles and genres of films they are reconsidering. Many of the essays have a moment when the author feels the need to theorize why the movies aren't as bad (misogynist, homophobic, bestial, or whatever) as they appear. Take two examples. Eric Schaefer examines closely the marketing strategies for the Adult Movies which increasingly found space across the 1960s. He shows the ways companies skirted legal threats and newspaper bans to emphasize the risqué nature of the films, until in the 1970s a newspaper-led new Puritanism squeezed them beyond the point of financial return. Schaefer argues that in effect a vicious circle was created:

> Newspaper bans on adult film advertising in key markets served to substantially disable the economic viability of the form. Yet it was the adult film distributors themselves who sowed the seeds of the advertising ban early on. By employing appeals that focused on sexual excitement, adventure, curiosity, and experimentation, they had shaped a negative profile of the sexploitation customer. *Despite evidence to the contrary*, the sexploitation audience was framed as dangerous and deviant.
>
> (2007: 42, my emphasis)

Schaefer is at pains to argue that in fact, as far as there is evidence, the audience for these films was 'normal': the typical film-goer was not a rain-coated 'dirty old man'. What Schaefer exactly intends here by 'normal' isn't clear. But it is striking that he wants to appeal to 'him'.

My second example is more elaborated. Tania Modleski considers the films of one of the few female directors of sexploitation films, Doris Wishman, whose output included *Nature Camp Confidential* (1961), *Bad Girls Go To Hell* (1965), and the two 'Chesty Morgan' films. Modleski opens with a telling anecdote: the discomfort that many Americans felt when Lenara Bobbitt offered as part of her justification for cutting off her husband's penis that he didn't satisfy her sexually. This leads her to discuss a woman's search for the right to pleasure *within* a context where 'sex is killing her'. Despite films 'leaving a nasty aftertaste' (2007: 65)

because of the frequent depiction of violence against women, and thereby shocking her feminist students, Modleski wants to reclaim Wishman for women's appreciation. To do this, she has to find a way to rethink feminist film theory's ideas about 'identification'. First, then, she must reject *tout court* a male student's suggestion that some women might enjoy the films by joining in blaming the female characters:

> This is not what I meant. I am assuming there may be a kind of split response on the part of some female viewers who recognize their connection to the woman on screen but are ready to face the most extreme forms of female victimization without blinking, that is, without letting themselves be victimized (terrorized) by a *representation* of that victimization.
>
> (Modleski 2007: 63)

There is here a worried search for a theory which can conceive this kind of split response (needing to be the opposite of the masochistic split which Laura Mulvey conceived as women's way of 'living' the male gaze). Modleski assumes that any woman watching a film with sexual violence *must* see in the female victim a version of herself. She cannot, for instance, see her as belonging to another *class* or another *race* or anything else which might challenge 'recognition of a connection'; and she cannot even see her as a 'creature of a genre' which can only operate with such characters and events.

Schaefer, Modleski and other contributors are operating with a defensive, normative account of what audiences *ought to be like*. As so often, the picture gets more complicated the moment we look at what those audiences themselves have to say.

If academics writing about these films often can't ever quite escape their politico-theoretical orientations, that other breed of writers, the fan-scholars, can allow us to see more. There is a very instructive structured ambiguity in their writings. Take Stephen Thrower's (2007) *Nightmare USA*, a huge compendium of counter-films from 1970–85. I've picked on his description of one film – *Baby Rosemary* (John Hayes, 1976), obviously referencing Polanski's *Rosemary's Baby* (1968), about a disturbed young woman who can only find satisfaction in abusive sex – to illustrate:

> Then there's the rape scene. In psychological terms, poor abused Rosemary might conceivably respond to being raped by 'getting into it'. ... The issue is not one of fictive plausibility – the problem lies

in the way we're invited to watch. As feminist critics would explain in much more detail, the placement of the camera and use of film-style is crucial. ... The rape scene is a pure spectacle of cruelty and we're invited to the feast either as sadistic voyeurs mindful of our amoral enjoyment, or mindless voyeurs for whom the question is too complicated to think about. ... The most shocking aspect of the rape is not visual; it's verbal. In fact, the language throughout is frequently crude and gloatingly abusive. This is one of the strengths of the film. ... Hayes plays hardball with the audience through obscene, tellingly realistic dialogue. Even if the sexual politics of the era elude the director, he maintains a frank, unflinchingly honest grip on vernacular. ... *Baby Rosemary* is one of Hayes' best films, but it's also one of his most problematic, revealing a terrible cynicism that plays strangely against the compassion to be found elsewhere in his work.

(Thrower 2007: 262–3)

It would take a long commentary to draw out all the themes in just this (edited) passage, but here are some of the main ones. There's intense awareness here of: the scene-driven (as opposed to narrative arc) nature of these films; the relevance of serious critical positions; the cinematic construction; how attention to that can hold the film at a safe distance, but also how it can be ignored, and the film just indulged in; the contexts out of which the film comes, and the film's own engagement with those; narrative and motivational strengths and weaknesses; and the position of this within a broader corpus (both Hayes' other films but also, by implication, the broader genre and entire history of counter-cinema). But to me most significantly of all, for Thrower, every extreme feature is *simultaneously bad and thereby good*. The film only makes sense by dint of the range and extremity of the reactions it can call forth. All responses, all evaluations are inevitably doubled. That is an idea I want to hold on to in the rest of this chapter.

Researching audience responses to sexual violence

Thrower's account is of course at the intellectualized end of the possible spectrum of responses. As a fan-scholar, and working with the domain's leading publisher, he is producing a knowledgeable tome for his fellow enthusiasts, and thus adding gravitas to the field. To get at a wider range of responses, other kinds of research are necessary. In 2006, I led a research team in a project for the BBFC. The BBFC asked us to gather

evidence on how naturally occurring (as opposed to experimentally assembled) audiences make sense of five films involving sexual violence and what, if any, difference was made to their viewing responses by the cuts which in four cases the BBFC had made. The five films were *À Ma Soeur* (Catherine Breillat, 2001), *Irreversible* (Gaspar Noé, 2002), *Baise Moi* (Virginie Despentes, 2000), *Ichi the Killer* (Takashi Miike, 2001) and *The House on the Edge of the Park* (Ruggero Deodato, 1980). Our research design involved: a close study of the 50 most important websites debating each of the films; a web questionnaire which attracted 839 respondents (many of whom reported their responses to more than one of the films); and four focus groups per film in different parts of the UK, bringing together people who most strongly 'embraced' (our term for positive engagement) each film. Our full report (2007) is available as a download from the BBFC's website. But the materials we gathered were sufficiently rich to allow us to address many further kinds of question.

Here, I draw on just one set of responses, to *House on the Edge of the Park*. *House* is without question a challenging film. It opens with a man's rape and murder of a woman whom he has forced off the road; then, the bulk of its narrative follows the same man Alex (played over-the-top by David Hess), and his slightly retarded friend Ricky, after they are invited to a party. This gradually gets out of hand. A theme of class insults and conflict emerges between pseudo-sophisticated middle-class hosts and crude macho working-class men. The two men increasingly threaten, then attack, their hosts, culminating in Alex forcibly stripping one virginal late arrival, Cindy, and running a razor blade over her breasts (to the haunting menace of him singing her name, in a version of the main extra-diegetic music). While this is happening, outside, one of the other women has taken pity on Ricky and consented to sex. When Ricky thereafter tries to stop Alex's torture of Cindy, he gets slashed by Alex for his pains. In the ensuing mayhem, one of the hosts pulls out a gun and shoots Alex in the genitals. Alex dies melodramatically in their swimming pool – at which point it is revealed that the whole point of the invitation to the party was to get him there, to exact revenge for his earlier killing.

The BBFC's judgement on the film was unequivocal: it 'contravened the Board's policy on works which "eroticise or endorse" sexual assault'; the 'most pernicious scene' was the assault on Cindy where lingering shots of her full-frontal nudity and the razor threat was 'further eroticised by being intercut with an unlikely consensual sex scene', and the 'effect of illicit pleasures sexualised is increased by the apparent youth

Figure 13.1 Alex attacks Cindy, *The House on the Edge of the Park*, Ruggero Deodato, 1980

of Cindy. This is a potent sexualisation of violence'.[3] Eleven substantial cuts were required for the film to obtain a certificate.

If the BBFC had such problems with its potential impact on viewers, what did our research reveal about the people who embraced the film, and how they participated in and enjoyed it? 165 people who had seen *House* completed our questionnaire, of whom 79 had seen it at a special screening we organized in Aberystwyth when we became aware that our response rates were lower for this film than for the others. Table 13.1 below presents the rankings of the film for those who had seen the film independently, and for those at our Aberystwyth screening. These were in response to two questions, each with a five-point scale:

a) Could you tell us what you thought of it *as a piece of film-making*? [Excellent; Good; Mixed feelings; Poor; Awful]
b) Could you tell us what you thought of the *ideas it was dealing with*? [Extremely valuable; Quite valuable; Mixed feelings; Little value; No value at all]

These figures are in themselves revealing in small ways. Of the five films we studied, this one received the lowest levels of approbation by its naturally occurring audiences, both as film and as bearer of ideas. But

Table 13.1 Audience evaluations of *House on the Edge of the Park*

%	Aberystwyth screening		Other respondents	
	Film quality	Ideas quality	Film quality	Ideas quality
Highest	1.3	5.1	9.4	5.9
High	11.4	16.5	41.2	17.6
Middle	41.8	35.4	23.5	31.8
Low	32.9	32.9	20.0	21.2
Lowest	12.7	12.7	5.9	23.5

still significant proportions do value the film. And those seeing the film independently were more likely to rate it highly than our assembled group. In particular, they were more likely to rate it as a *film* (over 50 per cent awarding it a Highest or High rating) whereas our assembled audience marginally more highly rated it for its *ideas*.

The differences in ratings are explained in striking fashion by one figure. We asked respondents to explain how they arrived at their judgements on *House*. This gave us an opportunity to discern their working criteria. 26 (just over 30%) of the independent respondents chose the expression 'exploitation' to categorize *House* (15 also name-checking director Deodato), whereas just one of our Aberystwyth audience deployed this term (and not one name-checked Deodato). Calling *House* 'exploitation' could associate with all kinds of judgements on its value, as the following examples illustrate:

The only people who would watch this movie are fans of Hess or exploitation cinema in general. The movie is so badly written as well as purely dubious in all respects that anyone else in the potential audience wouldn't want to watch the film.

It's almost a satire about class war but at its heart it's an exploitation movie and an extremely tense and brutal one at that.

This is the nastiest of the films I have commented on by quite a margin. Again like *Baise-Moi* it is a pure exploitation film although one which is a lot more thought-provoking and well made.

Ruggero Deodato is an accomplished filmmaker compared to many of his brethren but *House* is simply an extreme exploitation film and nothing more, although whether deliberately or otherwise Deodato at times makes interesting comments about the class barrier.

The film is pure exploitation cinema and doesn't have the need to be 'valuable' in my mind.

As a fan of exploitation cinema and in particular Ruggero Deodato, I thoroughly enjoyed *House*. I felt that Deodato made this movie to capitalise on the success of a string of increasingly more graphic exploitation shockers that had gone before it such as Wes Craven's *Last House on the Left* (1972).

The film is pure exploitation and a good one as far as this type of film go.

I am a fan of Ruggero Deodato's work, especially *Cannibal Holocaust* (1980). In addition I like actor David Hess' sadistic on-screen persona in other films like *Last House on the Left* and *Hitch-Hike* (Pasquale Festa Campanile, 1977). *House* is classic Italian exploitation film. I knew it was supposed to be nasty and nihilistic before seeing it.

It seems clear that 'exploitation' operates like a genre for many people and thus generates a terrain of criteria, expectations and debates. *House* is measured in specialist ways – rather in the manner that we might distinctively measure holiday novels or junk food or bad jokes. Each has distinctive uses.

But there is, I want to argue, more than this at work. Consider one non-Aberystwyth respondent: a 26–35 year old man, who adjudges himself a knowledgeable film viewer and nominates Italian *gialli* films as his favourite kind. Typical of this group, Respondent 38 rated *House* 2 for film quality, and 3 for the themes and ideas it addresses. We had asked: 'What can you recall about when and where you saw this film? Did it have any impact on your feelings about the film?' 38's answer is quite long and considered:

I first viewed this as I was so impressed by Deodato's film-making with *Cannibal Holocaust*. I obtained and imported the uncut DVD version as I don't like to be told what I can and cannot see. It's your run of the mill rape and revenge drama so popular at this time. The violence was sexualised, but due to the savagery of the acts were quite repugnant and personally I did not find them sexually arous-ing. The women in this film have been misinterpreted as sex objects, yet they use their sexuality with cunning to either get out of the situ-ations or to use it to ensure the two hoodlums get their just deserts

at the end. The sexual violence is ugly but so are the characters that carry out the acts. The rapes that occur are always inflicted on the bourgeois by working class perpetrators and therefore is an act that we could hypothesise represents the ultimate hatred between the classes. The violation scenes are explicit and could be considered sexualised, but this is exploitation so I would be surprised if they were not, and due to the nature and age of the movie seem terribly dated and just grubby vignettes of sleaze. The way in which such sequences are filmed are so melodramatically executed, and the motives so ridiculous they come across not shocking or depraved just turgid and because of the nature of this film come as no surprise either.

Consider this answer in detail, not as a *right* or *best* answer, but for the criteria at work in it. He feels the need to say that he didn't find the sexual violence arousing – this is a judgement he wishes to avoid, even while he clearly resists general attempts to censor his viewing. In a later answer this leads him to differentiate, also, *kinds* of viewers:

> It is evident that the rape and violence is shown to bring in the lira (most films of this genre did this, whether giallo police/crime and horror Italiano) but not solely for the money; it also takes into consideration the appeal it should have for the thrill-seeker amongst the cinematic audience.

The curious thing here is that the 'thrill-seeker' is here being differentiated from and even raised above those going just because of the film's commercial appeal.

House is evidently sought out and then measured as one of a genre, which is loved as the product of its particular time. This is more than a fact of film history – it has also to do with the interpenetrating themes of sex and class. In another answer he expands on this:

> It also is a time capsule that demonstrates how far we have evolved and only in its uncut form can we awaken to where we are in social acceptability now. Of course the director did not foresee this but this is now finally achievable, thanks to retrospection. The reason I have mixed feelings about the ideas it had dealt with is that they have no relevance to me now. Back in the early 80s there was a huge class division that in 2006 has not disappeared altogether, but significantly lessened.

That final claim can of course be questioned, but the important thing is that for him it relativizes the themes that he identifies.

The comparison with the iconic *Cannibal Holocaust* is significant. That film, as I have argued elsewhere (Barker 1984), is marked by quite overt discourses about the nature and operations of 'primitiveness'. Its story, of film-makers' journey into a jungle to find and document a cannibal tribe, whose recovered footage increasingly reveals the film-makers themselves to be driven by savage motives (humiliation, sex, violence, cruelty to animals), ends with a blunt and overt question about savagery's location and a decision (of course, paradoxical) to 'suppress' the film that we have just watched. *That* film ranked high for him, far above the 'run of the mill' *House*. Yet 38's responses to *House* still suggest that watching this through the lens of the category 'exploitation' does some complicated jobs, making its sex and violence much more than just something extreme that he watches. It resonates with the themes he perceives in the film.

Audience viewing strategies for 'exploitation films'

So, what, for our audiences, was caught up in this notion of 'exploitation cinema'? How might putting the film within this 'genre' condition one's way of watching? Clearly a key to the style of successfully watching these films is allowing very negative emotions to count as positive. Indeed, the more one can list a range of apparently inconsistent emotions, the better the film appears ('I liked the way the film felt entirely unpretentious and down-to-earth. It was suspenseful, engaging, amusing and shocking'). Shock becomes the point of the exercise. Horror becomes exciting. Disgust, even, becomes fascinating ('There is a tension and a feeling of palpable disgust (which is actually quite thrilling)' (both 518)). But this precondition then elaborates into a complicated set of processes of watching and responding and judging. I want to sketch a portrait of what I would see as the predominant viewing style, before giving examples. With caution (because I acknowledge that to a degree I am 'cherry-picking' elements of responses to build an ideal-typical account[4]), I offer the following:

1. The 'exploitation' viewing style is made possible by the enveloping anti-realism of the films. They can be crazily incoherent, and have evident plot failures. They can be exaggeratedly or even just plain badly acted, as long as the film produces appropriate levels of tension, knots in the stomach. But their anti-realism turns the

films into a horrific equivalent of farce. A character in a farce who doesn't respond appropriately to the absurdity of what is happening around him or her is likely to be booed off stage. In the same vein, characters get 'what they deserve' within the excessive conventions of the exploitation genre. This makes it possible for people to enjoy deaths, mutilation, rapes, torture; and jeer at people suffering things which are inconceivable outside the context.[5] There are, however, limits. A character who 'strays' into a film's domain and is perceived not to deserve what ordinarily happens to its inhabitants, produces disquiet, unease. This, for many viewers, was the situation with Cindy. She simply didn't deserve what came to her – and the price of that was that Alex had to die, badly. But to arrive at this judgement, viewers have first to construct a sense of the 'logical rules' of these excessive worlds – and can be annoyed if those are not seen to be followed consistently.

2. But these very anti-realist qualities also do something else. The relative lack of narrative immersion means that these films for their audiences always hover on the edge of being philosophical. I want to state this carefully. There is a quality in many responses which verges on the level of wide-eyed disbelief that a film *dares* to do the things it does, leading to a 'what was *that* all about?'. That can remain a rhetorical question, but it can, and does, for many become a question which at varying levels they try to answer. These 'scenarios of excess' as I would call them are searched for a logic which, if found, shifts the film from pure body horror, to the level of ideas. So, *House* for quite a few of our viewers was made meaningful by its play with ideas of class, class conflict, and revenge. What is important is that *nobody* (with the exception of Cindy, who has 'strayed in' from elsewhere) is good, or worthy, or moral. So, whatever happens to them, they deserved it.

3. Audiences are always aware of each other. But in the case of exploitation cinema, there is a particularly strong sense of knowing your own kind. People don't have to like everyone within it, but they carry a strong sense of what their 'community' is and what its common practices and modes of interpretation are. It is, first, a very *knowledgeable* community, hoarding its genre's history, knowing the provenance (by date, country, director) of these films. It readily *compares and measures* films against each other (and of course then loves to debate the results of those comparisons – what is the point in being in a community, otherwise?). This is the basis, then, for those judgements on *how good an exploitation movie* something is.

I ask readers to hold this ideal-type in mind, and consider how it helps explain the following responses, from two men and two women who 'embraced' *House*, all dubbing it 'exploitation'. Respondent 33, a man aged 26–35, who judges himself to be 'very knowledgeable' about films in general, names 'horror' as his favourite genre, and had seen both cut and uncut versions of *House*: 'I saw it in a cut version from my video shop after seeing and being impressed by *Cannibal Holocaust* by the same director. I liked it enough to want to see the uncut version'. The complex of motives implied by this is part of, and sustained by, his sense of himself as a film expert. The comparison with *Cannibal Holocaust* is made the more interesting by his having judged it the most uncomfortable film he has seen ('That is not a criticism of the film which was superb').

Quite a long answer was given by 33 on the reasons for his ratings of *House* ('Good' both for film quality and issues raised). Again, he *situates* the film among others in assessing it: 'Technically it was well done. Good camerawork, sharp editing. Thematically ... well previously I had seen *Funny Games* (1997) by Michael Haneke, and I thought *House* came out better by the comparison, essentially because the villains and victims were grounded in a clear social context – a class context if you like – and the film, by turning the tables at the end, made clear how the aggression and rage of the excluded is merely part of a middle class "set up" which both titillates the better-off and serves their strategic purposes. And one really good bit! – when the villains are dispatched there is almost no attention paid to the mutilated baby sitter ... the bourgeois with the gun in the drawer just watched it happen! This is one of the key things about *House*. I read it being criticized for "pretending that there are no consequences to violence" and this is precisely what the film shows very boldly but – and this differentiates it from other such films – grounding that insight in a specific class political context.'

There is an intense awareness in here both of other films with which *House* might be compared, and of the accusations against it. Notice, also, the move to the issue of class, via a harsh comment on the idea of 'titillating the better-off' – if these are victims, they are not innocent ones. And the amusement at the narrative weaknesses (forgetting Cindy once the revenge begins, suddenly remembering the gun) emphasizes for him the political frame that the film is creating. These features don't so much distance him from the horrific events, as shift his capacity to make meanings from it all. So, while 'most memorable' is 'the razorblade and the babysitter', still, he 'didn't find any of it uncomfortable'. The meaning of the film thus becomes crystallized for him: 'The rage of

the excluded is often sexualised and turned into sexual violence'. This almost feels like a definition of the point of the genre.

This leads 33 to a very complicated response to the BBFC's evaluation of the film: 'Sometimes the camera takes the assailants' view, sometimes that of the victim, often it is more ambiguous. It's certainly possible to find scenes in the film exciting, perhaps "sexually" exciting. Someone who can do that would probably have the most useful insights about the film. It's like watching someone eat; perhaps the viewer will get hungry themselves, but the film is still objectively about food'. Notice the film literacy as well as general articulacy in here, but notice also how this couples for him with an acknowledgement of a *kind of viewing* which may or may not be his: one which *through attention heightened by arousal* gains more insights.

It is interesting, then, to see how *apart* this man holds himself. In telling us the 'most important personal thing' about himself, he marks himself off from 'the masses' who perhaps don't share his capacities: 'I don't necessarily disapprove of censorship. I like a paternal state watching over me ... On the other hand if I can't see a film which our censors deny to the masses, I get it from abroad or from downloads or bootlegs. The rules don't apply to me but that doesn't mean there shouldn't be rules'. There's a keenly implied awareness here that he has special skills which exempt him.

Respondent 783, a woman of 18–25 at our Aberystwyth screening, is a horror fan. Interestingly, she reports that on this occasion she felt *watched* at the screening: how would a woman like her respond to this? 'I was more aware of my reactions around other people at the screening – felt the sense of attention paid to me. This became part of my interpretation of the film – as if my reactions fitted with the film'. Notice the relative lack of distancing, even in the face of feeling watched. 783 rated *House* 'Excellent' for its film quality, and 'Good' for the ideas it addresses: 'I felt the film was very cleverly made, especially with the use of music and the sense of mocking references to romantic films. I found some of the concepts it dealt with very interesting – especially those concerning power, wealth and morality.'

In her answers there is the sense of the *mixing* of participation, film evaluation, and emergent ideas. Her account of her 'most memorable' moment catches this: 'when Alex raped the main female character, and the strange conflict of power, pleasure and anguish in the scene'. Revealingly, the 'most uncomfortable' answer exactly matches my ideal-type of seeing Cindy as *outside the terms of the film*: 'When Alex attacked the virginal character. It felt very different to the scenes concerning the

other women in the film. The virginal character had more of a sense of innocence.' Within the film's main scenario, then, its exploitation status ensures a linkage of the showing of extreme events with the ideas these provoke. 783's answer on the contribution of the scenes of sexual violence makes this very clear: 'They played with the idea of power in sex, and sex as a mental weapon. They were key to the debates of power and morality in the film'. As a result, the BBFC is, to her, right but wrong – right, in that these scenes do eroticize, but wrong, because it is this very eroticization which allows the ideas to emerge: 'I felt the scenes of sexual assault eroticised sexual assault with the 3 main women in the film but also raised questions *through this* about to what extent it was sexual assault and what it meant. I feel it was important to see the whole of the scenes in order to consider this'. I have added emphasis to the words 'through this' because they make very concrete this woman's perception of these crucial links.

It is therefore fascinating to hear her account of one film which she rates among her three favourites, but which she also finds the most uncomfortable to watch: '*Straw Dogs* (Sam Peckinpah, 1971) – it was very difficult to interpret the rape scene in the film with the element of pleasure shown by the victim, and in relation to her relationship with her husband. I had to consider the scene a long time to reach any conclusions'. Thinking through arousal and discomfort becomes a significant stimulus to her. This is part of her politics, and part of her overall relations with films: 'I think the fact that I am female and my political/social interests and opinions impacted on the way I saw the balance of power in the film'.

Respondent 739 is a difficult test-case. This 18-25 man is a particular fan of 1970s horror, but thinks himself generally a film expert. 739 saw the uncut original of the film, and gave it top ratings for quality and ideas. His answers are very short, and that poses a real problem for analysis, as I have noted elsewhere (Barker and Mathijs 2007: 152–3). He tells us his overall reasons: 'Love David Hess, love Deodato, love the genre, love the film'. This unqualified and wide-ranging enthusiasm frames his single word answer to the 'most memorable' moment: 'Cindyyyyy'. This displays what I can only call a relish for the person, the character, the scene, and the excitement of the experience – even perhaps for the contribution of the song (the elongated word hints at the song's slow threat). The implied intensity of his engagement with the scene is powerful. This is never an overtly intellectualized response. Again, his short answer to the contribution that the scenes of sexual violence make is pithy and unapologetic: 'They are hot and sexy'. This is surely the kind

of viewer that the BBFC is frightened of: a young man delighting in watching sexually violent scenes. His is a deeply participative response. But even in its brevity, there are hints of complication. The 'most uncomfortable' element for him was the very one that he also relished: 'awhh the most tortured, because she was young and new to the film and I thought they might get away with it'. It's as though the scene's arousing closeness and his relish of its dreadfulness intensified the issue of their 'getting away with it'. Hence, then, his minimalist overall summary: 'vengeance … lol, well how else can I say it … great film'.

With such short answers, any commentary has to be incredibly tentative. Yet it is the very *expressiveness* of his comments that is most striking. He wants to communicate his excitement at the film, but that excitement comes across as comprising several interlocking elements. He is enticed by the sexiness of the film, and this makes even more meaningful to him whether the bad guys are going to get away with their acts. This very doubling redoubles his excited delight. To abstract the 'bit' of his excited arousal from the rest of his answers might suit a simple moral disavowal, but it does not help an understanding.

Respondent 729, a woman aged 26–35, is another kind of test-case. Selective in her choices of films, and choosing 'romantic horror' as her favourite kind, how she saw *House* mattered greatly: 'I saw this film late at night with my boyfriend at home. This meant that I felt safe. This environment probably encouraged me to have an open mind and examine any emotional responses I may have had, because this is his type of film.' The meaning of this 'safety' will prove crucial.

She judged *House* 'Good' on both dimensions. Her explanation is quite long, and I treat it in sections because it is so interesting:

> I liked the aesthetics of the film and seeing as that is the main medium for a film, I thought that in this sensory aspect it was successful. I thought that the dialogue was unnatural and dramatic but I find this to be true of quite a few real life conversations so in this sense there is no standardisation for what I perceive as realistic, and therefore expect as a result from my own experience.

In this first part of her answer 729 allows that there are complexities in what is 'realistic' and is therefore willing almost to set aside her first reaction that the film is 'unnatural'. She continues, more philosophically:

> Watching a film is for me a journey to another place and mind and belief; another person's diary. The ideas that the film dealt with are

fascinating; the idea of rape and rape fantasy and vengeance and genuine human behaviour and deception and bullying and conforming and leadership qualities are terrifically engaging to me. I think that some men somewhere will always want to rape women, and that some women somewhere will always want to be raped, and that some men watching or creating a film like this will be able to come quite close to what they want, but will deny themselves for the sake of social acceptability and fear of reprisal.

This remarkable excursion places the film and its ideas into a wider system of beliefs about the motivations associated with rape and being raped. It links, not to condemnation, but to welcoming the film's opportunity to 'journey to another place and mind and belief'. It becomes part of a critique of a hypocrisy that she senses:

> For me, the idea of a woman being raped is hideously deceitfully simplistic. The idea of it being a power trip for the perpetrator is sickening to me because it negates the woman's role entirely, thereby rendering her as a true victim of the man's sexual whim. What these films seem to gloss over or ignore like an elephant in the living room is that for a woman to be raped is for a woman to be irresistible and all powerful; her desirability animalizes a man; reduces him to a beast burdened by his painful sexual frustration, and it is only her all-powerful hypnotising physicality that can return him to his humanity. I don't know if what I feel is right or wrong, but I know that the dismay I feel at rape in films and this never escapable sexuality I have been cursed with is demonised and thwarted by men. I have no desire to use my sexuality as a currency, but it is the only currency of value today. Films like this are endless in their lust to sexualise and consume femininity. Either a woman can be beautiful and raped, or a non-entity.

So, the contribution of sexual violence scenes? 'They are the meat. They are the wine. They are the desire the colour and its reason for existing'. And the BBFC's argument? 'I agree with the reasoning behind the cuts. But taken away from the film is taking away its reason for existing. This was a film about rape and rape fantasy. Without the explicit scenes I would not be able to conclude that they exist to make this film as subtle as a heart attack, and as serious and telling about male sexuality and insecurity as it is. This film is in its entirety a commentary and psychological profile on the director's ideation of the female gender and the people who watch it and seek it out for the reason of being as close

to a rape and an act of vengeance without committing one'. This is film as revelation and disclosure. It is film as unintended denunciation, hated and valued at the same time – as in her comments on *Cannibal Holocaust*, her choice as 'most uncomfortable film', which

> troubled me very much but I think that was because of the insecurity I was experiencing at the time in my most important relationship. I also think that because it was accompanied by animal cruelty I couldn't cope. I think that this made it something that was just too horrific for me to rationalize. Human sexuality is grim sometimes and seeing a young girl raped by a group of men with a woman witnessing it and doing nothing to stop it was testimony to the many ways that this grimness manifests. Coupled with animal cruelty was the straw that broke my heart.

It is what this woman reveals as her 'most important personal factor' which throws a weird and horrible light on the 'safety' and 'insecurity' which she references: 'Yeah, my Dad keeps trying to get in my knickers'. This sad closing revelation could explain both the importance of the 'safety' of being with her boyfriend, and her feeling of being endlessly sexualized. But the striking thing here is that this leads, not to rejection of the film, but to a grasping of it for her own purposes.[6]

Within all these responses, 'arousal' takes on a particular pertinence. In one sense, and in accord with what Linda Williams (1991) has argued, the *whole point* of such films is to arouse strong bodily responses in people. Although Williams does not name 'exploitation' as a specific kind within her discussion of 'body-genres', it evidently fits well.[7] But inasmuch as 'arousal' might be equated simply with sexual excitement, that doesn't fit. Exploitation fans know the differences between these films and porn. And while the sexual explicitness and violence are clearly understood to be a necessary part of a film such as this, it simply makes no sense at all to detach these from their complex generic context.

The evidence from our audience responses also suggests a modification of Jeffrey Sconce's influential (1995) account of 'paracinema'.[8] Sconce has argued that the valuing of 'trash films' is part of a historically located tendency, rooted in a temporary rejection of a high class culture by 'various disaffected segments of middle-class youth' (1995: 375) aiming to produce 'a calculated strategy of shock and confrontation' (1995: 376). He argues among other things that the pleasure of finding fault in films is associated with confirming viewers' knowing superiority as part

of their rejection of 'good taste'. While in some ways taking this way of viewing seriously, it seems to me that Sconce comes close to attributing *showing off* or even *bad faith* to paracinematic viewers – they are not much above *pretending* to appreciate 'trash cinema'.[9] It is for him consequence-free viewing, and that is its limitation. That is neither my anecdotal experience of fans of 'exploitation cinema', nor, more importantly, does it fit with the responses we received to *House*.

Conclusions

In recent years there has been a surge of interest in the cultural study of bodies, the senses, and the emotions. Case studies of 'disgust' have nicely caught its historical locatedness. William Miller (2005), for instance, explores the significance of Darwin's disgust at encountering 'primitive peoples' and their lives, and the role this played in his application of evolutionary theory to humans. Robert Douglas-Fairhurst considers Dickens' response to watching a public execution in Italy, and growing worried about the 'audience's' reaction: 'Dickens was not alone in worrying that the spectacle of human suffering, far from provoking disgust, pity, indignation, or sorrow, might instead provoke little more than indifference' (2007: 60). This contrast of the disgusted with the disgusting, the properly with the improperly sickened audience goes deep. It is widespread in notions such as 'desensitization', and 'compassion fatigue'. And it is frequently coupled with the idea that *crowds* are particularly prone to this.[10] It is as ever an imputation. Our research materials indicate something rather different. Exploitation films like *House* by dint of their very limitations as films create terrains of intensified reflection. The 'doubling' of arousal and reflection, of excitement and horror, will never be comprehensible to nervous critics. But it is real, and we need to defend it. And, controversially, the more people are aware of and locked into communities of viewers, the more likely they are to see and to use films such as *House* in these ways.

Notes

1. Critelli and Bivona's recent (2008) meta-study concludes that between a third and half of all women experience rape fantasies.
2. For a splendid general history of the rise of Exploitation Cinema, see Schaefer (1999).
3. These quotes are taken from a summary of their reasoning and judgement supplied to us by the BBFC.

4. I am here using something like Max Weber's notion of the 'ideal-type'. Weber argued that because all human activities are oriented towards meanings, values and goals, it is a necessary procedure in social investigations to abstract emergent conceptions and *model* them in order to see what their unalloyed, full, and even 'utopian' expression would look like. It becomes a one-sided accentuation of the phenomena, stepping away from the inevitable messiness of concrete cases. It has value in as much as, once articulated, it can throw light back on those scattered and partial materials. See Weber (1949).

5. I am grateful to my colleague Kate Egan for pointing out to me the possible connections between this, and an idea nascent in Steve Neale's essay 'Questions of Genre'. There, reviewing recent developments in genre research, Neale picks up on the importance of genre-expectations, pointing out that these 'offer a way of working out the significance of what is happening on screen: a way of working out why particular events and actions are taking place, why characters are dressed the way they are, why they look, speak and behave the way they do, and so on' (1990: 46). Neale illustrates this with a rather 'safe' example of characters singing in musicals (a form of screen behaviour which would just seem bizarre in many other genres). Extending this idea of 'expectations' to horror or exploitation cinema may look decidedly 'un-safe'. But my central argument is that we misunderstand through ignorance or prejudice what audiences are *doing* with those expectations.

6. I thought long and hard about the appropriateness of using both this case, and this comment, and discussed it with several female colleagues before I decided to use it. As one put it to me, this woman chose to disclose this terrible fact about her life to me, and it *is evidently* important to understanding her reactions. I thank her for trusting me with this knowledge about her, and can only hope that she has managed to get away from the threat posed by this man.

7. In fact Williams deals with three very large general kinds of films – melodrama (associated with weeping), horror (cringing), and pornography (arousal) – and considers them primarily from the point of view of the 'excessive' deployment of women's bodies and therefore primarily associated with issues of gender identity and gender fantasy, and ultimately suggests rather timeless, ahistorical readings of the kinds of pleasure and engagement such films offer.

8. It is interesting to read one conference report on cult cinema complaining at the uncritical application of Sconce's ideas to a wide range of kinds of films. See Caine (2001).

9. In saying this, I am intentionally going beyond Joan Hawkins' amendments to Sconce's account. Hawkins points out that fanzine and mail order catalogues in the horror domain, curiously, will blend 'trash' films with avantgarde, experimental, and European art house titles. Her interest is in what she calls the implied 'deliberate leveling of hierarchies and recasting of categories' (1999/2000: 127). But Hawkins limits her consideration of the implications of how these films may be used, to comments about the taste reactions of 'the public', such that 'European art films may "leave audiences gagging"' (1999/2000: 131). Sconce in fact spells out his epistemological base more fully in a 2002 essay, where he writes of 'smart films' as 'an overarching belief in the fundamentally random and yet strangely meaningful structure of reality (even if that 'meaning' is total absurdity) (2002: 363)', thus 'fostering a sense of clinical observation' (2002: 360).

10. For important critiques of this wider view of crowds, see among others Rudé (1964) and Canetti (1973).

References

Barker, M. (1984) 'Nasties: A Problem of Identification' in M. Barker (ed) *The Video Nasties: Freedom and Censorship in the Arts* (London: Pluto Press).

Barker, M. and E. Mathijs (eds) (2007) *Watching the Lord of the Rings* (New York: Peter Lang).

Barker, M., Mathijs, E., Egan, K., Sexton, J., Hunter, R., and Selfe, M. (2007) 'Audiences and Receptions of Sexual Violence in Contemporary Cinema', *Report* to the British Board of Film Classification, http://www.bbfc.co.uk/downloads/index.php.

Caine, A. (2001) 'Conference Report', *Scope*, November, www.scope.nottingham. ac.uk/confreport.php?issue=nov2001&id=951§ion=conf_rep, date accessed 20 September 2010.

Canetti, E. (1973) *Crowds and Power* trans. C. Stewart (Harmondsworth: Penguin).

Clarke, C. (2010) 'I Love Blood. It's In All My Films', *The Guardian*, July 16, Film and Music, 3.

Critelli, J. W. and J. M. Bivona (2008) 'Women's Erotic Rape Fantasies: An Evaluation of Theory and Research', *Journal of Sex Research*, 22, 57–70.

Douglas-Fairhurst, R. (2007) 'Tragedy and Disgust' in S. A. Brown and C. Silverstone (eds) *Tragedy in Transition* (Oxford: Blackwell).

Hawkins, J. (1999/2000) 'Sleaze Mania, Euro-trash and High Art: the Place of European Art Films in American Low Culture', in M. Jancovich (ed) *Horror: The Film Reader* (London: Routledge).

Hite, S. (2003) *The Hite Report: A Nationwide Study of Female Sexuality* (New York: Seven Stories Press).

Masters, W. H and V. E. Johnson (1966) *Human Sexual Response* (NY: Bantam Books).

Miller, W. I. (2005) 'Darwin's Disgust', in D. Howes (ed) *Empire of the Senses: The Sensual Culture Reader* (Oxford: Berg).

Modleski, T. (2007) 'Women's Cinema as Counterphobia: Doris Wishman as the Last Auteur', in J. Sconce (ed) *Sleaze Artists: Cinema at the Margins of Taste, Style, and Politics* (Durham, NC: Duke University Press).

Neale, S. (1990) 'Questions of Genre' *Screen*, 31, Spring, 45–66.

Rubenfeld, J. (2006) *The Interpretation of Murder* (London: Headline Review).

Rudé, G. (1964) *The Crowd in History: A Study of Popular Disturbances in France, 1730–1848* (London: Wiley).

Schaefer, E. (1999) *'Bold! Daring! Shocking! True!: A History of Exploitation Films, 1919–59* (Durham, NC: Duke University Press).

Schaefer, E. (2007) 'Pandering to the 'Goon Trade': Framing the Sexploitation Audience through Advertising', in J. Sconce (ed) *Sleaze Artists: Cinema at the Margins of Taste, Style, and Politics* (Durham, NC: Duke University Press).

Sconce, J. (1995) '"Trashing" the Academy: Taste, Excess, and an Emerging Politics of Cinematic Style', *Screen*, 36:4, 371–93.

Sconce, J. (2002) 'Irony, Nihilism and the New American "Smart" Film', *Screen*, 43:4, 349–69.

Sconce, J. (ed) (2007) *Sleaze Artists: Cinema at the Margins of Taste, Style, and Politics* (Durham, NC: Duke University Press).

Thrower, S. (2007) *Nightmare USA: The Untold Story of the Exploitation Independents* (Godalming: FAB Press).

Weber, M. (1949), 'Objectivity and Social Science and Social Policy', in M. Weber *The Methodology of the Social Sciences* (trans. E. Shils and H. Finch) (New York: The Free Press).

Williams, L. (1991) 'Film Bodies: Gender, Genre, and Excess', *Film Quarterly* 44:4, 2–13.

14

His Soul Shatters at About 0:23: *Spankwire*, Self-Scaring and Hyberbolic Shock

Julia Kennedy and Clarissa Smith

In a nondescript bedroom, four friends (three males, one female) sit together in front of a computer screen and wait for a film to begin. Expecting to be scared by what they'll see, the quartet film themselves with a web-cam. Music plays and the friends begin to squeal and exclaim, offering a shocked commentary on what they are watching. One young man excitedly walks in and out of frame while another stares wide-eyed at the computer screen in front of him. He doesn't move even when the young woman tries to pull his face towards hers. After a minute and a half, the film ends with much laughter and the exclamation 'Oh. My. God!'

The above describes Cougarguy222's *Spankwire* Reaction video on YouTube – a clip which has been viewed more than 480,000 times and is described as 'friends watching the HORRIBLE video, *"Spankwire"*. It's the worst video EVER!!!!' This is one of more than a thousand YouTube postings which record the reactions of viewers watching '*Spankwire*: One of the Scariest Videos Out There' – a two and half minute video montage primarily accessed via the Spankwire.com porn hubsite (hence its title) which went viral sometime in 2007–8. Viral videos are a feature of internet communications, tending towards the spectacular – at the 'softer' end exemplified in the display of a celebrity caught in an awkward moment, a household pet doing something out of the ordinary or a politician filmed 'candid camera' style. Of course, there are harder and more explicitly sexual materials amongst these 'must-see' clips or memes, emailed or blue-toothed around the world 'violat[ing] inboxes faster than a drunken Hasselhoff' (Blue 2007) and often sent with the express intention of scaring the receiver – and *Spankwire* is certainly one of the 'hardest'.

This chapter focuses briefly on three connected layers of representation – on the 'origin-video' *Spankwire*; YouTube reaction videos filming

an instance of viewing *Spankwire*, and the commentaries on those left by YouTube members. With the advent of YouTube, amateur and professional videos of all kinds can be collected in one space and have been likened to the early Cinema of Attractions. Certainly, the video-postings we discuss here (and the original *Spankwire* film) seem to have much in common with Eisenstein's definition of 'attractions' in cinematic contexts as 'any aggressive element that 'subjects' the spectator to a sensual or psychological impact'. (Gunning 2006: 35) The reaction videos and the commentaries on them can also be understood as instances of mise en abyme – the presentation of a story within a story or the mirror reflection of an image within itself – *Spankwire* is only 'seen' on YouTube through the reactions of viewers and its particular 'horrors' glimpsed in the tantalizing reflections of it in the sounds and flickering light of the YouTube postings. YouTube offers opportunities to 'gawk' that become invitations to 'respond and participate' (Rizzo 2008) thereby duplicating and amplifying the potential 'shock' of the original *Spankwire*, made present through the exhibition of its audiences. These audiences structure further responses to *Spankwire* and become legible, as we discuss, as forms of freak show and 'attractions' in themselves.

Despite its primary location on a porn site, the origin video *Spankwire* is most frequently described as a freak show: on spankwire.com it is tagged as 'extreme', 'scary' and 'bizarre' with seemingly no expectation that viewers might be sexually aroused by its contents. *Spankwire* conforms to the ways in which the freak show is not just a presentation of the 'abnormal' but a construction designed to outrage 'normality'. 'Freakery' is 'a way of thinking, of presenting' (Bogdan 1988: 10) that draws attention to and exaggerates the exotic and erotic elements of bodies through practices of 'enfreakment' that 'render these bodies aggrandised freaks or exoticised (eroticised) freaks' (Richardson 2010: 206) The freak show has continuously evolved, maintaining a foothold in changing media landscapes – during the 1990s in the TV talk show – and now, the Internet, with its seeming immunity to restriction, relocates the freak show into a user-generated Cinema of Attractions for the twenty-first century through which exhibition, shock and sensation are constantly accessible. The Internet offers the ultimate pixelated fairground: enabling the coming together of transient communities to share in the experience of spectacle and sensation and the affective and intensely bodily pleasures of being 'shocked' and 'horrified'.

Spankwire takes its place in the pantheon of films circulating online that includes *2 Girls 1 Cup* and *BME Pain Olympics: The Final Round*[1] and which, despite their outlandishness, have achieved mainstream

notoriety. What these share (along with images of death and violence available on sites like *Ogrish* and *4Chan*) is the exhibition of 'graphic spectacles of the body' (Lockwood 2009) and an interest in extreme states or practices – sexual or otherwise. These 'shock videos' are likely culprits in some of the recent controversies which have claimed young people are increasingly accessing 'extreme' pornography and they certainly feature in the widely expressed concerns that people (especially children) are exposed to 'unwanted' problematic content during otherwise innocuous web-surfing activities; that people, again particularly children, can find and access content to which they are forbidden, either by parents or the law; and that such exposure, whether intentional or unintentional may have negative psychological or behavioural effects. These concerns also manifest themselves in suggestions that to be interested in viewing or engaging with shock images, or 'problematic' content more generally, is to already suffer from some deficit in moral and/or ethical understanding.

The consensus on videos such as *Spankwire* is that because of their spectacularization of the body in 'mutilated' states, they are a form of 'body horror' or 'gore porn' and thus cater to 'morbid tastes' (Tait 2009: 92) offering a range of pathologized pleasures – the represented fetishization of pain, voyeurism and objectification – most usually ascribed to a 'pornographic' imagination. As Tait has suggested, the use of pornography as a metaphor to explain these pleasures and interests signals particular moral outrage at the ways in which bodily states (especially pain and injury but also degradation and/or self-abasement) are commodified as entertainment to be watched/observed/rejected but not enjoyed for their own sake. Indeed the shock video, like other 'body genres', is subject to a range of classifications which seek to render them 'beyond the pale' – as low cultural products and as 'problem' media, likely to corrupt and debase any viewer. They are amoral in themselves and in their effects in that they 'desensitize' viewers to the pain/debasement/defilements they depict. Most worryingly, for their critics, they don't wait for viewers to come looking for them, they seek out the innocent, the naïve, the unguarded and infect them with their horrific images.

What makes *Spankwire* particularly interesting to us here is that it has been at the centre of at least one attempted prosecution (in the UK) under the provisions of the Criminal Justice and Immigration Act 2008 (R v Holland 2010) which forbids the possession of any image, created for sexual purposes, depicting actual or realistic injury to the genitals. Ironically, at the time that the prosecution was being brought (June 2010), *Spankwire* had logged almost two million hits on spankwire.com

alone. The UK authorities' attempts to designate this video as 'extreme pornography' and consequently a form of imagery which, in its hypothetical pleasures, is particularly dangerous, seem laughably inappropriate in the face of such numbers and, moreover, singularly out of touch with the ways in which 'ordinary' law-abiding citizens may enjoy viewing the taboo. Because so many people have viewed *Spankwire* and some of them have captured their responses for sharing and archiving on YouTube, the normally ephemeral pleasures of being shocked, horrified and/or amused are available to examine how and in what ways shock/outrageous/disgusting images may circulate.

Exploring the attractions of *Spankwire*

Spankwire owes its styling to a genre of video montage popular since the early 1980s – specifically extreme sport videos which collage 'horrible' moments resonant with aficionados of the particular sport: in skateboarding and skiing these are 'wipeouts' or 'bails' where the participants fail to make a risky jump or particular manoeuvre resulting in a spectacular fall. This kind of video features fast editing, unconnected segments, no narrative 'voice', a 'banging' soundtrack and multiple 'aah' or 'oooh' moments. Although primarily aimed at practitioners of the sport, these also 'speak' to non-practitioners as evidence of the recklessness, bravado and panache of 'extreme sport' participants. Consisting of 40 scenes each lasting between five and ten seconds, *Spankwire* depicts various kinds of genital modification and instances of fire-play, suspension and needle-play. Two of its scenes feature a woman's body, but the majority focus on male genitalia and the actions of cutting, binding, squashing or inserting objects into the penis. In *Spankwire*, the clips bring together a range of practices that many will find 'extreme' but, for those interested in body modification, also recognizable as thrilling and/or meaningful for their 'outlaw' status. The extremely fast-editing can make it difficult to see exactly what occurs in each scene compounded by the grainy, badly lit and poorly composed character of 'amateur' video. The soundtrack is a loud and raucous version of Destiny's Child's 'I'm A Survivor' by punk band Knockout. The lyrics (I'm a survivor (what)/ I'm not gonna give up (what)/ I'm not gon' stop (what)/ I'm gonna work harder (what)/ I'm a survivor (what)/I'm gonna make it (what)/ I will survive (what)/Keep on survivin' (what)) underscore the sense of endurance displayed in the individual sequences.

In its original circulation, *Spankwire* does not seem to have been offered as specifically sexual or horrifying but as a taster for a community of

body-modifiers meeting on the website BME.com. Although many visitors to BME.com will have more mainstream interests in piercings and tattoos, BME.com is also a place to discover the 'body-play' practices of the Modern Primitive movement which grew out of the Los Angeles' subcultures of the 1980s that accords particular significances to the 'body as project' and which observes its own 'rules' of bravery where pain has an important role in achieving 'states of grace' (Musafa in Favazza 1996: 325). Significant piercings, tattoos and body modifications are understood as conscious rejection of the Western ideals of the 'body beautiful'. Indeed, many body modifications defy the idea of the properly functioning body – genital piercings mean that even the most 'natural' of bodily functions such as urination or, in men, ejaculation, are altered – for example, the Prince Albert piercing will require its owner to sit while peeing instead of the more 'normal' standing position. The body modifications presented in *Spankwire* transgress standards of bodily wholeness and, in particular, the sanctity of the genitals and 'proper' sexual function.[2] Moreover, some scenes reject normative genital pleasures: one *Spankwire* section features a wasp crawling over a bifurcated penis conjuring up excessive pleasures, sensations and interests premised not on attractiveness or 'proper' functioning, but as acts sought for a very different ecology of pleasures. As it circulates into new locations through YouTube, *Spankwire*'s insistent display of penises renders their modifications 'shocking', 'fascinating' and 'disgusting'.

Tait's study examines Ogrish to trace the site's re-articulation of itself away from 'gore-porn' to a self-appointed locus for moral engagement with body horror. The focus seems to be on 'disavowing the pleasures of looking at body horror' (Tait 2008: 92), and re-framing it as a 'call to conscience' by the site for the viewer. The same kind of moral framing is not an evident feature of the YouTube interface but as we'll go on to discuss, the reaction video performances of disgust and revulsion and the commentaries which accompany them suggest YouTubers' attempts to 'contain' the pleasures of illicit looking; for example, in our sample, only a very tiny minority of YouTubers suggested a desire to enjoy or emulate the spectacle of modification. Instead, there was an almost universal interest in rejecting the practices on display and insistence on *Spankwire* as a form of horror.

Pleasure in horror has been well-documented, for example, Hand and Wilson (2002) draw attention to the 'functioning apparatus-of-horror' in relation to Grand Guignol, a theatrical form of horror which enjoyed considerable success during the first half of the 20th century, and which they describe as a constructed 'apparatus' of horror dependent on

flesh, seats, darkness and illusion. Grand Guignol audiences sought out performances which promised a plethora of bodily affects and its audiences were noted for their extreme reactions. Rather than see audiences as 'victims' of their chosen entertainments, Hand and Wilson suggest they were an important 'cog' in the 'machine', willing to be 'horrified' by spectacle and, in their screaming and fainting actually contributing to the performance on stage. Brophy also describes a similar willingness to participate in contemporary horror film audiences,

> 'Horrality' involves the construction, employment and manipulation of horror – in all its various guises – as a textual mode. The effect of its fiction is not unlike a death-defying carnival ride: the subject is a willing target that both constructs the terror and is terrorized by the construction. 'Horrality' is too blunt to bother with psychology – traditionally the voice of articulation behind horror – because what is of prime importance is the textual effect, the game that one plays with the text, a game that is impervious to any knowledge of its workings.
>
> (2000: 279)

As an example of this playing a game with the text, twenty-something American male, BlyndePyro speaks to his webcam 'Yeah, I'm about to watch *Spankwire* video, I've just watched BME Pain Olympics – it wasn't that fucking bad but ... hear this one is supposed to be a lot worse. So here goes.' The film starts and immediately his jaw drops open, BlyndePyro makes various exclamations though rarely beyond the inchoate 'What the fff???' Eyes wide-open, he occasionally glances at the web-cam as if seeking a response. *Spankwire* finishes and he exclaims 'Holy Fuck! Dude! I'm fucked for the night!'

In the contemporary horrifiable subject of the YouTube reaction video we see individuals or groups who are demonstrably aware that what will be shown is a representation which requires a dramatic reaction at the same time as seeming to respond entirely spontaneously. We see on YouTube a reflexivity about the sensational visual experience, an ability to manipulate the experience in pursuit of reactions such as fear, arousal, entertainment and, possibly, catharsis. The dark space of the auditorium is replaced by brightly lit domestic spaces – usually a bedroom, and the stage replaced by the computer screen, but the screams are pure Grand Guignol. And, because YouTube viewers are watching others' reactions to viewing *Spankwire*, the staging is doubled as they watch another audience as 'theatre' through computer screens in their own bedrooms.

Reacting to *Spankwire*

Our exploration of *Spankwire* reaction videos examined the top 120 videos by view and their corresponding comments sections. We considered responses according to gender and groupings and identified generic traits or forms of responses. Out of 120 videos analysed, 29 were performed by male only groups; 25 by mixed groups; 23 by female only groups; 23 by single males, and 20 by single females. Group responses generally outnumbered single responses, making up 64 per cent of all responses recorded. Male responses were the most popular across both group and single categories, with male groups representing 24 per cent of the overall responses in comparison to 21 per cent for mixed and 19 per cent for both female groupings. Single male responses accounted for 19 per cent of the overall sample, with single female responses occupying the remaining 17 per cent.

A number of generic traits and conventions surfaced: we observed a great deal of repetition in the physical and verbal responses of those being filmed. The most frequent of these were covering of the faces/eyes; mock vomiting actions; turning away from the screen; grabbing one's own crotch in a protective action and a vast panoply of facial expressions of disgust and disbelief. Responses are primarily characterized by amazement, horror, shock, revulsion and black humour. As they set up the video-recording, posters give their reasons for watching – 'My friend Dave told me I shouldn't watch this, so that usually means I HAVE to watch it!' Being scared beforehand seems to be a key requirement – 'I don't think I want to watch this'; 'I'm not watching this I'm gonna be scared'. Other posters adopt a more macho posture – 'I've seen the others, Pain Olympics, 2 Girls 1 Cup and 1 Man 1Jar, this is supposed to be worse, how much?' Thus, in the majority of the films we viewed, participants are aware that they are about to watch something that ought to elicit an extreme response. There is a common intention to withstand 'the horror' or 'shock' of *Spankwire* as a self-imposed challenge - as they watch, many reactors shout out, 'That's not real!', 'That CAN'T be real', 'Why would you do that?', 'Is this really a pleasure for people', 'Do they survive?' and 'Is it over?'. And finally, there is a seeming disavowal of one's own pleasure in viewing: 'That was foul! Who watches that for pleasure? Oooooooohhhhhh!' where the desired response – disgust and horror - is located and conflated in *Spankwire* and other people. Screaming and laughter are also extremely common, especially in the group reactions. The affective responses – the screaming, the turning away from the screen and exclamations – reinforce *Spankwire*'s reputation as the 'scariest video out there'.

Commenting on reaction videos

Lange suggests that 'youth and young adults use YouTube's video sharing and commenting features to project identities that affiliate with particular social groups', their projections are 'conducted in public view (versus as private video exchanges) and ... these choices reflect different kinds of social relationships' (2007: 361). In the reaction videos the violation of social taboos is marked by hyperbolic performances of affect that are purposed towards social interaction and participation. YouTubers are invited to laugh and engage with video-posters via the site's comment facility. In the textual commentary, bodily sensations operate as forms of affiliation and connection as YouTubers demonstrate their own bravery and subcultural capital and mark their participation in these spectacles of affect. The site's comments function has attracted widespread condemnation for the levels of 'infantile debate and unashamed ignorance' displayed by YouTubers (*The Guardian* 2009) and we certainly found plenty of 'juvenile' observation. The majority of comments demonstrate that YouTubers take a general pleasure in the sight of others' evident discomfort in viewing *Spankwire* – often drawing attention to physical jolts and facial expressions, yet there is also much to be learnt from the comments, particularly about the ways in which shock videos have meaning beyond their literal content.

In our research, the sharing of reactions (whether video or textual commentary) is not premised on maintaining friendship groups so much as a wider sense of a community of experience based on the visceral effects of disgust, horror and shock and their hyperbolic performance for camera. Haidt et al. (1997) define disgust as a response that is both biological and cultural in its roots: 'core disgust' resides in foods, animals and body products and all cultures prescribe a correct human way to handle the biological functions, typically reviling those who breach the codes (ibid: 112). There are sub-categories of 'elaborated disgust' refering to sexual behaviours deviating from the cultural ideal of 'normal' heterosexuality and to forcible body 'envelope' violations such as 'bloody car accidents, mutilated corpses, surgery, wounds and physical deformity' (ibid.: 112). These social taboos often hinge around notions of the body as a temple and vessel for the soul within. Whilst core disgust guards against material contamination and conflation with the animal, concerns about sex and envelope violation relate to more nuanced threats to the 'soul' (as indicated by the response borrowed for the title of our chapter).

We observed a great deal of incredulity about the sanity of the actors in the original *Spankwire* film, often articulated through a kind of

rhetorical questioning which made reference to the 'devastation' or 'ruination' of the body:

> *101RiseAgainst* ... why do people actually do that to there self seriosly is there any reason or like sickness or mental disease jesus fucking christ its gross.
> *KilltheFluXz.* It's real allright. It's actually a fetish doing that kind of stuff to their own genitals. couldn't you see the guy coming after creating another hole down there? Some clips might be fake, but mostly is real. They're probably under a heavy influence of drugs or something, but people actually get off to self-pain, believe it or not. It's hard to believe for all of us normal people: S

Commentaries also offer a 'welcome to the real world' kind of cynicism which is at pains to highlight posters' more knowing worldliness. Many respondents were interested in discussing the possibility of fakery:

> *taveon125* ... I've watched this video and it shows no realism at all. It is 100% fake. I do realize people have pleasure from pain but until a point. Mutilating your penis can cause the most severe amount of pain and the only way someone can actually stand to do something like that is if they have an extreme PCP overdose. It's way to obvious it's fake. 1. No one would do that.

The following respondent offers pharmacological detail to position the acts witnessed outside of a conscious possibility, claiming that the actors must have been drugged:

> *ipodmanischen* these people must've been forced to do this after being administered some strong substances. And I'm not speaking of conventional substances, this must have been powerful sedatives and sedative-hypnotics like Ambien, Amobarbital, Scopolamine, Pentothal, Flurazepam, Halcion, Quazepam, Solzidem, etc. A cocktail of those would surely do it ... Otherwise, i just can't imagine someone doing this to themselves.

The effort to blot out the possibility of such behaviours as voluntary is interesting. It eschews the guttural, visceral response in favour of a knowing, scientific discourse that refuses to countenance acts of mutilations as anything other than played out on unwilling victims, and suggests that other commentators are gullible dupes. There is no comprehension here

of new primitivism, or Musafa's 'states of grace' but a rationalization of these practices which both refuses to accommodate voluntary submission to pain and sneers at those viewers who might think this is real.

YouTube's capacity to accommodate the contemporary 'freakshow' is evident here as responses transform the exotic into the emetic. Through constant exclamations of 'is it real?' and 'why would you?' which constitute 'acts of community', the message becomes 'we're normal and they are not'. But 'normality' is also referenced as rather fragile and likely to be soiled by contact with *Spankwire*:

> *65infanteria* The creepiest thing is the mentally challenged 'assistant' with the naked hung lady with the claptrap at her thing. I shouldn't say more ... the review alone might pervert lil youtubers.

But perverting 'lil youtubers' is one of the pleasures to be shared. Many of the group reaction videos involve a member who has already seen *Spankwire* introducing uninitiated friends to the video and taking particular pleasure in the gross-out of the innocent(s). In line with this is the particular appreciation of watching unknowing initiates reacting to *Spankwire*: a gleeful pleasure in seeing others lose their 'souls'. These responses are gendered and also age dependent, with congratulations to young men (late teens/early twenties) for 'making it' through the film, whereas for younger boys (early teens) there seems to be pleasure in seeing them 'lose their religion'. When it comes to girls, there is evident pleasure in seeing the horror played out on a pretty face as in the range of comments on Babybaybay's video:

Don123q	Damn you are beautiful
Ninjademonz95	I feel bad for you :(
Mrlebowski562	her mouth is wide open
Sam987123456	you*re even beautifull during watching such crank shit o_O ;)
Vgamedude12	Lol love the look on your face at 2.00.

This pleasure in 'defilement' is taken a stage further in the following respondent's description of young women becoming 'desensitized' as they watch a range of shock videos:

> *cerebulon*: It's interesting to see Remi's progression from this video to the others. She' pretty disturbed here, but as she watches more of these she gets desensitized and starts cracking these sick jokes to piss off Julia. Go check out their Vomitgirl reaction.

Further pleasures of viewing and responding to the reaction videos seem to be derived from 'winding up' the uninitiated, seeking context and advice from the initiates. The articulation of change and contamination through the experience of watching the video was common as an affective response. Posters reported wanting to 'rip their eyes out', and wishing to 'unsee' the video so they could return to an implied state of pre-*Spankwire* innocence:

> *bambooleaf*: (2 years ago) If i could go back in time and never watch it, i would.

For those who haven't seen it, *Spankwire* becomes a Bloody Chamber of temptation. Some posters lurk around outside the door asking others what is in the video, presumably as a way of making their decision to watch it, or of vicariously experiencing what they are afraid to witness personally. Others seek information about where it can be located so that they can experience their own version of the adrenaline rush of shock and disgust they have witnessed:

> *cutekenzie103*: yo i wanted to vomit wen i saw diss shidd!!! haha i felt like killin miiself lmfao
> *zxcvb9081*: what is it?
> *Dahidex*: I watched that horrible video ... and wanted to put a bullet through my skull.

The initiated perform the role of knowing advisors to the newcomers with many comments passionately entreating people not to watch *Spankwire*:

> *4imbecil2009vs*: the vid is just people, doing anything bad you can think of, to their genitals. Literally anything. This one guy puts these hooks in his ass so it gets stretched to like 4 inches wide. If you haven't seen it, please don't watch it:s Glad to save you from watching this ungodly abomination.

Others made comparisons to the shock video 'canon', insisting that *Spankwire* is the worst that can be seen:

> *charmed6057*: Dude, '2 girls 1 cup' is like kindergarden level for what's out there. LIST! This (from reaction) 'BME pain Olympics' (all 3), '2 men 1 horse', '1 guy 1 jar', '2 kids in a sandbox', 'Putrid Sex object', '1 girl 1 phone' (which isn't that bad), 'New veggie is born', '1 guy 1 screwdriver'. There are so many, i can't count. Just never

watch these two: '3 guys 1 hammer' and some Russian neo-nazi shit. Anyone will regret it if you do.

These comments demonstrate the hierarchies at play, but these are also discursive distinctions which demonstrate levels of knowledge on the part of commenters – expressions of cultural capital. For example, this viewer rejects the received wisdom that viewing these videos should be advised against:

> *KBillsterC*: ive seen this all the way thru (not meaning to brag or anything) and i want to try and find the worst shock site ever, is there any video worse that this one, if so plzz plzz send me the link in a PM (and dont just tell me not to watch it cos i wont listen) thanks in advance.

The difficulties of finding *Spankwire* are endlessly referenced in the YouTube commentaries, helping to enhance the film's reputation as a peculiarly illicit pleasure – contributing to the unsavoury reputation of *Spankwire* and to the 'outlaw' status of its viewers. Such comments work to build a reputation for *Spankwire* and for those who have viewed it, confirming its notoriety and cementing viewers' daring in having actually seen the film. Comment posters who have seen *Spankwire* confirm the 'proper' reaction to it, often emphasized through claims of adverse effects:

> *65infanteria*: i watched it a couple of weeks back ... haven't, you know, ever since for fear I might break my john ... by the way I watched the whole thing though it took me three sittings. Had my heart pounding like a wild thing and i covered my eyes a couple of times.

Many comments also feature an insistent vulgarity which actively seeks to continue the level of disgust or the pleasures of revulsion.

> *weezelanimal*: dude i made it thru whole video ... But i must say ... jesus christ officially took a shit in my cereal bowl on this one

Weezelanimal is both articulating his/her endurance in watching the video, and effectively employing scatological irreverence to locate themselves differently to the more common responses from posters who explicitly reject the practices of self-modification. It builds on the idea of a horrified response but increases the humour quotient to amplify the affect, indicating a posting position beyond rejection where disgust

is a pleasure sought for its own character. This more scandalizing attitude may be linked to claims of being sexually aroused by viewing *Spankwire* – an admittedly rare claim in our sample – which could be read as a form of trolling but also aggressively challenges the idea that there is only one appropriate response to *Spankwire*. In that challenge is a viewing position which embraces the contravention of the normative response for further hyperbolic effect – if the appropriate response is to be horrified, how 'hard' must one be to embrace the film as a turn on? But surely this is a knowing intention to disgust others by refusing to be disgusted by the disgusting! Even as such posters indicate their very individual response, they engage with *Spankwire* as a locus for the shared experience and acknowledgement of sensational reaction to thrilling material. Posters indulge in a form of 'self-scaring', a joining in with others who have survived the same kinds of viewing and an 'emotional exhibitionism' and pleasure in disgust, dread and/or hyperbolic shock.

Conclusion

Our conclusions about the meanings and importance of *Spankwire* and its circulation via YouTube can only be tentative but examination of these commentaries show a level of performed and performative disgust which seems to have escaped the attentions of those who view shock imagery as a form of pathology. While a commonsense view – and the law – assumes there is an obvious purpose to extreme and/or controversial images the ways that people respond to and consume them may well be much more complicated. The virtual audiences of contemporary YouTube attractions are primed for the enjoyable sensations of being horrified and are playfully aware of the sets of judgements that might be made of their pleasures. There may be nothing new in the fascination with imagery of the human body in all of its states, as Linda Williams notes in *Hard Core* 'the desire to see and know more of the human body ... underlies the very invention of cinema' (1989: 36). What we see in the reaction phenomenon are the ways in which audiences of body imagery use new technology to place themselves centre stage as both consumers and producers of sensation.

Notes

1. *2 Girls 1 Cup* is probably the most notorious of all these videos and is a trailer for a Brazilian fetish porn film, *Hungry Bitches* (2007). Produced by MFX Media,

2 Girls 1 Cup shows two women defecating into a cup and taking turns to consume its contents as well as passing the excrement to each other's mouths. The video's notoriety was cemented by its circulation on message boards and blogs and then, from late 2007, the appearance on YouTube of videos in which first-time viewers recorded their reactions. *BME Pain Olympics: The Final Round* takes its name from the website on which it was first hosted – *Body Modification Ezine* (BME.com) and the Pain Olympics – an occasional contest held at *BMEFest* where contestants compete to demonstrate their exceptional stamina and tolerance of pain. The video shows two men performing genital self-mutilation (at one point using a meat cleaver). The mutilations are faked; Shannon Larratt who created the video has confirmed that the two men depicted are actually the same person and that prosthetics, fake blood and make-up were used to create the appearance of extreme modifications. Even so, the video often circulates as real and is also the subject of thousands of reaction videos on YouTube.

2. See for example, discussions of the bio-politics of the penis by, among others, Stephen Maddison, which explore the ways in which proper erectile functioning – the ability to get hard, stay hard and 'perform' for longer – has become a kind of moral imperative for men.

References

Blue, V. (2007) 'The Top Ten Sex Memes of 2007', *San Fransisco Gate*, http://www.sfgate.com/cgibin/article.cgi?f=/g/a/2007/12/27/violetblue.DTL#ixzz1 AOcjvFA6, date accessed 7 January 2011.

Bogdan, P. (1998) *Freak Show: Presenting Human Oddities for Amusement and Profit* (Chicago: University of Chicago Press).

Brophy, P. (2000) 'Horrality: The Textuality of the Contemporary Horror Film' in K. Gelder (ed) *The Horror Reader* (London: Routledge).

Favazza, A. (1996) *Bodies Under Siege: Self-mutilation and Body Modification in Culture and Psychiatry* (Baltimore: Johns Hopkins University Press).

The Guardian (2009) 'Our Top 10 Funniest YouTube Comments – What Are Yours?', http://www.guardian.co.uk/technology/blog/2009/nov/03/youtube-funniest-comments, date accessed 12 March 2011.

Gunning, T. (2006) 'The Cinema of Attractions: Early Film, Its Spectator and the Avant Garde' in W. Stauven (ed) *The Cinema of Attractions Reloaded* (Amsterdam: Amsterdam University Press).

Haidt, J., Rozin, P., Clarke M. and Sumio, I. (1997) 'Body, Psyche and Culture: The Relationship between Disgust and Morality', *Psychology and Developing Societies*, 9, no. 1, 107–31.

Hand, R. J. and Wilson, M. (2006) *Grand-Guignol: the French Theatre of Horror* (Exeter: University of Exeter).

Lange, P. G. (2007) 'Publicly Private and Privately Public: Social Networking on YouTube', *Journal of Computer Mediated Communication*, 13, no. 1, 361–80.

Lockwood, D. (2009) 'All Stripped Down: The Spectacle of "Torture Porn"', *Popular Communication: The International Journal of Media and Culture*, 7, no.1, 40–8.

Maddison, S. (n.d) 'The Bio-Politics of the Penis', http://www.uel.ac.uk/ccsr/documents/TheBiopoliticsofthePenisCSNowweb.pdf, date accessed 23 April 2011.

Polhemus, T. (1998) 'The Performance of Pain' in G. Berghaus (ed) *On Ritual* (London: Routledge).

Richardson, N. (2010) *Transgressive Bodies: Representations in Film and Popular Culture* (London: Ashgate Publishing).

Rizzo, T. (2008) 'Youtube: the New Cinema of Attractions', *Scan Journal*, 5, no. 1, http://scan.net.au/scan/journal/display.php?journal_id=109, date accessed 5 November 2010.

Tait, S. (2008) 'Pornographies of Violence? Internet Spectatorship on Body Horror', *Critical Studies in Media Communications*, 25, no. 1, 91–111.

Wertham, J. (2007) 'Unspeakable YouTube Vids Spark Bevy of Hilarious Reaction Shots', *Wired*, http://www.wired.com/underwire/2007/11/its-kind-of-lik/, date accessed 1 July 2011.

Williams, L. (1989) *Hard Core: Power, Pleasure and the 'Frenzy of the Visible'* (Berkeley: University of California Press).

15
Playing with Controversial Images in Videogames: The Terrorist Mission Controversy in *Call of Duty: Modern Warfare 2*

Vincent Campbell

This chapter explores questions about controversial images in video-games. It is centred on a significant media controversy surrounding the biggest selling videogame of 2009, *Call of Duty: Modern Warfare 2* (Activision). The game generated public criticism over one specific mission depicting a terrorist massacre and fire fight in which players can participate. In the context of this volume, this alone would make it worthy for consideration as a starting point in thinking about the nature of controversial images in videogames. However, the specific form of the 'controversial images' in this individual game offers additional insights into fundamental questions about the nature of videogame controversies, and why, given videogames increasing predominance in popular culture and everyday life, there may be more potential for controversy over imagery than in other media. The chapter is not concerned with debates about videogame effects, not only because of the intrinsically problematic approaches in media effects research that apply as much to videogame effects research as to other media (Poole 2000; Tavinor 2009), but also because videogame content can often be seen as problematic regardless of potential behavioural consequences (Tavinor 2009: 159). Objections to *Modern Warfare 2* were less to do with traditional complaints about encouraging violent copycat behaviour than with moral condemnation of the narrative context offered in the specific mission framing the gameplay. The chapter is thus concerned more with affects than effects, and possible reasons as to how and why *Modern Warfare 2* generated the controversy that it did, and why those objections to the game may have arisen.

The conventional position is that games are potentially more problematic because they are interactive (Tavinor 2009: 163). I argue that the

'restricted play' (Brookey and Booth: 2006) of games is central to the controversy around *Modern Warfare 2* and to its critical merit. The chapter also explores some related concepts that may additionally explain the nature and extent of affective responses to the controversial *Modern Warfare 2* mission, specifically concepts of immersion (Murray 1997) and presence (McMahan 2003). Finally, the chapter will, following Tavinor (2009: 168), consider *Modern Warfare 2* as an illustration of the maturing nature of videogame design, whereby videogame players are gradually beginning to be confronted by game narratives and scenarios requiring self-reflection and moral decision-making, moving videogames firmly into the realm of legitimate art. In this sense the chapter concludes that controversies of the type surrounding *Modern Warfare 2* are to be welcomed as they indicate videogames developing into a more sophisticated and challenging art-form.

A brief history of videogame controversies

Controversy in videogames goes back a surprisingly long way in videogame history, and essentially can be categorized as centring on three aspects relating to their manifest content, their attitudinal position towards that content (and the expected/presumed attitudinal position of the player), and the actions players are expected/allowed to engage in (Tavinor 2009: 159).

The first press-worthy controversy occurred in 1976 surrounding the arcade game *Death Race* (Exidy) (Kent 2001: 90) only four years after the videogame craze began with the release of Atari's *Pong* in 1972. *Death Race's* graphics were barely more sophisticated than those of *Pong*, and therein lay some of the problems. The game involved players controlling a car with which they run over 'gremlins', which were interpreted by many as people. Although the game's producers asserted that the game was about killing demons and not people, they have subsequently acknowledged that the controversy didn't exactly harm business. Exidy founder, Peter Kaufmann, has said '[i]t seemed like the more controversy ... the more our sales increased' (in Kent 2001: 92). Violence against people has become a staple component of many videogame genres since then. In 1982, for instance, the game *Custer's Revenge* (Mystique), produced and marketed as an explicitly adult game was widely condemned for its depiction of rape and racism (Kent 2001: 227). The player guides his character, Custer, across the screen avoiding Native American arrows, and if successful, reaching a Native American woman tied to a post whom the player then rapes. Complaints were

raised by both anti-pornography groups and Native American groups (Kent 2001: 227). Again, whilst the graphics are crude and simplistic to modern eyes, it is the notion of the actions engaged in that is core to the game's controversy.

By the early 1990s, however, videogames were becoming more visually sophisticated to the point where graphic sexuality and violence was beginning to systematically attract the attention of politicians (Kent 2001: 470). In the US, two games in particular brought this lucrative industry into direct conflict with policymakers, with the release in 1992 of *Mortal Kombat* (Acclaim) and *Night Trap* (Digital Pictures). *Mortal Kombat* followed in a long line of martial arts-based fighting games but its producers decided they would 'make it gruesome' (Boon in Kent 2001: 464) and introduced (for the first time) graphic depictions of blood and gore in so-called fatality winning moves. *Night Trap*, on the other hand, was controversial in a slightly different way. *Night Trap* was distinctive for being one of the first games to use live action filmed sequences, using actors for its main imagery rather than digital animation. The player's role is essentially that of a voyeur watching a slumber party of beautiful young women and trying to prevent them from being killed by invading vampires. Filmed sequences of blood, gore and scantily clad young women were cited as 'gratuitous and offensive' (Lieberman in Kent 2001: 475) in US Senate hearings concerning the marketing of violent videogames to children. Despite the subsequent introduction of ratings systems and ratings boards in several countries through the 1990s controversies have continued. Rockstar Games in particular have found themselves at the centre of such disputes on many occasions, in relation both to their well-known *Grand Theft Auto* (1997–) series and also to the lesser known *Manhunt* (2003, 2007) games. In *Manhunt* (2003) the player takes on the role of a death row criminal who sneaks up on opponents; the more gruesome the manner of killing, which includes suffocation with plastic bags, the better the progress through the game. The first game in the series was critically acclaimed, but after the news media linked it to a violent murder in Britain, some stores withdrew it from sale and it was banned in Australia and New Zealand. Its sequel *Manhunt 2* (2007) was actually refused a classification by the ratings board in Britain and given an 'Adults Only' rating by the ESRB in the USA, both decisions effectively preventing the game's release in two key markets. Rockstar re-edited the game to ensure a lower rating in the US and to get a rating for its eventual release in Britain in 2008.

Rockstar's famous *Grand Theft Auto* series has been subject to a variety of accusations, court challenges, and media controversies since the first

game appeared in 1997. In general the series has been criticized for placing the player in the role of a career criminal and has been described as a 'crime simulator' (Tavinor 2009: 150). These games pioneered a type of game environment now referred to as a 'sandbox', where players aren't directed in a single, linear direction through a game but are allowed to complete missions flexibly (for instance, a mission to kill a mob boss may be done in several different ways, from running him over in a vehicle to shooting him with a sniper rifle). Sandbox games usually take place in a large bounded space around which players can move completely freely; in *Grand Theft Auto* games these are typically cities. The games also contain side activities, designed partly to enable players to become more familiar with the game space, but also to prolong game engagement after the main narrative arc of the game is completed. In later versions of *Grand Theft Auto*, one side activity to provoke criticism is the ability to hire prostitutes and engage in virtual sex with them (which restores health level). Although the sex is only animated as a rocking car, with accompanying audio soundtrack, the sandbox format allows the player then to attack and even kill the prostitute to recover the money spent on her services. So this emergent capability in the game's structure attracted criticism of the possibilities of player choice rather than simply of game design.

Modern Warfare 2

Modern Warfare 2 belongs to a genre of games that have been at the centre of videogame controversy since their inception: the First Person Shooter (fps). Both *Wolfenstein 3D* (id Software, 1992) and *Doom* (id Software, 1993), which essentially created the genre, were cited in the 1993 US Senate hearings due to their use of graphic violence and, in the case of *Wolfenstein*, because its World War II setting involved lots of Nazi imagery (Kent 2001: 458).

Three attributes of fps games stand out. First, as the name suggests, fps games are presented from a first person perspective, and while first-person perspective games had existed before, it wasn't until the 1990s that console/computer power began to enable full colour, solid, 3-D environments that could be moved through at the kind of real-time speed gamers had come to expect from other types of game (scrolling shooters and driving games for instance). Typically fps games depict only a tiny fraction of the player's avatar on screen – often just the weapon the avatar is carrying at the time – and while movements of the controller guide the player through game space, looking down, for

instance, does not normally result in the player seeing their avatar's feet. Moments in fps games where the avatar's body is depicted are sometimes used, however, and occur in both *Modern Warfare 2* and its predecessor in significant ways.

Second, since the late 1990s the technical capacity for multi-player online games has been particularly important for fps games, and games that lend themselves to multiplayer play have become dominant in terms of sales and popularity. The majority of fps games, though, retain an offline single-player 'story' mode which takes the player through a specific narrative. Fps games therefore, unlike *Grand Theft Auto*-style sandbox games, generally take a much more linear approach to directing the player through the game's narrative – another important point with regard to *Modern Warfare 2*.

Third, fps games have, roughly speaking, developed along two clear trajectories with regards to the narrative contexts provided for their gameplay. One sub-category is games based firmly on science fiction and fantasy scenarios, such as the phenomenally successful *Half-Life* (Valve Software, 1998) and *Halo* (Microsoft, 2001), whose environments are based on imaginary alien or mythical worlds and which use invented weaponry. The other category consists of games grounded in realistic portrayals of real world military conflicts, in terms of both the historical narrative and the gameplay (e.g. realistic weaponry and tactics needed to complete the game). Series such as *Medal of Honor* (Electronic Arts, 1999–) and the original *Call of Duty* (Activision 2003–) games have made World War II in particular a dominant narrative context for story modes in many 'real world' fps games.

The *Call of Duty* series was initially seen as a solidly-made series of games but somewhat overshadowed by bigger brands like *Medal of Honor*. After several World War II-set iterations, *Call of Duty 4: Modern Warfare*, which shifted to a contemporary setting, was released in 2007 across a number of platforms and sold over 12 million copies by the end of 2009 (BBC 2009), making it one of the most successful games of all time. The game's commercial success was matched by its critical reception. Acclaim focused on the narrative dimensions of the game as well as the quality of the graphics, gameplay, and multiplayer facilities.

The game, set in the near future, opens with a highly acclaimed credits sequence in which the player takes on the role of a president of an unnamed Middle Eastern country being driven through the streets of a city in the midst of a coup. All the player can do is use the controller to look around through the windows of the car. The sequence ends with the player being executed by the coup leader. This kind

of 'restricted play' (Brookey and Booth 2006) in the game's narrative progression is a regular trope in the Modern Warfare games. The main game proceeds on two fronts. One involves American military forces intervening in the Middle Eastern country to prevent the coup from succeeding; the other, a British SAS unit trying to find and capture the Russian ultranationalist leader believed to be ultimately behind the coup, who is using it to distract the US and the world in order to conduct a surprise attack on the US. The player assumes several different characters during the game; a distinctive feature of the game is that characters played by the gamer die as part of the central narrative. In one notable sequence, the player's character (a US marine) reaches a helicopter safely at the end of what appears to be a successful mission completion, but events change dramatically when the helicopter crashes. After a brief blackout the character comes round, but the player can only make him drag himself slowly out of the helicopter wreckage and look around to see a nuclear bomb's mushroom cloud nearby before the screen fades to black, with the character clearly dead. The story proceeds through the successful defeat of the coup and the pursuit and eventual successful killing of the ultranationalist leader via other playable characters.

Modern Warfare 2 essentially continues the plot of the previous game. Killing the Russian ultranationalist villain is shown to have enraged Russian anti-Western sentiment and placed ultranationalists firmly in control in Russia, where popular sentiment is being fomented further by a former associate of the main villain of the previous game committing a variety of terrorist attacks and blaming them on the US. Again the player takes on several characters' roles during the game, within US armed forces, and US/UK Special Forces units as they attempt to prevent further terrorist attacks, and catch the ultranationalist villains.

'No Russian', the controversial mission in the game, is a pivotal point in its narrative. Playing as an undercover US Army Ranger who has infiltrated the ultranationalist terrorist group, the player is required to participate in an attack on a Russian airport. The terrorists simply walk through the terminal massacring the public, before fighting their way out of the airport past security services and armed forces. In terms of the narrative, the mission ends with the player being killed by the terrorist leader who knew that the player's character was American, with the intent of leaving the American's body to blame the US for the terrorist atrocity. This leads to an all-out invasion of the US by the Russians, paralleled by continued efforts from Special Forces units to find and kill the terrorist leader. The denouement of the game has the twist that the

American commander, who is supposedly leading the fight against the Russians, has actually been the ultimate villain all along, and was looking to use a conflict with the Russians to reassert a more authoritarian and militaristic US.

Modern Warfare 2, in this particular mission, offers a combination of all three aspects of controversial games: the content depicts the terrorist slaughter of innocent civilians, which the player cannot prevent, and can, if they wish, participate in. Interestingly, and unusually, the game developers included an option both at the beginning of the game, and then immediately prior to the mission, for the player not to have to play the mission. (If players opt out of the mission, the event it depicts is recounted in the between-mission cut-scene narration, so players can still follow the story.) The mission featured in press mentions of the game in numerous countries, such as in *The Daily Telegraph* in Australia (October 9 2009), *USA Today* (November 10 2009), *The Guardian* in the UK (November 10 2009), *The Globe and Mail* in Canada (November 11 2009), *The Irish Times* (November 14 2009), and the *Christchurch Press* in New Zealand (November 24 2009). Journalists' comments varied on whether controversy was justified in relation to the game. One commentator in *The Washington Times* in the US declared '*Call of Duty: Modern Warfare 2* is another immersive first-person game offering players the chance to vicariously participate in acts of violence for the sole purpose of ... entertainment' (Hicks 2009: 22). David Aaronovitch writing in *The Times* in London rejected these criticisms, regarding the game as an 'all-encompassing' experience (2009: 4). Gerard Campbell in the *Christchurch Press* found the mission difficult, saying, 'I didn't fire a shot, I just couldn't, and felt the game could easily have done without the scene as whether you shoot or not, the end result is always the same' (2009: 9). Derek Pedly in *The Advertiser* in Australia was strident, declaring the mission to be 'the most sickening five minutes I have ever endured in front of a TV screen – games, movies or otherwise' (2009: 24). In Britain, the controversy briefly extended beyond press columnists, when the then Home Affairs Select Committee chairman, Labour MP Keith Vaz, called in parliament for the game to be banned on the grounds that it contained 'such scenes of brutality that even the manufacturers have put in warnings within the game', and indicated that banning the game was about 'protecting our children' (quoted in Aaronovitch 2009: 4). Apart from a robust defence of the games industry from fellow MP Tom Watson this call met with little wider response and the game went on to be the best-selling game of the year in Britain, pretty much as elsewhere.

Interactivity and restricted play

Videogames apparently differ most from other media in their potential for controversy because of the 'active' role of the player. As Tavinor suggests:

> If someone plays a videogame in a violent manner, even if that violence is only fictional, we still might pause to consider the moral significance of the content they have had a part in generating ... the *interactive* nature of videogames gives us a stronger reason to blame not just the author of the fiction, but the player as well, because of the player's active role in generating the fictionally violent and immoral content.
>
> (2009: 163, emphasis added)

Because videogames require players to do things that, in a sense, create the imagery and progress the narrative of the game (at the most fundamental level, press buttons and move controllers) there is a colloquial and often intellectual presumption of greater involvement, engagement, and as Tavinor suggests, responsibility for the images produced. But the concept of interactivity is far too simplistic to really address the potential 'problem' of videogames. For a start, if interactivity is to be simply reduced to the physical interaction of the player with the computer/console interface then, as Manovich suggests, this is essentially tautological (2001: 55). What is important is not physical interaction, but psychological interaction, 'processes of filling-in, hypothesis formation, recall, and identification, which are required for us to comprehend any text or image at all' (Manovich 2001: 57). Thought of in this sense, all art forms are interactive (Manovich 2001: 56). Moreover, the presumption that videogames are necessarily more interactive than other media texts ignores the significant number of elements common to videogames that are decidedly non-interactive, even in the physical sense. As Newman points out, videogames 'do not offer a consistent experience of interactivity' (2004: 75). The most common example of this is the 'cut-scene' – short movie-like sequences, often used to open, close, and break up the action between sections of a game (Newman 2004: 76; Brookey and Booth 2006: 218). Cut-scenes began to become popular when it was possible to offer graphically more sophisticated sequences that were unplayable but efficiently presented and drove the narrative of games. Several games licenced to major film franchises have used live-action footage from the films in this way, for instance

games linked to *The Lord of the Rings* films (Brookey and Booth 2006). Even when some interaction on the part of the player is allowed, like the limited degree of control over the camera position in the opening sequence of *Modern Warfare 1*, the player is still 'rendered passive and has no agency in changing the game's narrative' (2006: 219).

A more substantive limitation of videogame interactivity is noted by Brookey and Booth (2006: 218). If interactivity implies that the game player is active or has agency, they argue that this is quite different from notions of the active audience in other media. 'Active audiences' are said to interpret media texts in ways that resist or oppose the texts' intended meanings. In videogames, however, the 'player who resists the rules of the game, or ignores or reinterprets them, is most likely to lose the game. In other words, video games reward compliance, not resistance' (ibid.: 218). In several senses then video games restrict rather than enable the player's interaction.

The interesting thing about the 'No Russian' mission in this context is the extent to which the relationship between physical and psychological interaction is deliberately manipulated in distinctive ways which may account for some of the strident critical responses to the game. Crucially, the player is unable to prevent the massacre; you can refuse to take part, but must still witness it and join in the fire fight later in the mission (when police and armed forces appear and start shooting at your avatar, not shooting back leads to death and mission failure, see Figure 15.1). This restricts the physical interaction of the player but heightens psychological interaction with what is depicted on screen. This could potentially result in players reflecting on the required actions of fps games i.e. that an fps involves missions where the objective is to get from point A to point B without dying and requires killing any or everything in your path. That reflection on genre conventions, combined with the death of the character being played at the end of the mission – which in itself could be seen as a kind of narrative disapprobation of the behaviour of players (or at any rate those who willingly join in the civilian slaughter) – seems to have been ignored or misunderstood by the most vocal of the game's critics (like Campbell 2009: 9). After all, the rest of the game (like all other first person shooters) involves killing people too; it just doesn't foreground the ethics of killing as this mission does by the overt restriction of interaction.

Immersion and presence

There are several features of videogames beyond 'interactivity' and the depiction of objectionable images which contribute to their potential

Figure 15.1 The 'No Russian' mission, *Call of Duty: Modern Warfare 2*, 2009

for controversy. For example, there is the capacity for videogames to generate in players a sense of 'immersion' (Murray 1997) and 'presence' (McMahan 2003: 69). From the earliest days of videogames it was recognized that the enjoyment of games lay partially in their giving players the means for 'losing oneself in a simulated world' (Turkle 2003: 508) and achieving 'flow' experiences (Calleja 2007: 255; Juul 2009: 247). The degree to which a game achieves this depends upon the level of involvement that various elements of the game can generate in a player (McMahan 2003; Calleja 2007). Being described as 'immersive' by reviewers is a much sought after characteristic for videogame developers of their games.

As Murray contends, the appeal of immersion lies in 'the sensation of being surrounded by a completely other reality, as different as water is from air, that takes over all our attention, our whole perceptual apparatus' (1997: 98). Pursuing the analogy with immersion in water, Murray continues that 'in a participatory medium, immersion implies learning to swim, to do the things that the new environment makes possible' (1997: 99). In terms of videogames, immersion is a vital component in getting players to play and keep playing the game. With games increasingly involving online components, this enables continued revenue streams through downloadable content that prolongs the game experience; it's a commercial imperative, not just a ludic one. The fundamental

tension in achieving immersion in videogames is that they depend on mediation and an interface. Indeed the recent growth of motion-based game systems like the Wii, Playstation Move, and Xbox Kinect, which reduce the degree of interface needed to interact with games, has arguably been pursued to try to engage those who remain stubbornly resistant to the requirements of traditional PC/console-based games with their complicated controller devices.

For Bolter and Grusin immersion stems from efforts to achieve what they call 'transparent immediacy' whereby 'the user is no longer aware of confronting a medium, but instead stands in an immediate relationship to the contents of that medium' (2001: 24). Thinking primarily in visual terms, they argue that one way of achieving this is 'by involving the viewer more ultimately in the image'; for instance 'interaction may be as simple as the capacity to change one's point of view' (2001: 28). While in painting or photography the viewer's point of view is fixed, and in film or television it is mobile but controlled by the director, in videogames the player has a level of control that enables a greater level of immersion in the game (2001: 28–9). The first-person point of view shot has been used in film and television for notable dramatic/narrative effect (e.g. the Steadicam sequence in Scorsese's *GoodFellas* (1990)) and, of course, part of the appeal of first-person shooter games lies precisely in their elision of the traditional on screen avatar, which enables a greater perceptual and psychological immersion in the game world (McMahan 2003: 77; Calleja 2007: 242). In *Modern Warfare 2*, specifically, the visual design of the game of the first person perspective enhances this immersive potential. Fps games usually overlay the screen with on screen icons (a type of head-up display) indicating various aspects of the player's game status (such as a timer, for when missions are against the clock, ammunition status, weapon status, sometimes health level and so on). All of these components are really what Bolter and Grusin would call examples of 'hypermedia', where the fragmented, multi-component, and essentially mediated nature of the experience is foregrounded to the user (2001: 31), and necessarily are in tension with efforts at transparency and immersion (as well as being non-interactive elements of games as discussed above). Games developers have thus begun to reduce the amount of hypermedia elements in games, and *Modern Warfare 2* uses one of the clearest examples of this. Instead of an overlaid icon on the screen indicating health level, players are given visual cues as to the amount of damage they've sustained by droplets of blood splashing onto the screen in ever greater quantities until the screen reds out, as though the player's eyes have become full of blood. Wounded players

regain health by finding cover, and avoiding being shot for a period of time sees the screen clear of blood and health restored. Whilst the actual physiological activity in the game here – getting shot, hiding, and recovering as a result of hiding – isn't in itself a good example of verisimilitude, the visual trope is an excellent example of an attempt at visual transparency enabling an increased sense of immersion, or what McMahan refers to as 'presence' – 'the perceptual illusion of nonmediation' (2003: 73). This capacity for videogames, and *Modern Warfare 2* in particular, potentially to generate a sense of being present, even in a clearly simulated world, may be central to the capacity for videogames to generate controversy over their imagery. In this sense, the 'No Russian' mission experience is far more immersive than, for instance, a similar sequence in a film or television programme. In other missions, showing parts of the avatar's body enhances this sense of presence: the avatar's arms are shown whilst climbing an ice wall, then later in a cut-scene he looks down at burnt and damaged hands before picking a gun up (the cut-scene segues into a playable sequence). In the climactic scene the player has to struggle to pull a knife out of their own character's chest and throw it to kill the game's villain.

Attitude and art

The effectiveness in *Modern Warfare 2*'s game design in generating immersion and a sense of presence may go some way to explaining critical reactions to the 'No Russian' mission, but they are not necessarily legitimating grounds for condemnation. It is not only a game's immersiveness but also the attitudinal positions it requires players to adopt that may contribute to its potential for offence and controversy, as Tavinor points out (2009: 162). Writers on videogames have previously highlighted a perceived simplicity in videogame attitudes, Poole for instance stating they had still 'not moved beyond the twin poles of attraction and repulsion' (2000: 233). Writing more recently, Tavinor identified an emerging capacity for games to have a 'morally serious point of view' (2009: 168) and to be morally disturbing and provocative as art-forms. In response to *Modern Warfare 2*, specialist videogame journalists noted that this has been a factor preventing videogames from being more widely accepted:

> There is a helplessness for the player in that sequence and games, somehow, are not being allowed to go into that creative territory. It's always somehow supposed to be typified as 'fun' ... I'm not

going to go so far as to say it is right or wrong. I feel that is really in the eyes of the beholder. What I do feel is defensible is it is within [producers'] right to be creative and move into kind of a taboo area for video games.

(Sessler quoted in Snider 2009: 8)

Indeed, the British Board of Film Classification (BBFC) took the narrative context and outcome of the mission into consideration when rating the game. Although ratings officials note that 'video games can be played with the user giving scant regard to the narrative' such as skipping cut-scenes, with *Modern Warfare 2* 'the "undercover" storyline leading to the airport scene was taken into account and most significantly the fact that whatever action the player took ... the player-character would be killed' (Blatch quoted in John 2009). Whilst the BBFC took this into account, critics seem to have missed the clear moral context offered by *Modern Warfare 2*'s narrative framing of the airport massacre mission: the deliberate and overt manipulation of the interactive dynamic foregrounds critical reflection on the part of the player as to their own actions. The game does not, narratively speaking, endorse the actions of the terrorists, and the plot plays out highly conventionally with the hunting down and punishing of the villains of the piece. Perhaps the successful immersion of the gameplay overrode some players' capacity to critically reflect on their own gameplay. Some critics undoubtedly lacked sufficient familiarity with videogame contextual and gameplay tropes to recognize how the game was morally provocative and challenging. Nonetheless the potential for games to be morally transgressive as art forms (Tavinor 2009: 168–9) is clearly, if tentatively, presented in the 'No Russian' mission of *Modern Warfare 2*. It parallels other videogames that offer clear moral dilemmas and consequences for players who make 'good' or 'bad' decisions. Games like *Red Dead Redemption* (Rockstar Games, 2010) and *Heavy Rain* (Quantic Dream, 2010) involve denouements or climactic scenes where player characters are killed, often because of transgressions performed knowingly or otherwise in the course of the game. Arguably then, *Modern Warfare 2* is not an instance of a videogame being irresponsible and sensational, but rather contributing to the maturing of an emerging art form.

Conclusion

Concerns over the game have continued, most notably the January 2011 bombing of Domodedovo Airport in Russia was directly linked

to *Modern Warfare 2*'s 'No Russian' mission by the mainstream Russian media (*Metro*, 26 January 2011). Kneejerk responses to videogames' wider impacts will undoubtedly continue as games become ever more central to the creative and cultural industries, and developers experiment with ever more sophisticated game design. A combination of advances in graphical complexity, gameplay dynamics, and searching for narrative contexts, such as terrorism, that provide the hooks that bring people into games are likely to generate controversy. For instance, the most recent instalment in the *Medal of Honor* series (Electronic Arts, 2010) was set in Afghanistan, and prompted criticism from the British Defence Minister over initial reports that the multiplayer mode would allow players to play as members of the Taliban (this was changed before release to 'the opposing force') (Whitworth 2010). However, these games, just like any other media form, require close analysis rather than superficial dismissal. *Modern Warfare 2* shows that videogame developers are beginning to move beyond just concentrating on making games more immediate and with more immersion and presence. They may also require gamers to reflect on the morality of their actions. For videogame this is the marker not of sensationalist trash, but the emergence of a new aesthetic sophistication.

References

Aaronovitch, D. (2009) 'A Computer Game in which Civilians are Blown to Bits has been Attacked in Parliament. But it's Beautiful, says David Aaronovitch, and Those Who Won't Play are Missing Out', *Times*, 14 November, 4.

BBC (2009) 'Modern Warfare "set for record"', *BBC News Online*, November 10, http://news.bbc.co.uk/1/hi/8351370.stm, date accessed 26 January 2011.

Bolter, J. D. and Grusin, R. (1999) *Remediation: Understanding New Media* (London: MIT Press).

Brookey, R. A. and Booth, P. (2006) 'Restricted Play: Synergy and the Limits of Interactivity in *The Lord of the Rings*: The Return of the King Video Game', *Games and Culture*, 1, no. 3, 214–30.

Calleja, G. (2007) 'Digital Game Involvement: A Conceptual Model', *Games and Culture*, 2, no. 3, 236–60.

Campbell, G. (2009) 'The Brutal Face of War', *Christchurch Press*, 24 November, 9.

Hicks, M. (2009) 'Then Again ... Reject Violent Video Games', *Washington Times*, 11 November, 22.

John (2011) 'The BBFC Talks Modern Warfare 2, Censorship and How They Keep Gaming Standards High', *Not Actual Game Footage*, 6 February, http://www.notactualgamefootage.com/featured-articles/the-bbfc-talks-modern-warfare-2-censorship-and-how-they-keep-gaming-standards-high.html, date accessed 8 February 2011.

Juul, J. (2009) 'Fear of Failing? The Many Meanings of Difficulty in Videogames' in B. Perron and M. J. P. Wolf (eds) *The Video Game Theory Reader 2* (London: Routledge).

Kent, S. L. (2001) *The Ultimate History of Videogames* (London: Prima Publishing).

Manovich, L. (2001) *The Language of New Media* (London: MIT Press).

McMahan, A. (2003) 'Immersion, Engagement, and Presence: A Method for Analyzing 3-D Video Games' in M. J. P Wolf and B. Perron (eds) *The Video Game Theory Reader* (London: Routledge).

Metro (2011) 'Russian TV Blames Domodedovo Airport Bombing on Call of Duty', *Metro*, 26 January, http://www.metro.co.uk/tech/games/853837-russian-tv-blames-domodedovo-airport-bombing-on-call-of-duty, date accessed 8 February 2011.

Murray, J. H. (1997) *Hamlet on the Holodeck: The Future of Narrative in Cyberspace* (New York: Free Press).

Newman, J. (2004) *Videogames* (London: Routledge).

Perron, B. and Wolf, M. J. P. (eds) (2009) *The Video Game Theory Reader 2* (London: Routledge).

Poole, S. (2000) *Trigger Happy: The Inner Life of Videogames* (London: Fourth Estate).

Snider, M. (2009) 'Modern Warfare 2: Creativity and controversy; Morality gets a workout in new game', *USA Today*, 10 November, 8D.

Tavinor, G. (2009) *The Art of Videogames* (Chichester: Wiley-Blackwell).

Whitworth, D. (2010) 'Makers of Medal of Honor do U-turn on Taliban Role', *BBC Newsbeat*, 4 October, http://www.bbc.co.uk/newsbeat/11465565, date accessed 17 May 2011.

Wolf, M. J. P. and Perron, B. (eds) (2003) *The Video Game Theory Reader* (London: Routledge).

16
'A Bad Taste Business': TV Journalists Reflect on the Limits of News Images

Paul Brighton

In the dying years of the nineteenth century, a young journalist wrote to his grandmother about what had become known as the 'dum-dum' bullet. He described how, in the course of his reporting, he 'wrote ... of the appalling effects that the exploding 'dum-dum' bullets used by the British had on the human body. The picture is a terrible one, and naturally it has a side to which one does not allude in print' (Toye 2010: 38). The journalist was Winston Churchill, and he put his finger on an issue which still resonates in the twenty-first century: How much of what actually occurs in conflict can and should be divulged to readers, listeners or viewers of media output? In this chapter I will look at how that dilemma plays out in contemporary television news. How much of what journalists witness can and should be shared with the viewing public? Who makes the final editorial decision where opinions differ? What is the nature of the arguments that take place off screen? More particularly, how do the journalists on the ground reflect on those discussions at the time and subsequently?

In recent years, a number of prominent British television journalists with extensive experience of reporting conflict and terrorism have written autobiographical books. Many of them reflect in passing on occasions where the desire of the reporter in the field to bring home the true horror of scenes of carnage or destruction clashes with the view of the editor or production team back in the studio who fear breaching guidelines of taste or incurring the wrath of an offended viewing public. Some of these volumes of memoirs adopt a considered and extended approach to the issue. I shall examine these published reflections to see how journalists choose to portray these debates in public. The purpose is not to study taste guidelines or broadcasting regulations on screen violence as such, nor to conduct an investigation of visual theories.

Rather, the intent is to explore how, and in what ways, the debate is framed by some of the most prominent exponents of television news. I shall concentrate, as the journalists do themselves, on how this plays out in the recorded television news report, rather than concentrating on exceptional moments (such as 9/11) where it spills over into what is shown live on television. The risk of something beyond generally agreed taste guidelines being shown on live television is always there. The issue in that scenario is usually how quickly and expeditiously it can be removed from view. That risk is not there in the same form in the case of recorded television news reports because a process of selection and editing is central to the construction of the television news 'package' (see Hudson and Rowlands 2007: 279–80).

There is an extensive literature of journalistic autobiographical writing in other nations (notably the US), and there have been instances in other nations where the issue we are exploring has obtruded into the public sphere. But this study focuses primarily on the published writings of British television journalists, and on references to British television output. I have not sought personal interviews with the authors, or any additional (or 'off the record') clarification of the published words, as the point of this chapter is to explore the extent to which these internal debates are deemed fit for inclusion in the published record. The historical development of British television news has been dominated by the BBC and its main terrestrial commercial rival, Independent Television News (ITN), and the examples used here come from people who have all worked for one or both of these important television news organizations.

Michael Nicholson worked for ITN from the 1960s to the 1990s, covering events from Vietnam to the Gulf War. In his memoir *A Measure of Danger*, he wrote of his impressions of the state of television news in the early 1990s:

> Our editors and news producers have a voracious and frantic – nympholepsy is the word I found tucked away in the dictionary that best describes them. It means an ecstasy or frenzy caused by the desire for the unattainable. They also have an insatiable passion for violence. They are bemused by it. The bloodier the offensive, the bigger the coverage; the worse the atrocity, the bigger the by-line. The news agenda has become bloodier and bloodier. At times, it almost borders on titillation.
>
> I once complained to an anonymous face over a large whisky in the Hotel Royale in Saigon: 'Once the bosses were satisfied with a corpse.

Now they must have people dying in action. But when they really do get something that shows what a mortar does to a man, when they see how shrapnel tears the flesh and the blood explodes, they get squeamish. They want it just so. They want TV to be cinema.'

(1992: xii–xiii)

Nicholson's comments – among the first to be written of those we shall examine – are notable for not immediately depicting a scenario of tension between the reporter pressing for more immediacy of impact and a resistant newsroom attempting to persuade the reporter that less graphic images should be shown on grounds of taste. In fact, if anything, the reverse is the case.

Nicholson paints a picture of editors and news producers who are constantly demanding more shocking images, only then to recoil if they don't fit their own apparent template of what extreme violence 'should' look like. Nicholson's former ITN colleague, the late Reginald Bosanquet, a popular newsreader of the 1960s and 1970s, also surprises us with a view of how much could (and could not) be shown at that time. In *Let's Get Through Wednesday* he reminds his readers of a notorious piece of television footage of an American journalist being shot, (although he fails to specify where and when it occurred):

One of the soldiers forced him to lie down on the road and then ... the soldier aimed his automatic weapon at him and pumped bullets into him.

After this had been shown on TV numerous people remarked to me that the piece of film ended very abruptly ... I ... knew precisely why there was that abrupt end. In the version shown to viewers the final bit had been edited out because the American's body had gone into convulsions as the bullets hit it.

(1981: 73)

What might surprise the modern viewer about the account is not the decision (which Bosanquet implies was taken within the ITN newsroom) to omit the convulsions, but that the preceding sections were deemed fit for broadcast. This taste threshold, as I shall demonstrate, by no means remained constant in succeeding years.

David Loyn is a prominent BBC journalist who covered the Balkans conflicts of the 1990s, the 2003 Iraq War, and the conflict in Afghanistan since 2001. His book *Frontline* (2003) is not a personal autobiography, but an account of the Frontline news agency, with whom he worked in

those conflicts. Loyn's book also gives a subtle variation of the stereotype of 'risk-taking journalist/hesitant newsroom staff':

> They [the Frontline agency staff] have a strong sense that the audience should see more of the true horrors of war. Peter [Jouvenal] once told me that he often films things he KNOWS cannot be shown:
> 'If people are tied up and shot in the back of the head, then it's my duty to film it. It might be useful to an investigation later. But if you don't film it, then it's a form of censorship. It's as if the deaths never happened. It may not be YOUR duty to broadcast it, but I feel it is MY duty to film it. I do this all the time – like dogs eating people's faces in Liberia. If you don't do it, then when you send the pictures back as cut stories to people in London they start to think that war is not so bad. They need to be woken up occasionally. It's a message to these editors to wake up. This is a real war.'
>
> (2003: xv, original emphasis)

It is relatively rare to read a public admission by a journalist that they film material which they know will never be transmitted. Yet, interestingly, Peter Jouvenal, the Frontline Agency cameraman he refers to, speaking to Loyn, seems still to be conducting an almost imaginary dialogue with his own peers ('these editors') rather than with the potential viewing public. It is simply that he has resolved to operate pragmatically within the parameters he knows to exist, and not to engage in, or speak of, direct confrontations with news colleagues in the studio.

There are, however, other prominent written accounts of such direct confrontations. Here is BBC journalist and television news presenter Michael Buerk, internationally famous for his reporting of the 1984 Ethiopian famine, writing of an especially violent incident from his time in South Africa in the 1980s:

> It was difficult to know how to edit that night's report. Willie had filmed the murder, close-up and in full detail. Francois was a cleverer cameraman and more aware of the BBC's sensitivities. He had shot it in an impressionistic way. At the moment of the killing, you saw the knives rising and falling but you did not see the blows strike home ... The viewer could tell something dreadful was happening but could not see exactly what it was. ... I wanted to yell: 'Look at this! This is reality! This is what it really means!' ...
> The news editor I badgered half the night obviously thought I was cracked. He cut out all references to a murder. He left that glimpse of

'For Buerk, the point of
television reporting is "to get hold
of a story and then tell it well".
He is a master of the art.'
DAILY TELEGRAPH

The Road Taken

Michael
Buerk

AN AUTOBIOGRAPHY

'Brilliantly written... The story of his extraordinary life'
DAILY MAIL

Figure 16.1 Michael Buerk's account of war reporting, *The Road Taken*, 2004

pure evil on the cutting-room floor to save the BBC1 viewers from anything that might upset them. Who is to say he was wrong? I did, then and later. Now ... I am not so sure.

(2004: 316–17)

Buerk's is a classic account of the on-the-spot journalist, having secured strong and shocking footage, wanting to transgress the norms of television news, and engaging in a heated debate with the people 'back home'. He is more concerned than other writers to do so specifically for the impact it will have on viewers than for its 'educational' value for newsroom colleagues on the reality of violence. His subsequent admission of the loss of certainty is both tantalizing and arguably characteristic of the apparent open-mindedness and empathy which enabled him to make the transition from on-the-road journalist to studio presenter much more readily and convincingly than many of his journalistic colleagues. Unusually, Buerk was given another chance to revisit the original decision, in the shape of a subsequent *Everyman* documentary:

> I included the murders I had witnessed, including the terrible township butchery that News had refused to broadcast. We had to fight for it against those who felt it was just too dreadful to be shown ... 'You can look away', I said at the end of my introduction. 'I could not'.
>
> (2004: 344)

Buerk goes on to recount how he expected a much tougher fight to secure permission for its broadcast. The reason for his relatively easy victory, he tells us, was the BBC management's current preoccupation with the evils of bad language, 'the boy being cut to pieces was one thing. The top management did not want to hear the word "fuck"' (ibid.: 344).

Another classic piece of writing on this subject is a chapter in Martin Bell's book *In Harm's Way* (1995). Bell worked at the BBC covering conflicts from the 1960s to the 1990s, notably the Balkan conflict of the early 1990s, before briefly swapping journalism for politics in the late 1990s. In describing how he covered the death of Overseas Development Agency driver Paul Goodall in Bosnia in the winter of 1993–4, Bell writes of a conversation with a colleague:

> There was an anxious voice from the duty editor in London asking what I had got to offer. I told her, not very much ...
> 'You are not including any' – there was a hush in the tone and a long and awkward pause – 'BODIES, are you?'

'No,' I said. 'There's only one. It's in the camp, and the subject of an autopsy. Absolutely no bodies, I assure you.'

'Nothing that will upset people?'

'Well, the story itself is pretty upsetting, especially to the families, and they've been told. It IS a murder, you know, and a particularly brutal one.'

And then the voice said, 'Is there BLOOD? We don't want to see any blood, at least not before the nine p.m. watershed. It's in the guidelines, you know.'

Actually, I didn't know. And of course there was blood.

(1995: 211–12 original emphases)

This is a classic account for a number of reasons. It was one of the earlier examples of the recent crop of such autobiographies. Bell was (and remains, even after he has taken on different roles) one of the most recognizable of his profession, and he brings something of the novelist's art to his description of the conversation. He subjectivizes the dialogue and his description not just of the words but of the manner of their delivery ensures that his is the viewpoint the reader is likelier to empathize with. Like other writers in this genre, the author is seen as the fearless battler for truth, while his interlocutor is seen as rather lily-livered and excessively preoccupied with protecting viewers' sensibilities (and perhaps, we might infer, her own career). After reflecting on the way the BBC responds to audience research and feedback, Bell goes on to assess the nature of the debate within the BBC:

I believe we should listen to the audience and respond to its concerns, but in the internal BBC debate about the depiction of real world violence only one side has been heard, and it hasn't been the side of the BBC's troops in the trenches.

(ibid.: 213)

Bell cites the example of an incident in Vitez, Bosnia, in 1994, in which mothers and wives face the realization of their worst fears – the torture and execution of their sons and husbands:

These images also fell foul of the 'good taste guidelines': Even mourning was put out of bounds. The reports still ran, of course ... But all that was left in them was the 'bang-bang', apparently heroic pictures of camouflage-clad figures blazing away amid the ruins ... It was about as close to reality as a Hollywood action movie.

(ibid.: 214)

Bell's account is arguably the most thorough and thoughtful of all the accounts examined here. Just as the reader thinks he is building up a formidable indictment of the organization and the profession he would shortly afterwards leave for politics, he shows some of the same ambivalence as Michael Buerk. He comments:

[W]e were not only sanitizing war but even PRETTYFYING it, as if it were an acceptable way of settling disputes, and its victims never bled to death but rather expired gracefully out of sight. How tactful of them, I thought.

(ibid.: 214 original emphasis)

But this does not imply that there should be no limit to what is shown on screen 'yes, we do self-censor. Even those of us who resist the external censorship of real-life violence find images that we have to leave, as we used to say, on the cutting-room floor' (ibid.: 215). After citing as an example the mortar bombing of Sarajevo marketplace in 1994, Bell also refers to the burning to death of a Muslim family in Ahmici in 1993, and says, 'in the end I used a single picture, a close-up of a burned hand, as emblematic of the rest, and even that was hard to include, though necessary' (ibid.: 216). Bell also tells us that, in reporting this family massacre:

=I found that for the first time in my life the words would not come out. Horror paralysed thought. I was reminded of Elie Wiesel who said ... 'There are things I cannot say ... I cannot say them.'
 In the same way, there are things we cannot show ... we cannot show them.

(ibid.: 216)

Of course, chronology and evolution are important in all this. One of the most significant and thoughtful considerations of these issues in more recent years comes from the pen of Jeremy Bowen. At the time of writing, Bowen is BBC Middle East Editor, having previously covered Afghanistan, Bosnia, Kosovo, Chechnya, Somalia and Rwanda since the late 1980s. In his memoir *War Stories*, Bowen writes:

[D]eglamorising war on television can mean showing pictures of horrific events and telling stories that are hard to take. In Britain the editors of news programmes are less squeamish now than they were in

the 1990s. Once during the Croatian war in 1991, a released prisoner told me in an interview how he had been tortured, and went into some of the gory details. One programme editor asked me to cut it because what he was saying was 'too shocking'. We were not seeing it, just hearing his story, but she wanted a report that danced around what had happened but didn't show it and hardly described it. That probably would not happen now.

(2006: 217–18)

However, he counters this with an account of his work on the Bangladesh flood of 2005:

I had arguments ... with programme editors who did not want any pictures – not even one, distant shot – of dead people in my reports. I pointed out, more and more loudly, that the only reason I was in the country was the body count. It didn't make much difference. Reporters in the field had – and to some degree still have – a running dialogue with London about the portrayal of death ... The custom now is that corpses can be shown in moderation if they are filmed 'tastefully', usually after nine o'clock ... The images do almost nothing to show what high explosive, or high-velocity bullets, or hunger or disease, can do to the human body, but they show that life is extinct.

(ibid.: 219)

The scenario of the frustrated journalist in the field, seared by his experiences, and the nervous (and, perhaps, back-watching) duty editor remains unchanged despite the passage of years since Nicholson, Bell and Buerk were conducting similar conversations. Indeed, there is continuity, despite the changes Bowen notes, not merely with his older peers quoted above, but with Churchill's comments from the 1890s. It is also worth noting the vagueness of the phrasing in different accounts about 'guidelines' or 'the custom'. We recall that Bell drew attention to his unawareness of 'the guidelines', and Bowen refers to 'custom' in a way which sounds more like an unwritten, almost instinctive or intuitive, understanding rather than a written code of conduct. Interestingly, Peter Sissons, whose career from the 1960s to 2010 encompassed reporting and presenting with ITN and Channel 4 as well as a lengthy stint as a BBC news presenter, implies a potential recent change to this vagueness in his memoir *When One Door Closes* (2011). He describes the establishment of the BBC's College of Journalism after the Hutton

Inquiry into the BBC's reporting of the Government's case for the 2003 Iraq War, and notes:

> COJO, as it became known, started with a handful of people in a room making simple training videos on dilemmas reporters and producers might face – such as how much the camera should dwell on explicit scenes of violent death and carnage when reporting wars or terrorist atrocities.
>
> (Sissons 2011: 275)

However, perhaps tellingly, COJO is seldom referred to in other, more recent autobiographies.

John Simpson is currently the BBC's World Affairs Editor, and has covered many of the major conflicts of recent decades alongside others referred to here. He has also served (somewhat uncomfortably, by his own admission) as a newsreader and political editor as well as a foreign correspondent. In his book *The Wars against Saddam* (2003), Simpson registers what almost sounds like frustration with many journalists' inability, in the Gulf War of 1991, even to have a chance to be presented with dilemmas of taste and judgement:

> This was a war fought out between more than half a million soldiers, yet no journalists working within the American or British pool system saw any fighting with their own eyes, or obtained a single image of a dead body.
>
> (Simpson 2003: 199)

However, Simpson reports frustration of a more recognizable type in another of his books, *Not Quite World's End* (2007). Writing about an atrocity in the aftermath of the 2003 Iraq conflict, he describes the terrible scene in a hospital after a Sunni insurgency bombing:

> The floors of the corridors swam with blood, and groans and screams filled the place. I have seen this kind of sight many times, and, believe me, you will never forget it for as long as you live ... All together, twenty-seven people had been killed and more than sixty injured: by that stage, a moderate death toll. I was in the BBC bureau in Baghdad that day, and although we had some terrible pictures of the aftermath of the explosion ... I couldn't persuade my colleagues in London to take a report from me about it.
>
> 'If more people had been killed ...' someone said to me regretfully down the line from Television Centre.

The days when five or ten deaths in Iraq seemed worth reporting were long past. Now it had to be seventy plus.

(Simpson 2007: 181)

The scenario of the reporter desperate to disseminate the news he has just encountered recalls the earlier accounts of Bell, Buerk and Nicholson. However, the reasons given for the difference of opinion have changed pretty dramatically. From the earlier struggles to bring home the full horror of a story over whose news value there was no disagreement, we have moved to a position where it is the newsworthiness itself that is at issue, not the extremity of the images involved. Why 'seventy plus' as against 50 or 90?[1]

Simpson's earlier complaint (2003: 199) about the lack of opportunity even to be faced with the dilemmas we have outlined here may have its roots in a debate recounted by Knightley (2003). He quotes the director of CBS News in Washington, William Small:

When television covered its 'first war' in Vietnam it showed a terrible truth of war in a manner new to mass audiences. A case can be made ... that this was cardinal to the disillusionment of Americans with the war, the cynicism of many young people to America, and the destruction of Lyndon Johnson's tenure of office.

(in Knightley 2003: 451)

Subsequent attempts by the US and UK military to limit journalistic access to combat (already notable in the Falklands War, Grenada and Panama) had made it possible for John Simpson to make the assertion about the 1991 Kuwait War already quoted. Although extensively documented elsewhere, and not our main concern here, it did have some effect on the kinds of exchanges we have been studying between journalists and production staff 'back home'. The subsequent tendency to encourage 'embedded' journalists may also have changed the nature of the exchanges, although it is more difficult to cite published auto-biographical material to this effect. 'Embedding' is the practice whereby journalists spend extended periods of time living with, and sharing the experiences of, a particular military unit and reporting conflict from the perspective of that specific grouping. It remains a sensitive issue for journalists because of the perceived risk of over-identification with the troops whose experience they are sharing, and the consequent effects on their reporting. There has been less of a rush into print by 'embeds', perhaps because the ethical position of embedding as a journalistic

practice has yet to be resolved within the profession itself. To put it at its gentlest, it may not be something journalists wish to draw especial attention to in their published musings on their profession.[2]

Something of this ambivalence is caught by Kate Adie in *The Kindness of Strangers* (2002). Adie's career embraced radio as well as television, but much of her memoir covers her time as a BBC television reporter covering a range of conflicts in the 1980s and 1990s. Although not an 'embed' in the twenty-first century sense, Adie recalls her role in the 1991 Kuwait War:

> Censorship and journalism, especially with regard to military matters, are uncomfortable bedfellows. But, by deciding to be alongside the army in uniform, we had at least signalled to viewers that we had in some way 'done a deal', and changed position from that of completely independent reporters to that of Official War Correspondent.
>
> (2002: 331)

One of the consequences of this decision, Adie records, is that, in discussion with army press officers, four words dominated: Strategy and Tactics; Taste and Tone (ibid.: 331). The last two were accepted as the province of the media alone, and, just as Adie says there were only two direct army requests for censorship during her reporting of the 1991 War, she implies that there were few important internal media disputes. (If there were, they go unrecorded). Adie also notes some recent changes in television news:

> Some bulletins, without any public discussion or announcement, began to acquire a more 'popular' feel: more consumer-orientated, more feature-driven, and with a determined suppression of pictures of violent reality. Not a corpse to be seen before nine o'clock.
>
> (ibid.: 344)

So how, in this climate, does one give a sense of events lying outside the mainstream of most British television viewers' experience? It is a dilemma that applies to incidents such as public executions as well as to combat footage. In *Strange Places, Questionable People* (1999), John Simpson describes at some length a public execution in Afghanistan in 1996. Simpson makes a point of clarifying that it took place just before the Taliban took over Kabul, and that it was staged by the predecessor Rabbani government precisely to display its own willingness

to embrace the kind of strict measures later associated with their successors:

> It took us a lot of effort to get the kind of pictures which would avoid showing the nasty reality of what we had observed. All we used when the pictures were edited were shots of the three [executed men] standing in front of the gallows, but not having the nooses put around their necks; the cross-tree bending under the weight of the first and second hangings; the eager faces of the onlookers; the shadow of Nicmohammed's feet on the ground [one of the executed men]; and a distant wide shot of the three hanging there side by side. Even so, there were complaints from viewers. There always are.
>
> (Simpson 1999: 500)

It is instructive to compare Simpson's account of these executions with his extended section in *Not Quite World's End* (2007: 56–7) of the 2006 execution of Saddam Hussein. In the later account, Simpson is less preoccupied with explaining to us how much of the videos released on the Internet could and could not be shown on television news. He is more at pains to relate the differing impacts made by the two films of the execution. The first was deemed relatively 'dignified' (if such a term could ever be attached to an inherently violent act). It was without sound, and presented what looked like an almost consensual procedure. The second, with audio, left an entirely different impression, with the taunts, the chanting of Moqtada al-Sadr's name, and other last-minute indignities.

The debate over how much can be shown on mainstream terrestrial news bulletins has, for Simpson as for the rest of us, now arguably, become less vital – though clearly it still takes place. In an environment in which most television viewers with a computer know that they have the option to search the Internet for footage censored by television, the mainstream media's former role as the sole and ultimate arbiter of what is or is not suitable for the public sphere has largely gone. However, the sensitivities of television viewers must still be respected, whether or not they make an individual decision to seek out the uncensored Internet footage (see, for instance, Allan 2006: 27–8). Sometimes, the reporter's own subjective impressions are crucial in deciding what constitutes a powerful (and thus almost inevitably controversial) image. Gavin Hewitt is currently a senior BBC reporter whose career ranges from the 1980s to the present. In the early part of his career, Hewitt worked

in Northern Ireland, and witnessed Protestants ransacking a Catholic church in East Belfast in the 1970s:

> Just as we were walking away I saw a boy – aged about eight or nine – holding a statue of the Virgin Mary upside down and smashing the head against the edge of the kerbstone. In a second I knew this was the shot, this was the one moment that captured the blind tribal hatred ... I had to have the picture and I shouted at the cameraman. Even as we lined up the shot, rocks began landing around us. ...
>
> Afterwards the cameraman avoided me. He did not want to work with me again. In my ambition to capture the story he thought I had been careless of those around me.
>
> (2005: 4–5)

Here, we are dealing with the essence of journalistic instinct. Almost by definition, the destruction of a religious symbol or icon is relatively more or less shocking depending on the denominational persuasion of the viewer – though, at the same time, there is no reason whatsoever why a different sort of Protestant should not find such an image deeply disturbing as well as a Catholic. Media organization guidelines may seek to prescribe what forms or degrees of maiming or mutilation might be shown on the assumption that audience responses will be formed more by personal sensitivities than by religious or spiritual factors. In a case such as this, the controversial status of the image is for different reasons, and on a different register, although the shock itself may be no less profound.

Let us look at one more example of a report pushing at the edges of what can be shown on television news. Jon Snow has been the presenter of Channel 4 News in Britain for many years, having previously been an ITN field reporter covering conflicts in places such as El Salvador in the early 1980s. During his first stint there, he sometimes came upon sights that he knew were too shocking to broadcast:

> On one occasion the bodies of eight peasants were laid out on one side of the road, while their heads stood upright in the grass on the other. Sometimes the pictures were altogether too gruesome to transmit.
>
> (2005: 182)

However, on another occasion, the edges of the acceptable were reached and successfully navigated:

> Perhaps a hundred or more bodies were there on the day we went. They ranged from fleshless skeletons to very fleshy leavings, on

which perhaps an eye had been pecked out and a gunshot wound seeped from the chest. I felt physically sick, but Sebastian [Rich, cameraman] insisted I must do a report to camera in the fullest possible context of the bodies. 'Only then will they wake up to what is happening here,' he said. He was right: the shattered look of the reporter against the black backdrop peppered with bones and corpses was so shocking my editors were only just able to run it.

(ibid.: 182)

No intrepid reporter battling nervous, career-watching backroom staff in this account, but a bewildered reporter being prodded by a new cameraman on his first war zone assignment, pushing Snow into something intended to raise audience awareness of the scale of the conflict there.

Even after the often tricky negotiations between the newsroom and the field over what should or should not be shown on screen, sometimes there remains one more hurdle to overcome. Here is Martin Bell, on an incident in the fighting between Muslims and Croats in Bosnia in 1993:

[T]he front line shifted to the grounds of a mental hospital in ... Fojnica ... The hospital itself was in no man's land, its staff had fled, and its demented patients were wandering about in both sides' line of fire as helpless as children ... I had wished to end my report with the thought that this was what the conflict had come to, and there could hardly be a crueller image of it than a madhouse in a war zone. I was told that the use of the word 'madhouse' was no longer admissible: there were people who might be offended by it. I tried to make the case but in vain. The issue was a small one, but it seemed to me to be symbolically quite important.

(1995: 224)

On this occasion, the images themselves were deemed broadcastable. The true offence resided not in the sight of the mentally ill as helpless and entirely innocent victims being victimized by a conflict beyond their understanding, but in the use of a word no longer deemed politically correct in 1993. As with Buerk's account of management's aversion to the rogue expletive, for Bell, editorial pitfalls can lurk as much in a misplaced word as in a truly disturbing visual image.

What, then, do these published reflections tell us about the way television news handles extreme images of violence and conflict? And what role does the expanding genre of journalistic autobiography play

in its presentation to the viewing public? It is likely that the reader's empathy is often nudged into alignment with the perspective of the harassed, often vulnerable reporter in the field, rather than with the newsroom-based (and invariably nameless) editor or bulletin producer. However, these examples show that opportunities to caricature or exaggerate these perspectives are largely avoided. Indeed, on a few occasions, there is a decided ambivalence, and the published record becomes a space for retrospective self-challenge, not self-justification. Just as the conventional image of political memoirs is of self-justification and infallibility, so the perception of journalistic autobiographies is that they tend towards self-dramatization. In reality though there is a much more nuanced range of accounts. Journalists admit to knowing little about precisely what guidelines they are operating within. The accounts remind us that many reporters operate (or say they operate) on an almost intuitive sense of what is and is not broadcastable but, in different ways, they record themselves as consciously challenging and testing the limits of what the newsroom teams and the viewing public, whose interests newsrooms may see themselves as protecting, deem acceptable.

The accounts we have studied are, in large measure, free of the more overt forms of self-glorification. Rather, they provide initial framings for a debate which has rarely been unveiled in public before. To some extent, we have seen the reinforcement of the stereotype of the fearless, questing reporter overcoming the timidity of back-watching colleagues in the safety of the newsroom. However, in pulling the curtain aside, the authors present us with a range of new perspectives on the often uneasy balance between reporters, newsrooms and viewers.

Notes

My thanks to University of Washington colleague Magdalena Dushanova for her help in the preparation of this chapter.

1. See Brighton and Foy (2007: 32–4) for a discussion of the apparently inexorable laws of mathematics often invoked in these circumstances.
2. For a useful discussion of the origins of and issues surrounding embedding, see Knightley (2003: 531–4).

References

Adie, K. (2002) *The Kindness of Strangers* (London: Headline).
Allan, S. (2006) *Online News* (Maidenhead: Open University Press).
Bell, M. (1995) *In Harm's Way* (London: Hamish Hamilton).

Bosanquet, R. (1981) *Let's Get Through Wednesday* (London: New English Library).

Bowen, J. (2006) *War Stories* (London: Simon and Schuster).

Brighton, P. and Foy, D. (2007) *News Values* (London: Sage).

Buerk, M. (2004) *The Road Taken* (London: Hutchinson).

Hewitt, G. (2005) *A Soul on Ice: A Life in News* (London: Macmillan).

Knightley, P. (2003) *The First Casualty* (3rd edn) (London: Andre Deutsch).

Hudson, G. and Rowlands, S. (2007) *The Broadcast Journalism Handbook* (Harlow: Pearson Longman).

Loyn, D. (2006) *Frontline. The True Story of the British Mavericks Who Changed the Face of War Reporting* (London: Penguin).

Nicholson, M. (1992) *A Measure of Danger* (London: Fontana).

Simpson, J. (1999) *Strange Places, Questionable People* (London: Pan).

Simpson, J. (2001) *A Mad World, my Masters: Tales from a Traveller's Life* (London: Pan).

Simpson, J. (2002) *News from No Man's Land: Reporting the World* (London: Macmillan).

Simpson, J. (2003) *The Wars against Saddam: Taking the Hard Road to Baghdad* (London: Macmillan).

Simpson, J. (2007) *Not Quite World's End: A Traveller's Tales* (London: Macmillan).

Sissons, P. (2011) *When One Door Closes* (London: Biteback).

Snow, J. (2005) *Shooting History* (London: Harper Perennial).

Toye, R. (2010) *Churchill's Empire* (London: Macmillan).

Index

Printed and bound in the United States of America